LIGHTING

LIGHTING

Edited by Marta Feduchi Photography by Jordi Sarrà

HARPER
DESIGN

An Imprint of HarperCollins*Publishers*

GOOD IDEAS LIGHTING
Copyright © 2005 by HARPER DESIGN and LOFT Publications

First published in 2005 by:
Harper Design,
An Imprint of HarperCollins*Publishers*
10 East 53rd Street
New York, NY 10022
Tel.: (212) 207-7000
Fax: (212) 207-7654
harperdesign@harpercollins.com
www.harpercollins.com

Distributed throughout the world by:
HarperCollins International
10 East 53rd Street
New York, NY 10022
Fax: (212) 207-7654

HarperCollins books may be purchased for educational, business, or sales promotional use.
For information, please write: Special Markets Department HarperCollins Publishers Inc.,
10 East 53rd Street, New York, NY 10022

Executive editor:
Paco Asensio

Photos:
Jordi Sarrà

Text:
Marta Feduchi

Editorial coordination:
Aurora Cuito

Art director:
Mireia Casanovas Soley

Graphic design and layout:
Cris Tarradas Dulcet

Library of Congress Control Number: 2005925394

ISBN 0-06-074794-3

Printed by:
Anman Gràfiques del Vallès, Sabadell. Spain

D.L: B-29.053-05

First Printing, 2005

Lighting 6

Natural Light

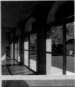

Direct Daylight 14

Diffused Daylight 38

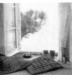

Light from Behind
and Above 58

Artificial Light

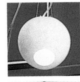

Light to Create an
Ambiance 94

Task Lighting 204

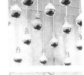

Decorative Lighting 226

Lamps 326

Collaborators 330

Lighting Shops
and Companies 332

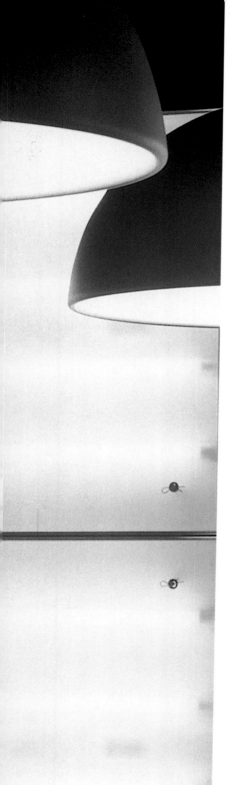

LIGHTING

This book is based on the premise that light is the radiation that makes objects visible. Thus, the purpose of this book is not to provide technical information about the concept of lighting, but to observe the effect of beams of light introduced into the interior architecture of houses.

Lighting is linked to the senses. Thus, light defines the spaces in which we live and in which our desired ambiance is created. Our basic knowledge of lighting revolves around the effect of sunlight on objects, depending on the angle of incidence on the subject. Light and shadow situate us in the space. If we examine the position of the sun in its journey from dawn to dusk, we experience the different visual registers suggested by each moment of the day.

In architecture, the positioning of houses and the distribution of windows and skylights determine the natural lighting in an interior. Home interiors have—depending on their geographic location, to which their architectural configuration must adapt— a characteristic lighting. The size of the windows, the orientation of the terrain, the materials, and other ways of making optimal use of the light are a product of the country in which the home is located.

Over the next few chapters, we will explore the four key groups of natural light: direct daylight, diffused daylight, light from behind, and light from above.

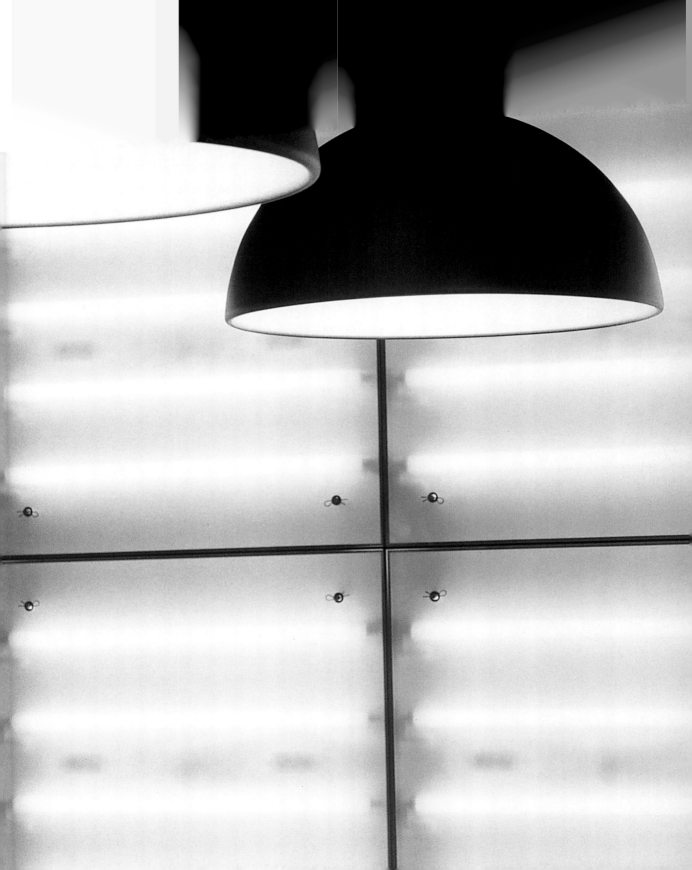

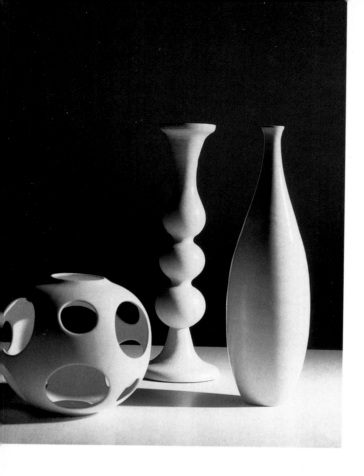

Direct Daylight

Direct Daylight

Direct daylight is the effect of sunlight hitting spaces or objects, producing a very marked sensation of light and dark. In both the well-lit and the darkest parts of the room, the colors and tonalities are well defined. Depending upon the angle of the light, the contrast may be sharpened even further. This is a lighting technique that, despite its harshness, perfectly defines all shapes and textures.

Diffused Daylight

Diffused Daylight

Diffused daylight is the result of filtering sunlight through translucent materials such as roller blinds, curtains, and shutters. This diffusion achieves a very soft effect, with low contrast, making it possible to fully appreciate the entire range of colors. In other words, the light/dark effect is much more subdued. This type of light is considered the most pleasant for interiors because it lends forgiving, soft light to the entire room, producing a feeling of peacefulness and comfort.

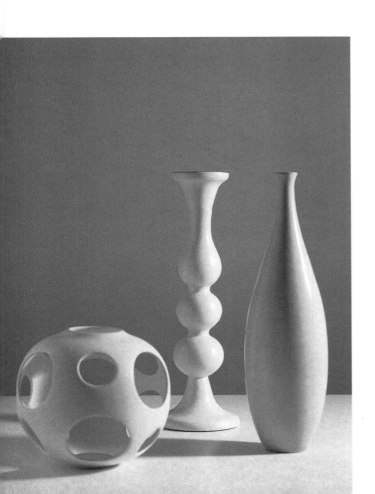

Light from Behind

Light from Behind

Light from behind, or back light, is produced when the source of light is opposite our viewing angle. All objects between these two points appear in silhouette. In other words, the images stand out against the source of light and almost nothing can be seen but their shape. If the point of light is higher than our viewing angle, though, it defines the textures of the images perfectly; and in any event the frontal light that is received always bounces off any surface.

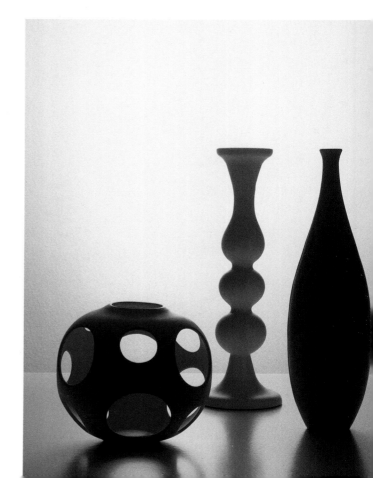

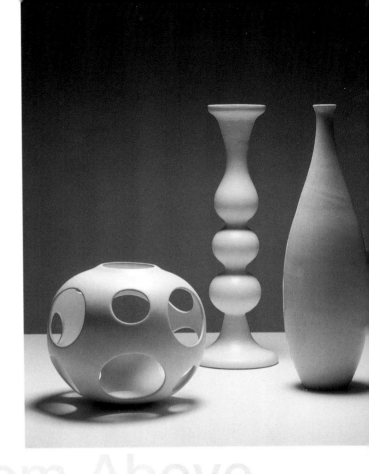

Light from Above

Light from above, or zenithal light, comes from the ceiling through such openings as skylights and clerestories. This light may be direct or diffused. Due to its vertical direction, light from above is distributed perfectly throughout a space and defines all the nuances, shapes, and textures of a room, though more precisely if it is diffused. Because of its all encompassing nature, this light is often used in visual arts and architecture studios.

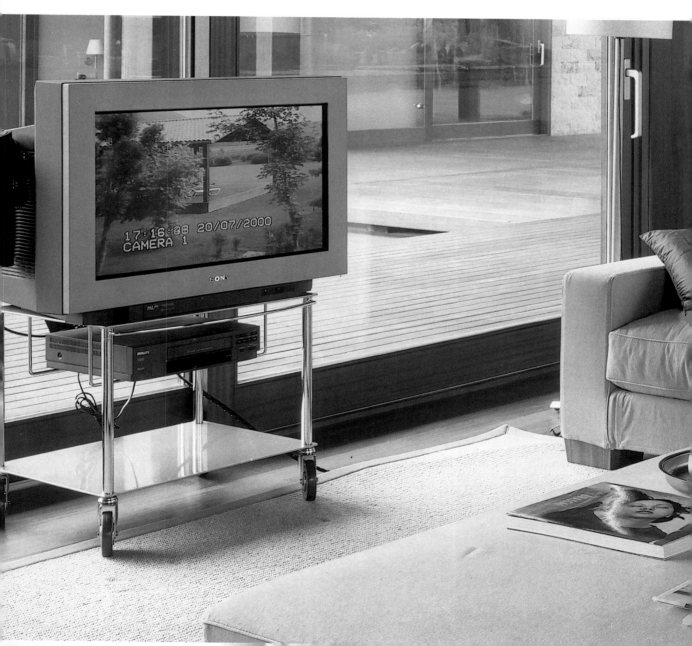

Natural Light

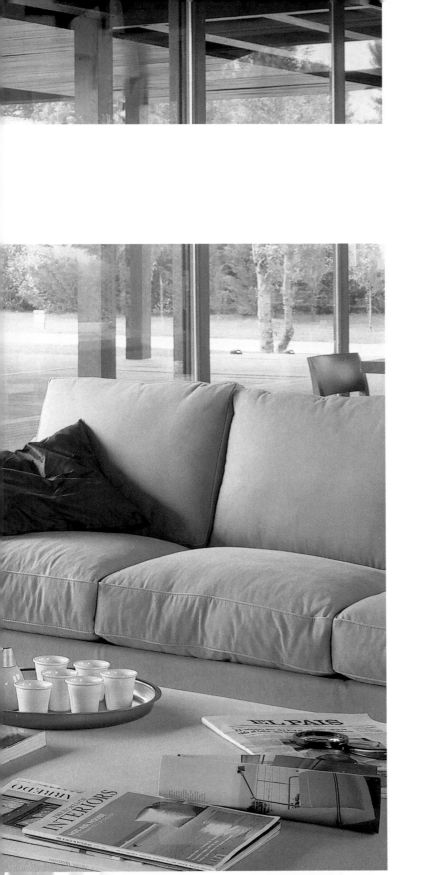
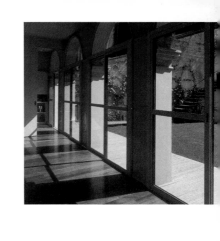
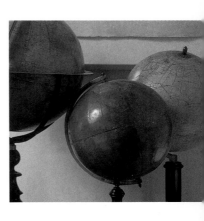
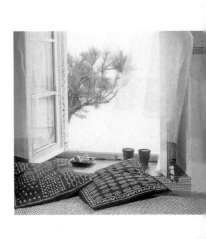

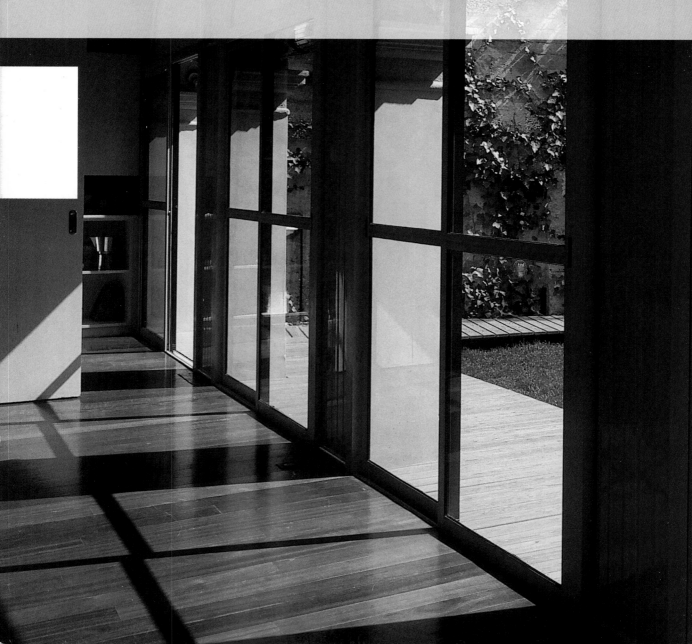

Direct Daylight

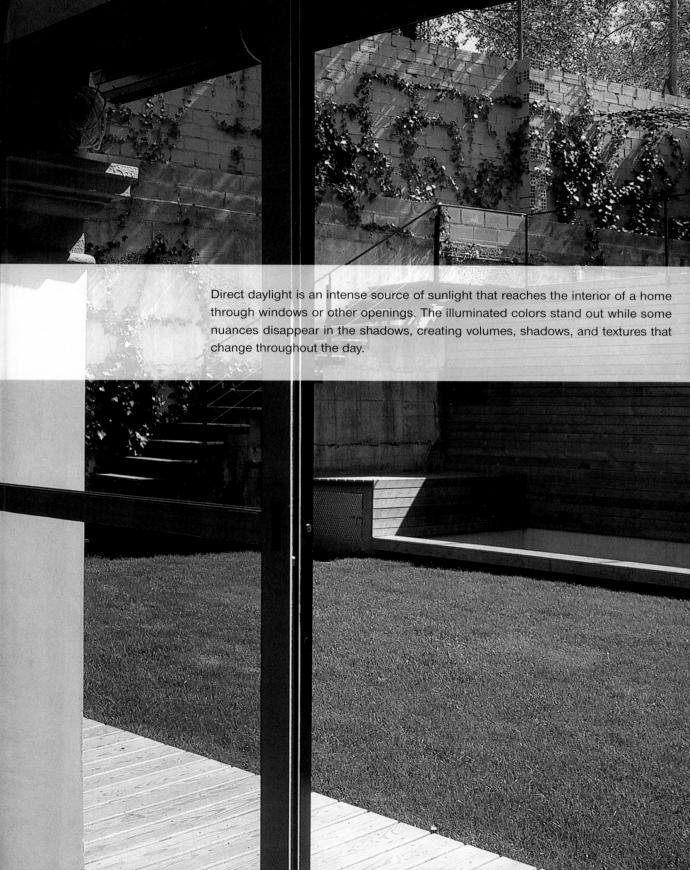

Direct daylight is an intense source of sunlight that reaches the interior of a home through windows or other openings. The illuminated colors stand out while some nuances disappear in the shadows, creating volumes, shadows, and textures that change throughout the day.

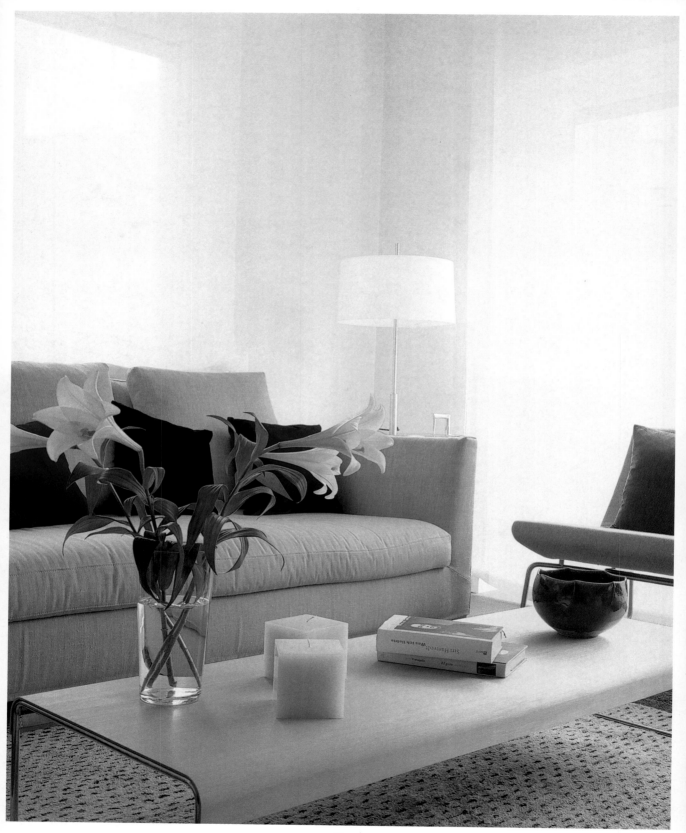

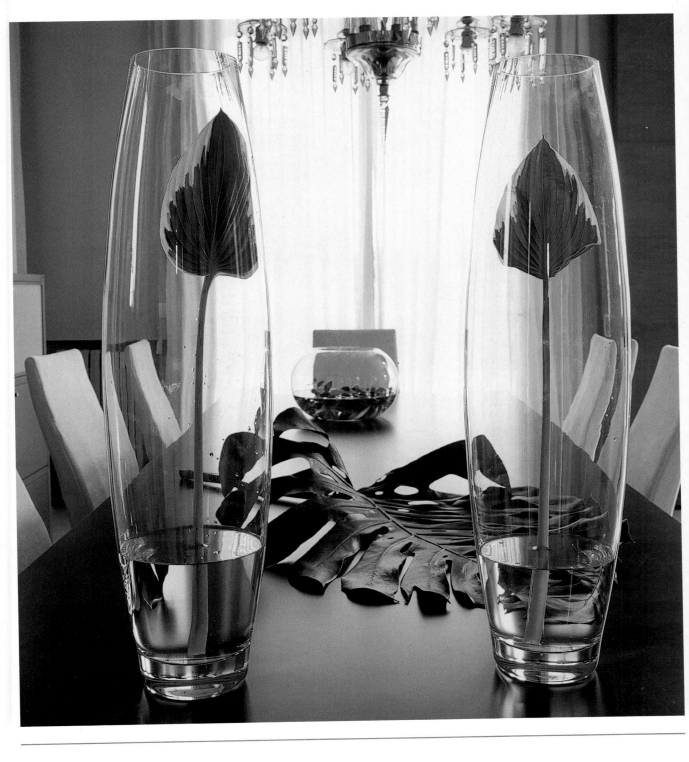

Natural light illuminates glass and china pieces on a dark wood dining room table next to the window, accentuating the light and dark tones that characterize the space.

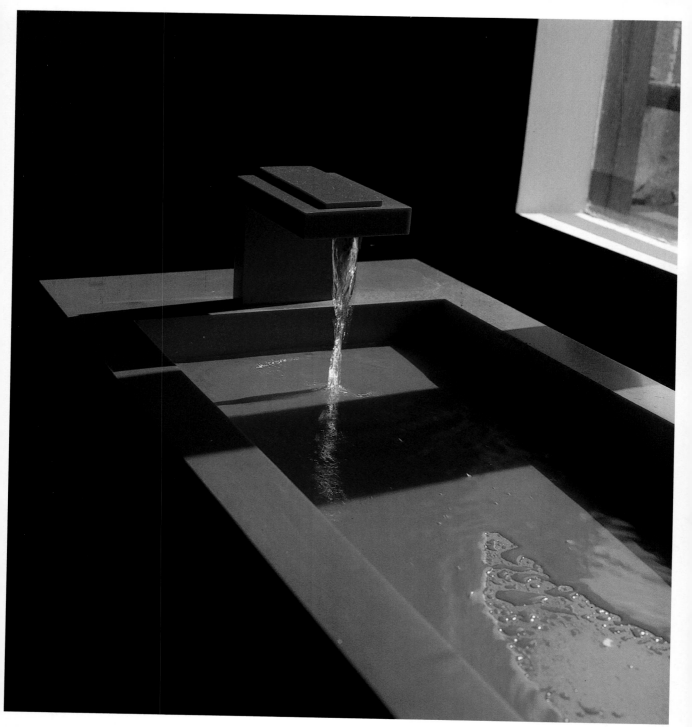

Placing the washbowl next to the window provides natural light for the entire room while producing a relaxing reflection on the water.

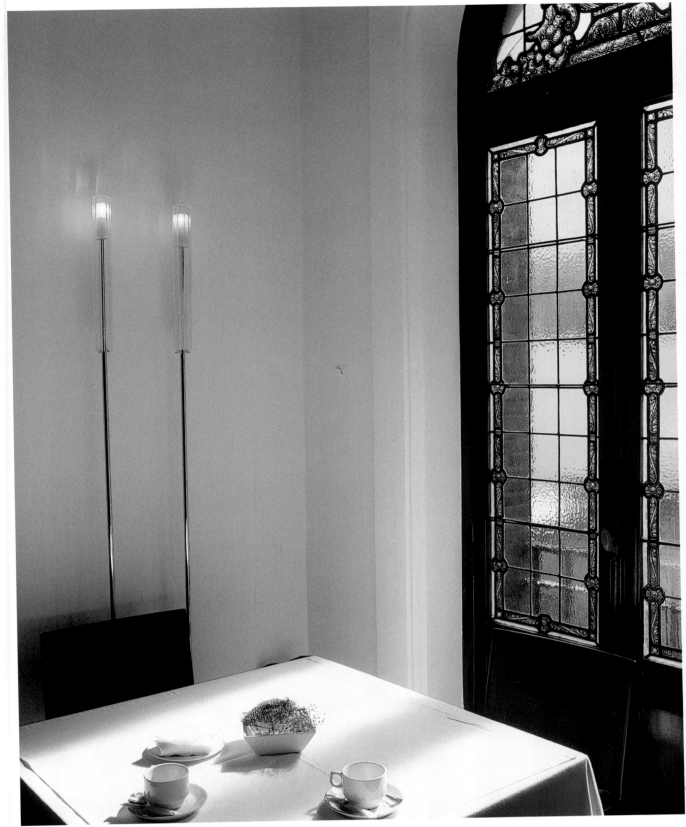

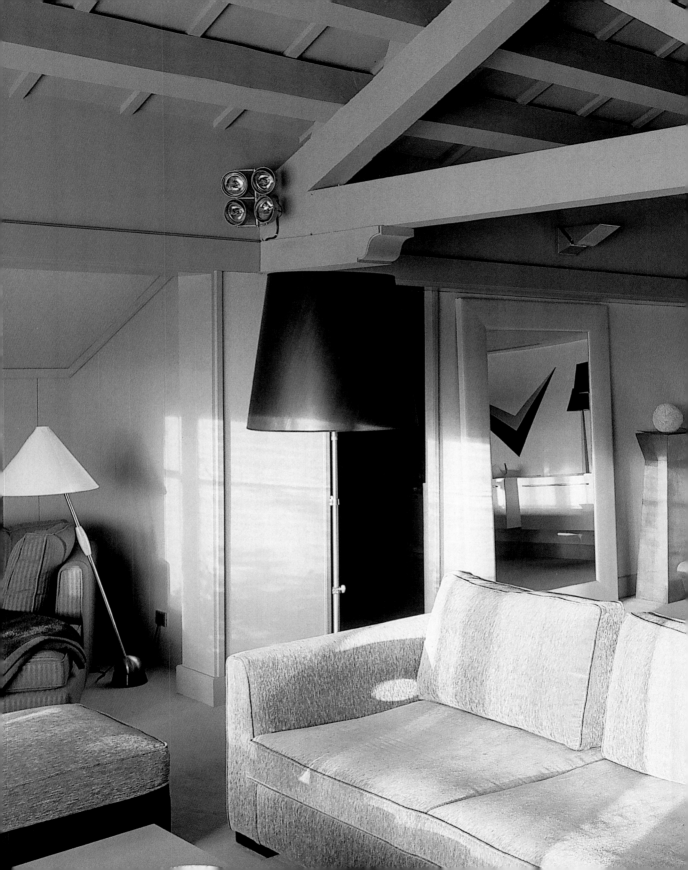

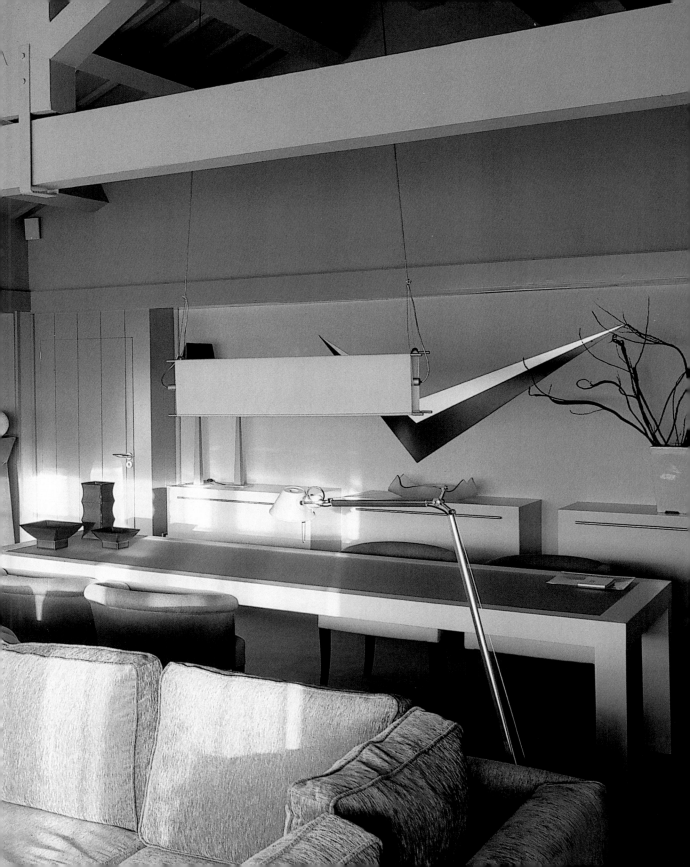

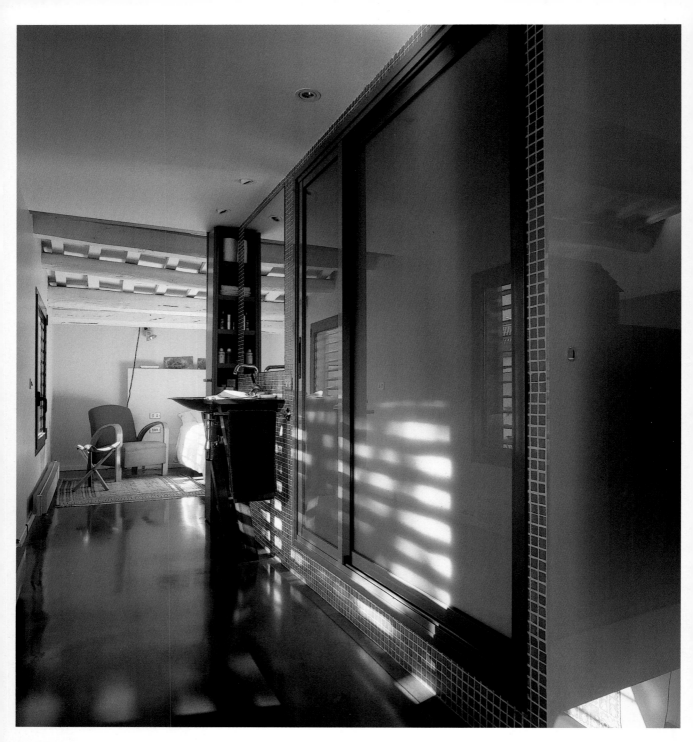

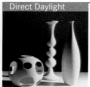

Natural light entering through the slatted blinds on the side produces this pattern on the bathroom partition.

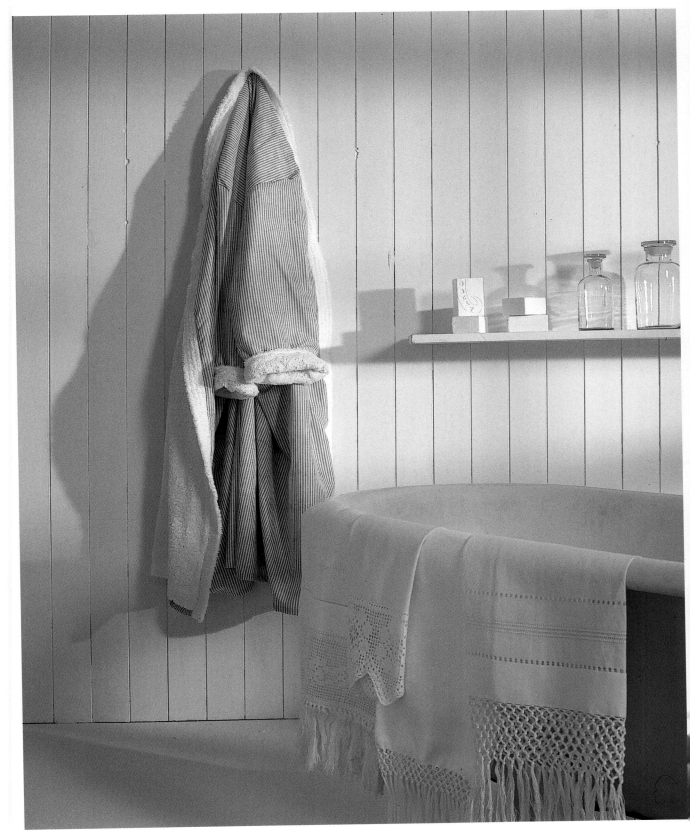

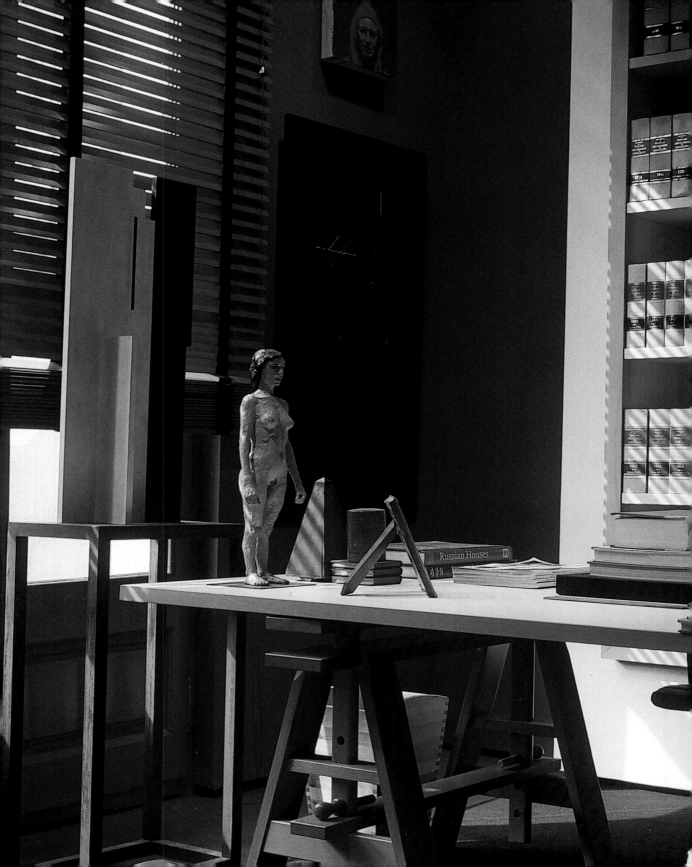

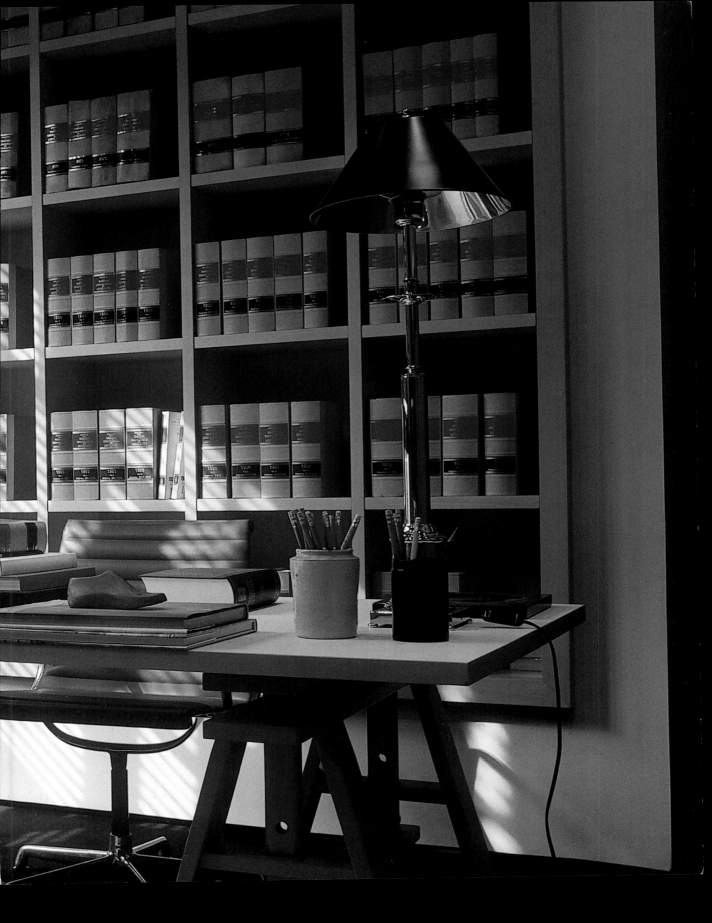

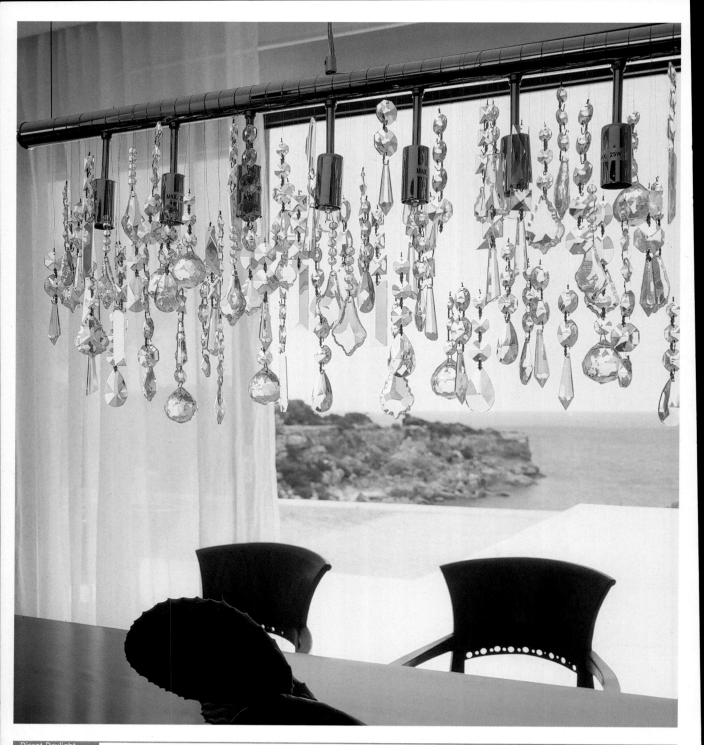

The glass teardrops of this modern chandelier refract the natural daylight that enters through the terrace, creating a luminous, sparkling effect inside the dining room.

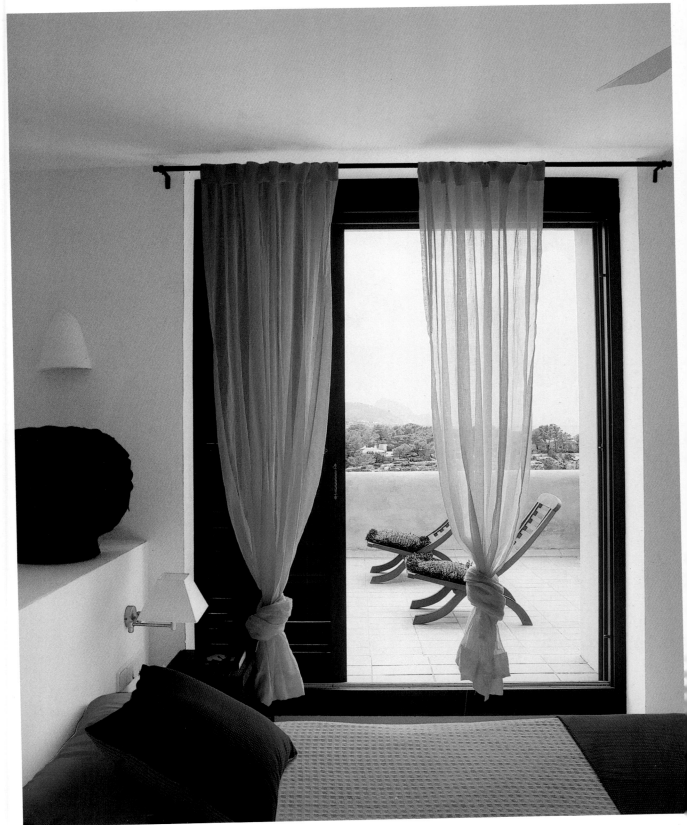

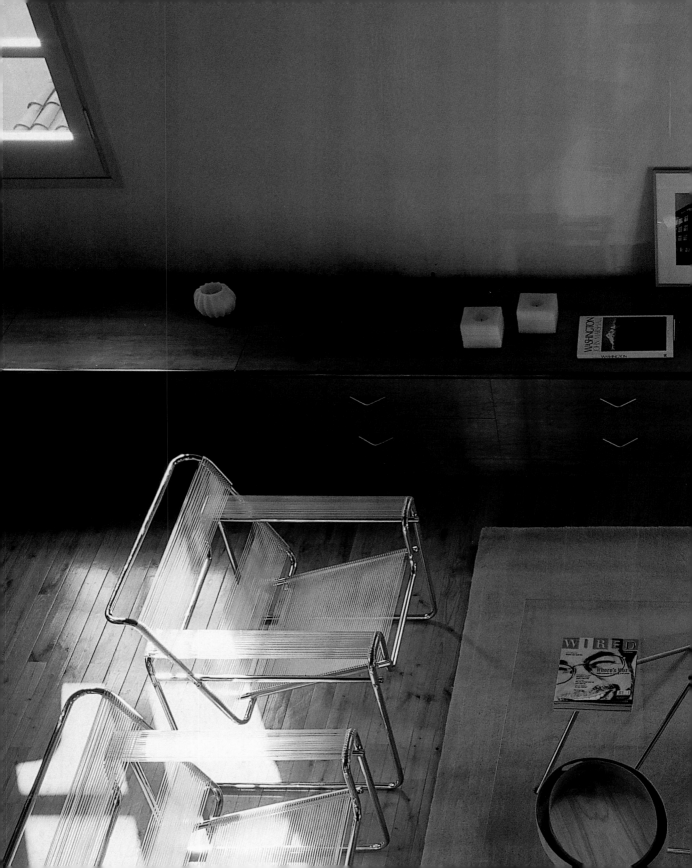

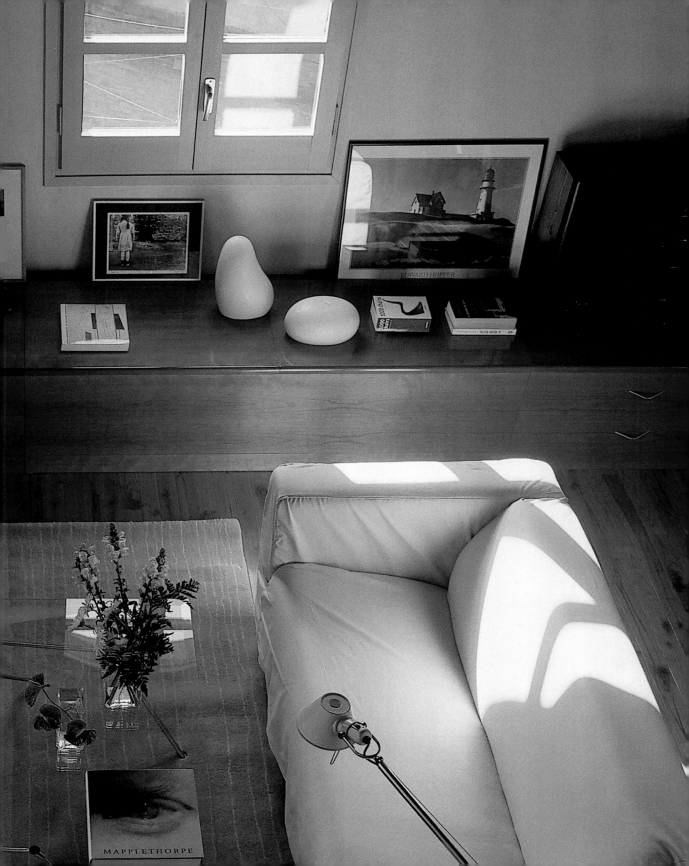

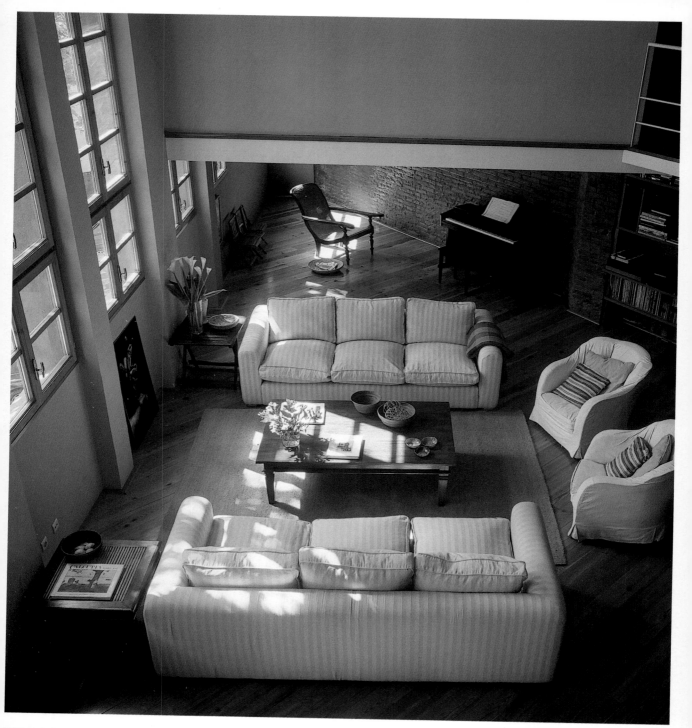

The height of the ceilings, the open-plan layout, the tall windows,
and the absence of curtains intensify the natural light that enters this living room.

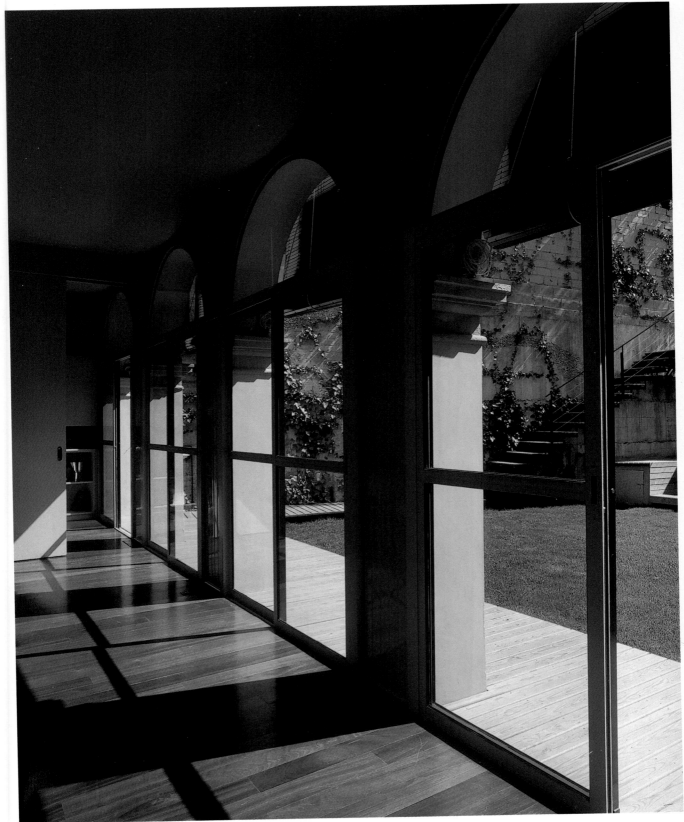

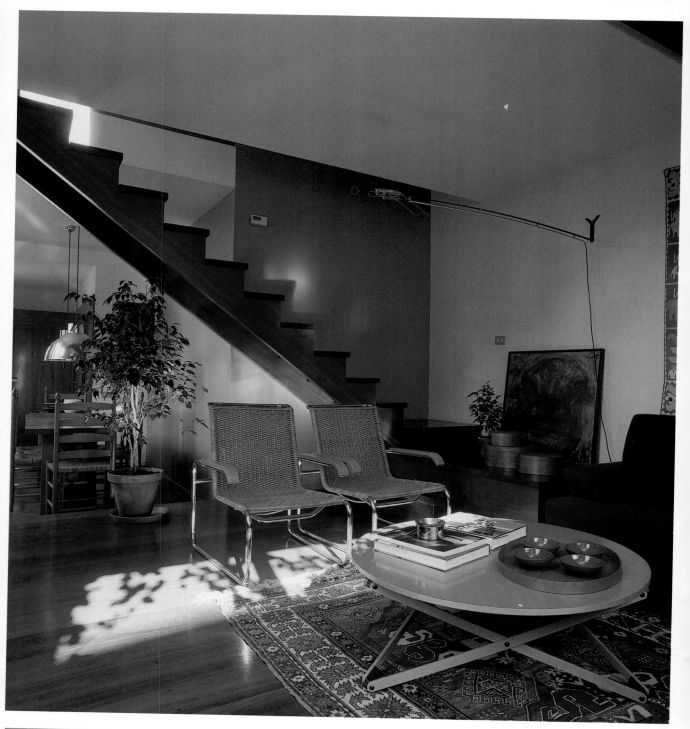

In this living room, sunlight enters through a curtainless window and dapples the wooden floor.

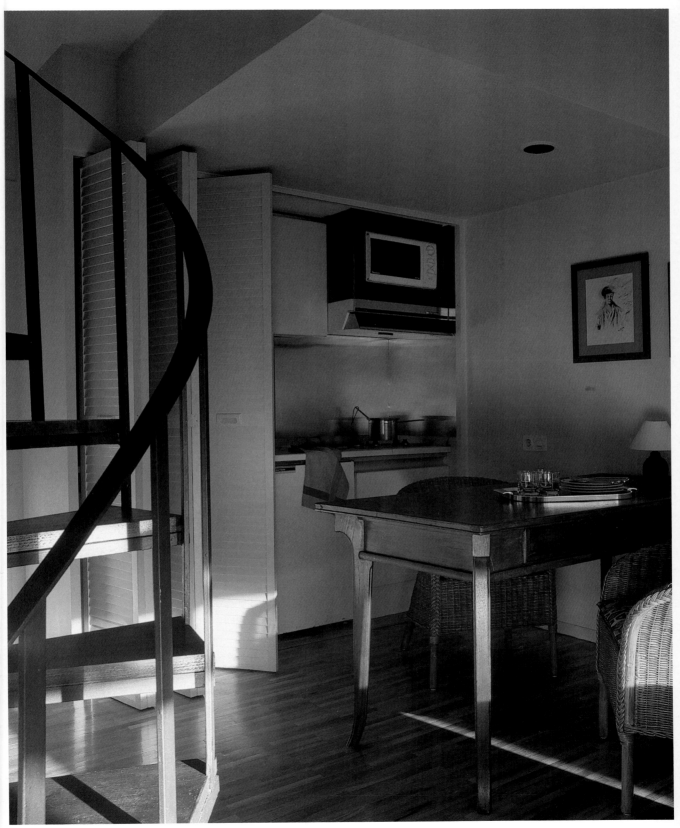

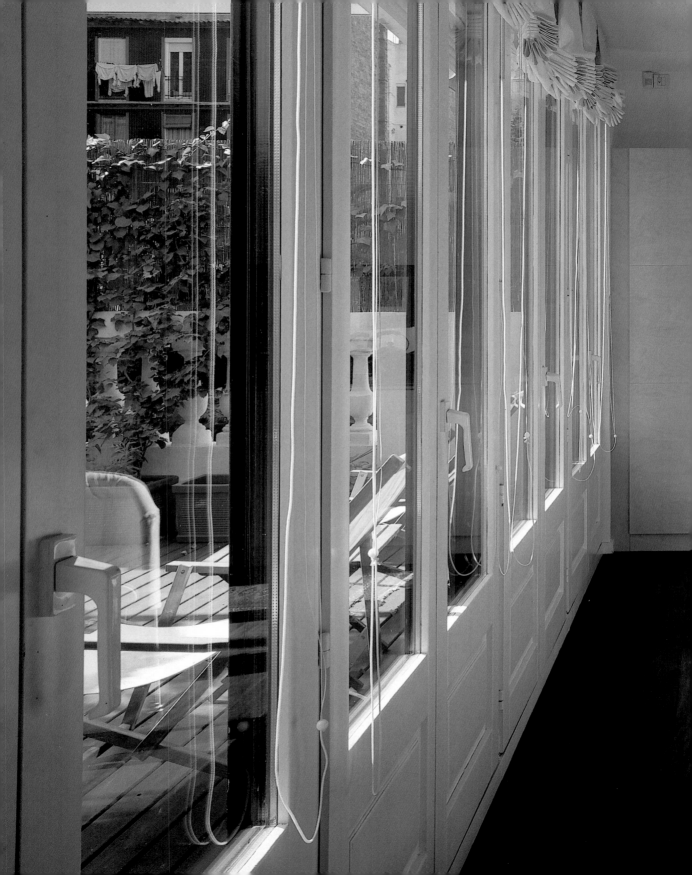

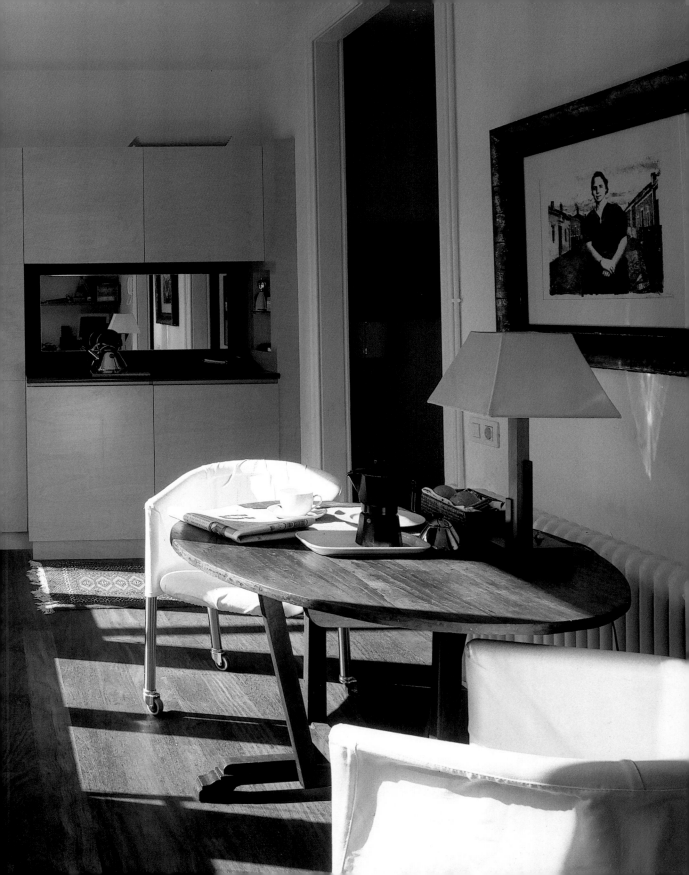

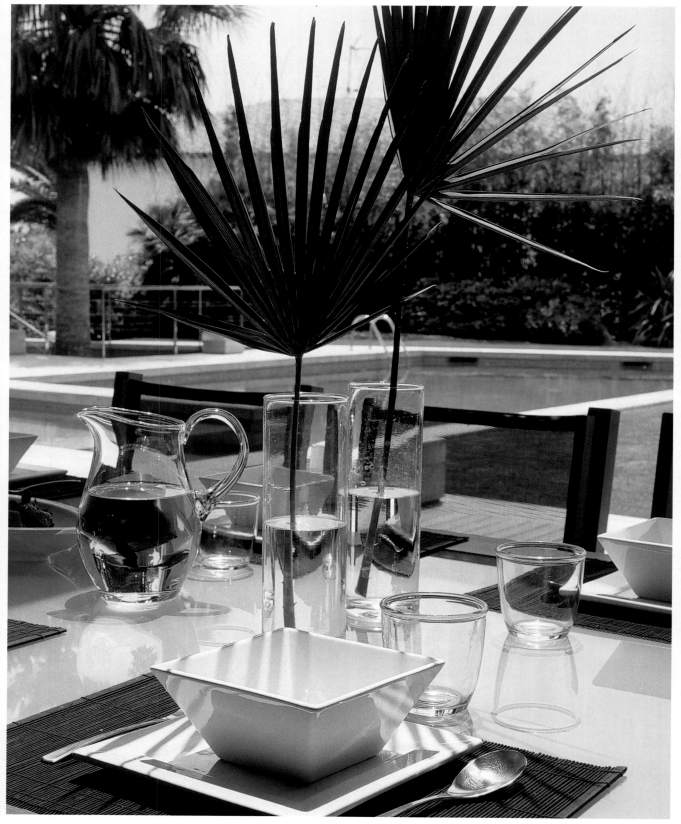

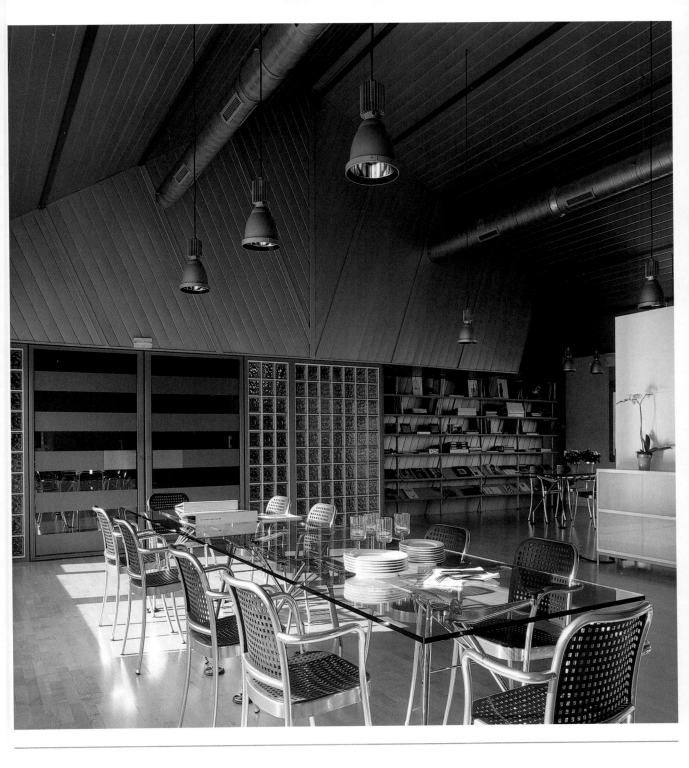

This modern loft reflects the industrial flavor of the architecture, retaining the large windows and tall ceilings that flood the room with natural light.

Diffused Daylight

Diffused daylight is created by light that is filtered, either by clouds blocking the sky or by other diffusers—such as roller blinds, curtains, and shutters—placed at points where light enters an interior space. This creates an enveloping sensation in which shadows and all the nuances of the objects can be seen.

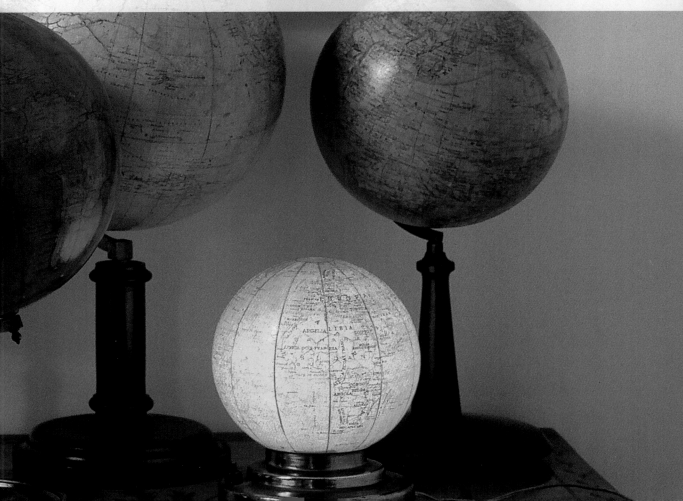

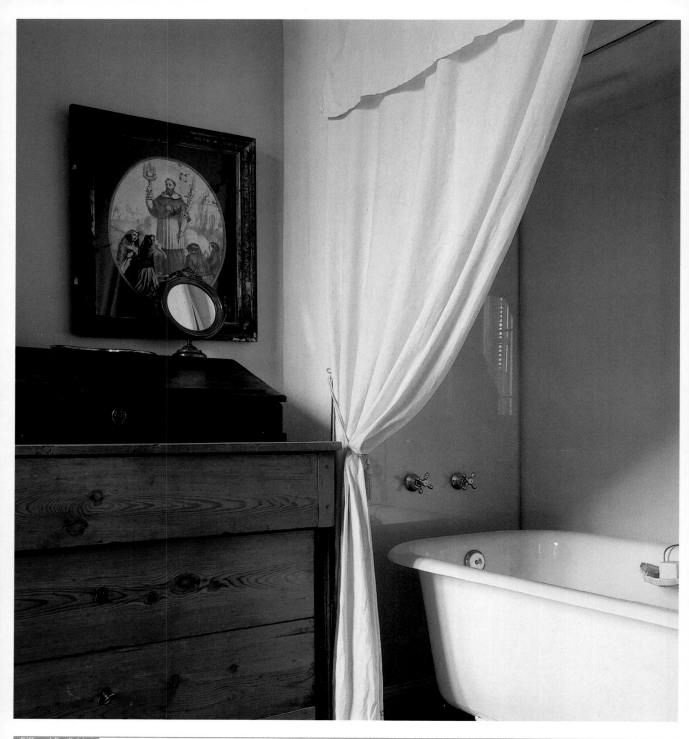

A simple vintage sheet converted into a curtain separates the bathtub from the rest of the room, diffusing light and making this bathroom an intimate and enchanting space.

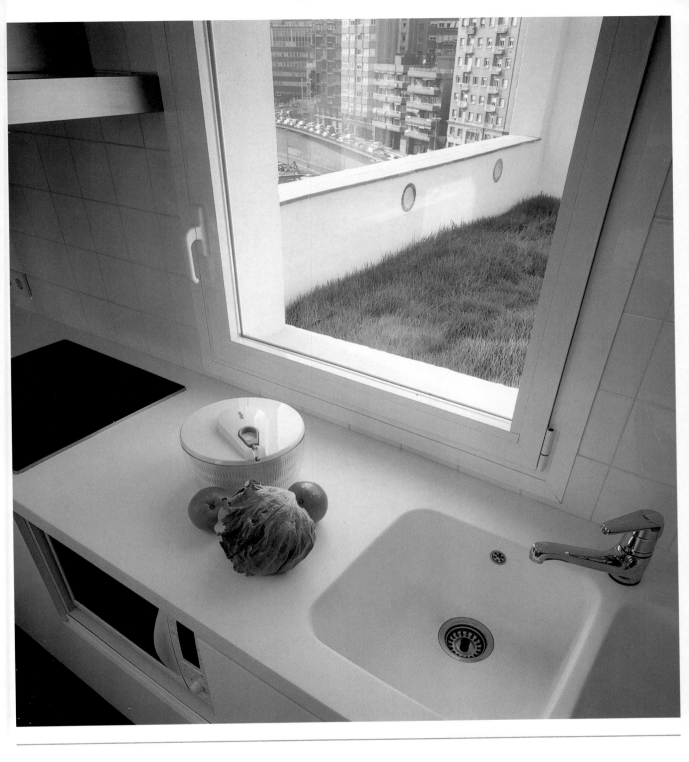

In small rooms like this kitchen, using white adds a feeling of spaciousness and brightness.
This is a simple technique that is always effective in enhancing the sensation of space and light.

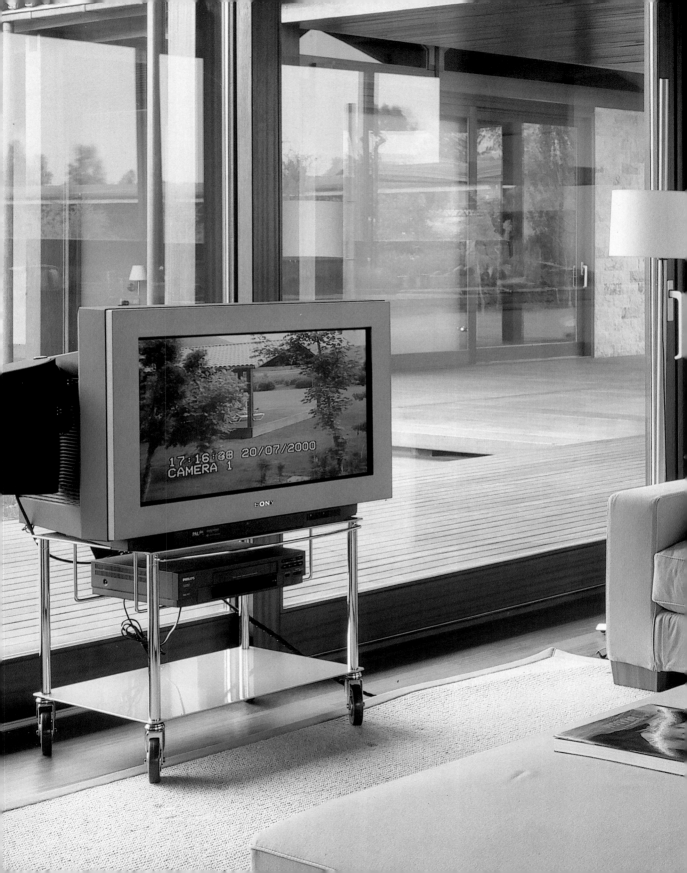

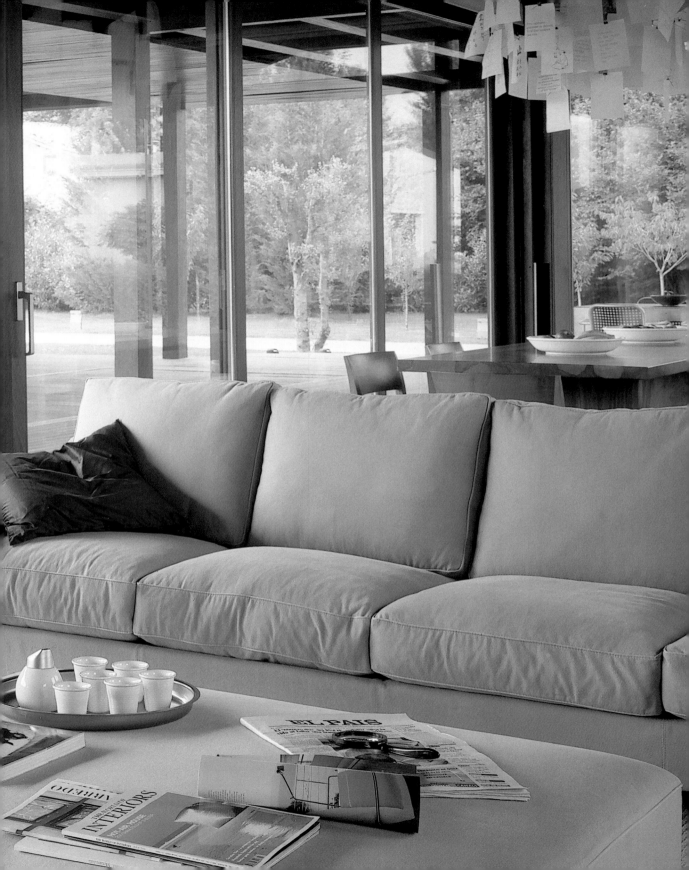

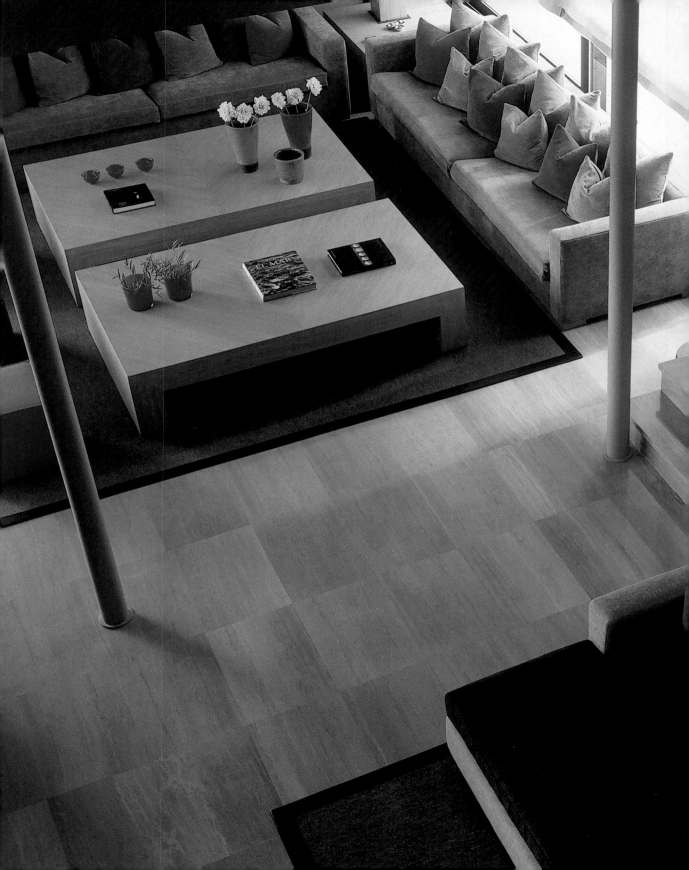

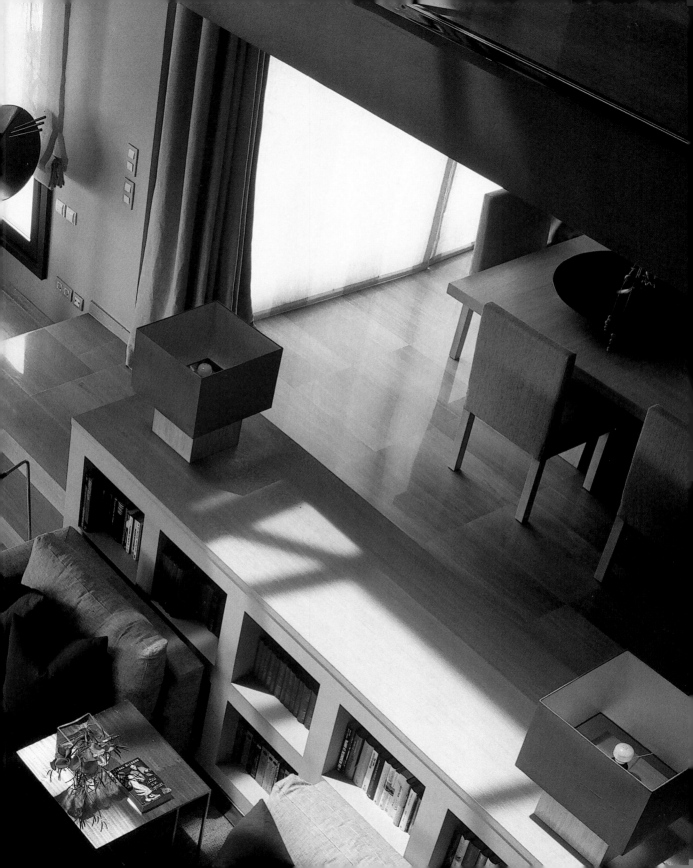

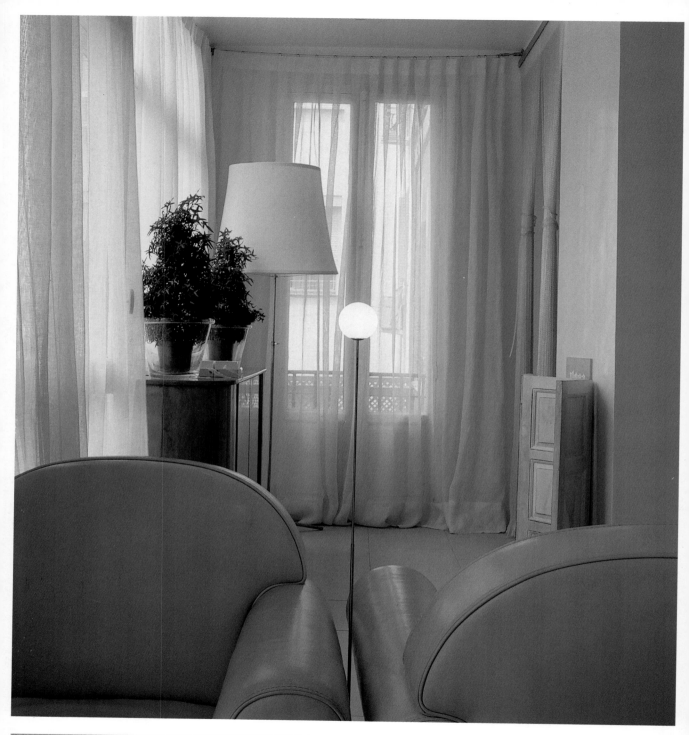

Diffused Daylight

Pull-cord curtains cover the windows of this corridor, diffusing light in a setting decorated with natural hues and elegant furnishings.

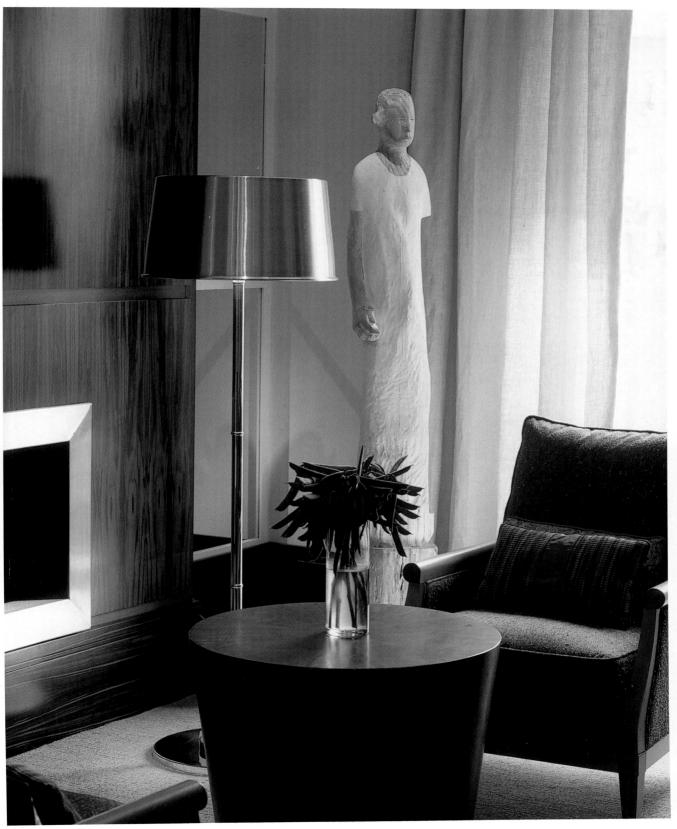

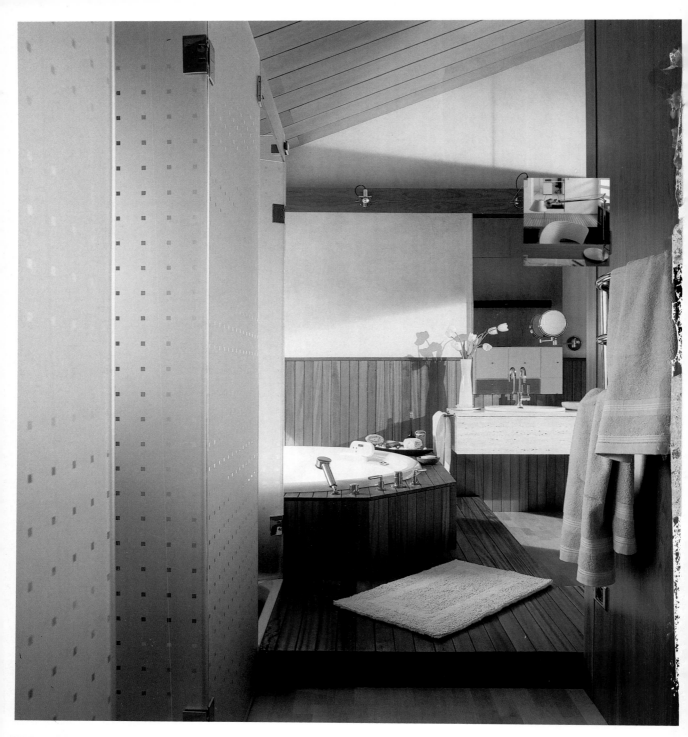

In areas such as the bathroom, where intimacy is the most important factor,
translucent glass can be used to provide privacy without obstructing the entry of light.

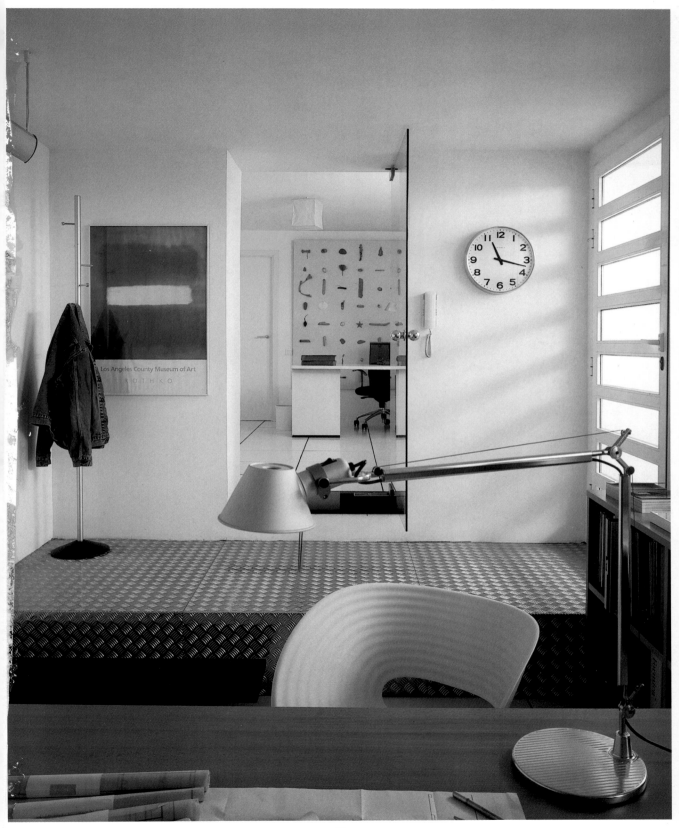

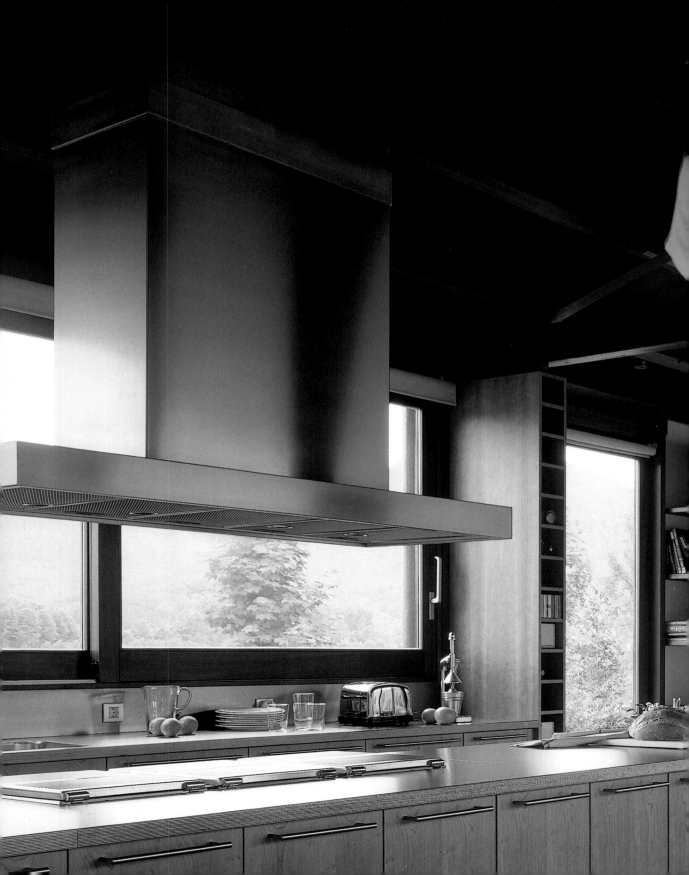

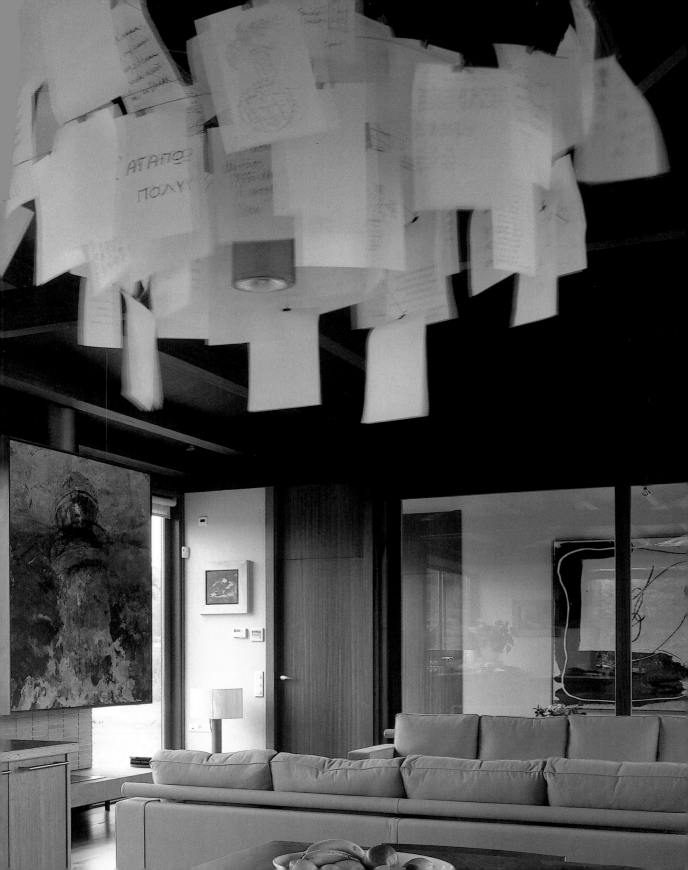

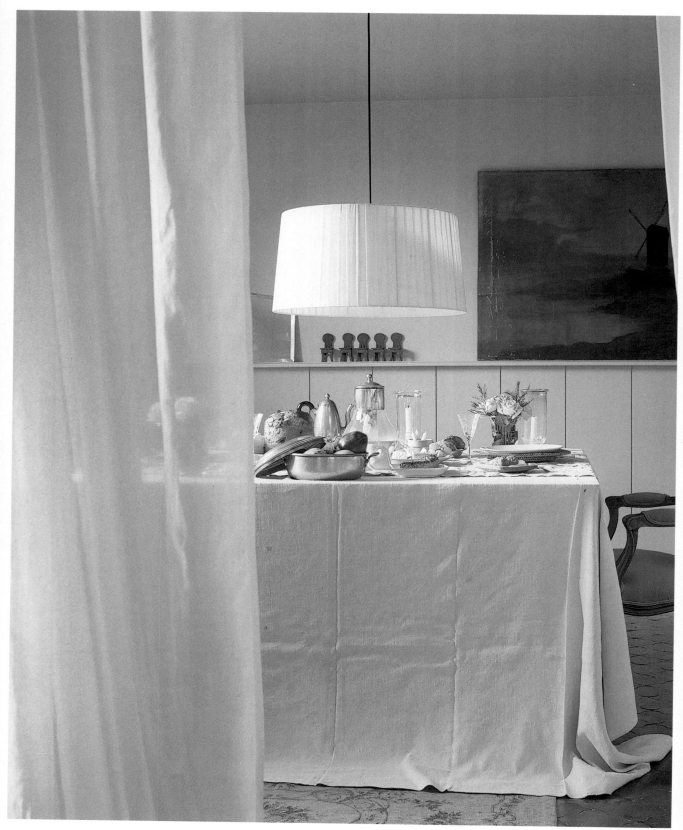

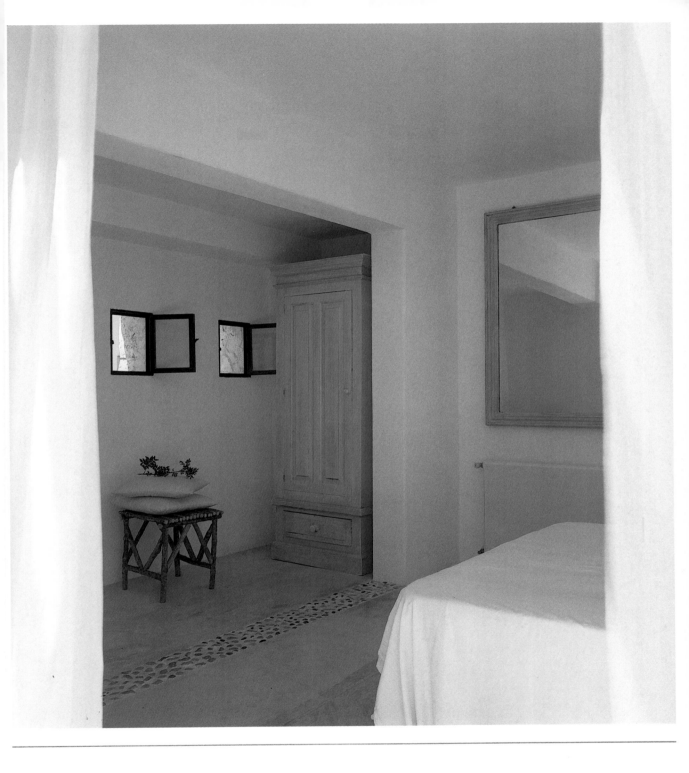

Small windows and white curtains inside this bedroom diffuse the light to create a relaxing atmosphere.

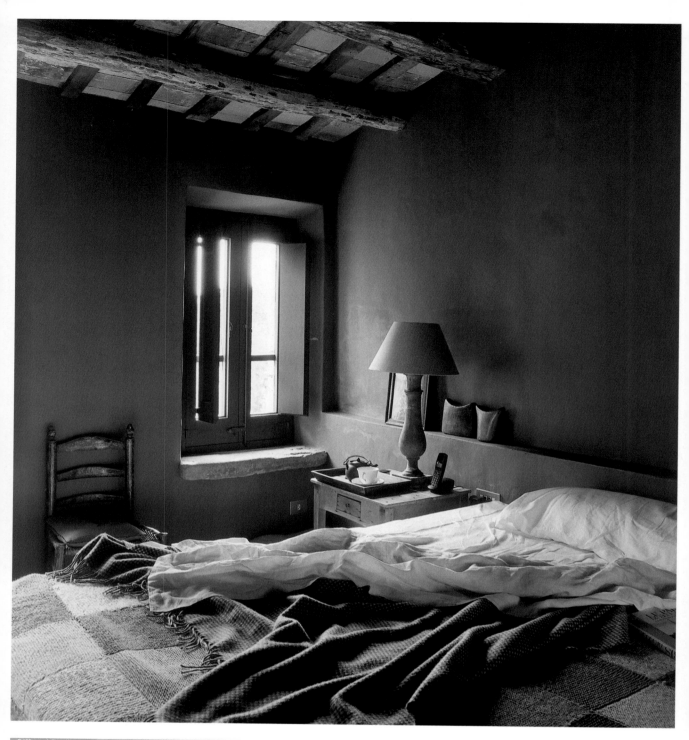

The dark gray of this bedroom, painted with natural pigments, diffuses the light entering from the garden.

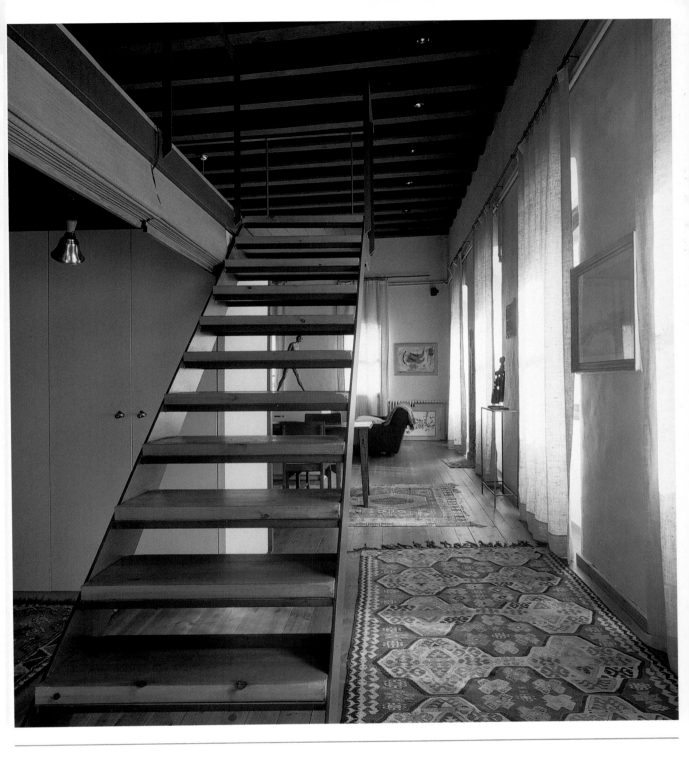

The many windows of this home were used to create a bright space in which the light seeps harmoniously into every corner of the house, creating a feeling of lightness and roominess despite the high ceilings.

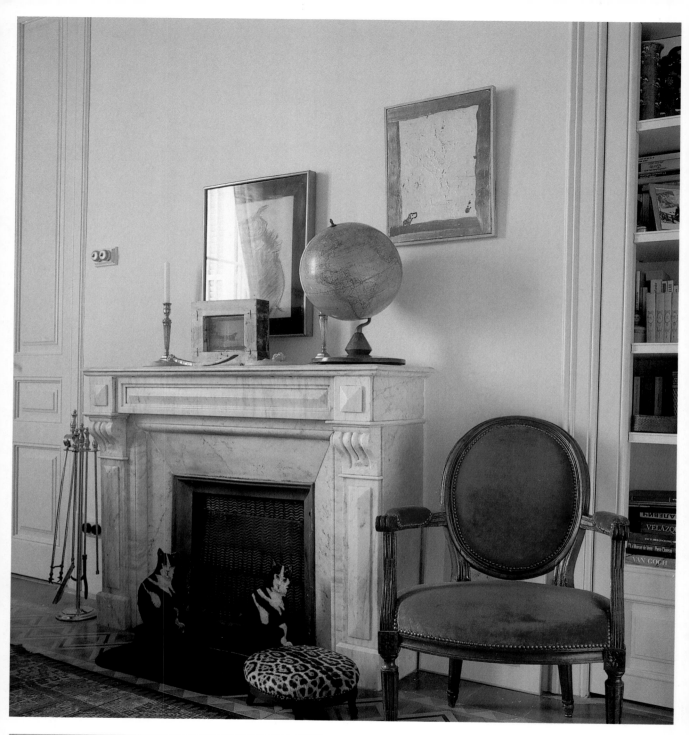

This area is bathed in diffused light that enters through the living room's white curtains and falls gently on an elegant mix of furniture and ornaments.

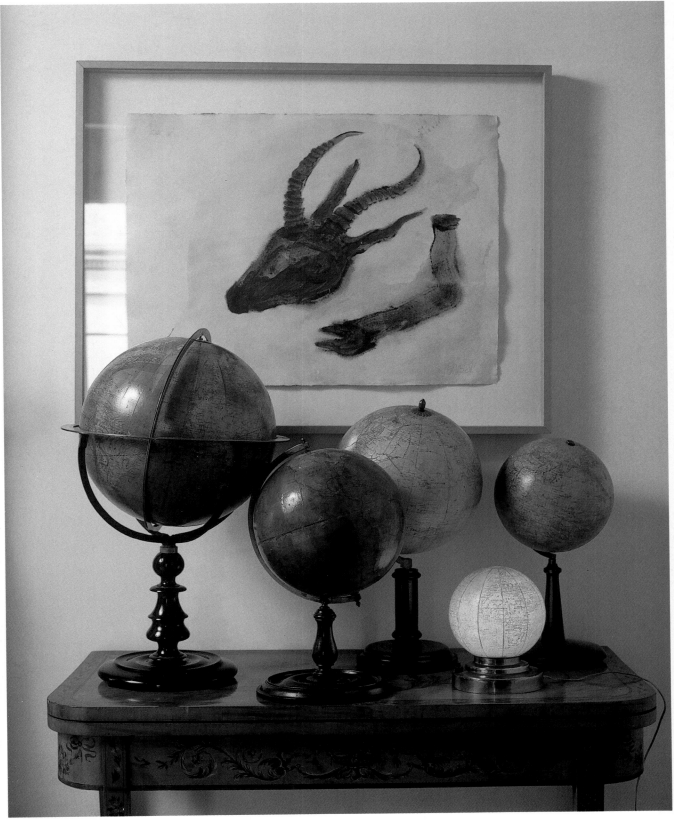

Light from
Behind and Above

Natural light, whether it illuminates objects from behind or above, creates outlines and silhouettes that allow us to make out objects against any type of background.

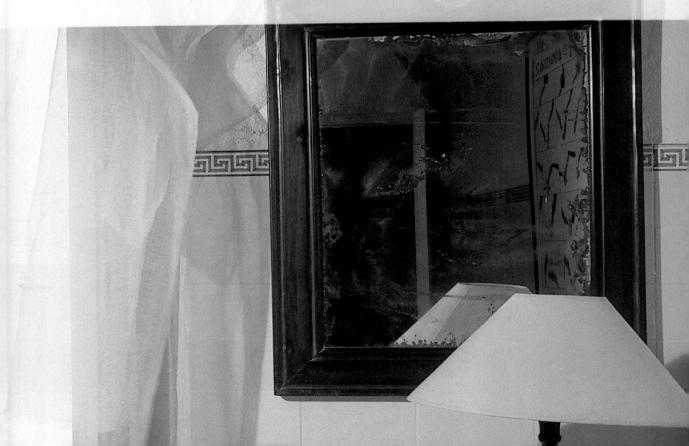

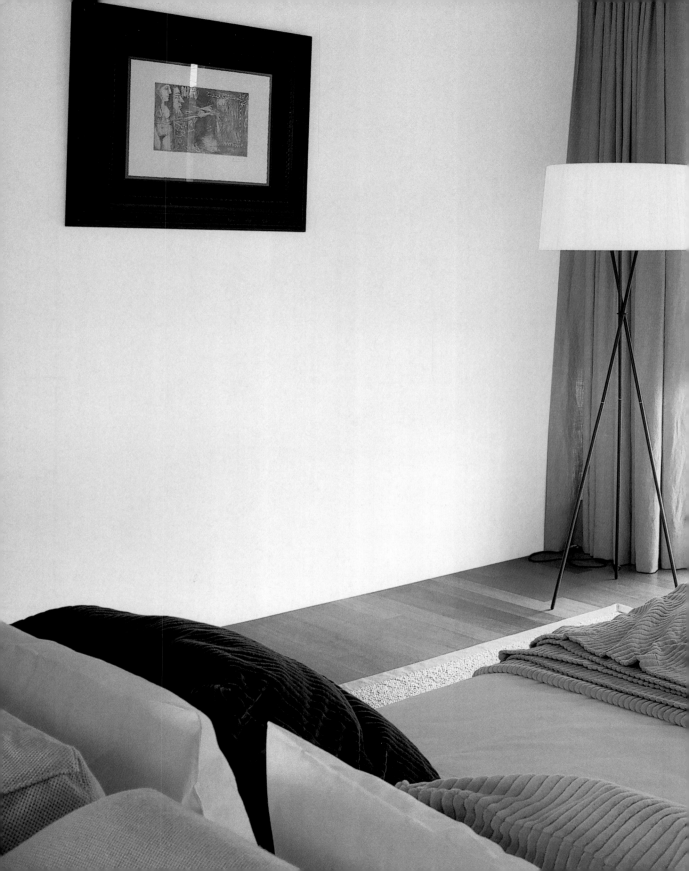

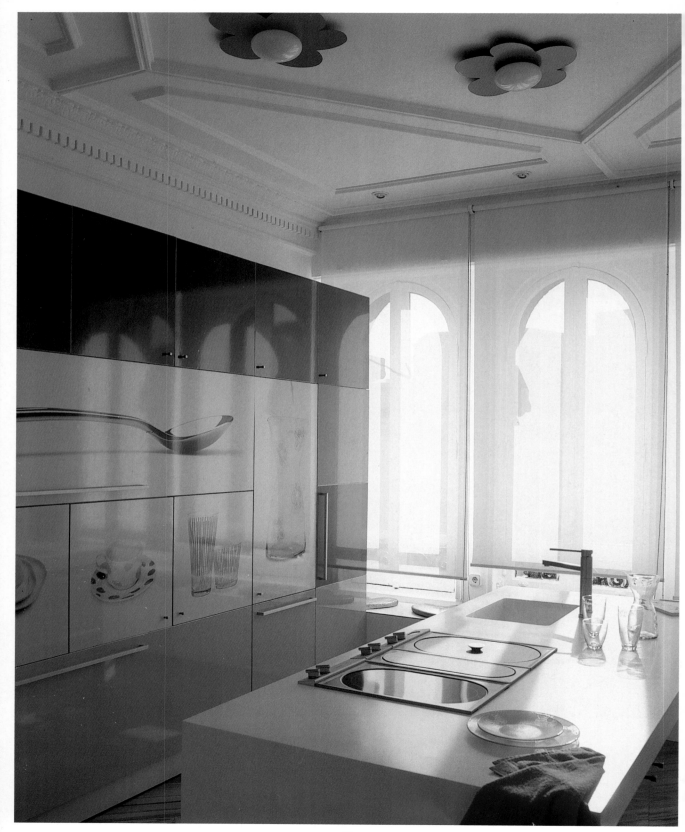

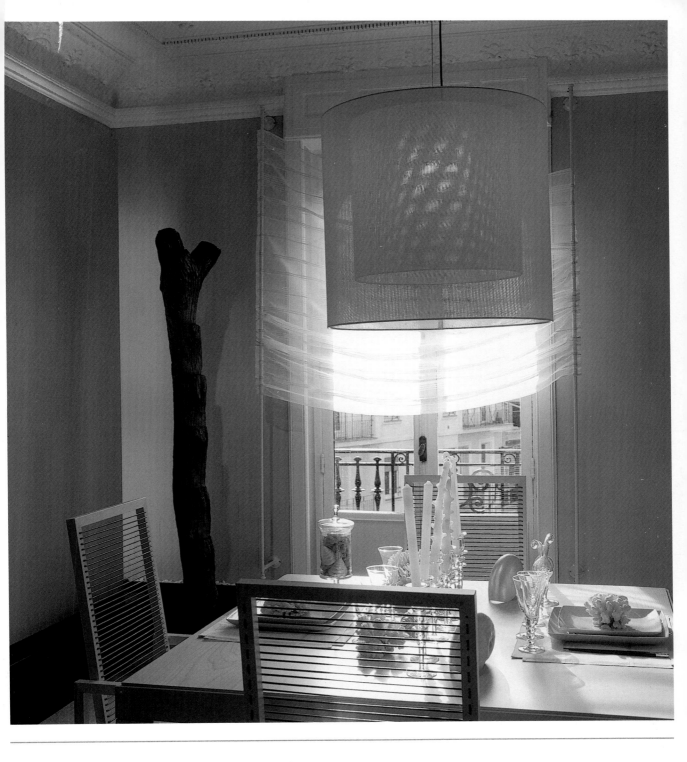

The sheer curtains filter the sunlight in an original and elegant manner without blocking the exterior views.

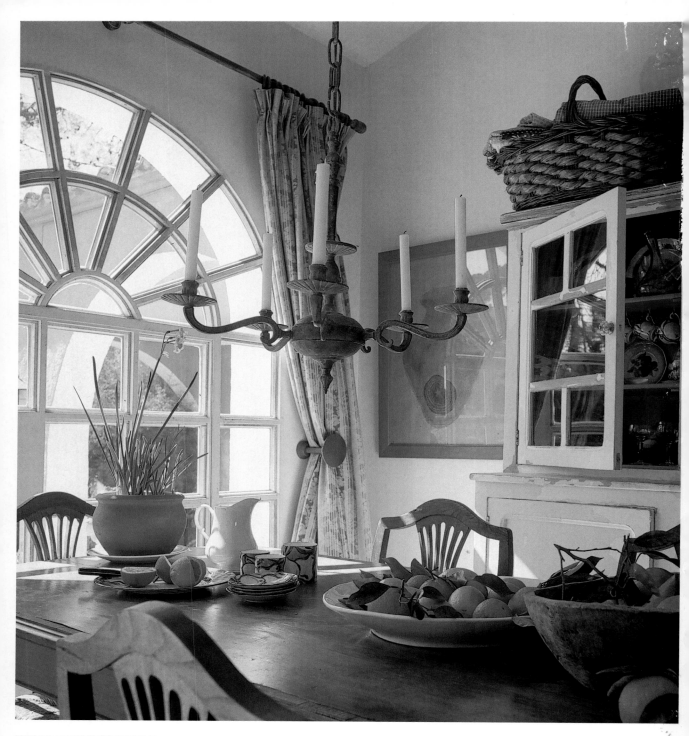

Wood in the furnishings, floors, and ceilings plays an important role in creating a cozy ambiance and neutralizing the intense sunlight that enters through the French windows.

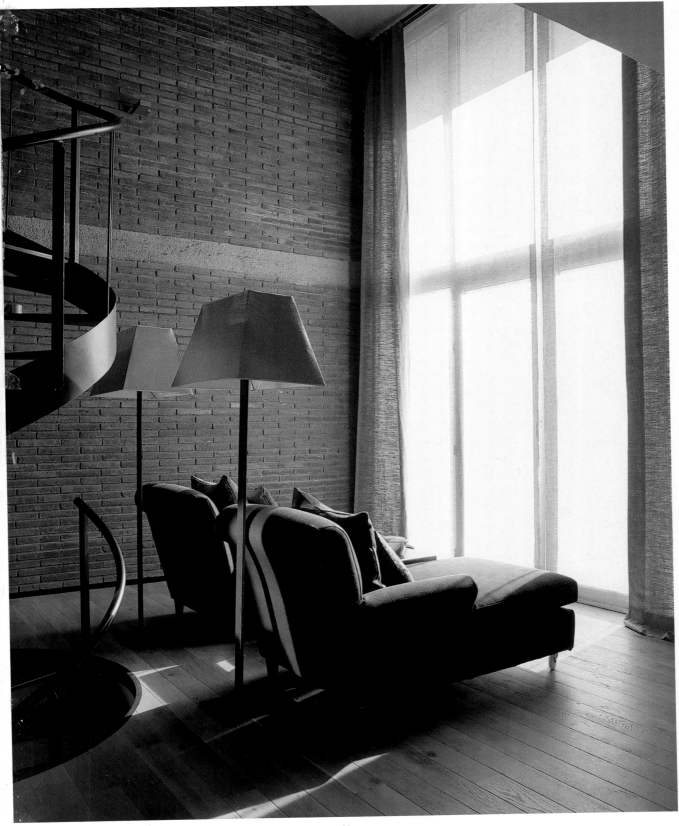

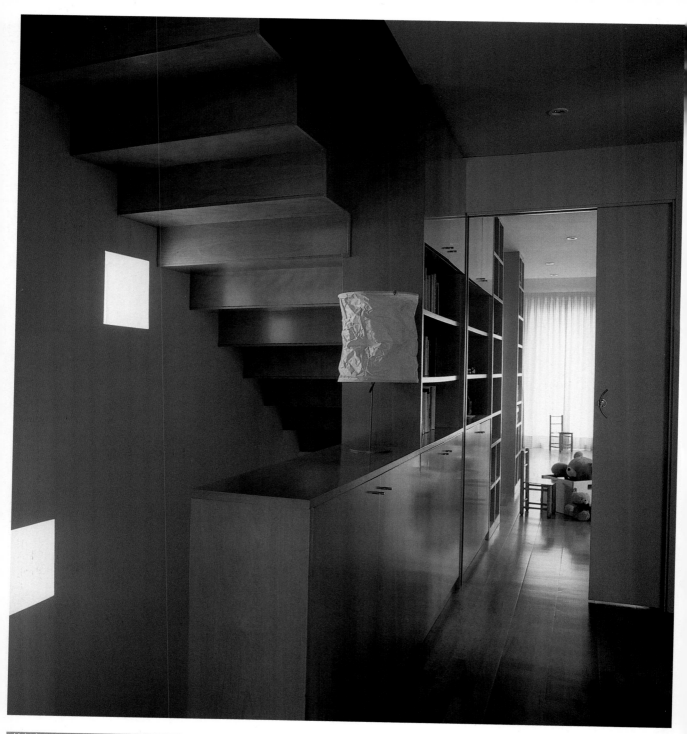

Small openings in the façade frame the light, forming squares of sunlight that illuminate the stairs.

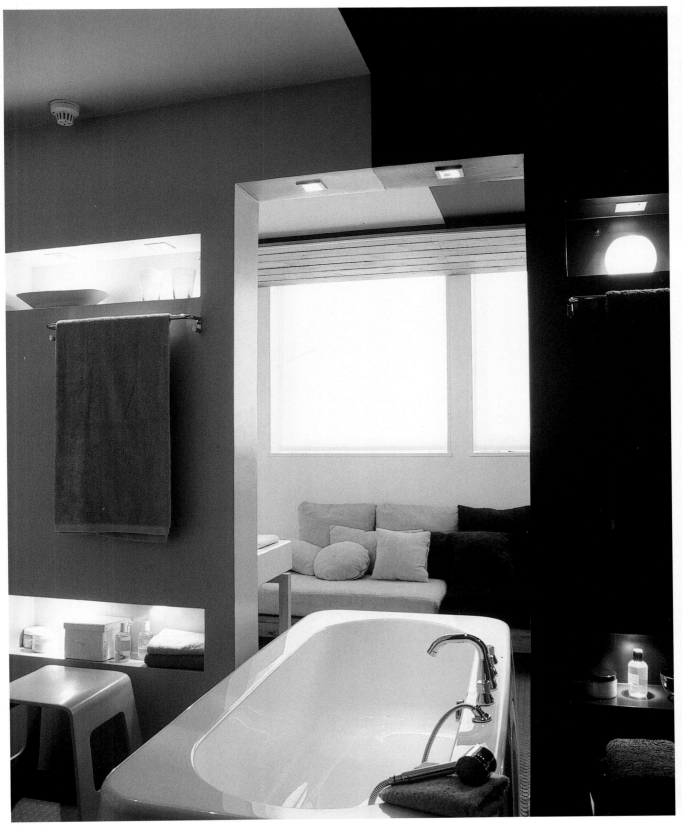

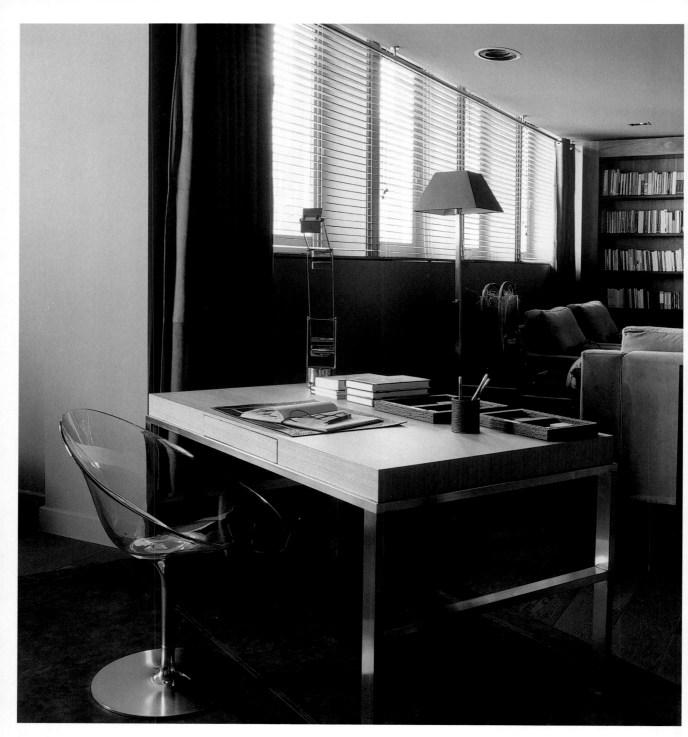

The blinds—placed along the windows—allow the amount of entering sunlight
to be regulated according to the needs of the tenant.

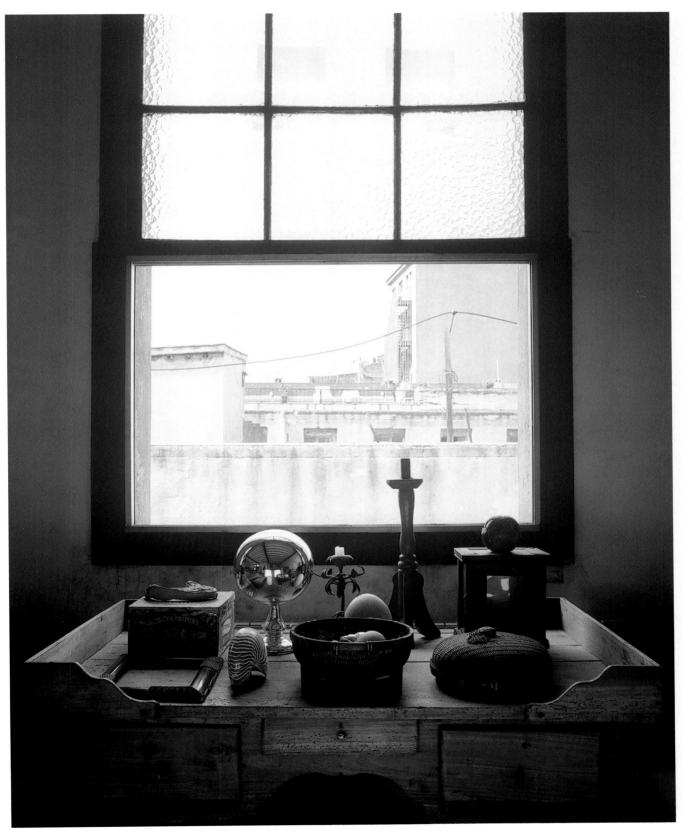

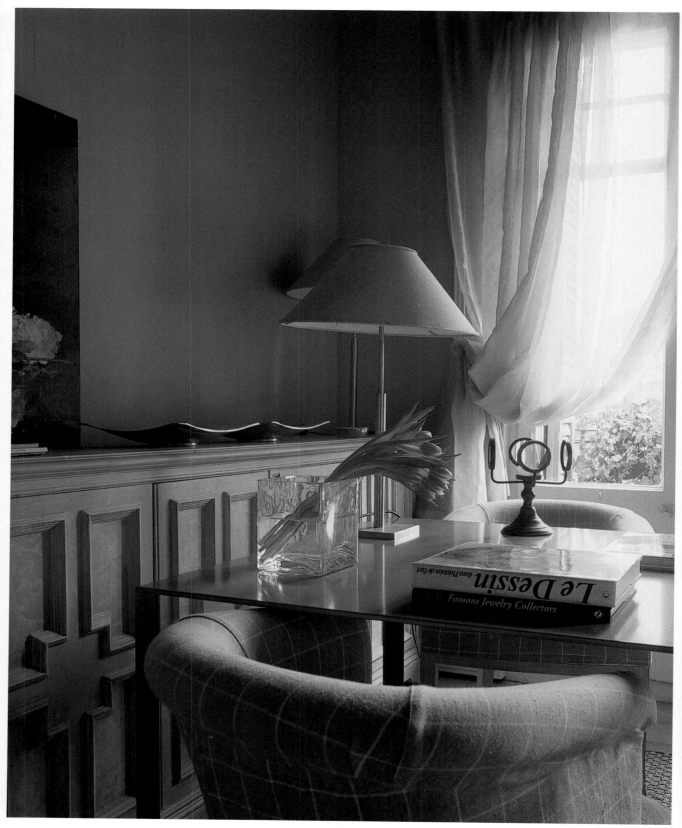

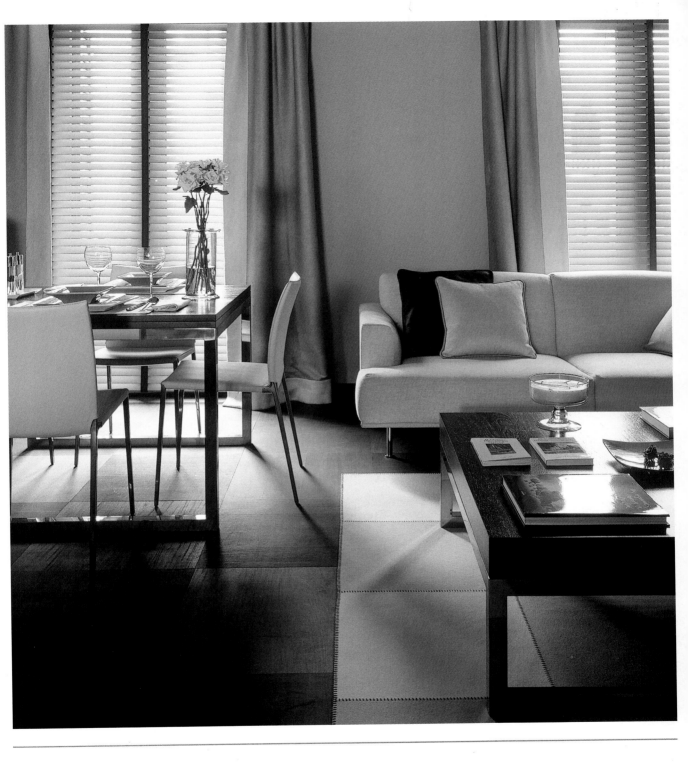

Natural light illuminates the area nearest to the living room windows, providing light from behind that outlines and highlights the predominantly neutral-toned furnishings.

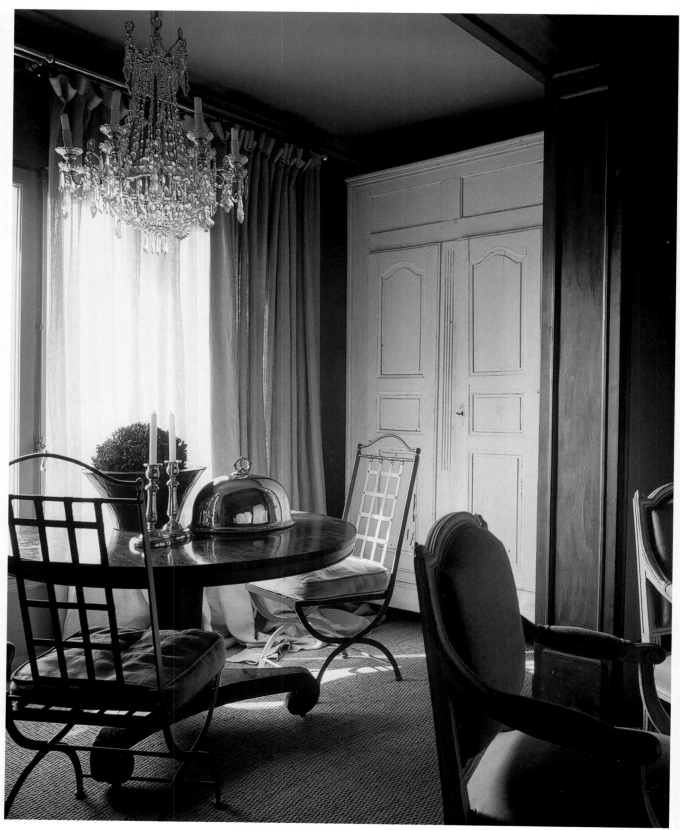

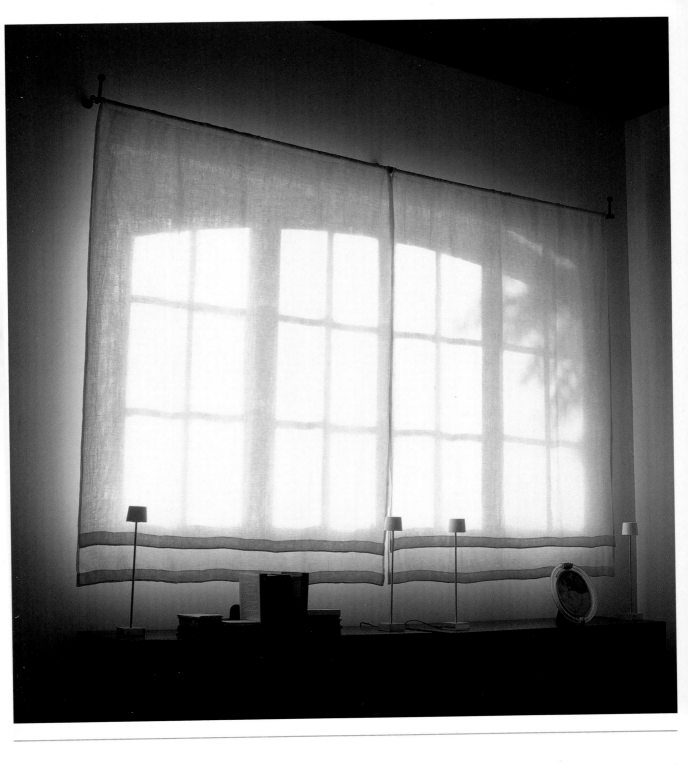

A simple linen curtain traps the sunlight and blocks its direct entry, creating a play of shadows and dim light.

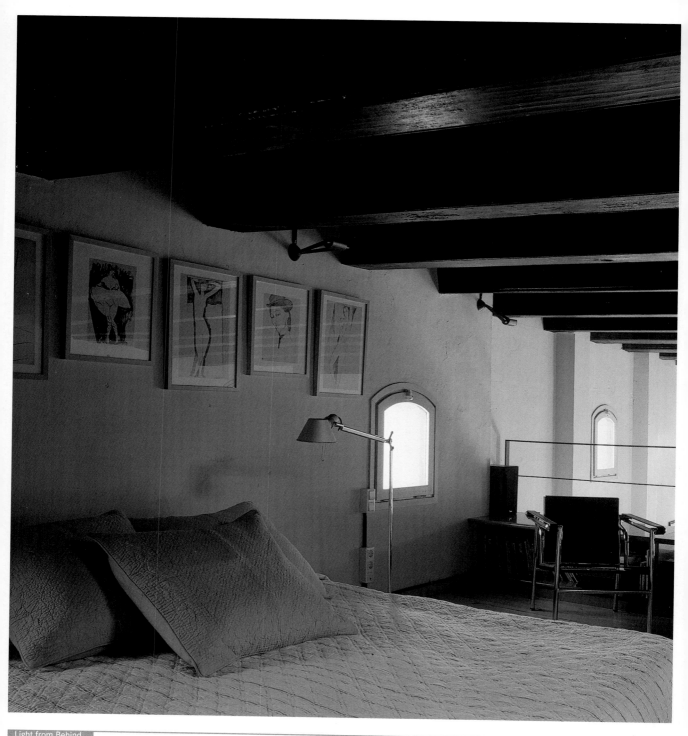

Taking advantage of the house's high ceilings, the designers planned this bedroom as an open loft above the living room, allowing natural, indirect light to enter.

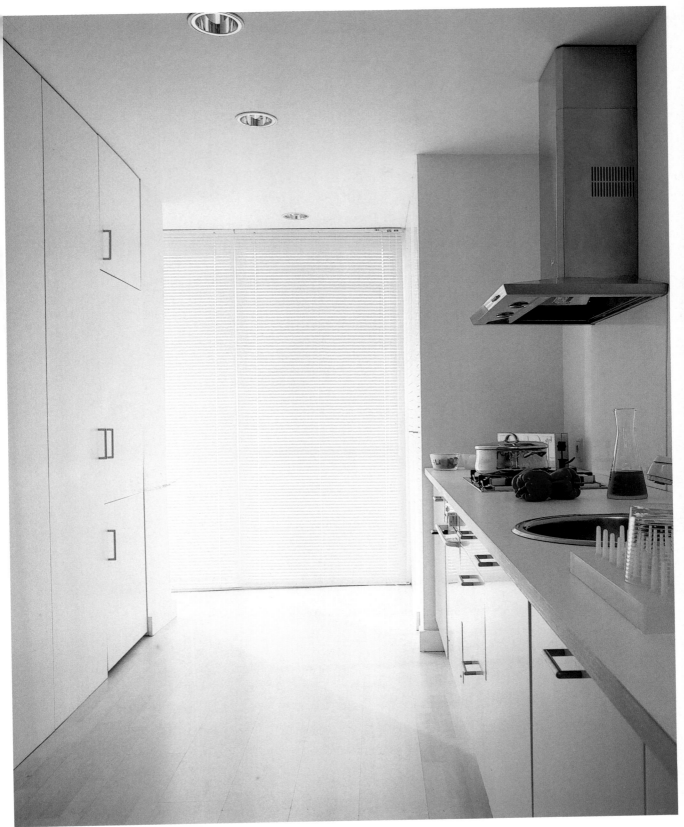

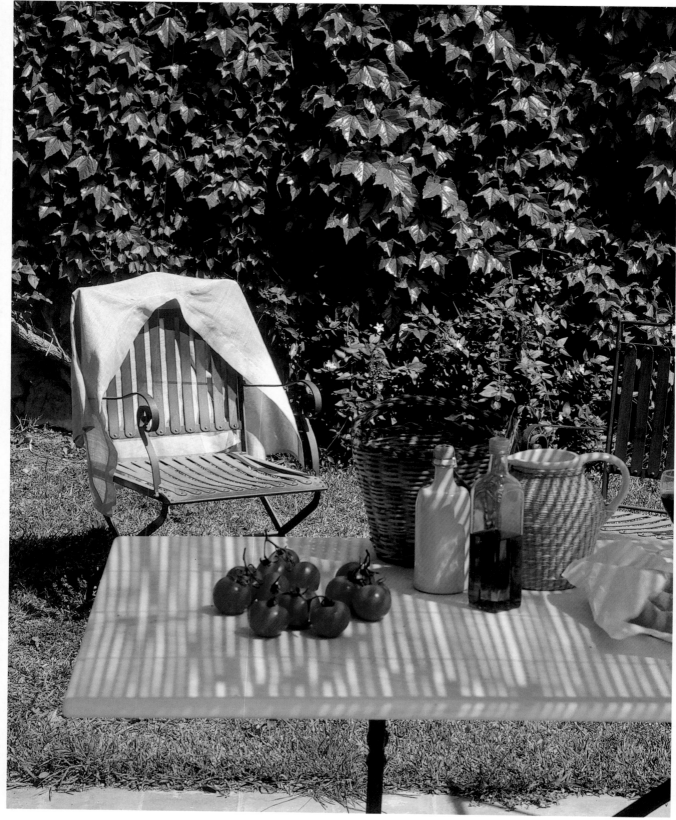

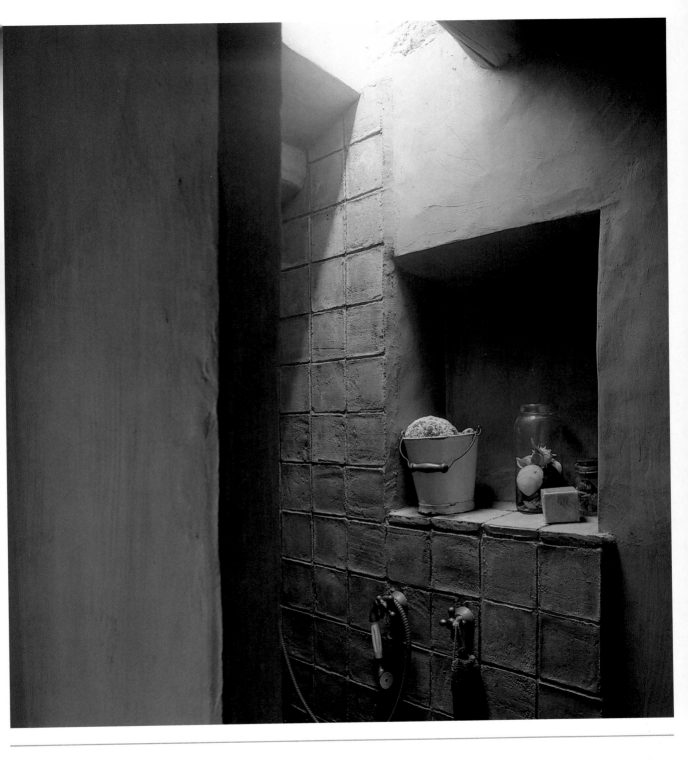

A small skylight was opened up above the shower to add brightness to this undersized bathroom.

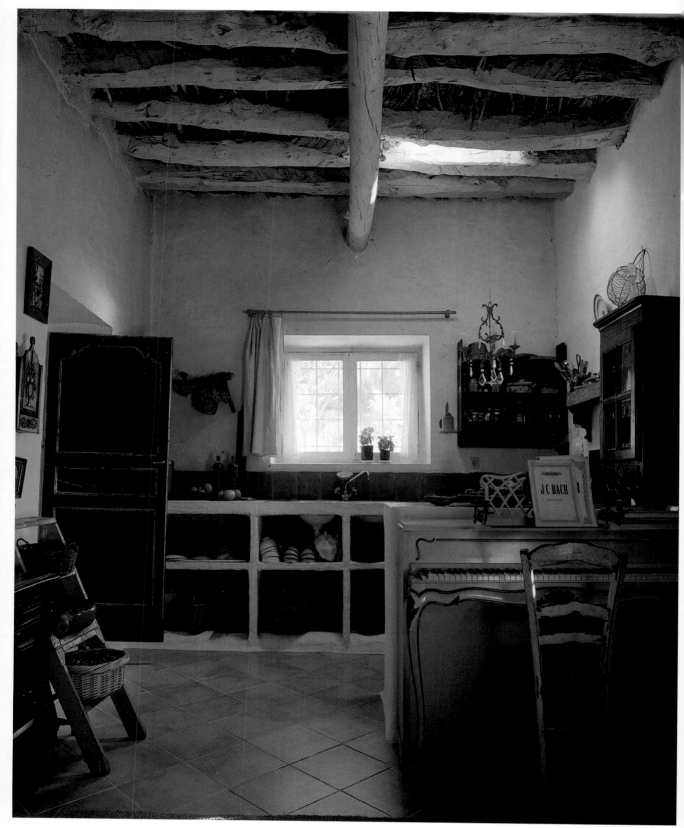

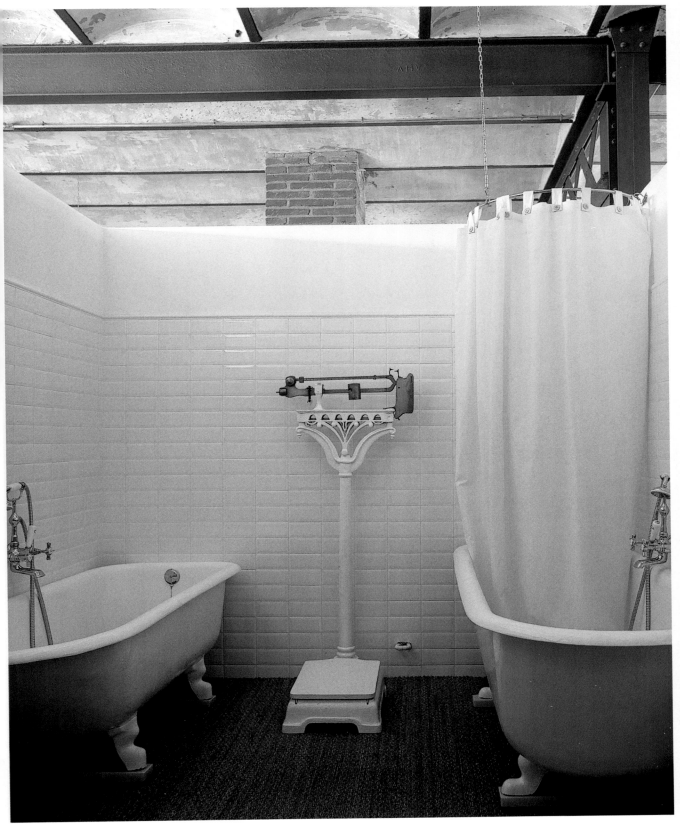

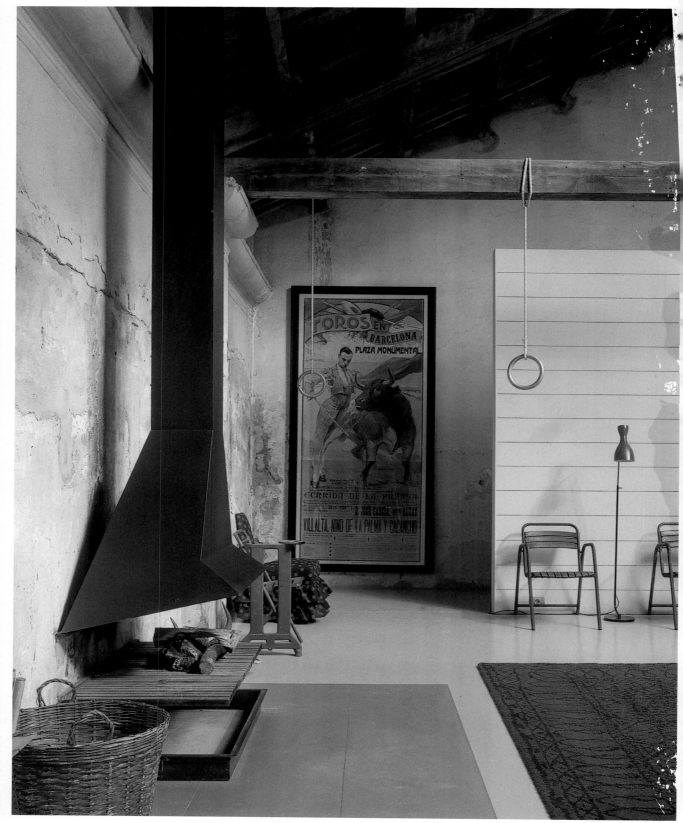

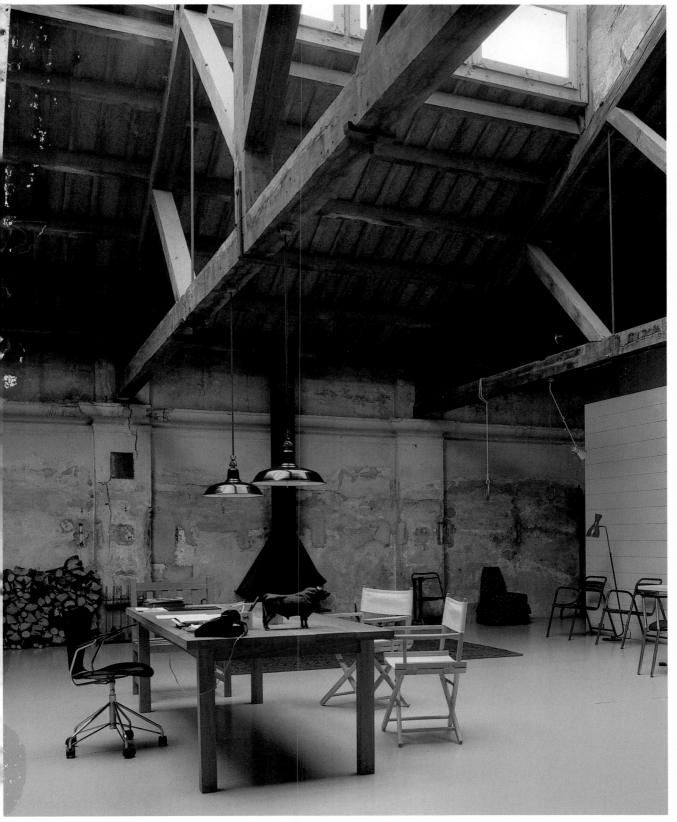

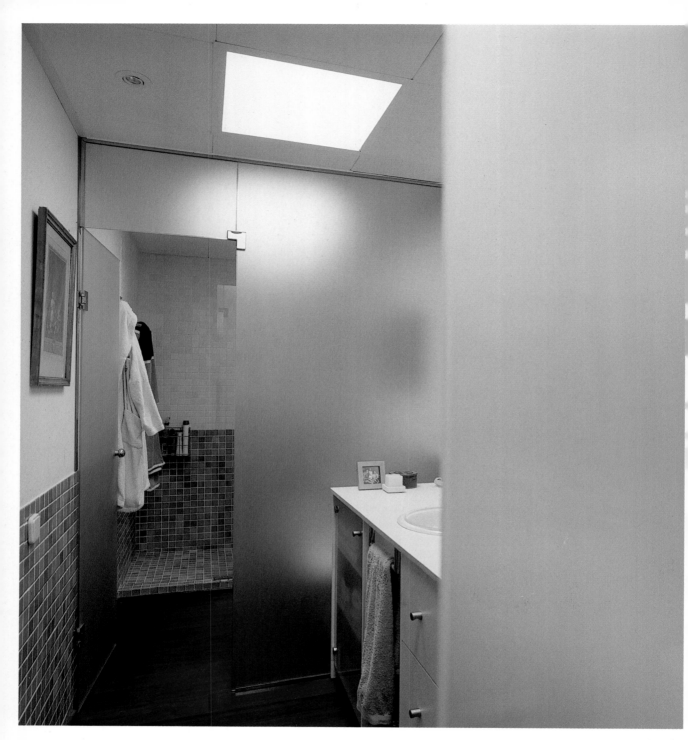

A skylight was opened up to provide natural light from above for this bathroom.

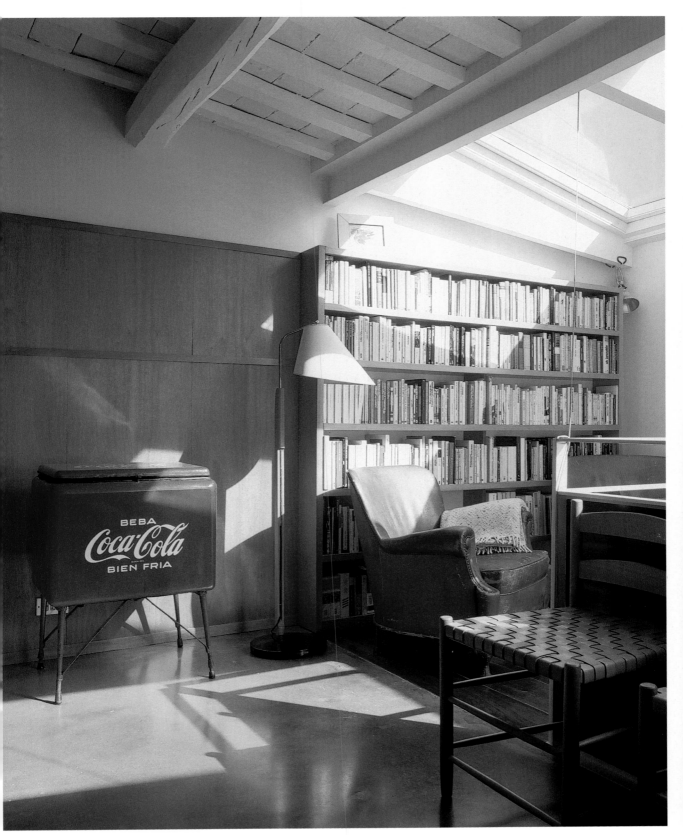

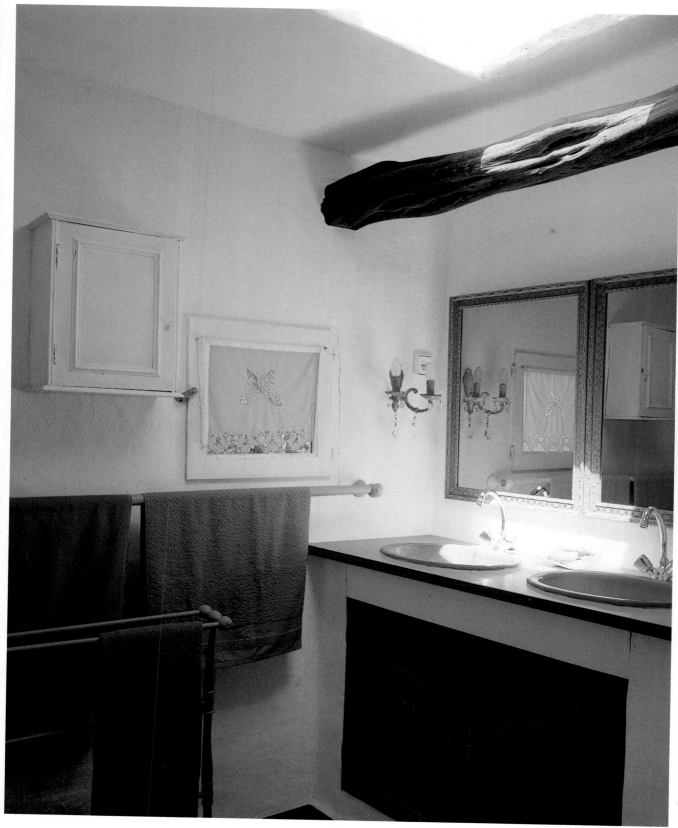

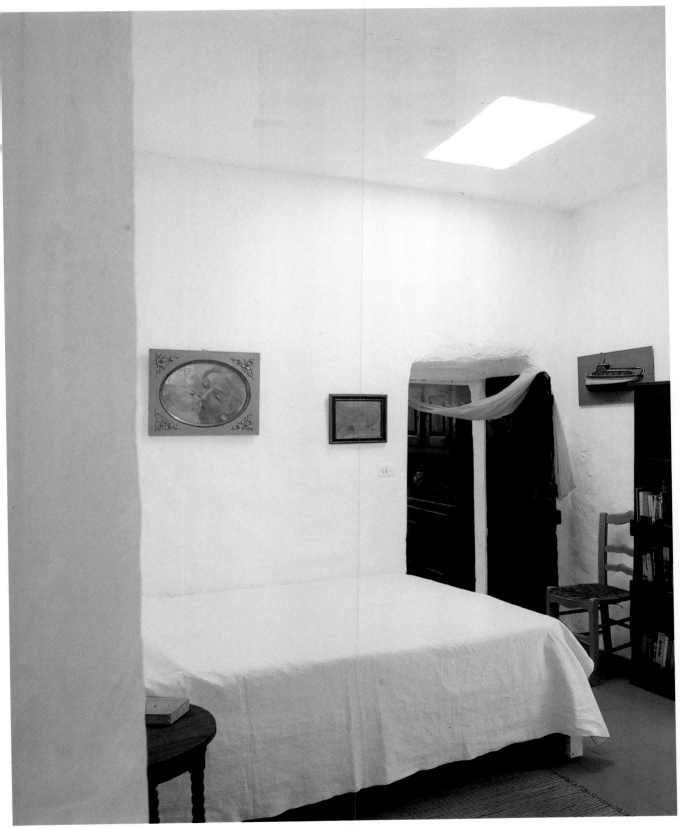

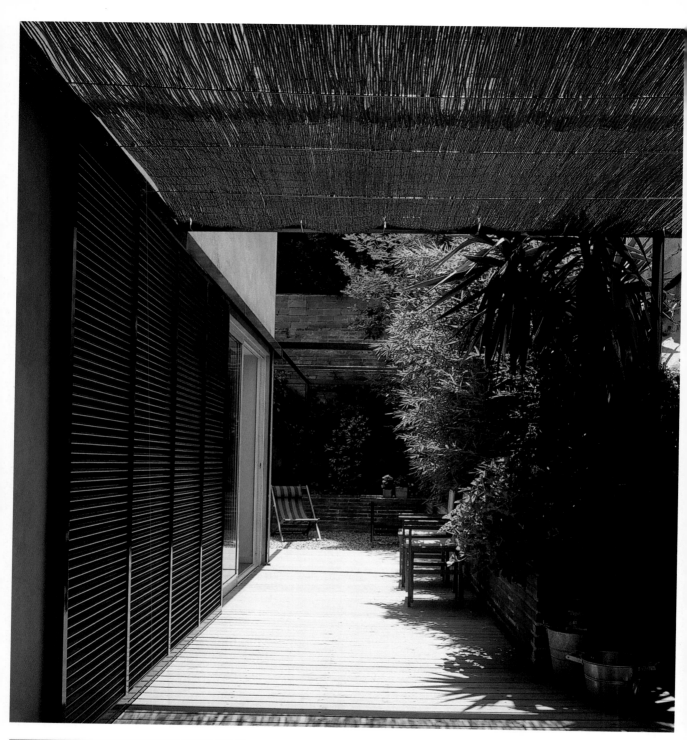

Cane screening in a passageway controls the entrance of natural light
and protects the interior of the home from the sun's rays.

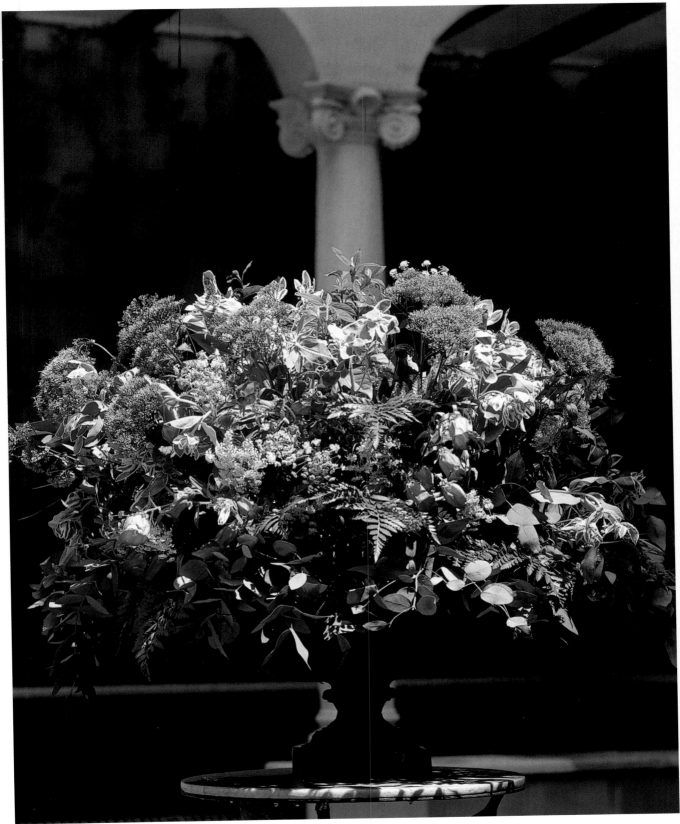

Artificial Light

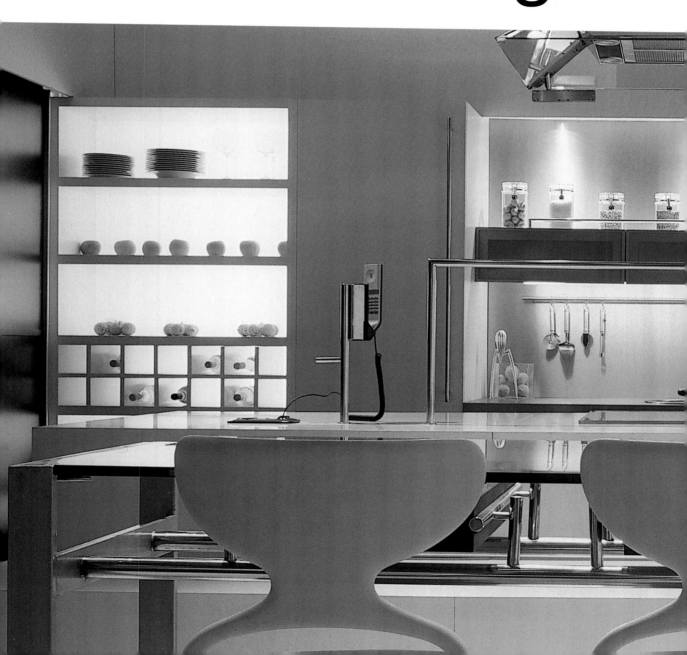

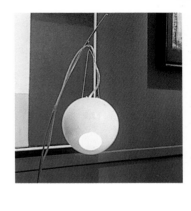

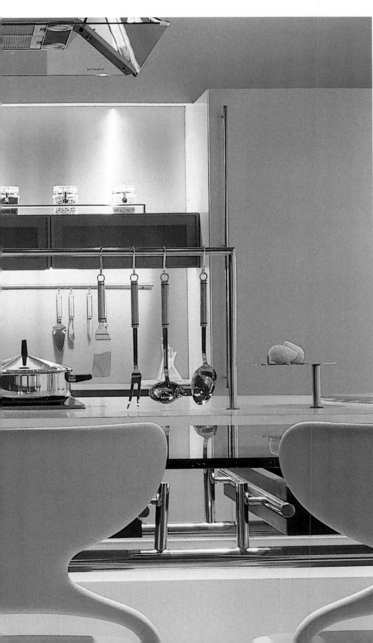
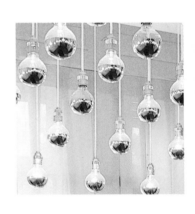

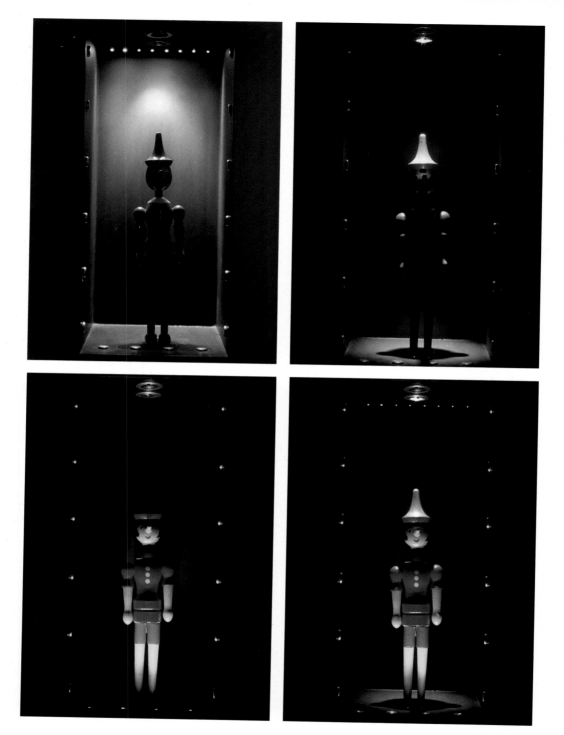

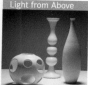

Fiber optics can light an object in many different ways.

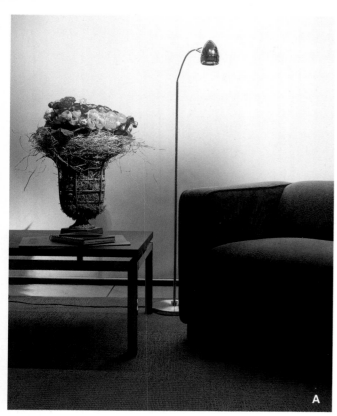

A

An incandescent wall washer, three halogen wall lights, and one halogen concentrate on the flowers.

B

An incandescent wall washer, three halogen wall lights, and one white sodium light shine upon the flowers.

C

An incandescent wall washer, three halogen wall lights, and one color master light up the flowers.

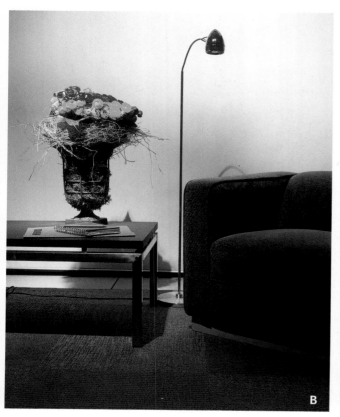

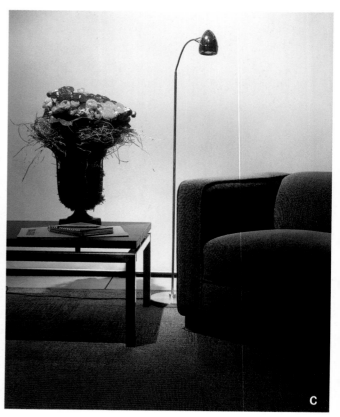

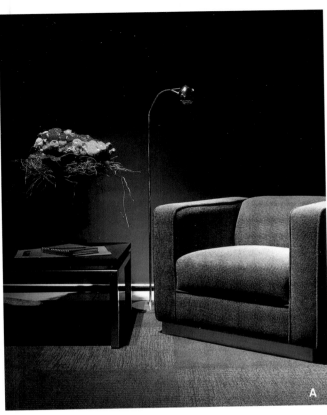

A

Master color (metal halide lamps), gray tones

B

Halogen

C

White sodium, warm tones

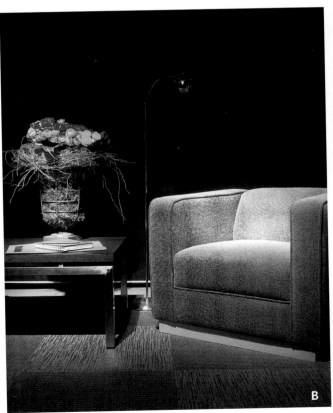

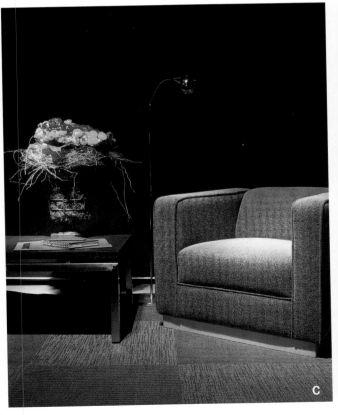

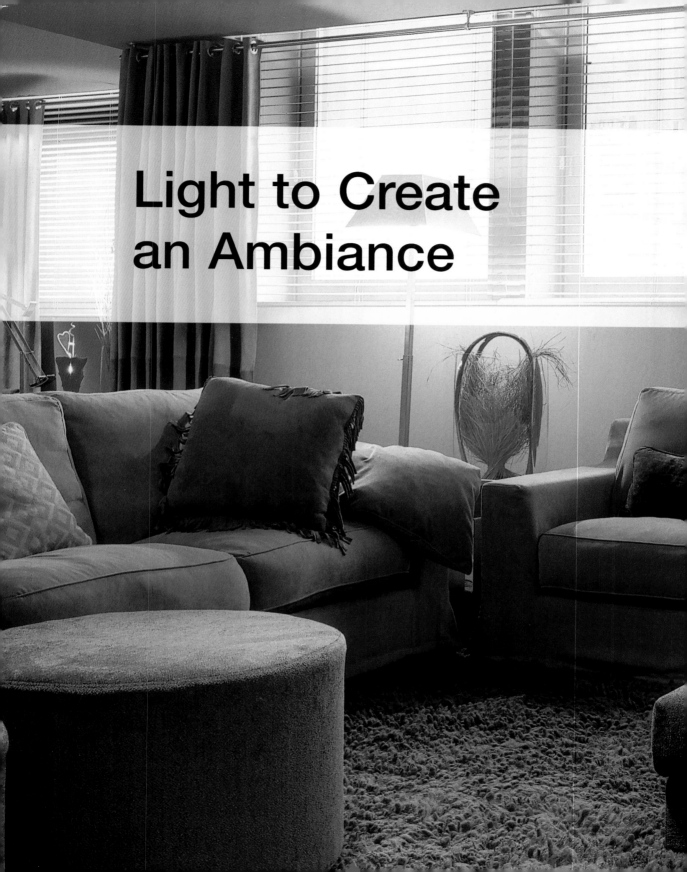

Light to Create an Ambiance

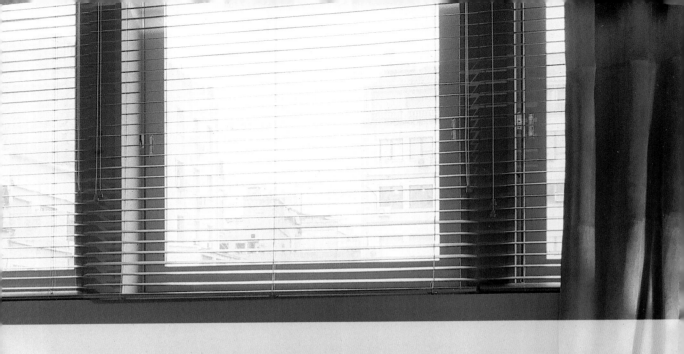

An ambiance is produced by mixing artificial light and daylight: the effect of the warm color from the lamps contrasts with the natural tones of the sunlight.

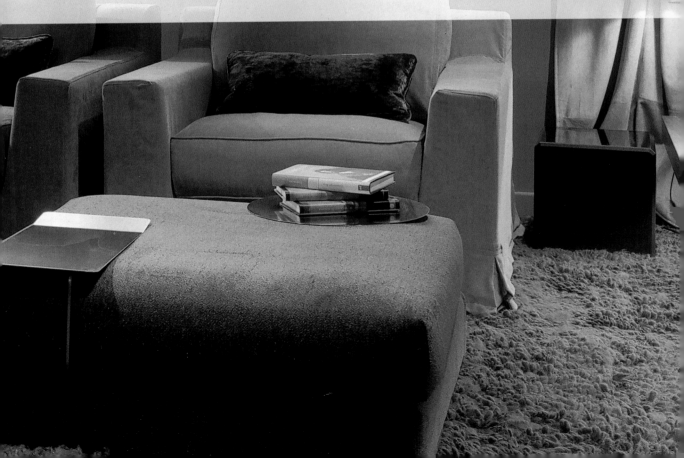

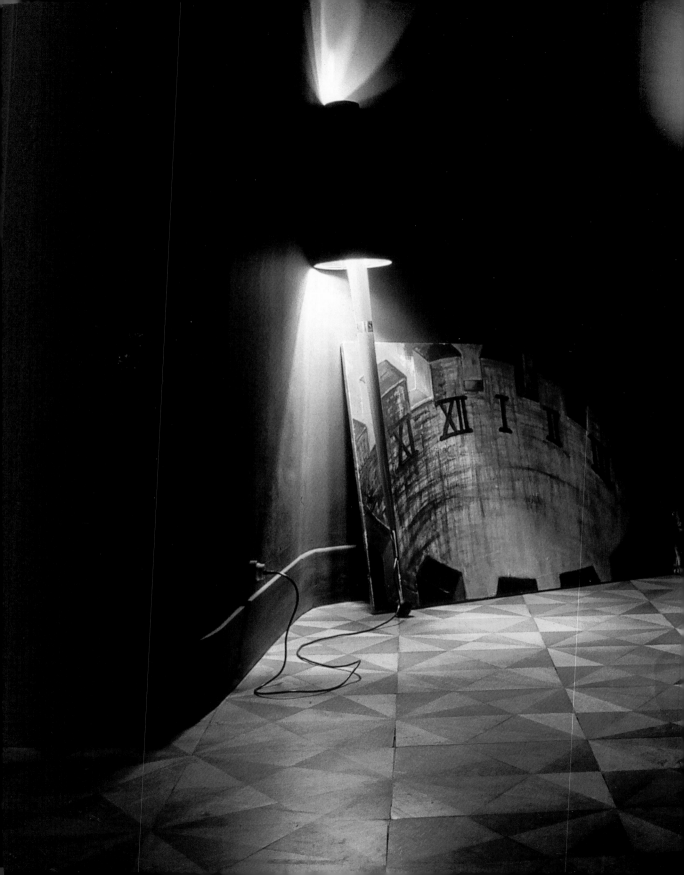

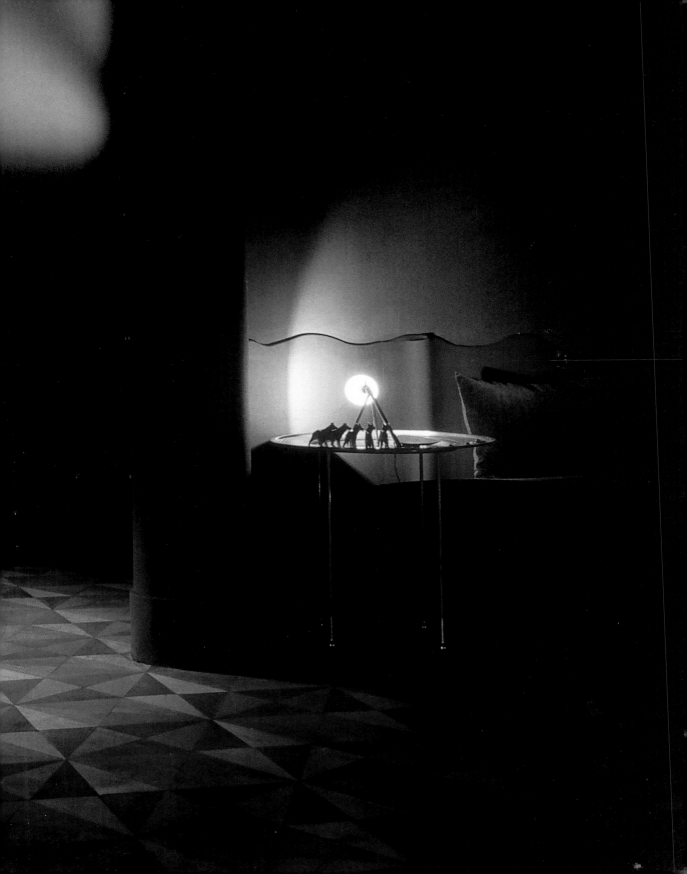

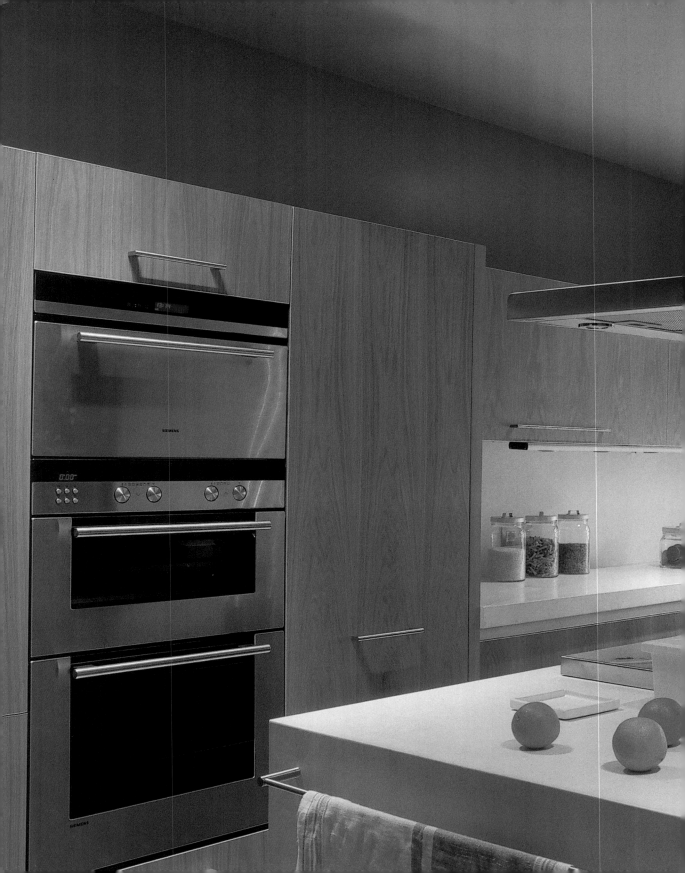

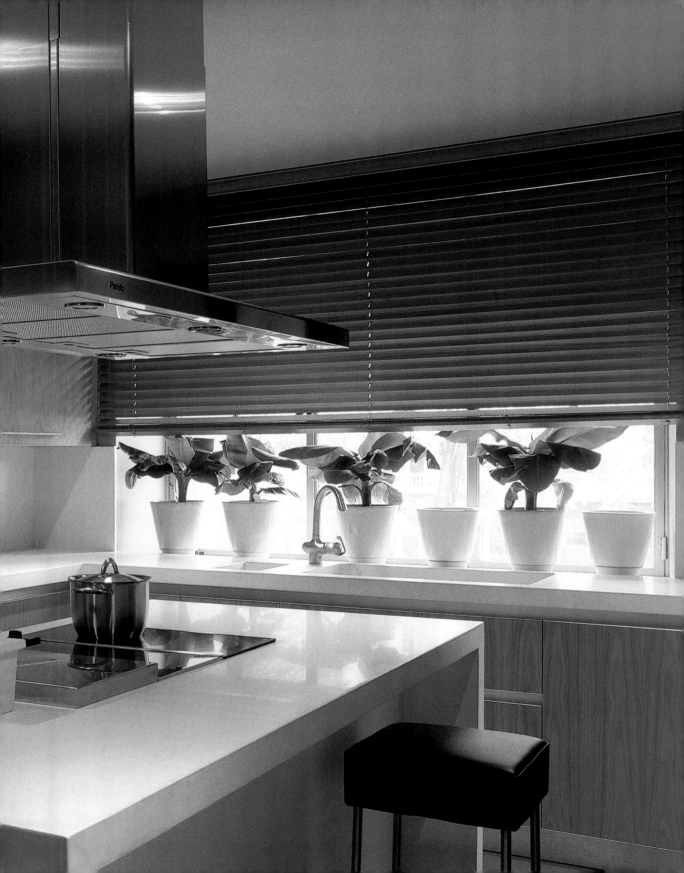

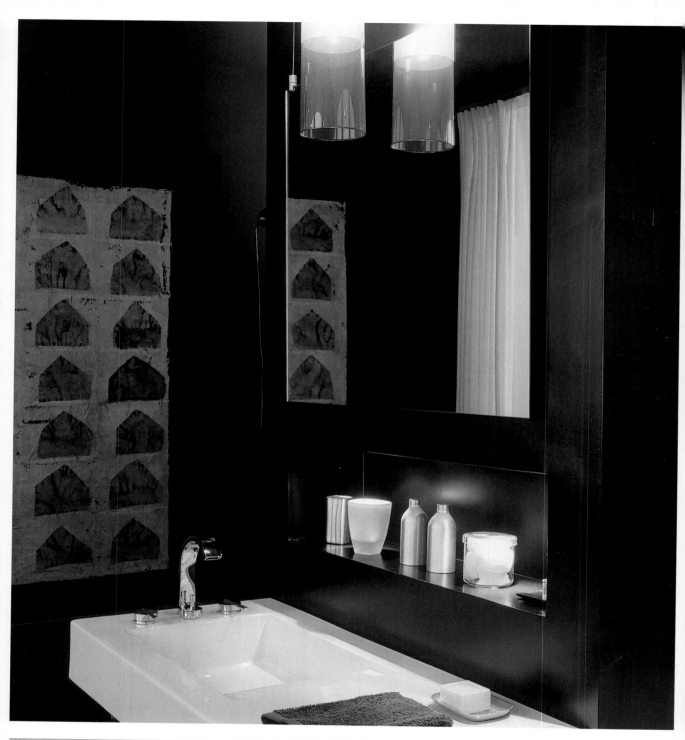

Halogen spotlights illuminate the items in this bathroom.

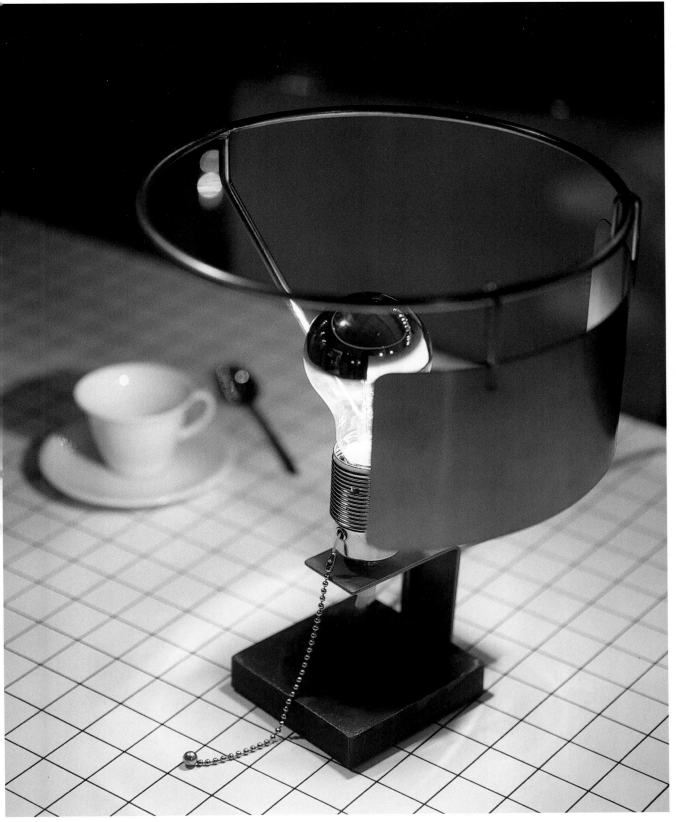

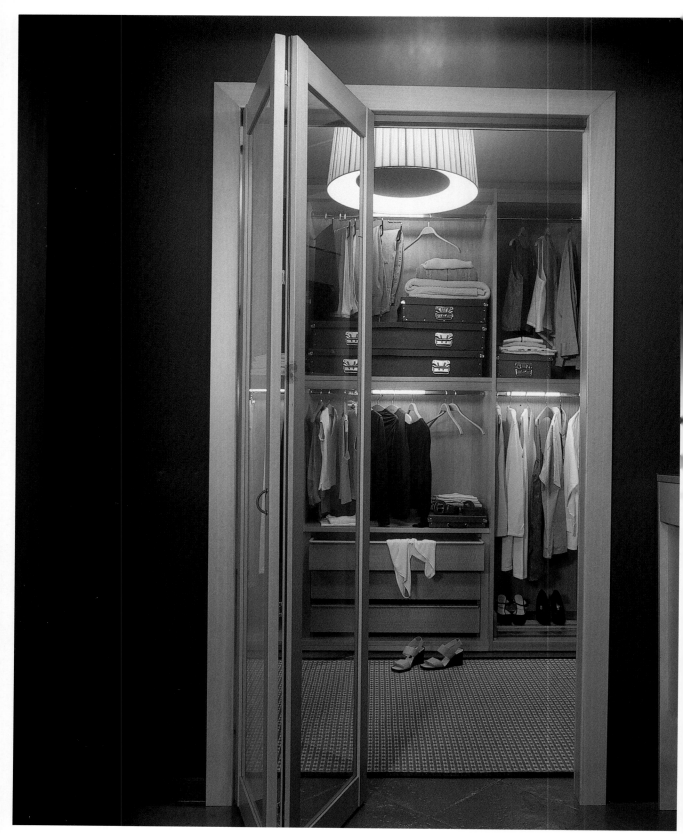

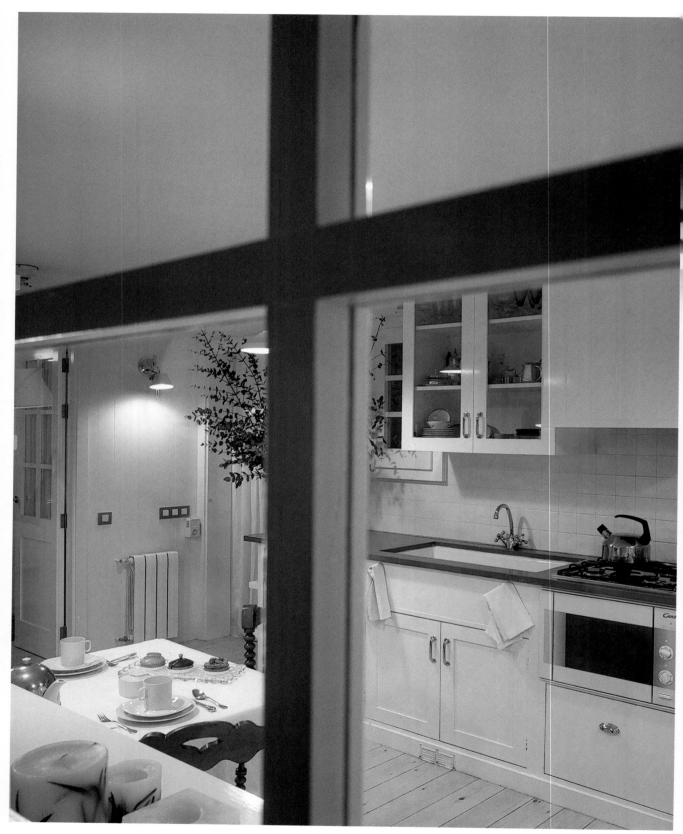

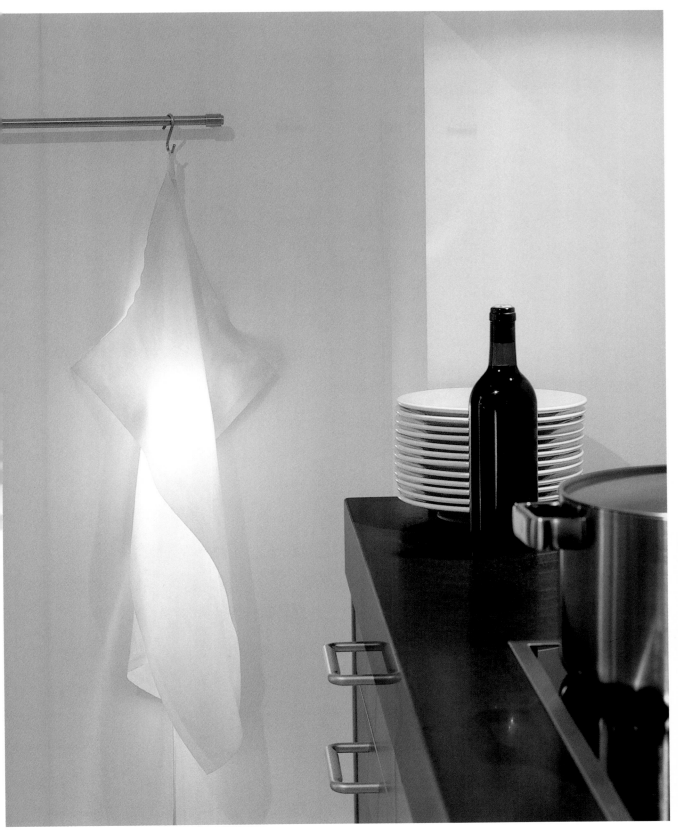

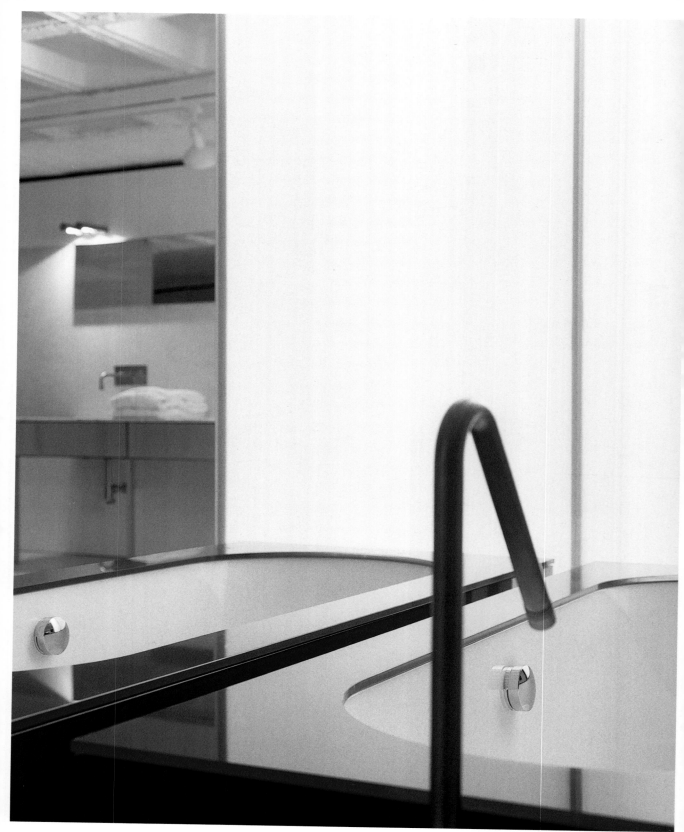

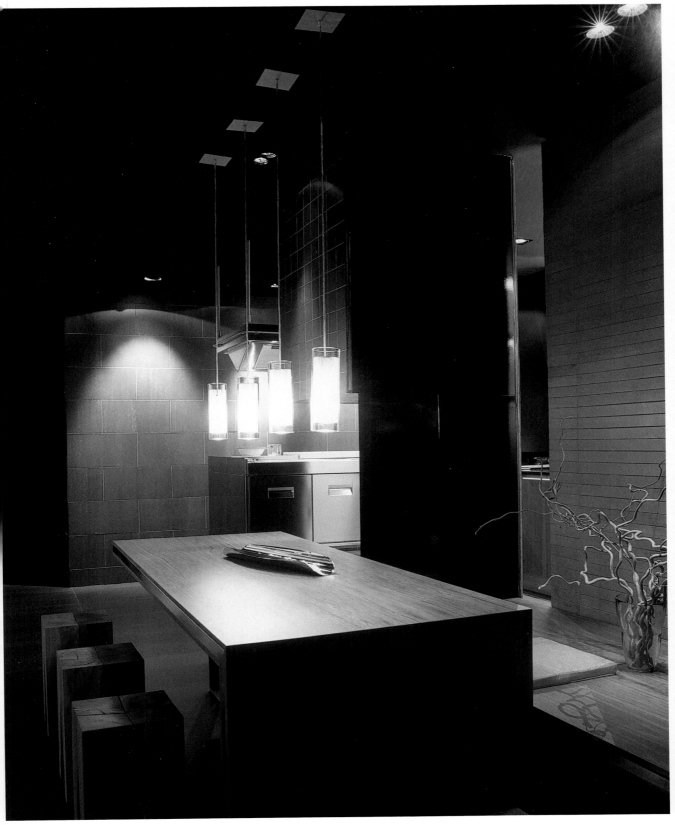

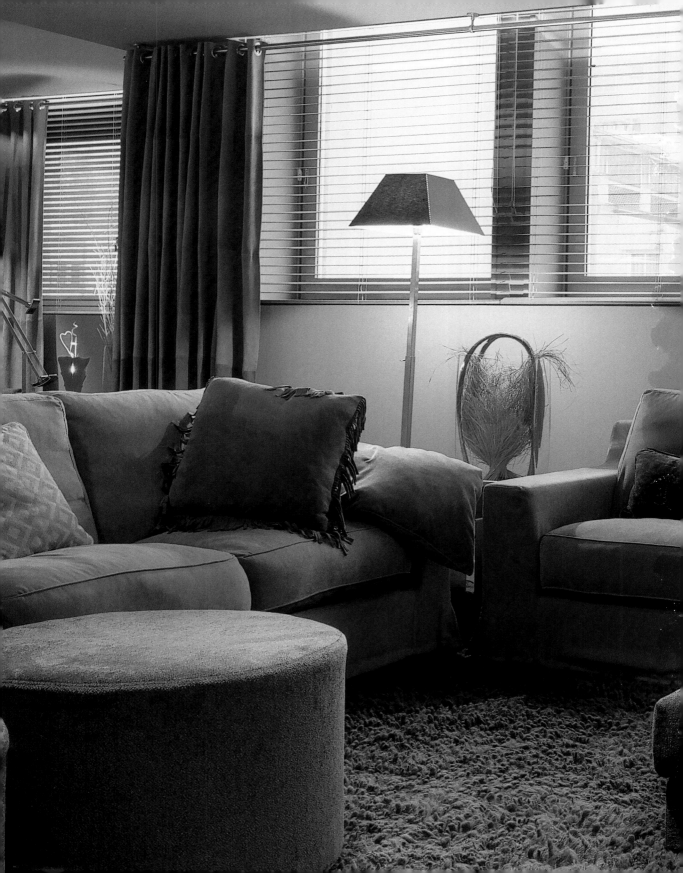

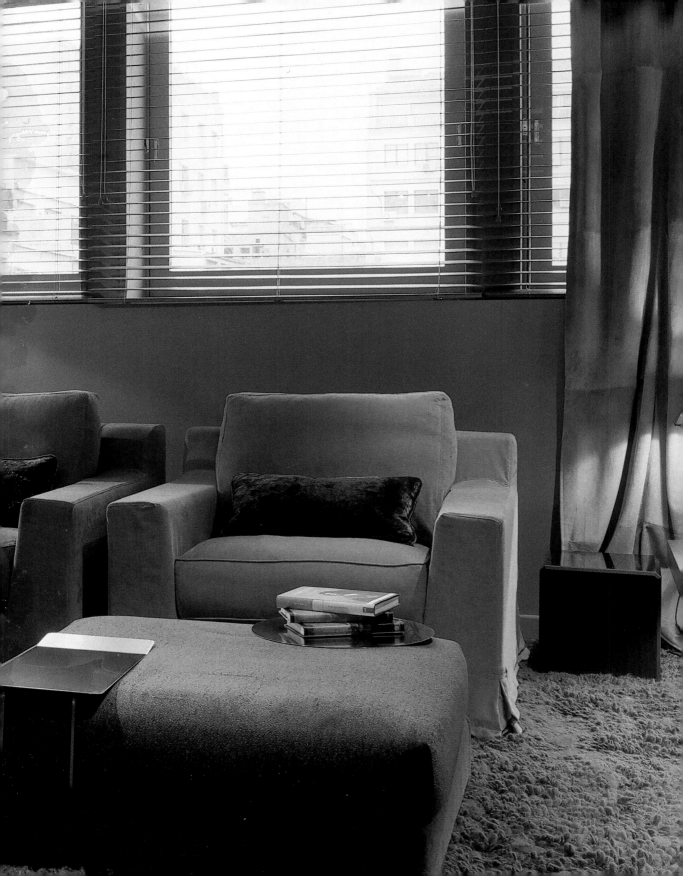

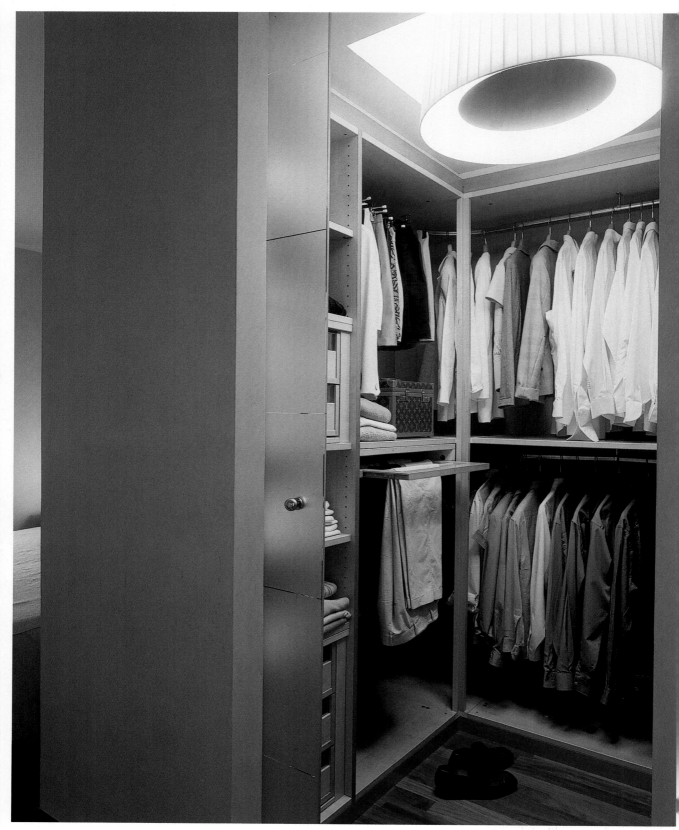

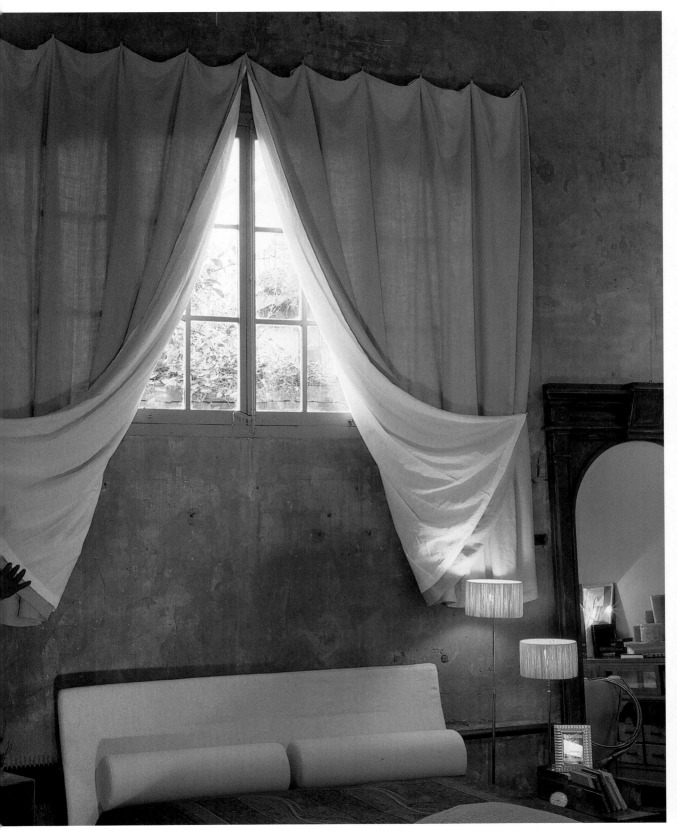

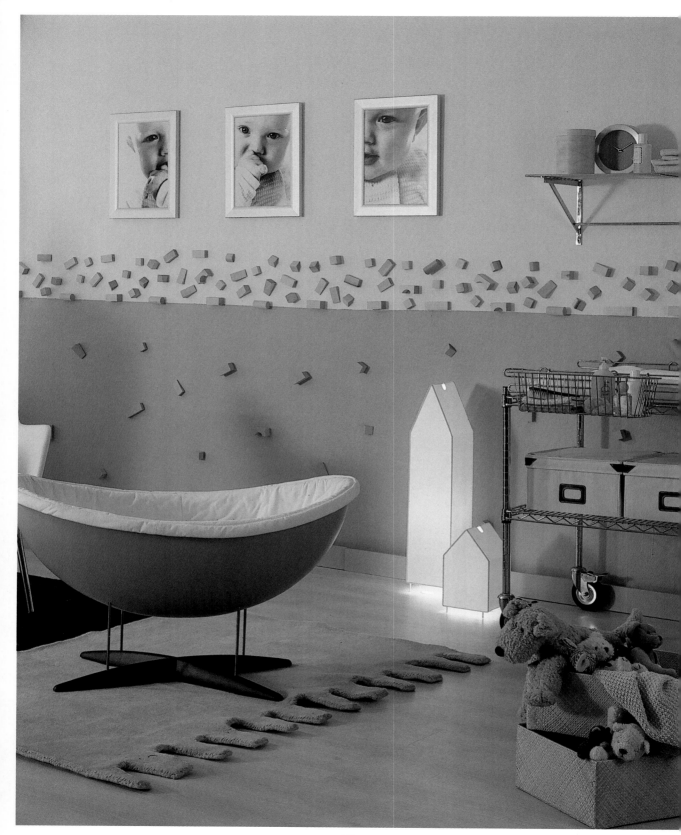

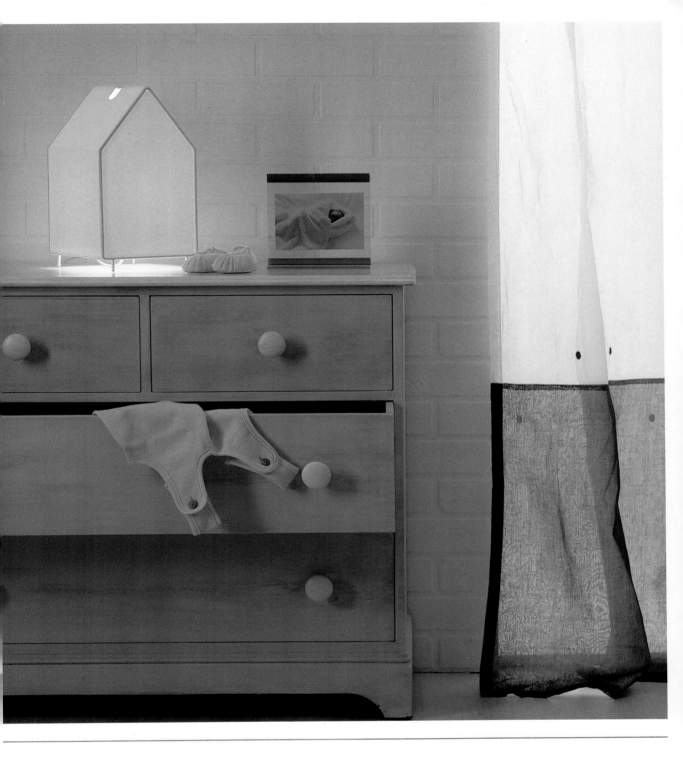

Small lamps that diffuse and filter light are perfect for children's rooms.

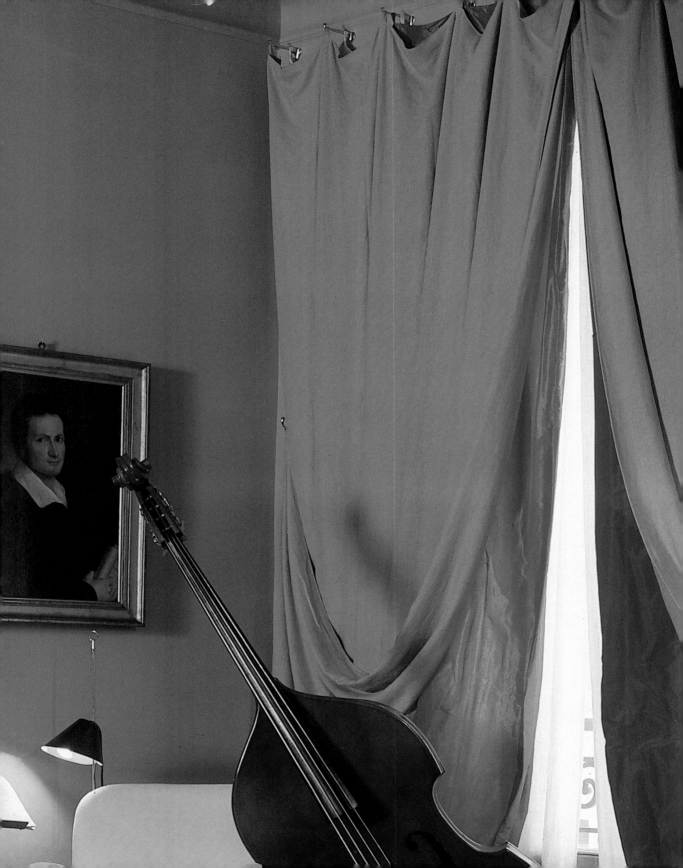

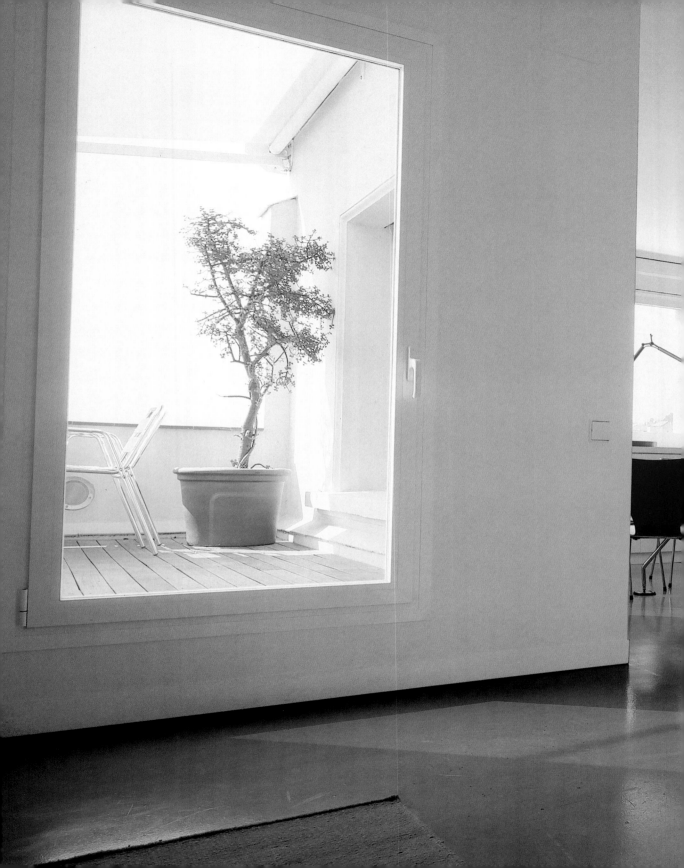

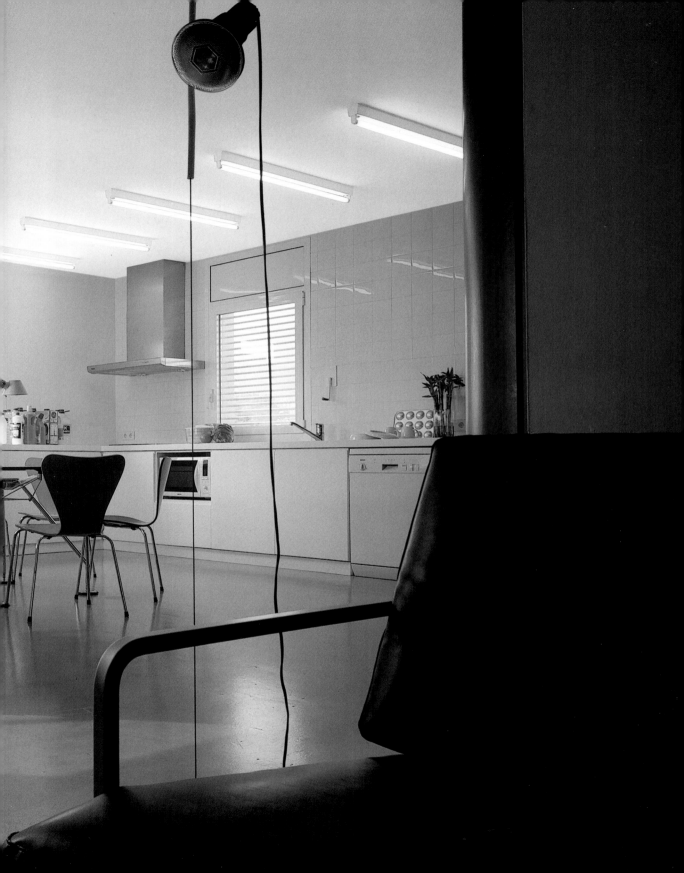

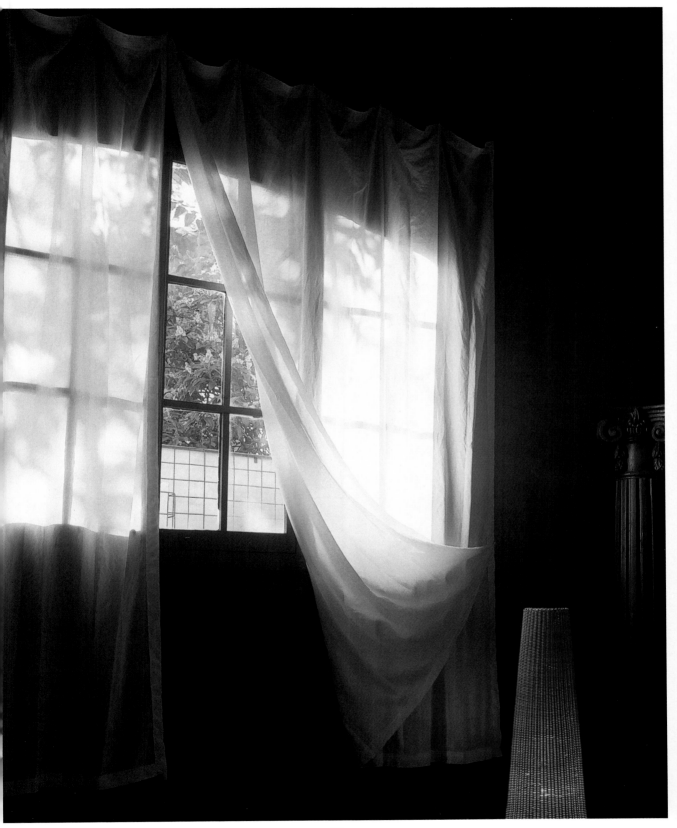

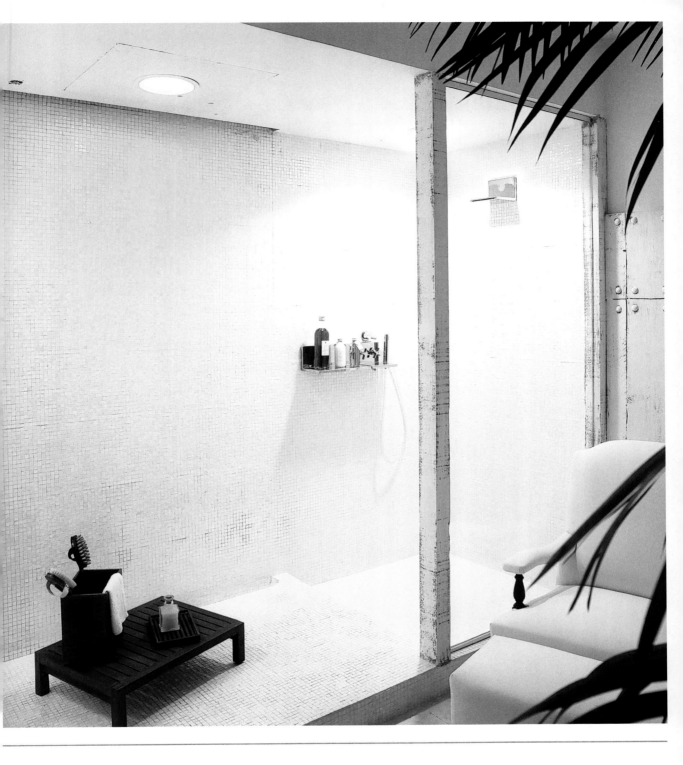

Two points of low-wattage, incandescent light lend an exotic element to this shower.

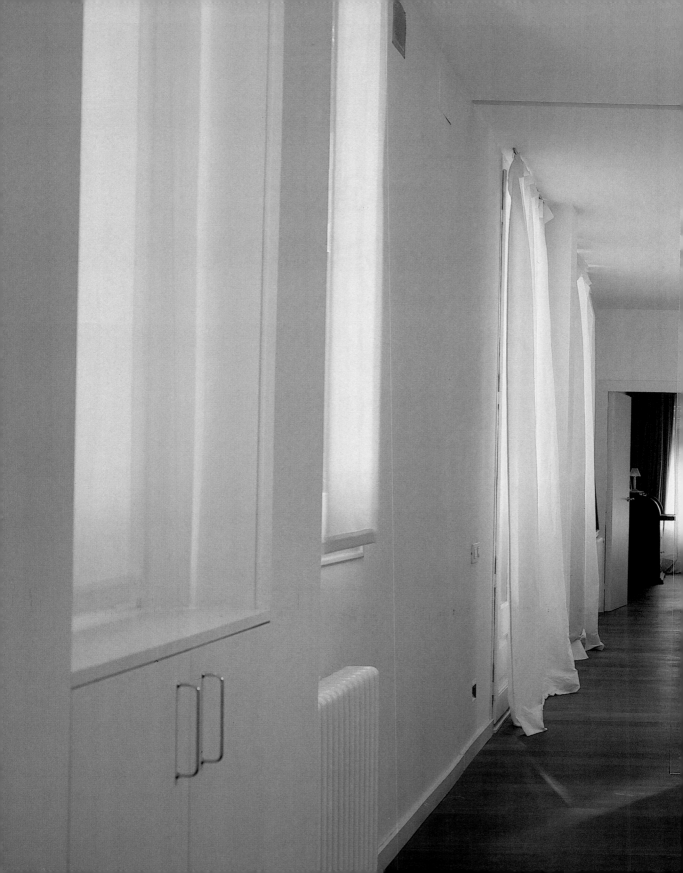

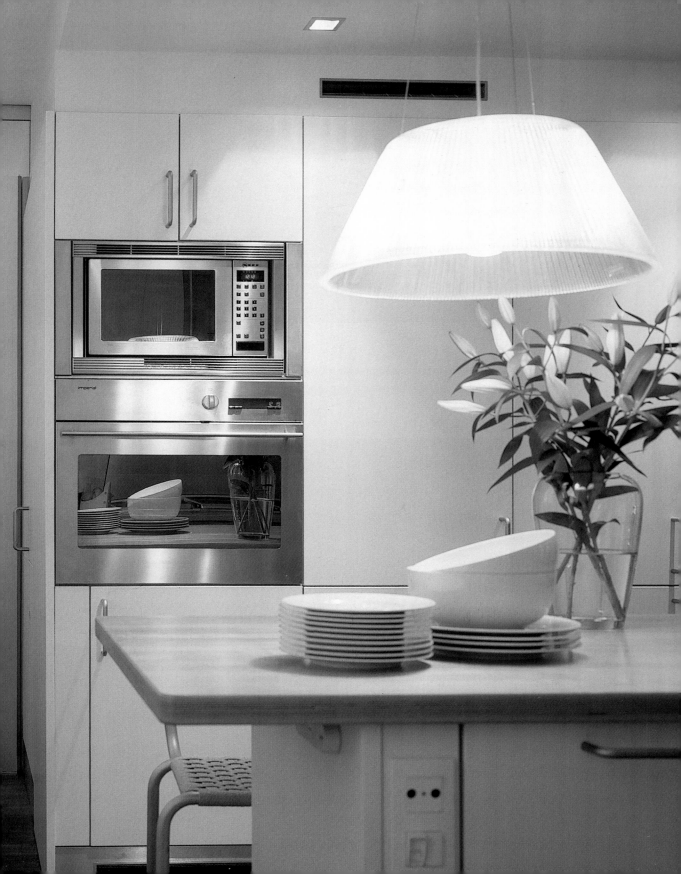

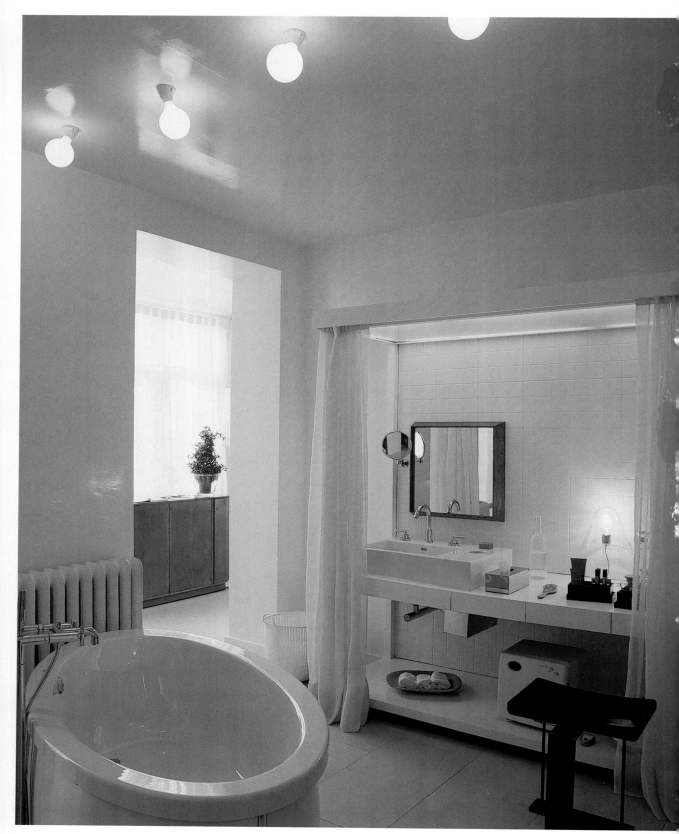

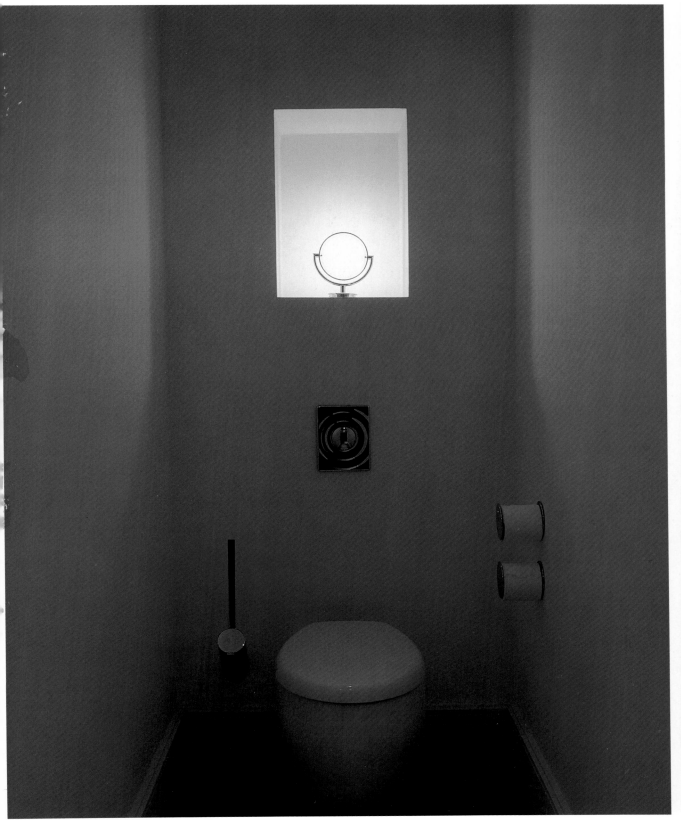

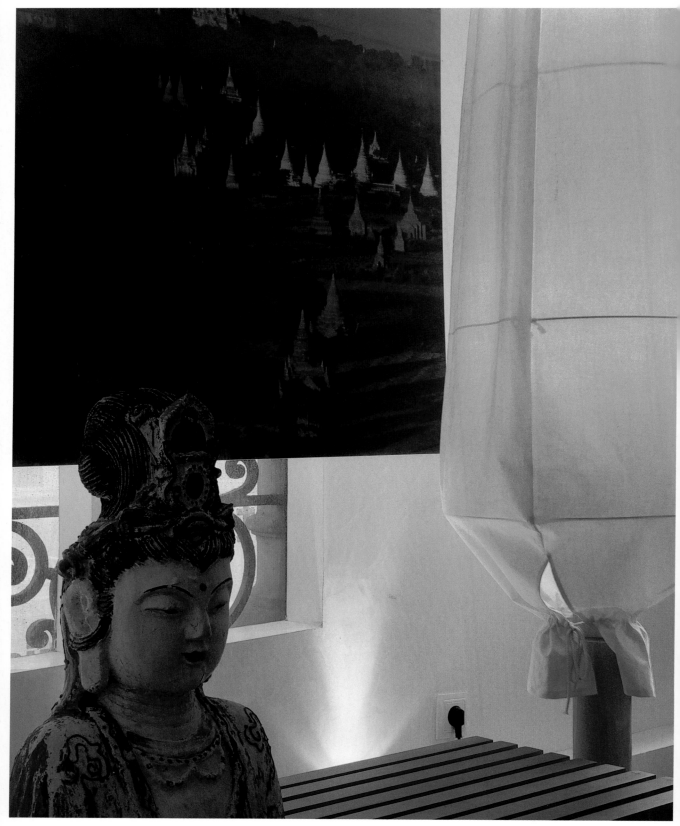

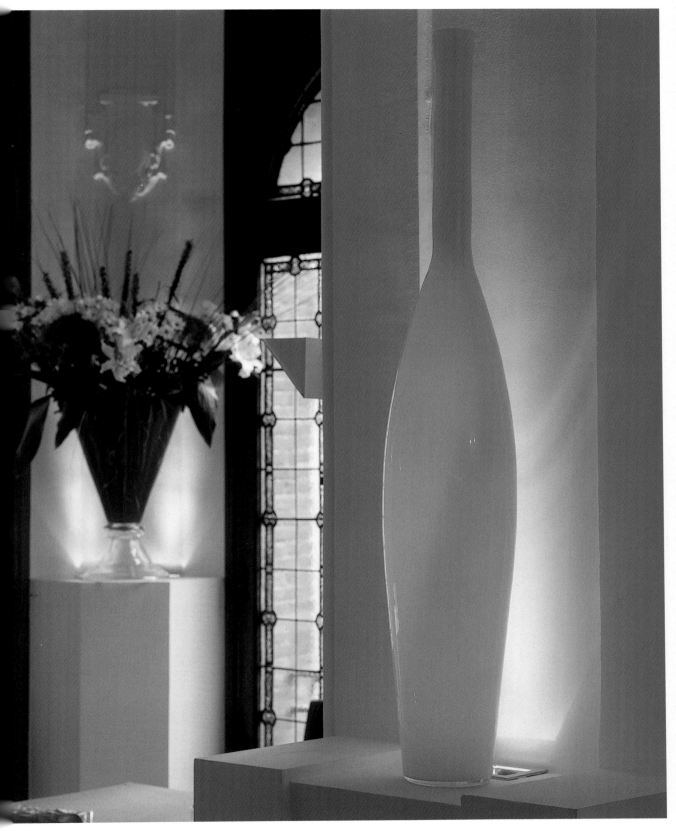

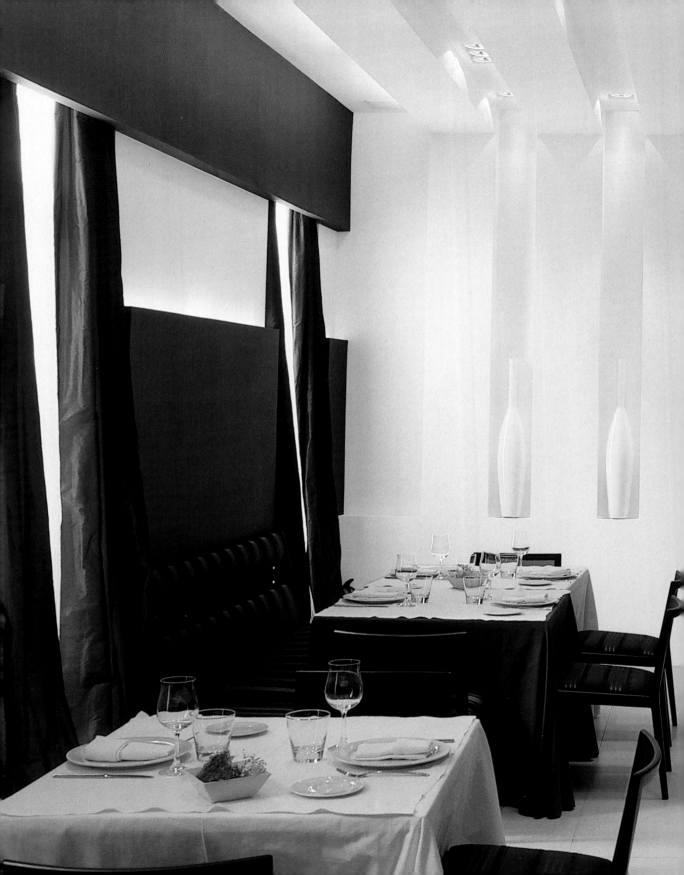

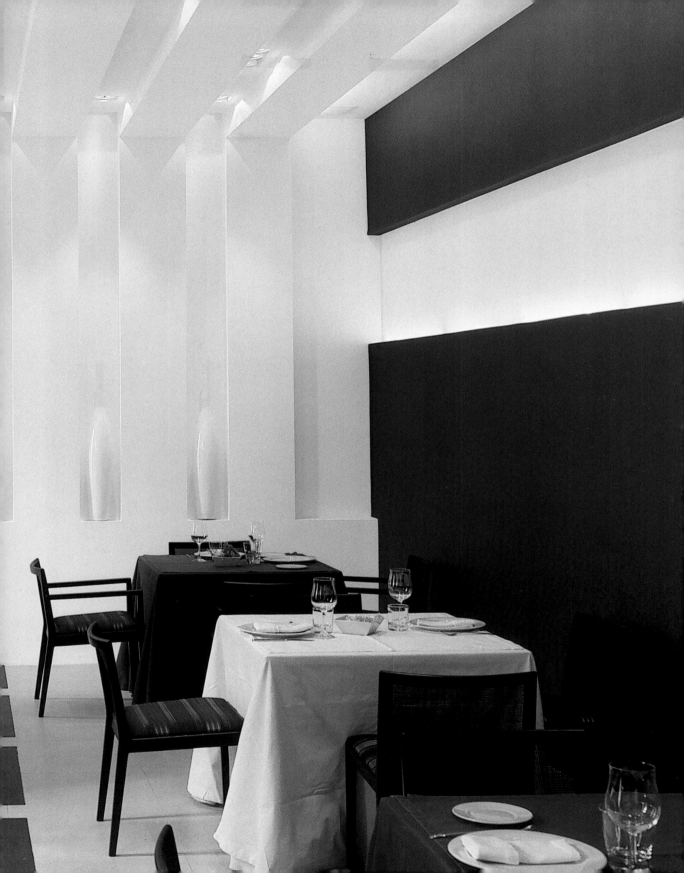

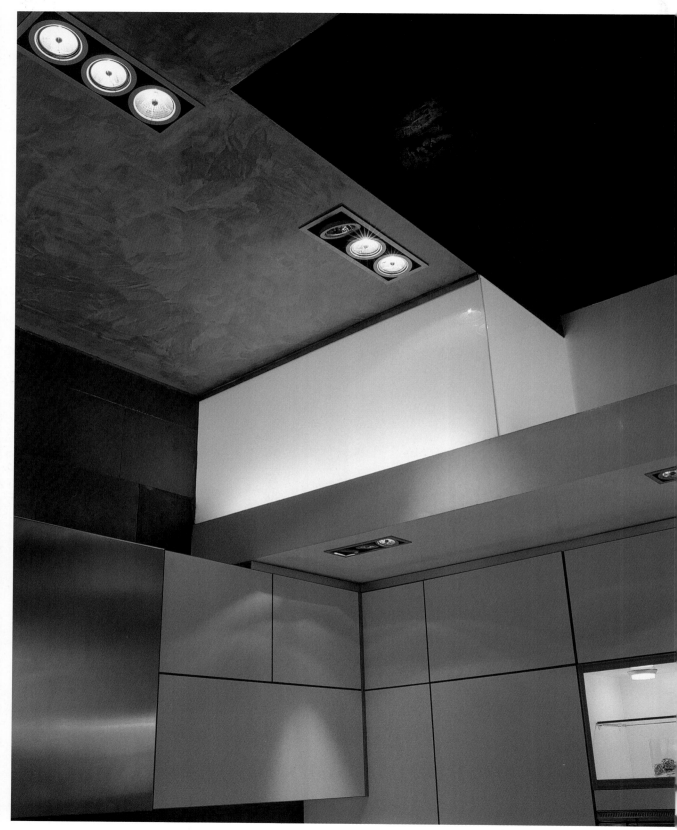

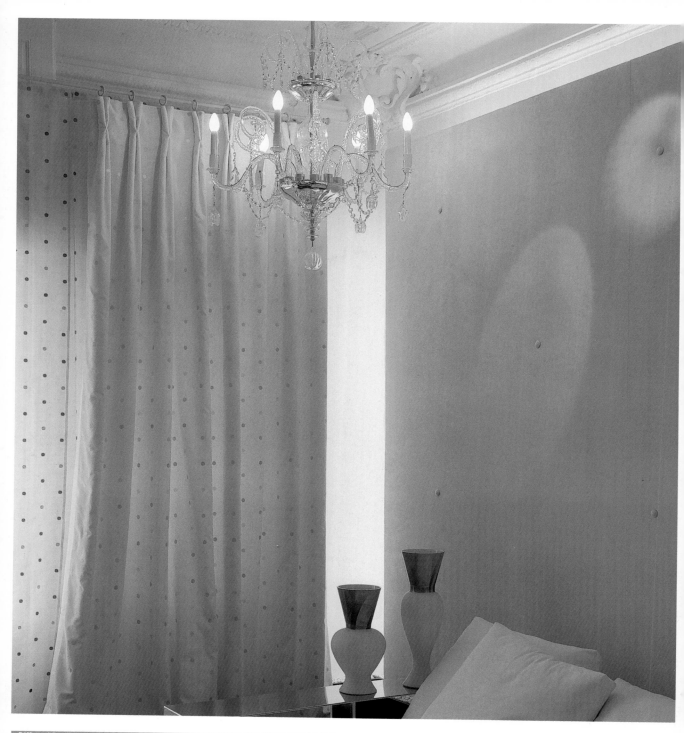

A border of continuous light lines the wall of this living room,
creating depth and mixing with the spotlights from the halogen lamps.

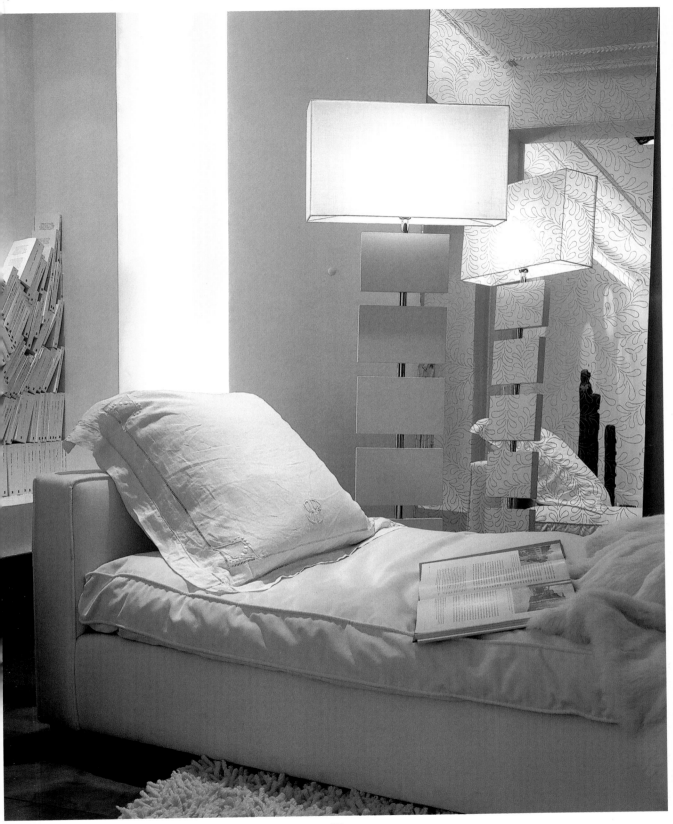

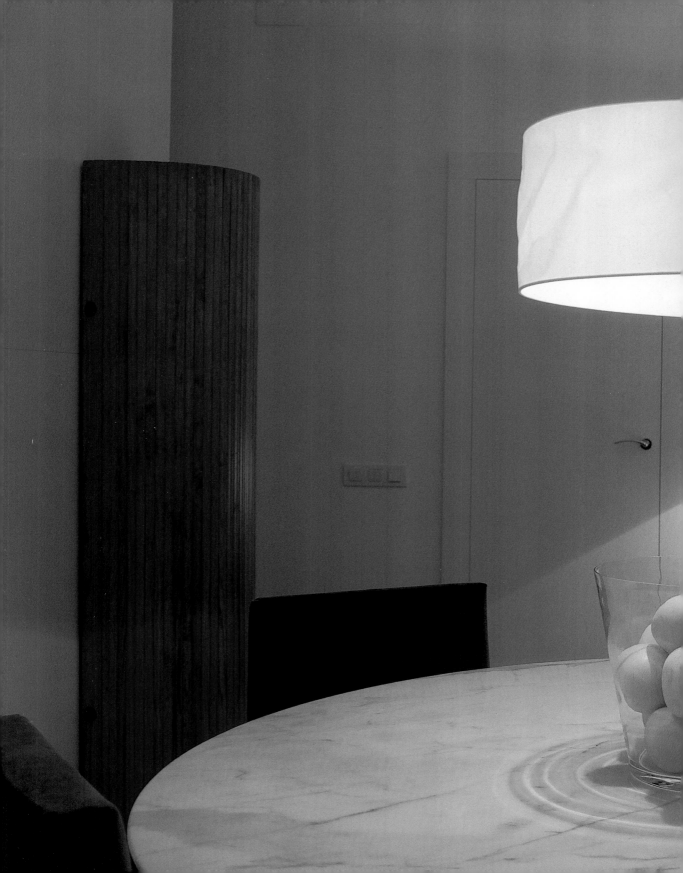

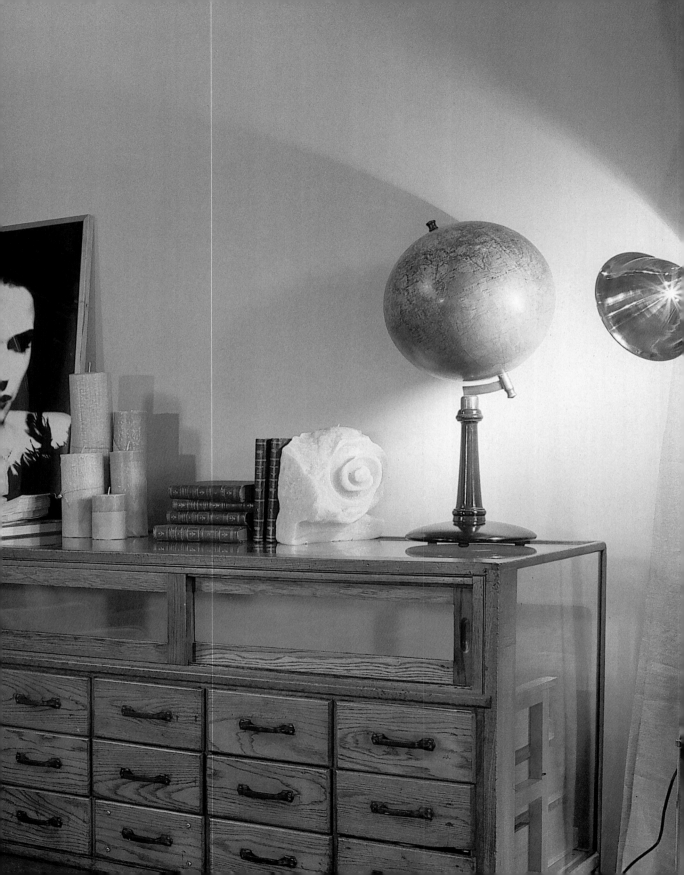

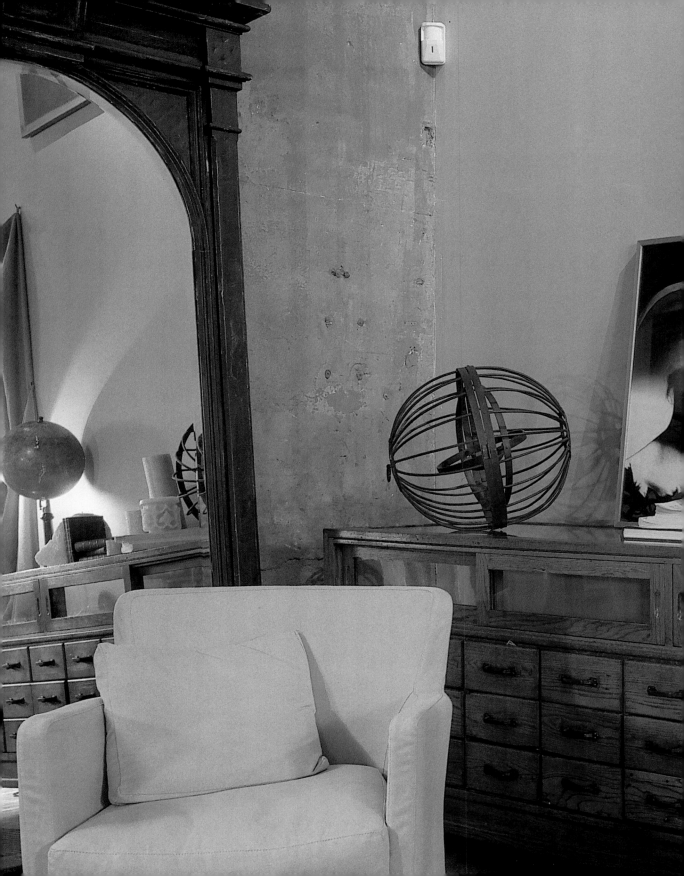

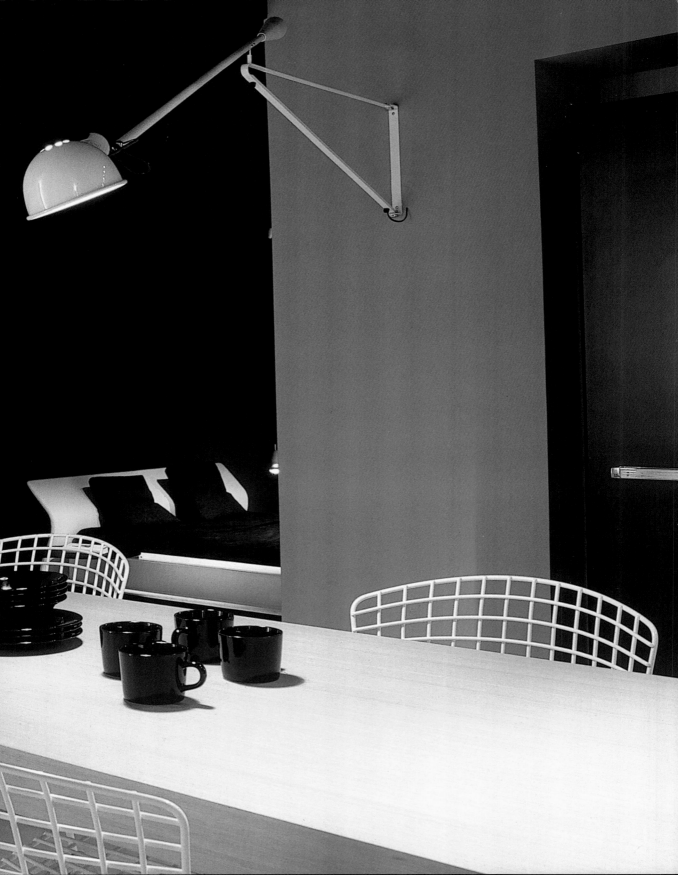

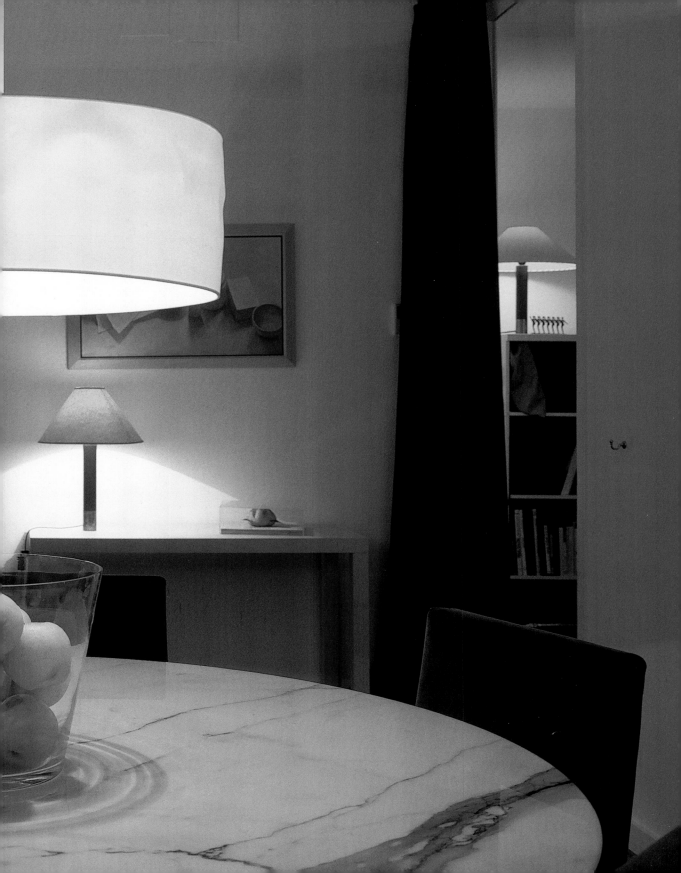

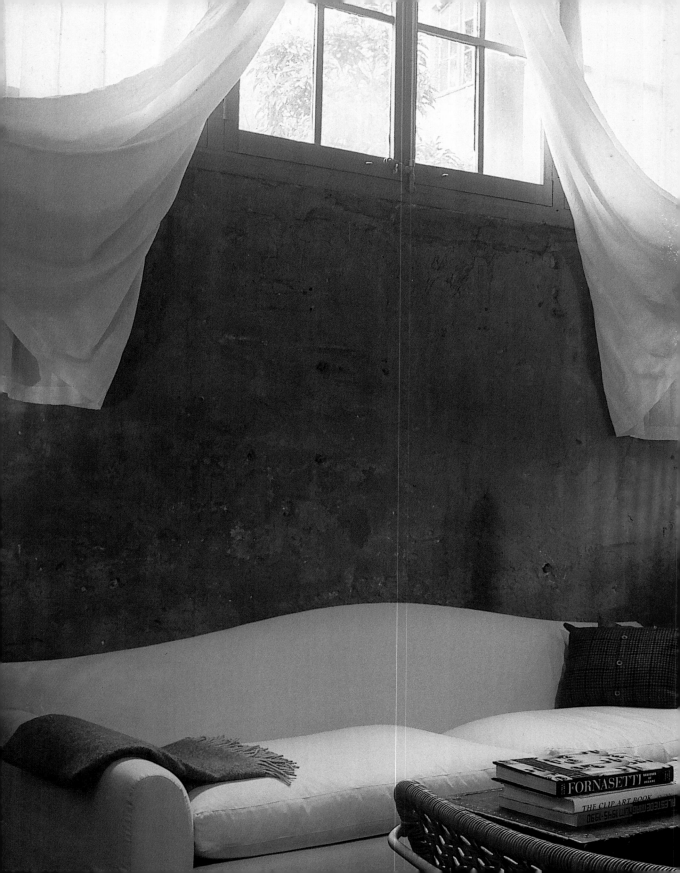

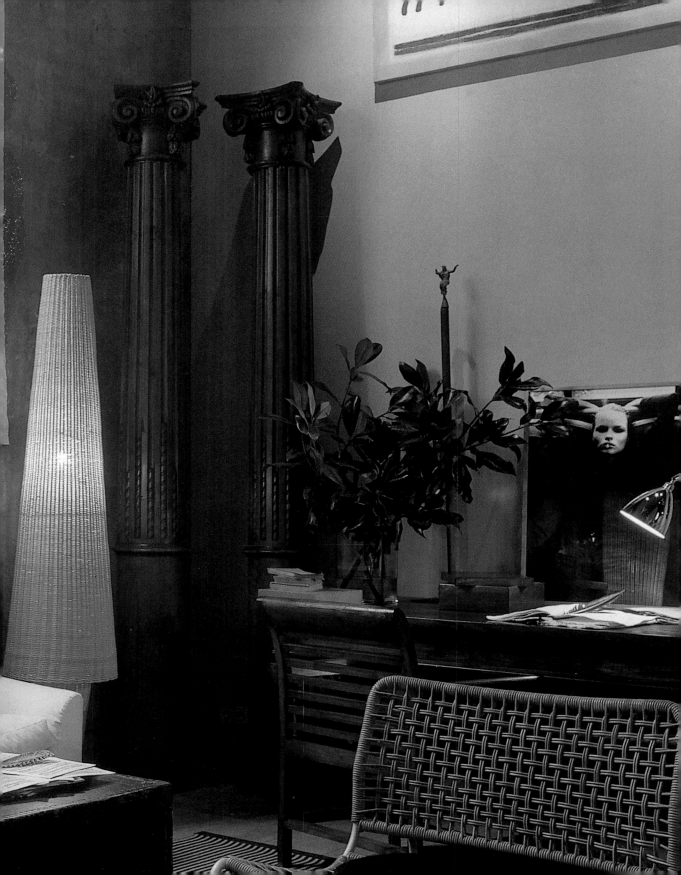

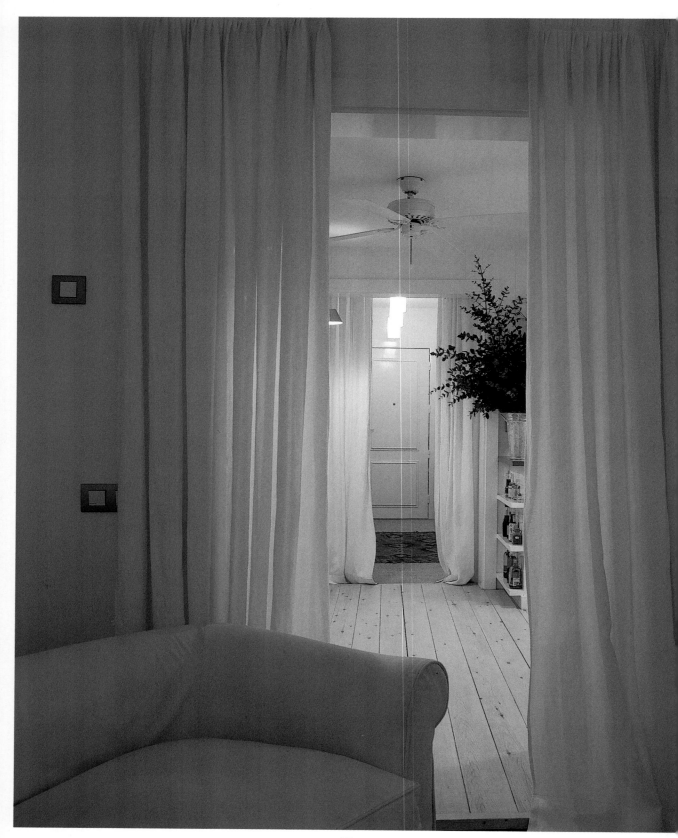

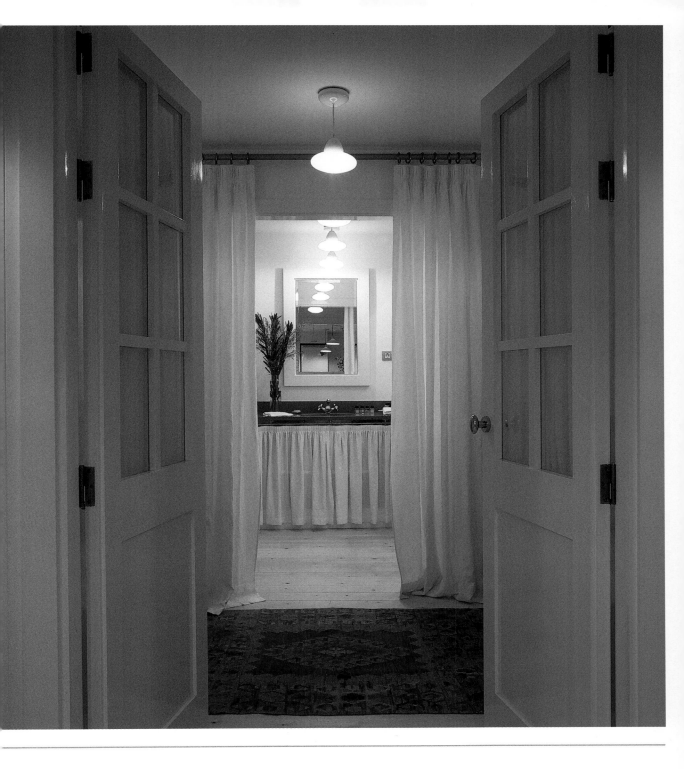

Lights in front of a mirror enhance the levels of brightness and make the space appear larger.

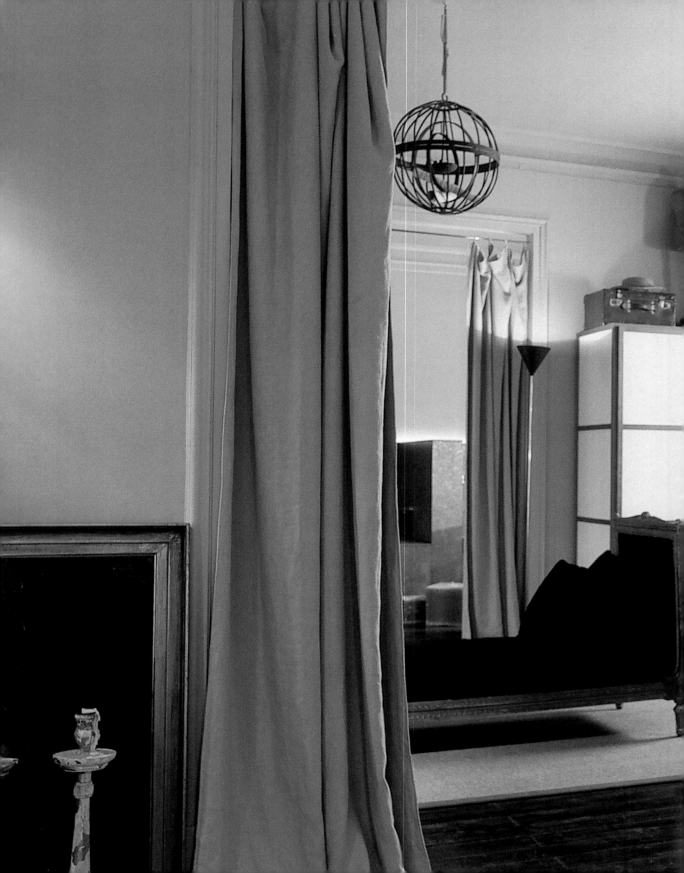

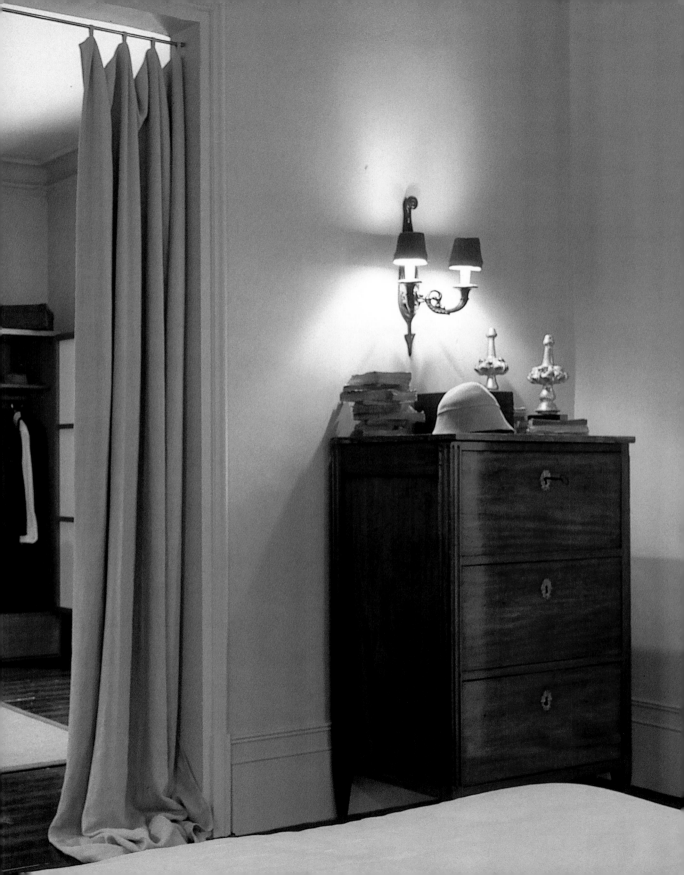

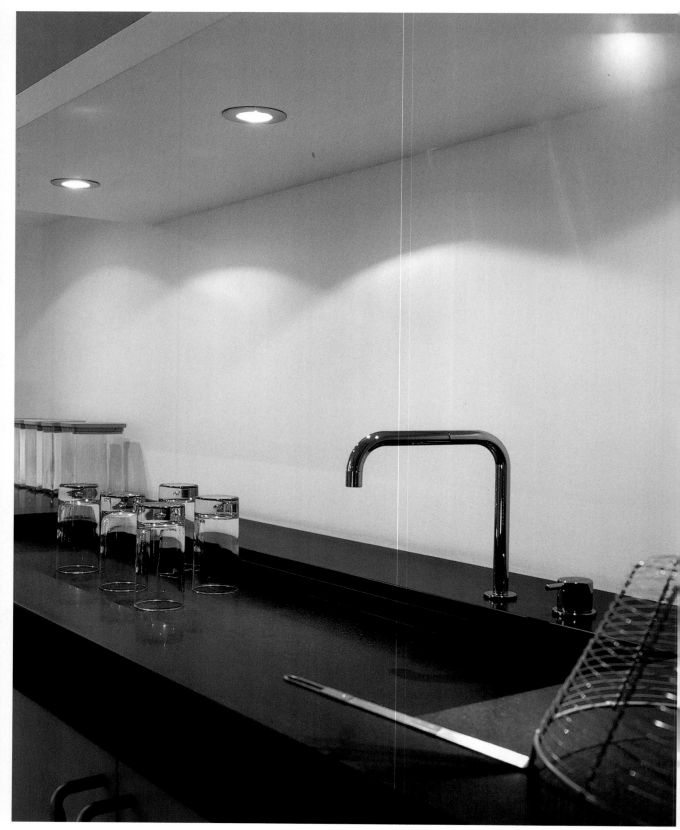

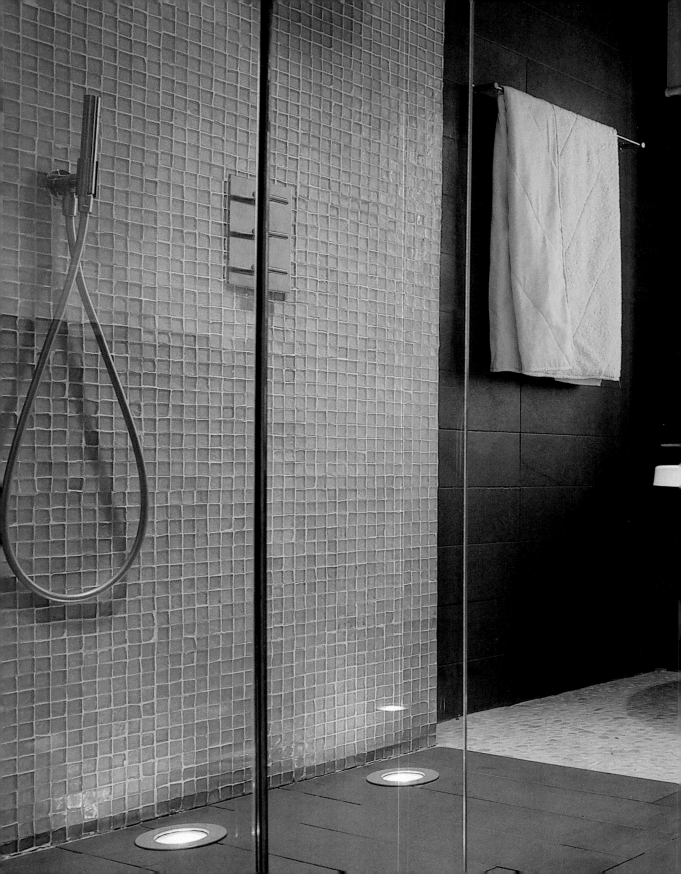

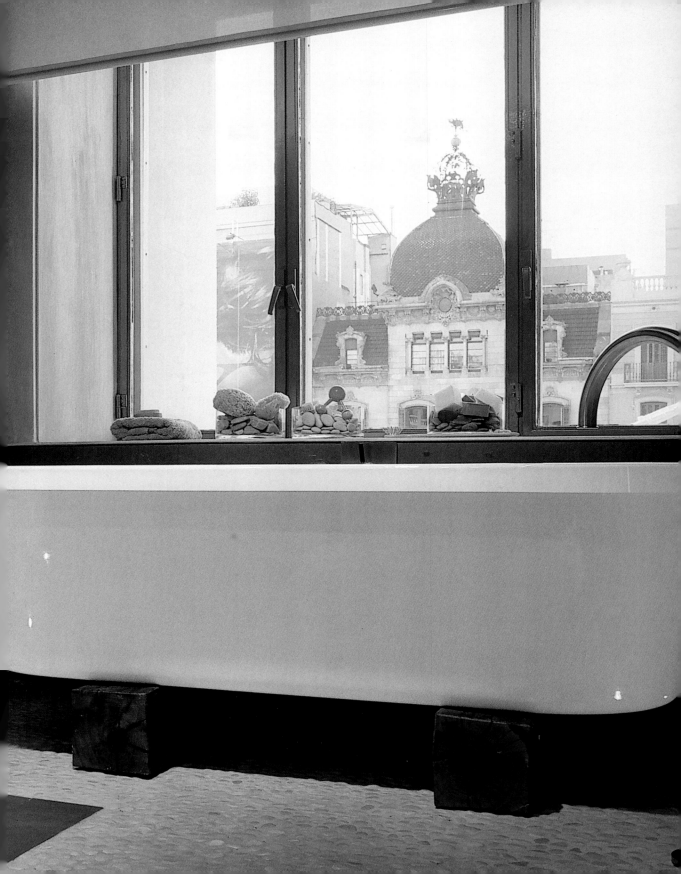

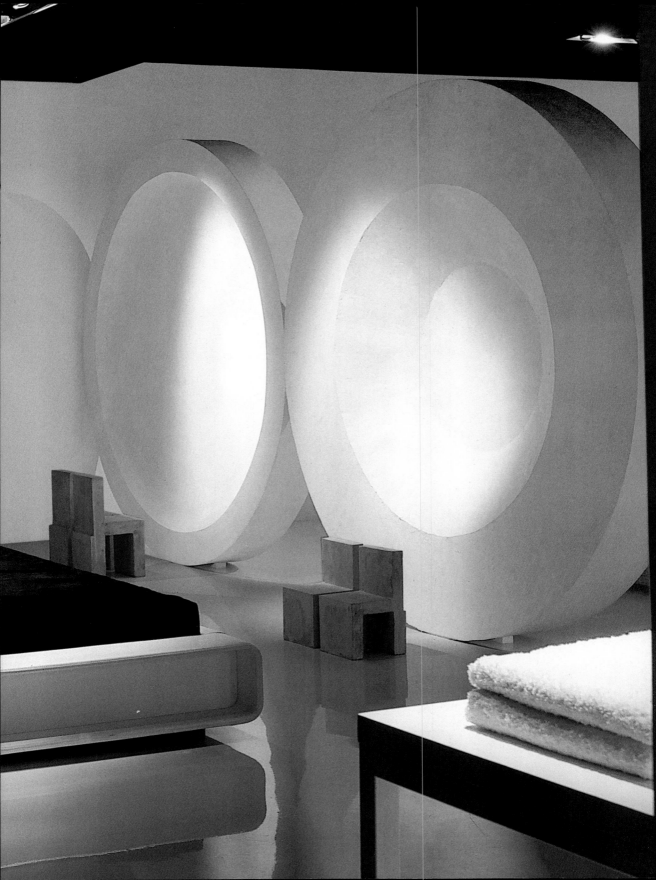

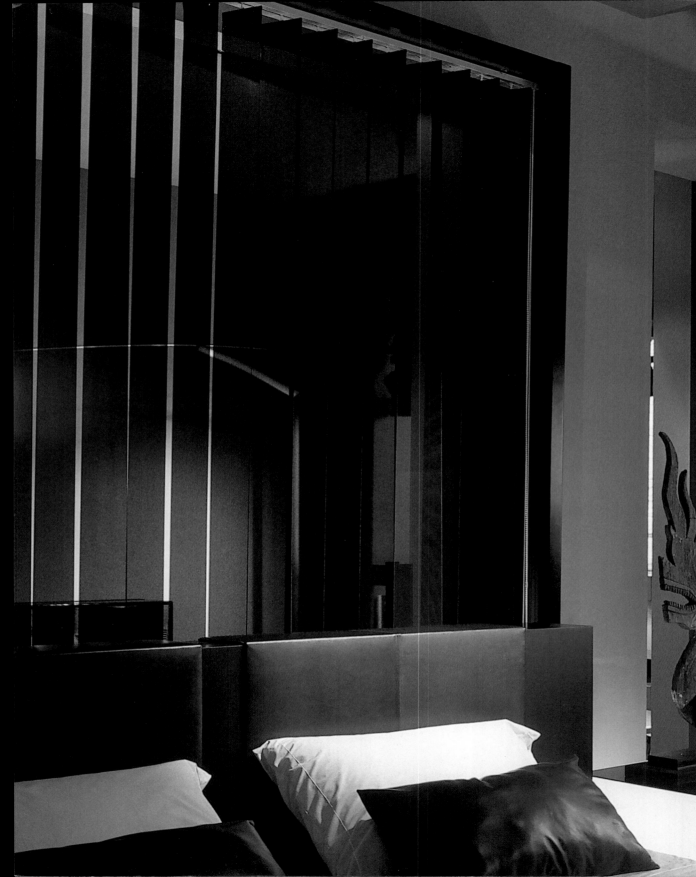

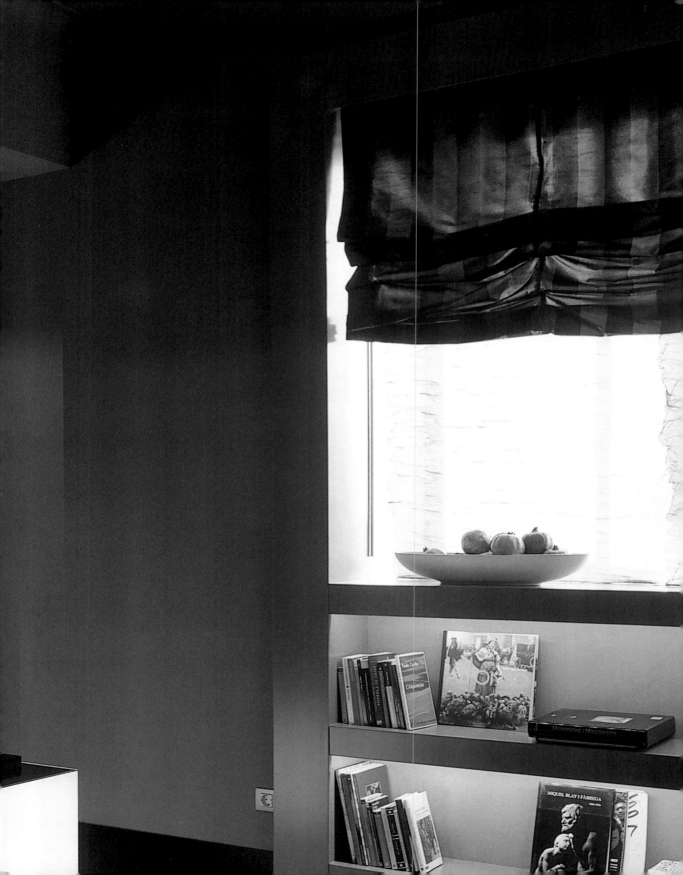

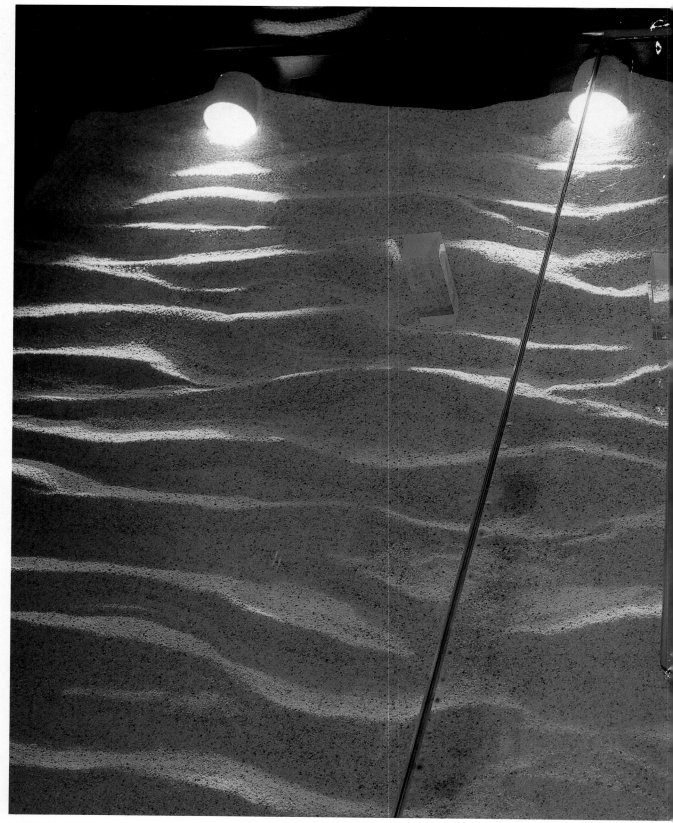

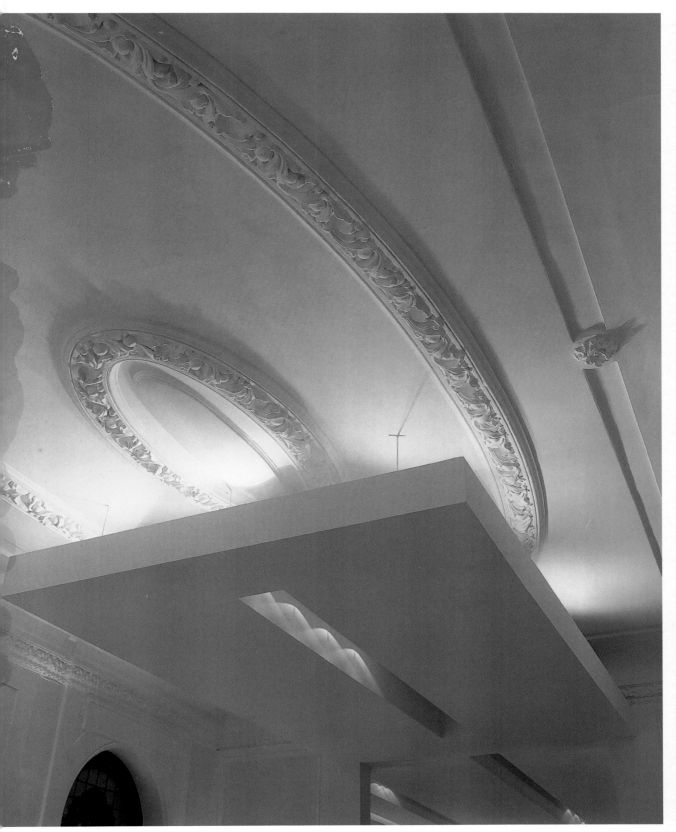

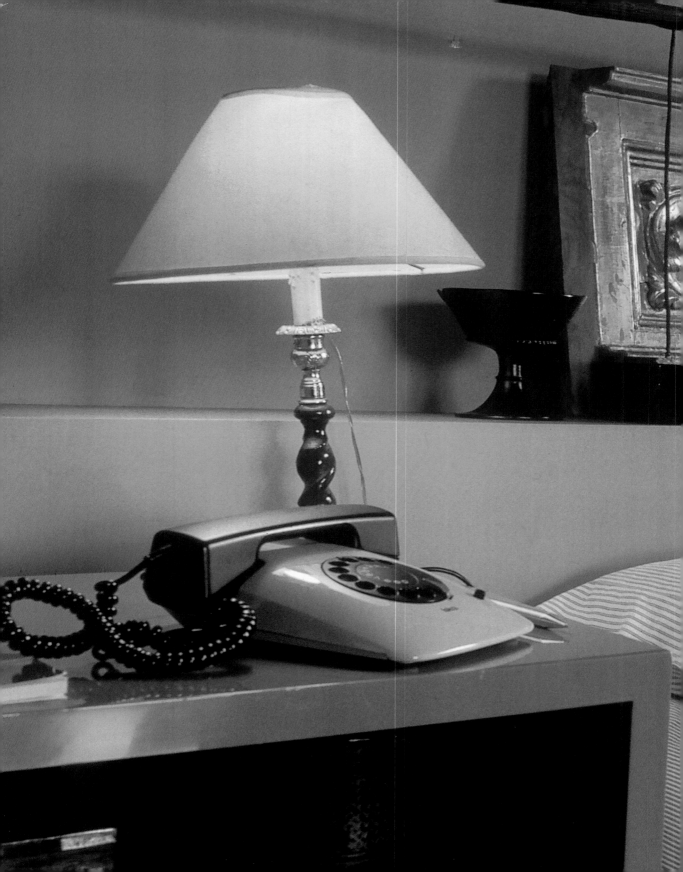

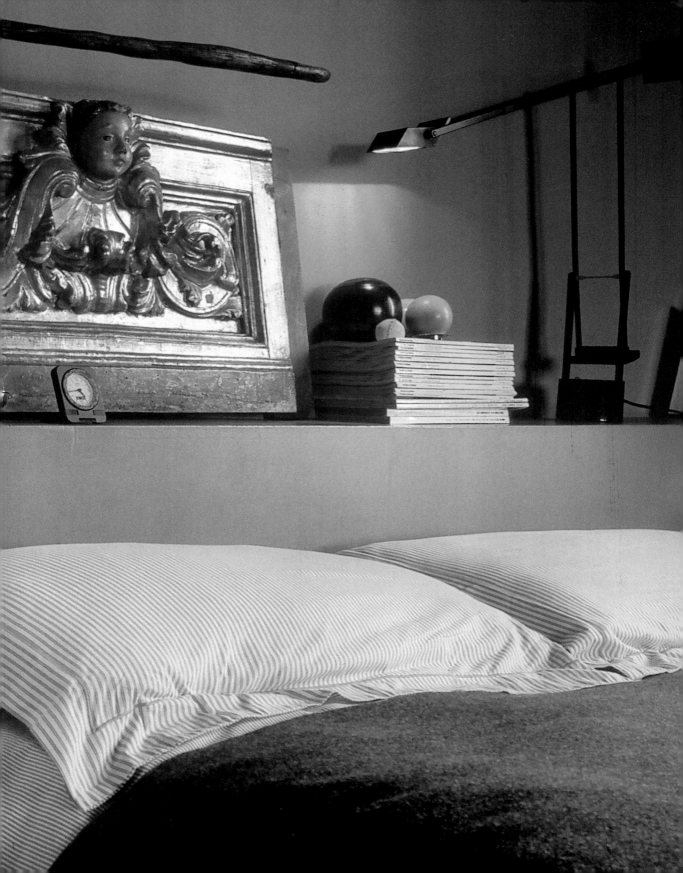

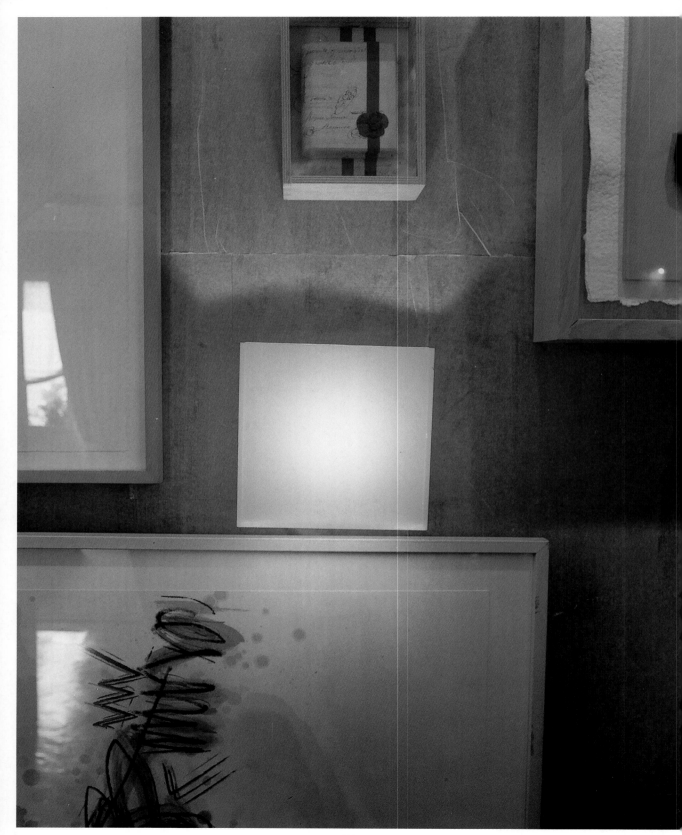

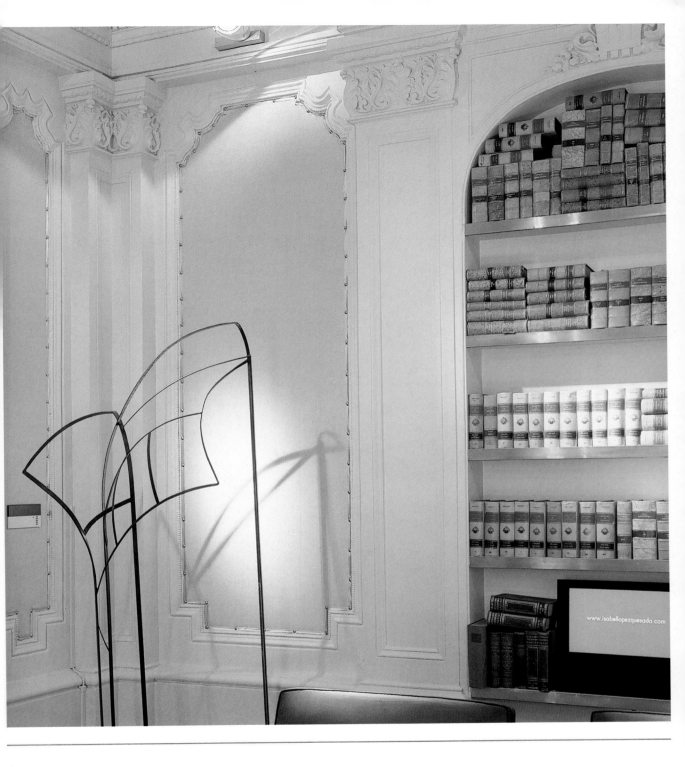

Spotlights from the halogen lamps built into the ceiling create plays of shadow that emphasize the objects and furnishings in this living room.

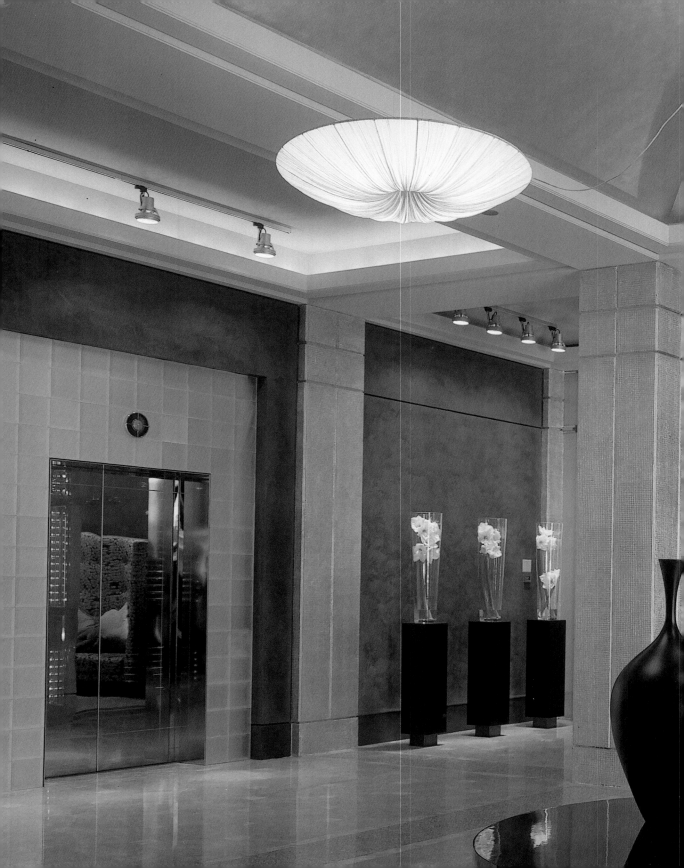

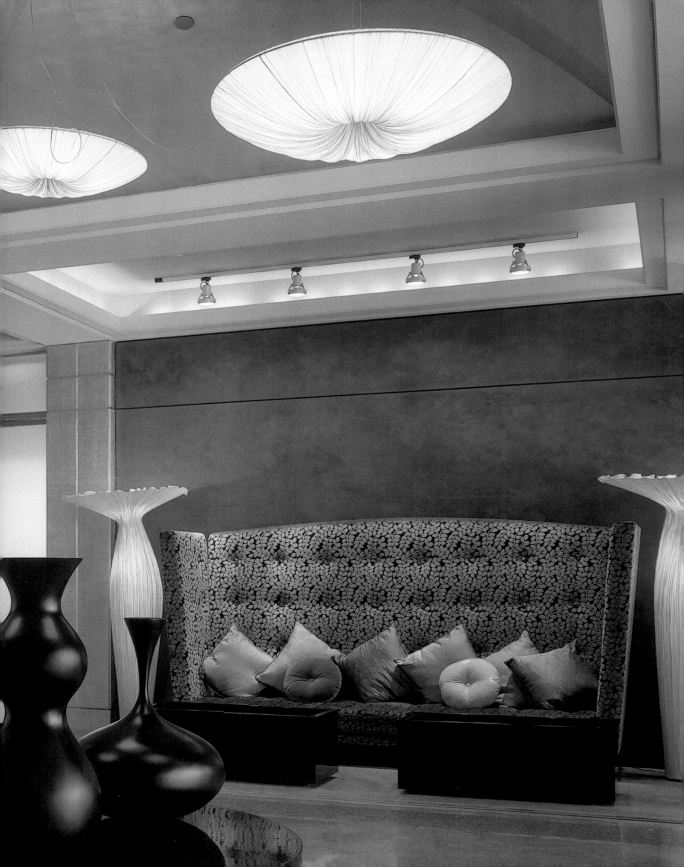

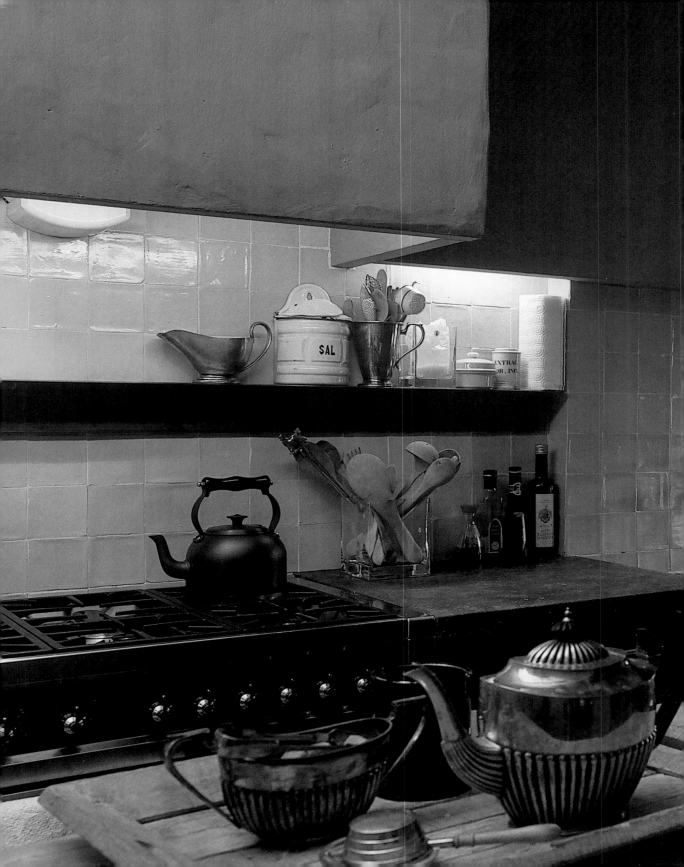

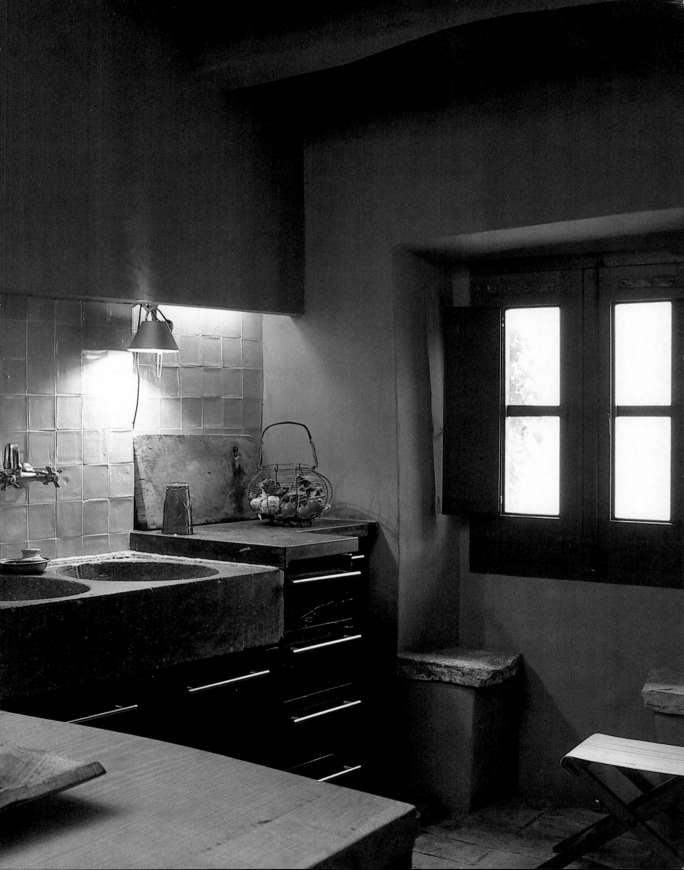

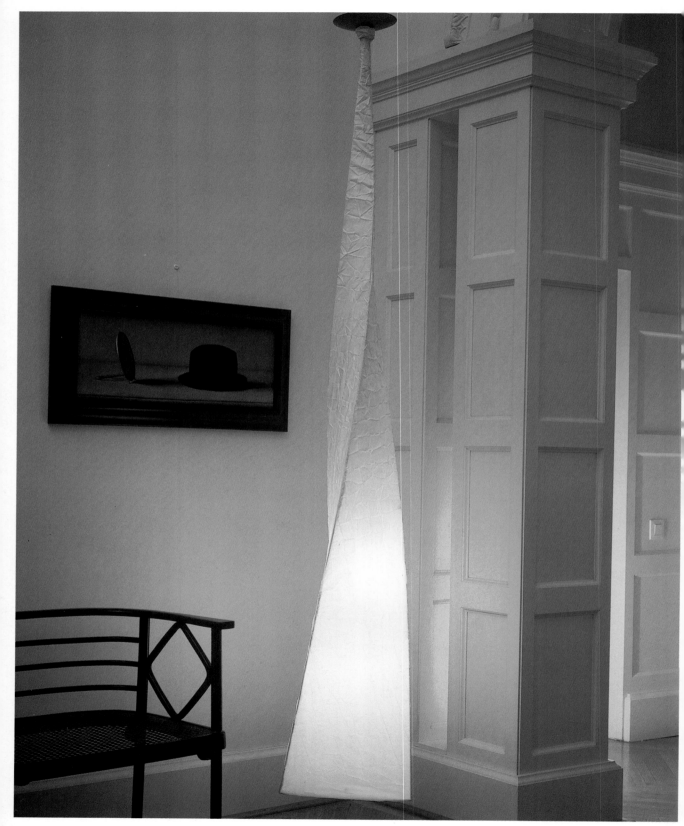

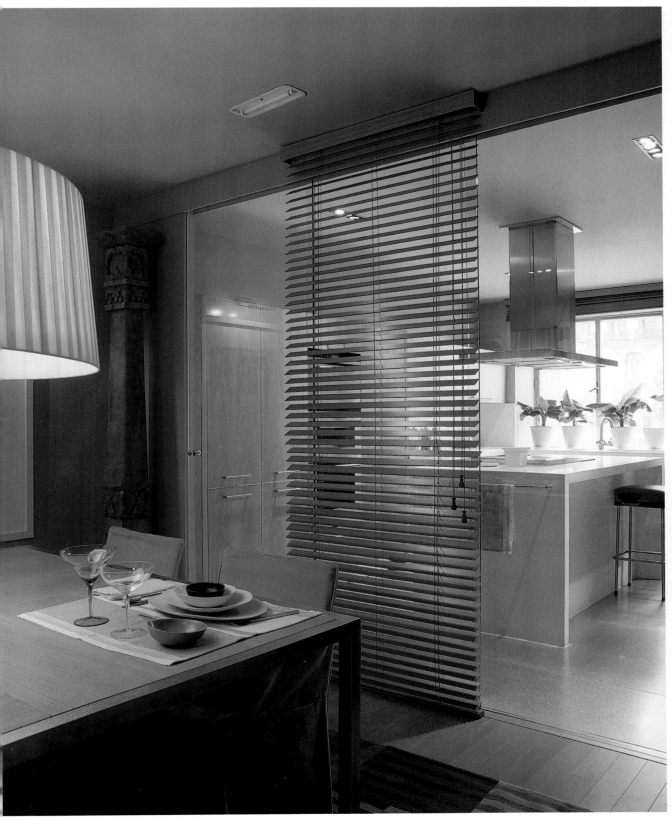

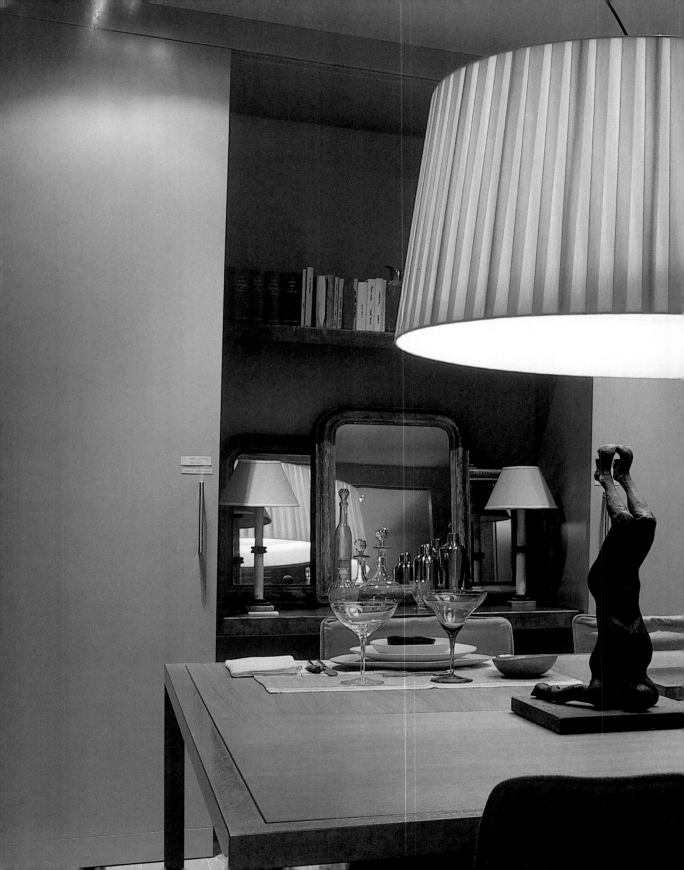

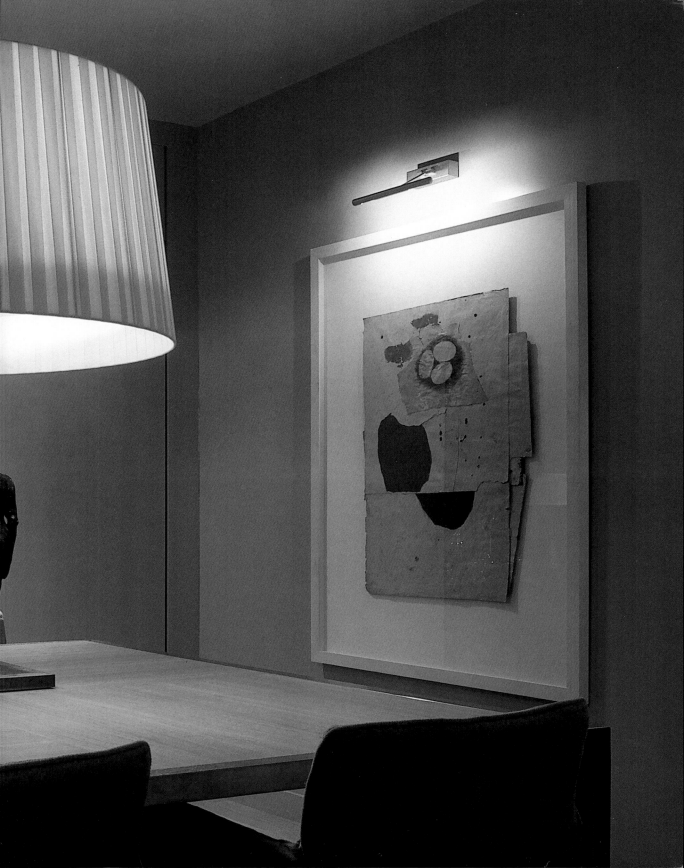

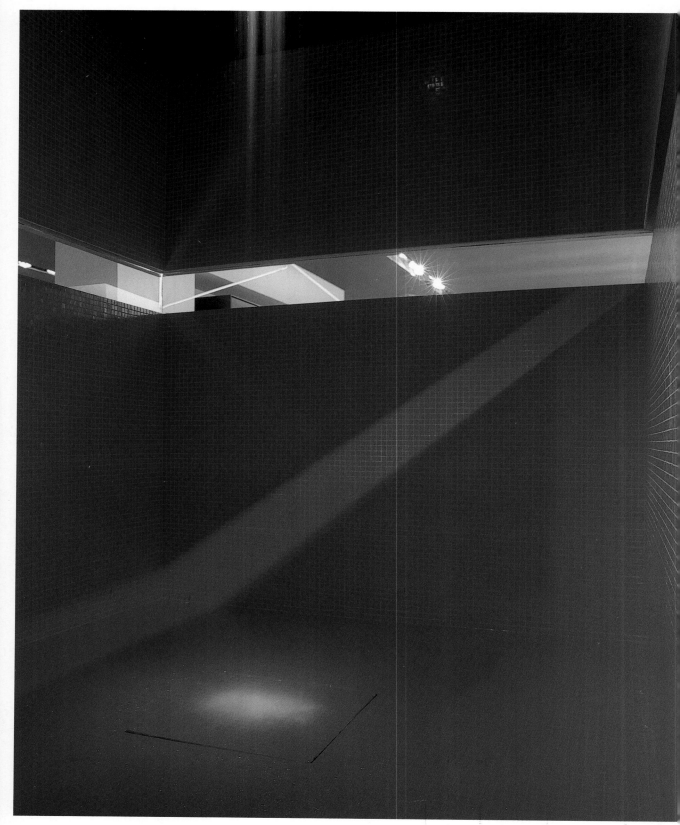

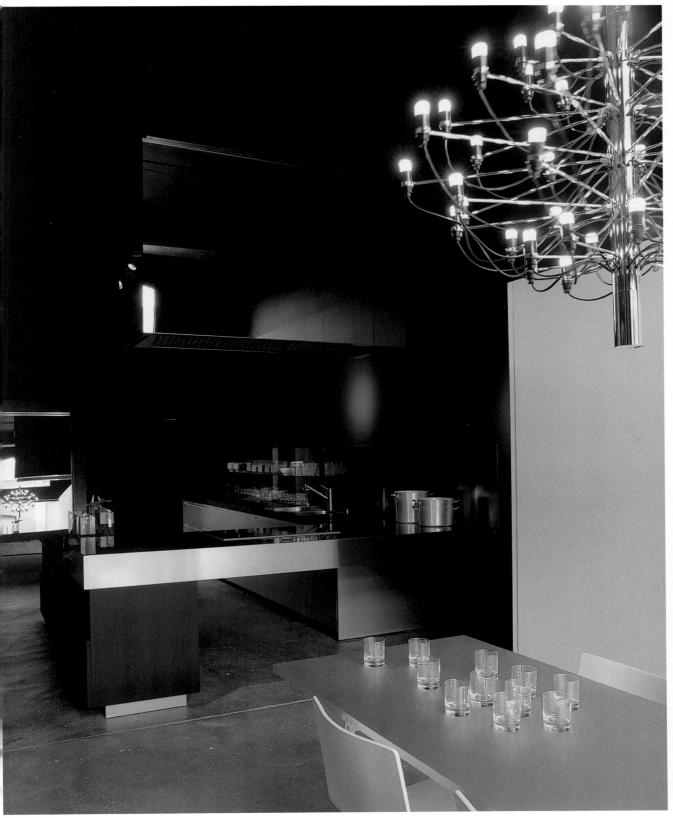

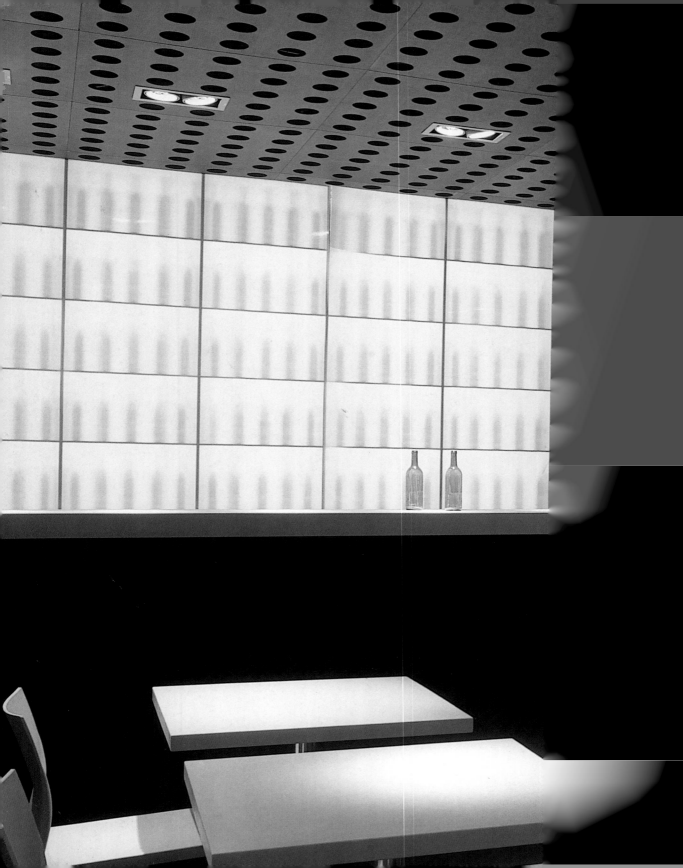

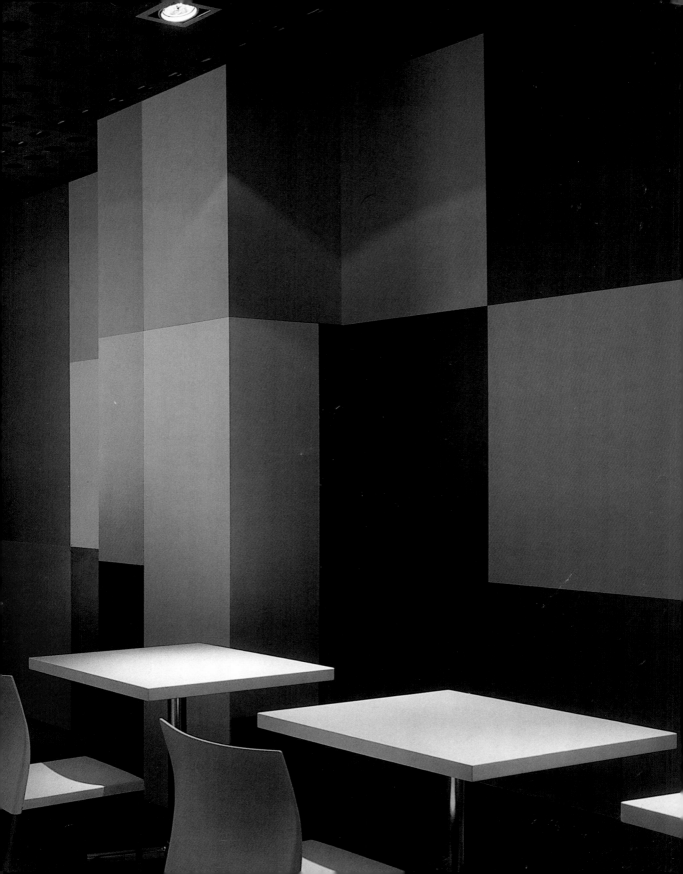

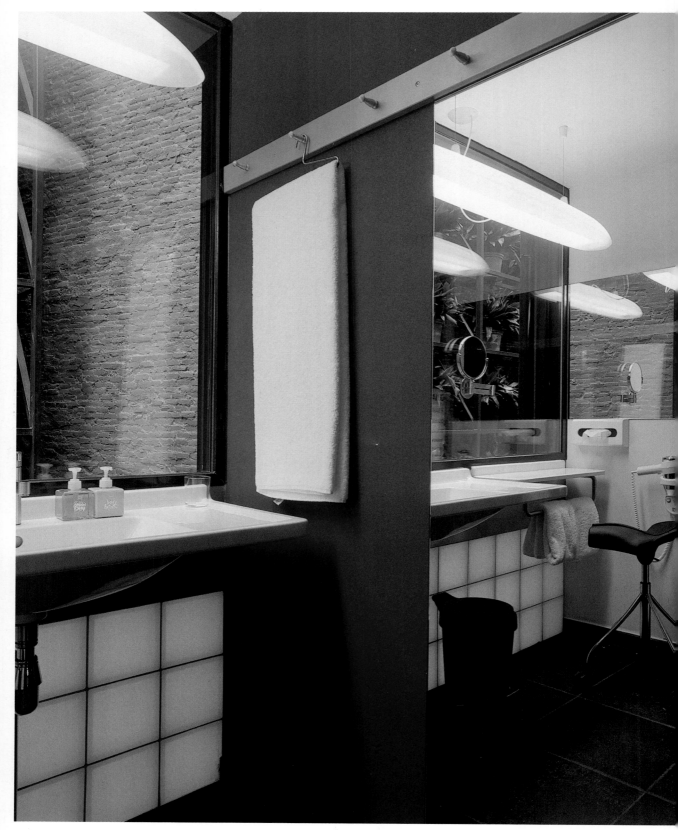

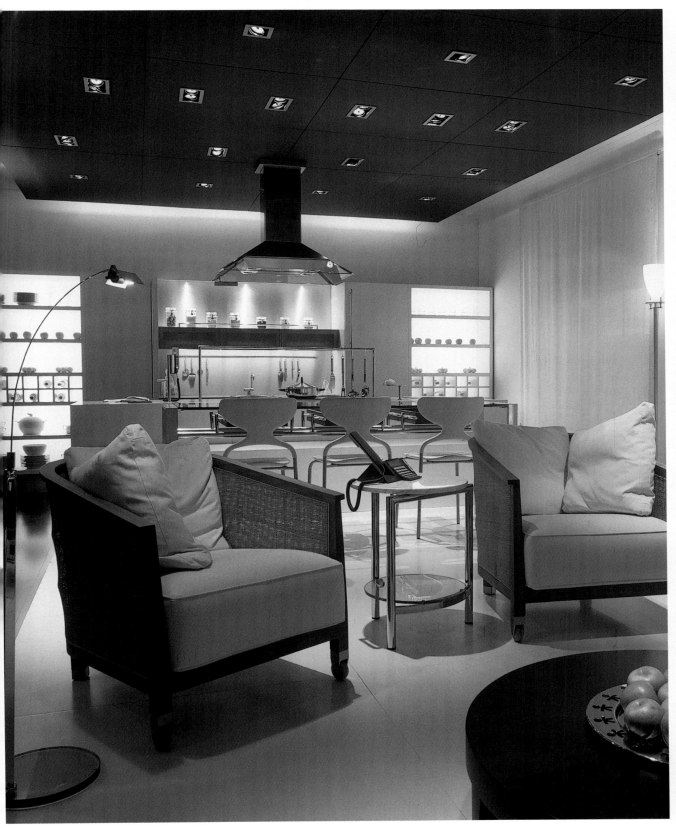

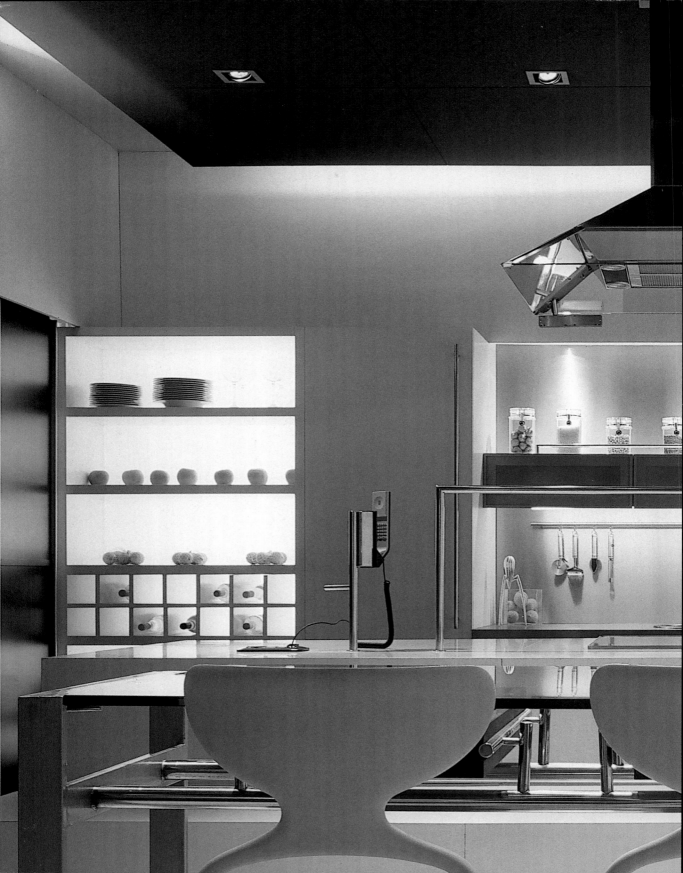

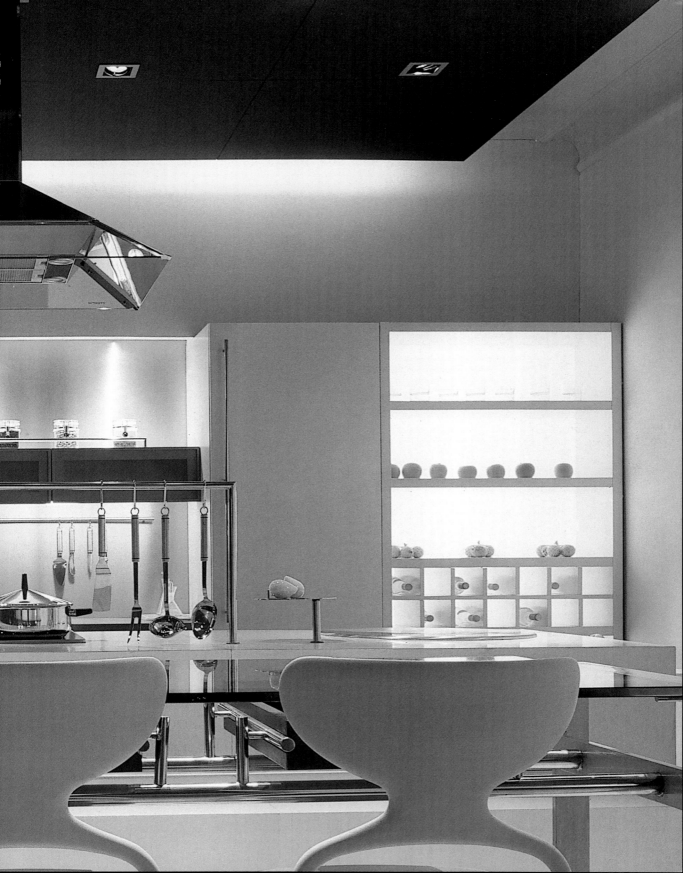

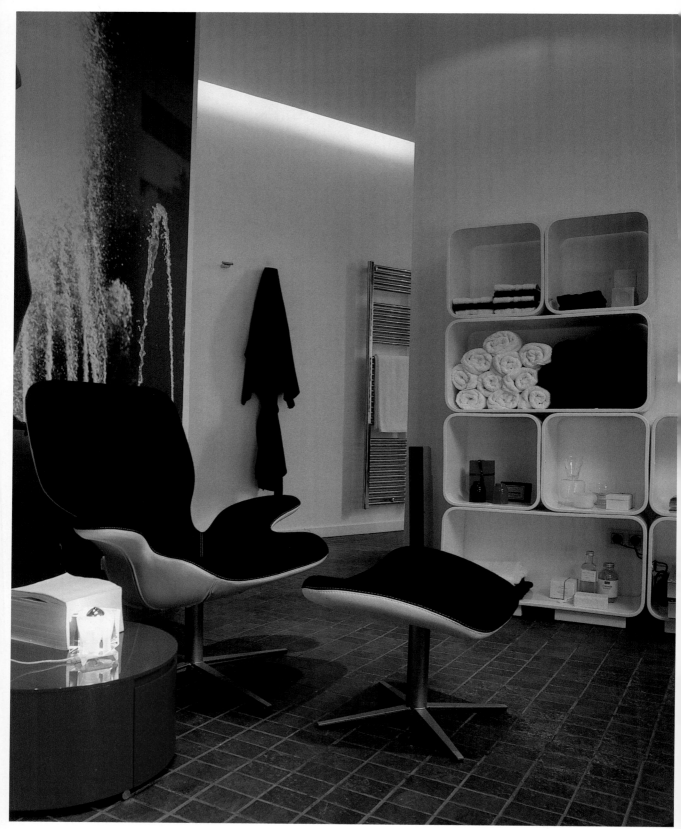

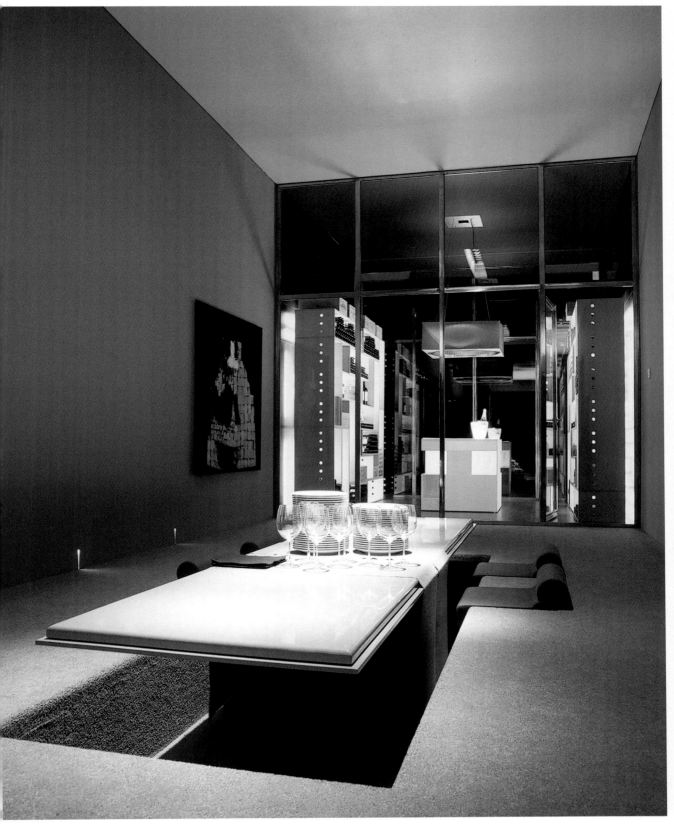

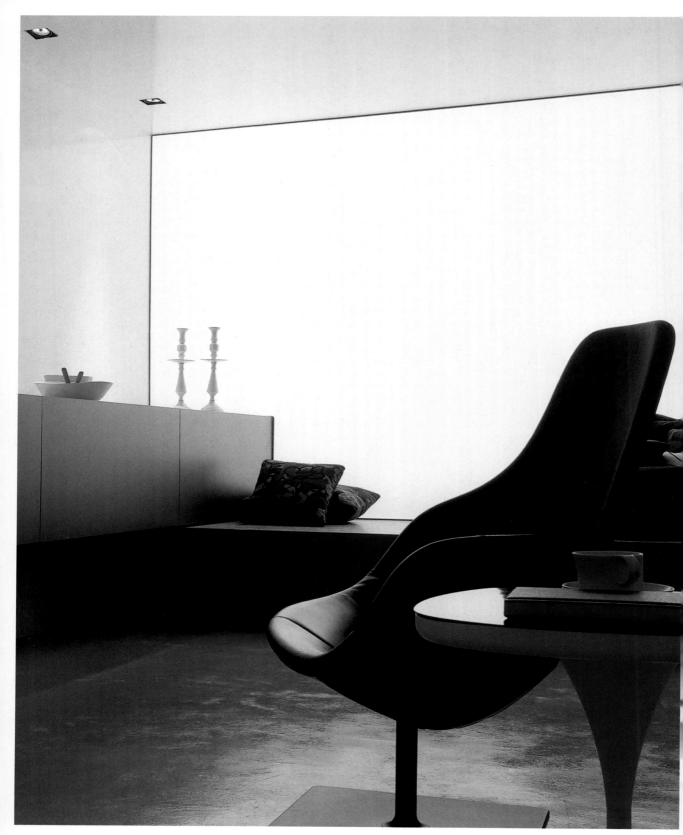

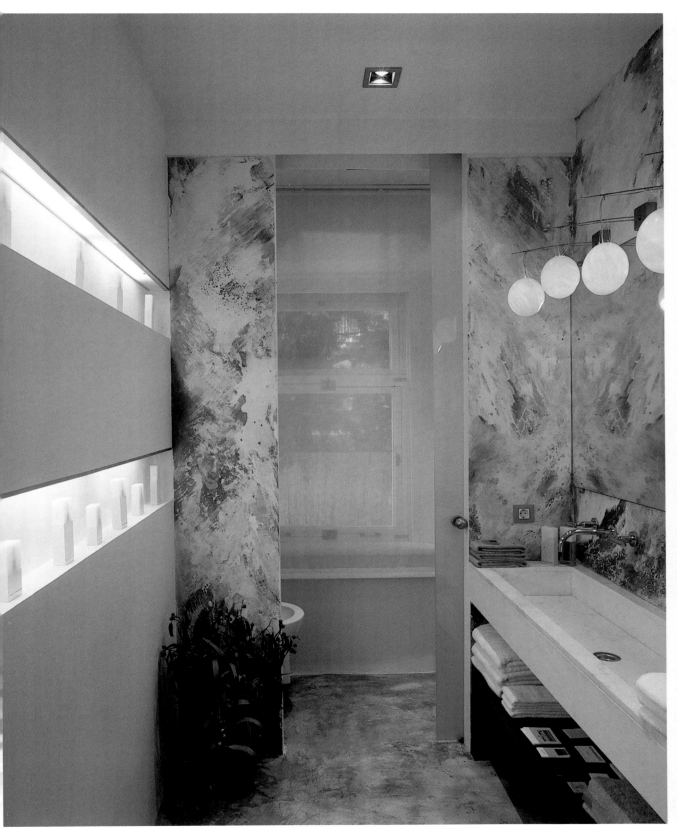

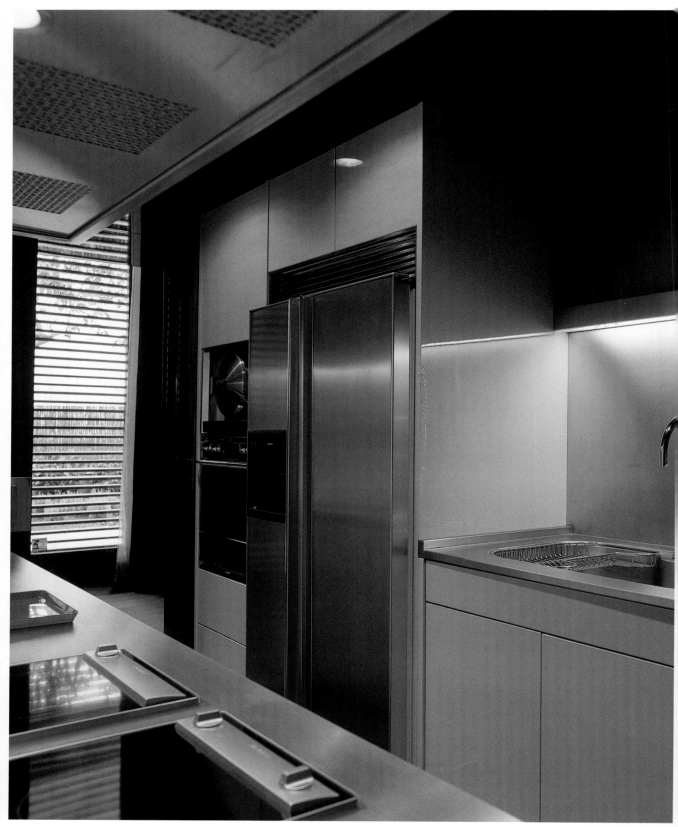

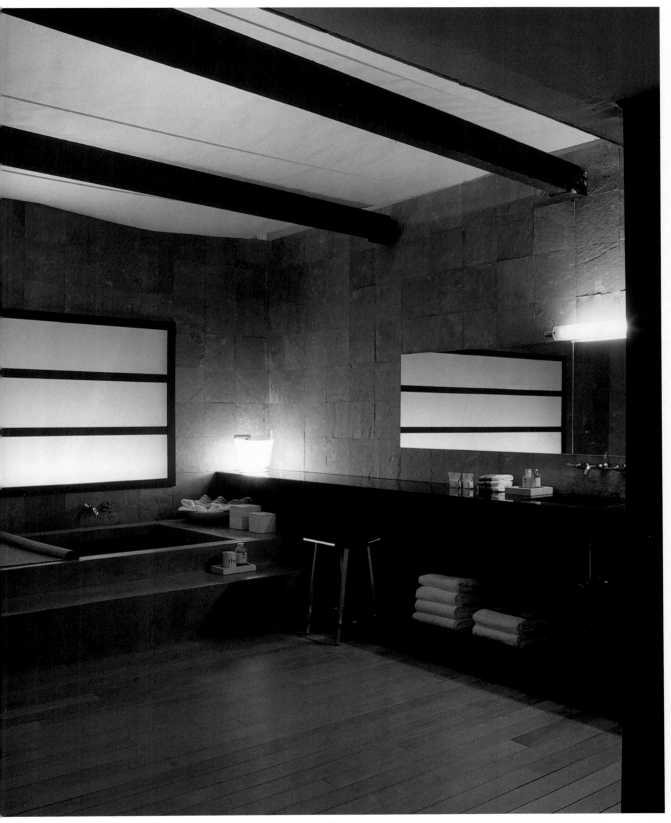

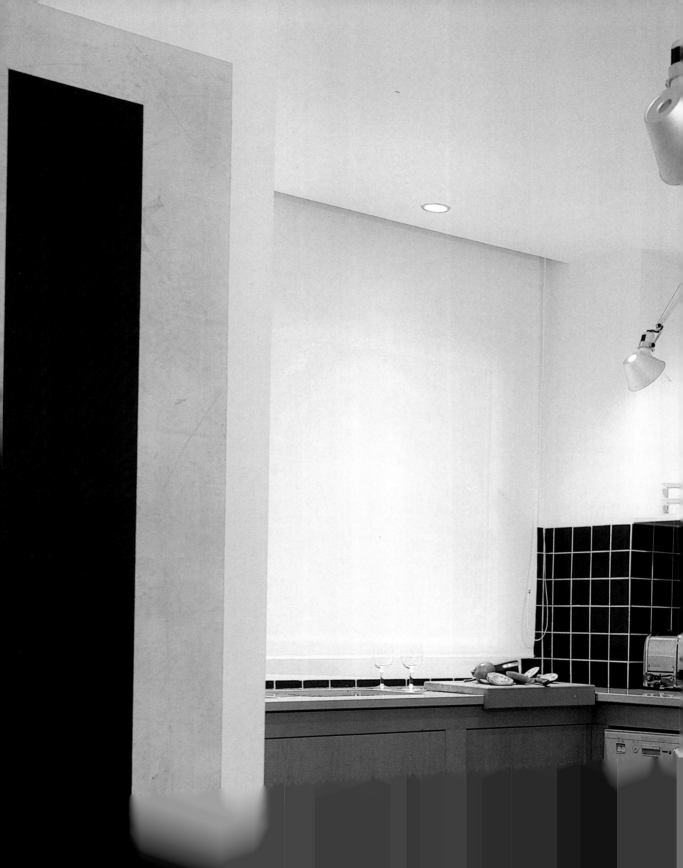

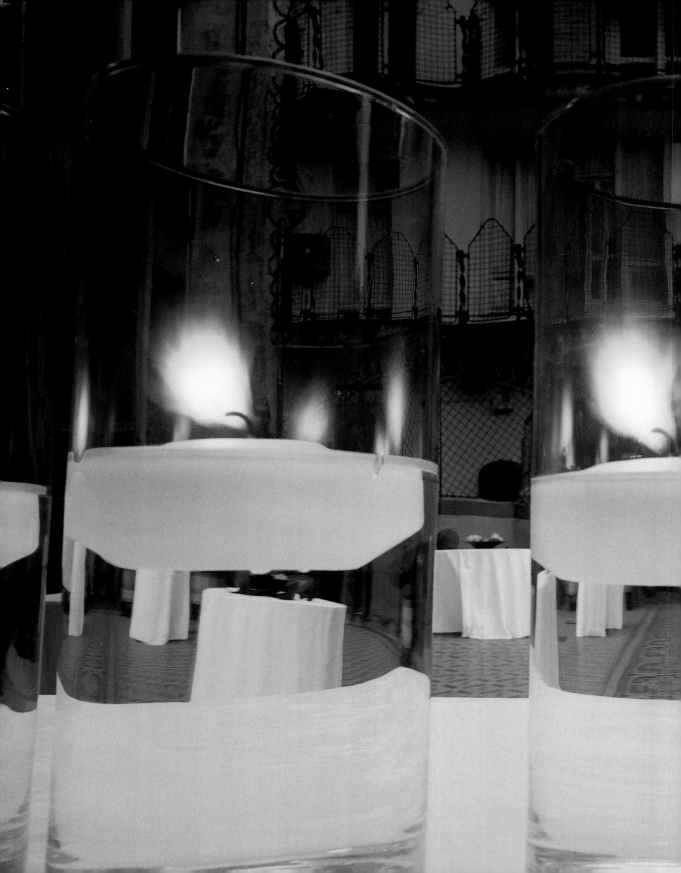

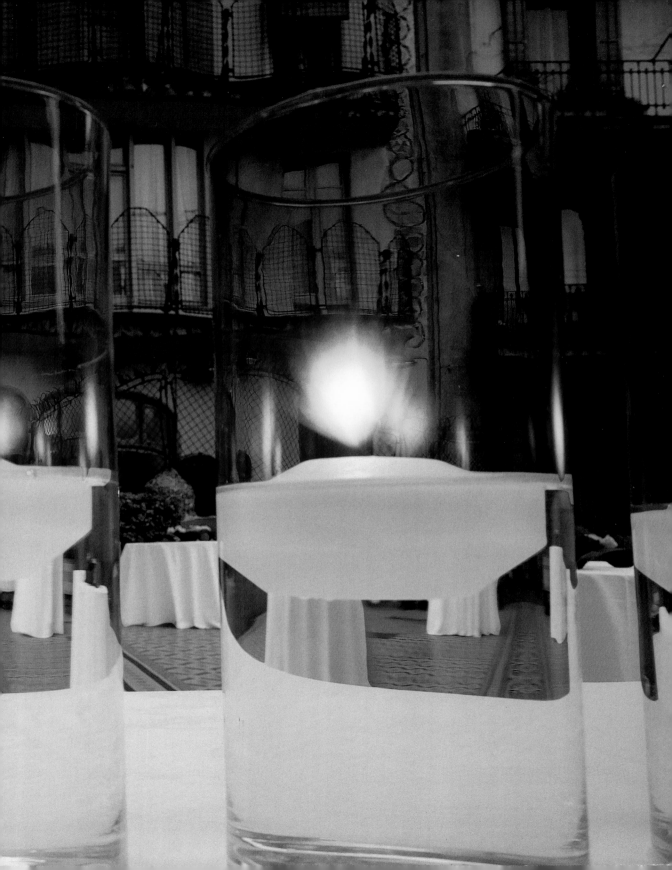

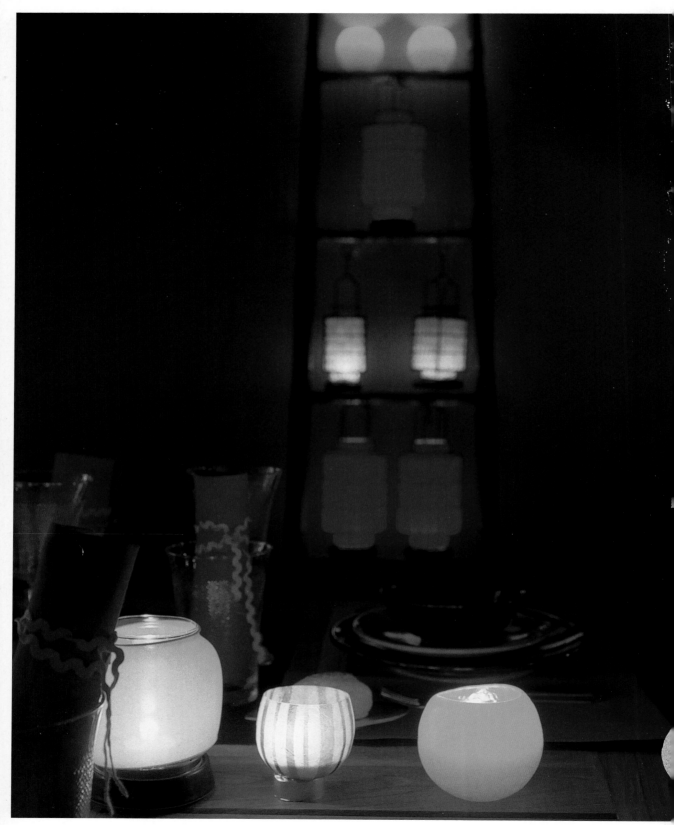

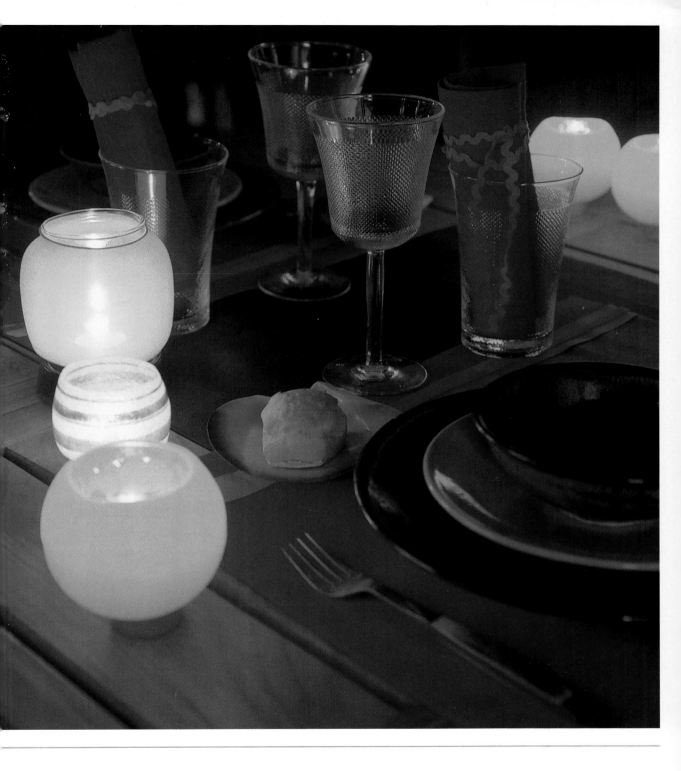

Glass candelabras and candles of different sizes are ideal for creating a relaxing atmosphere.

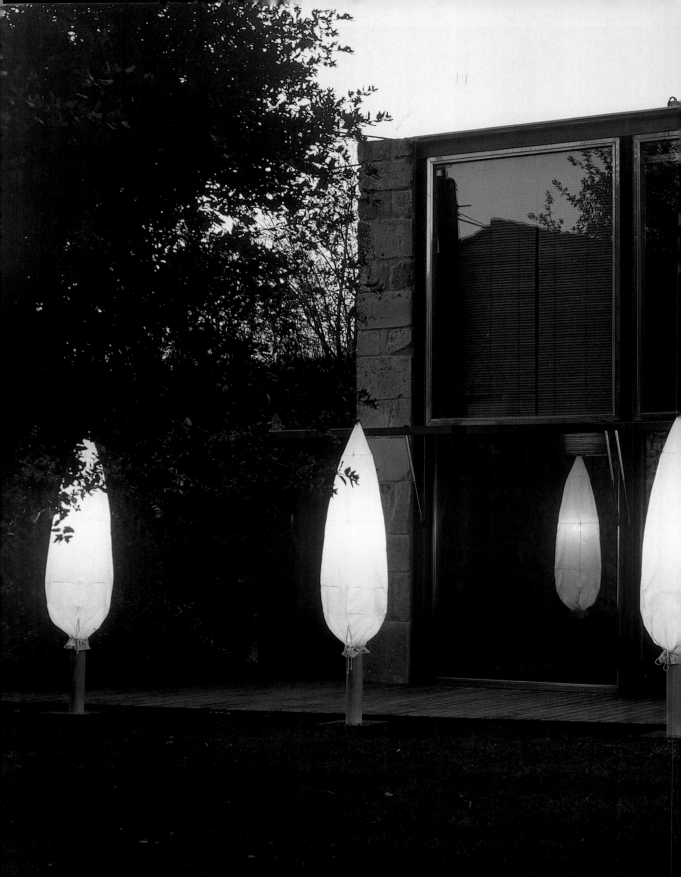

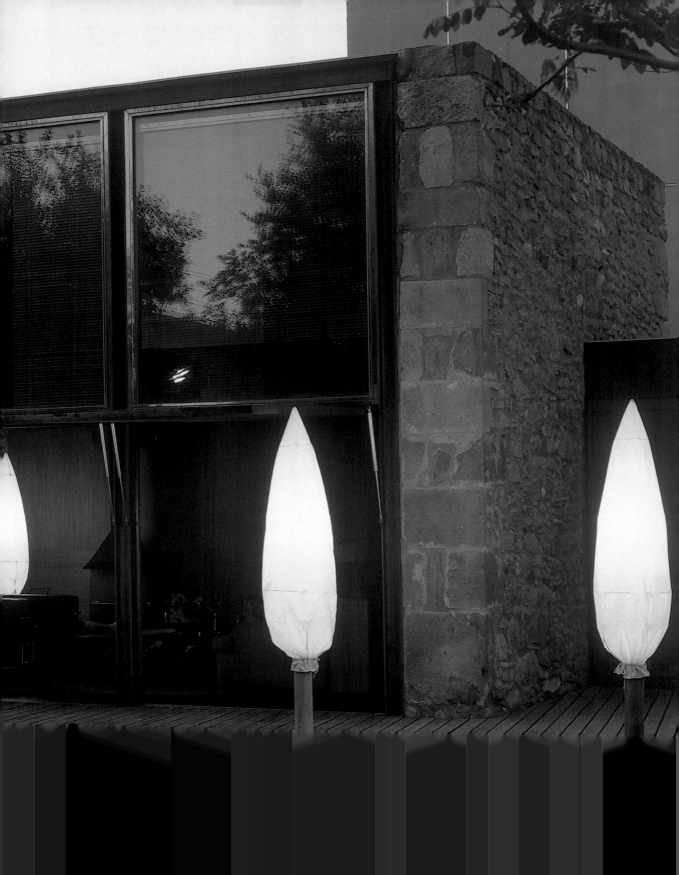

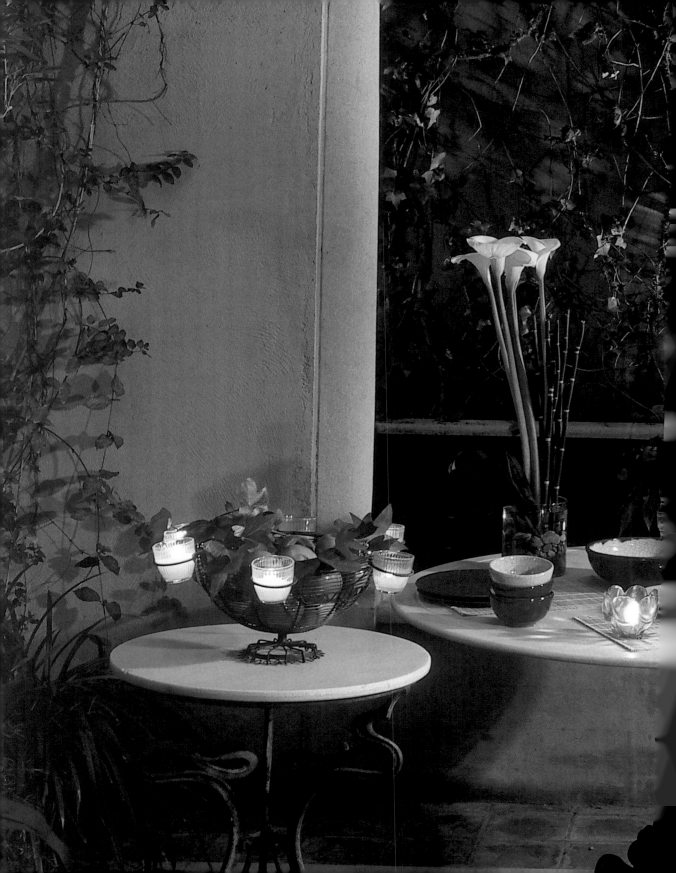

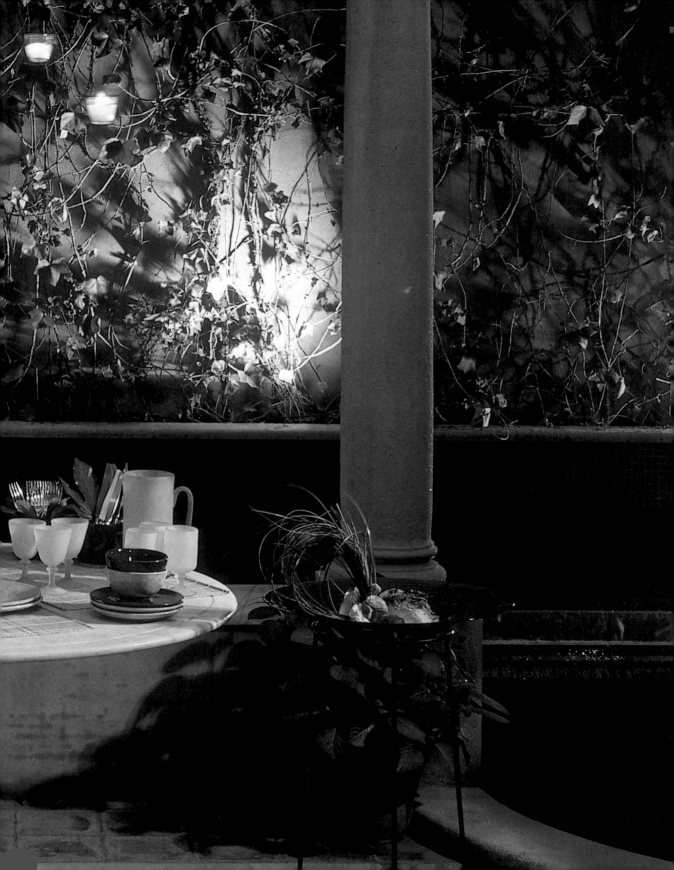

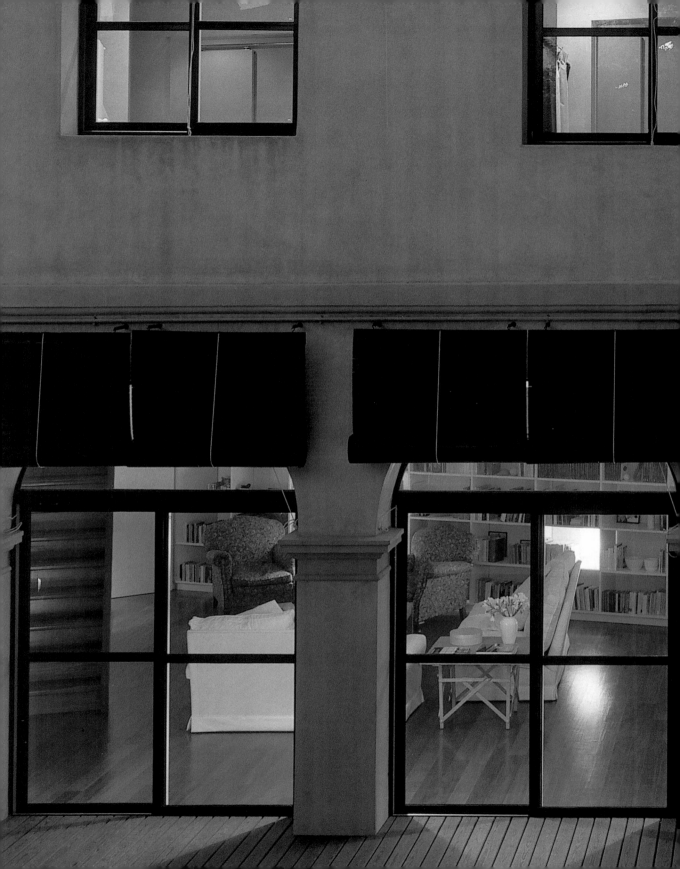

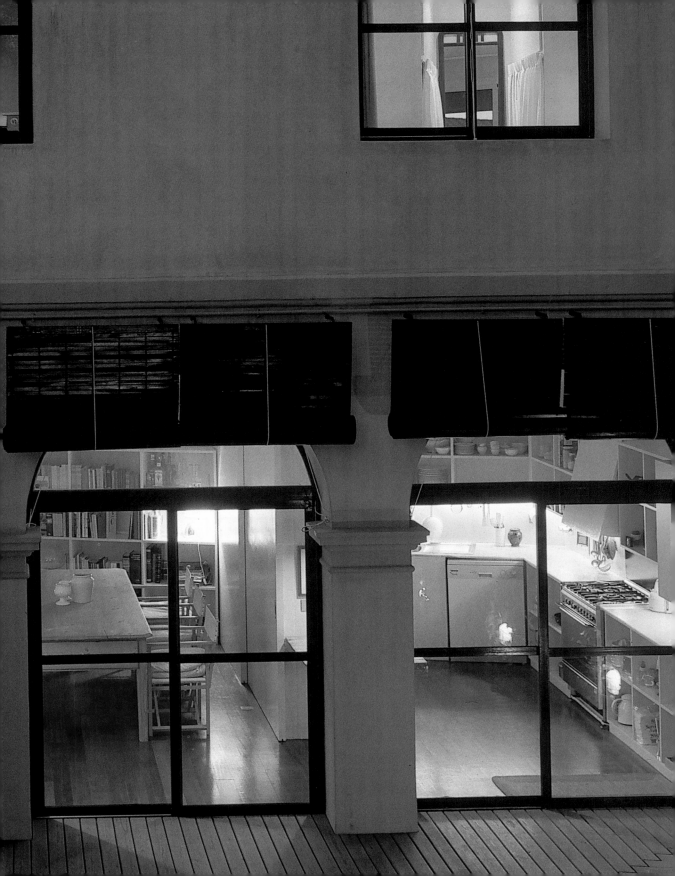

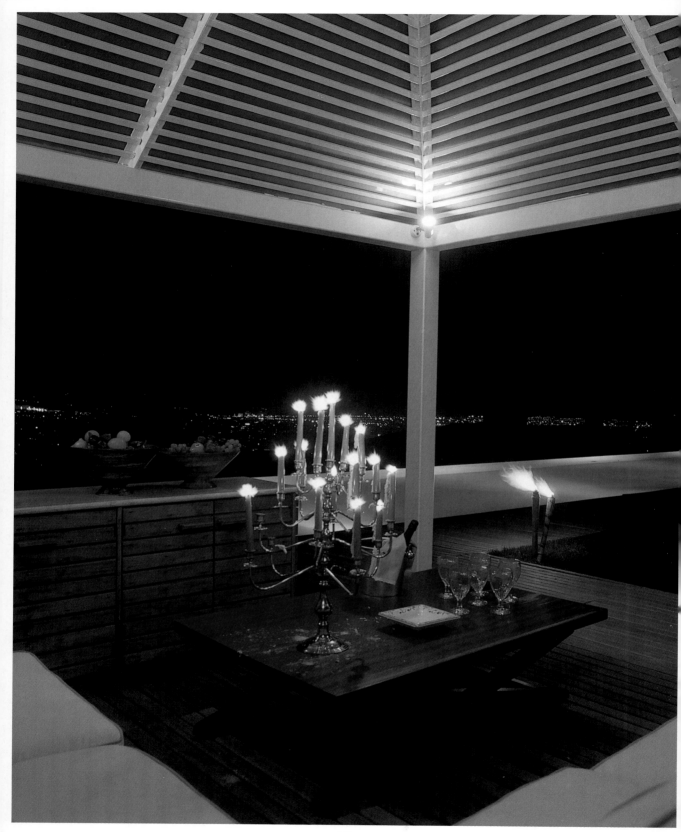

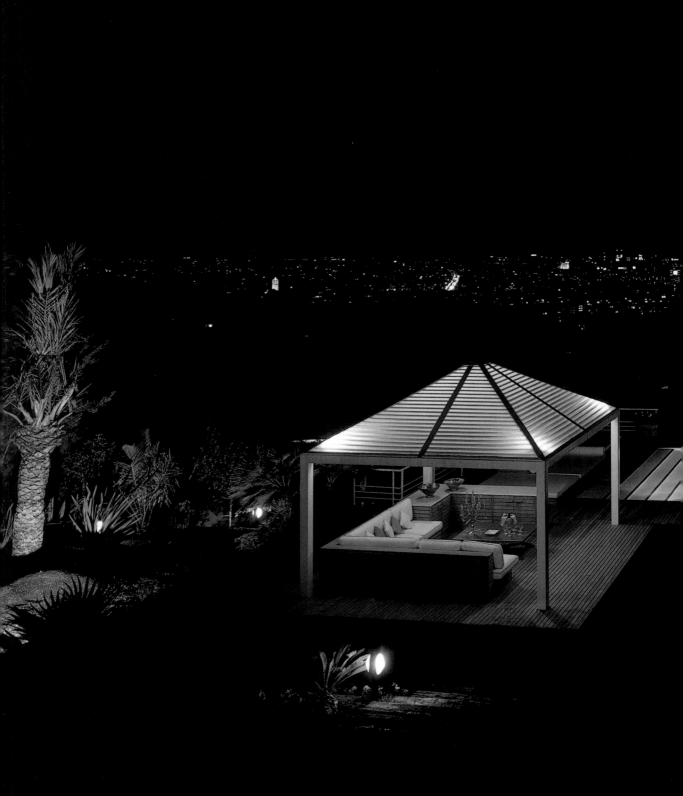

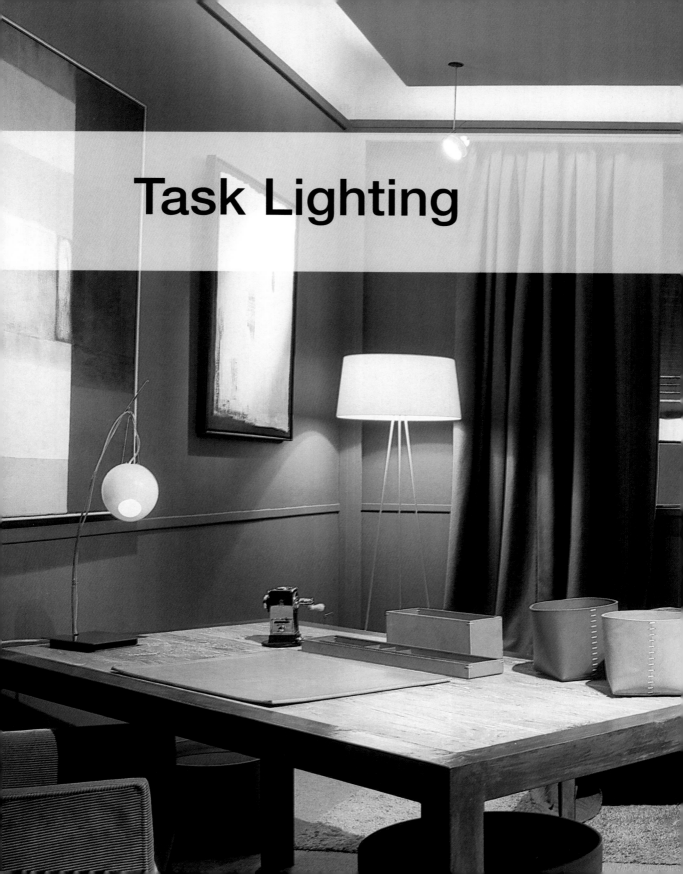

Task Lighting

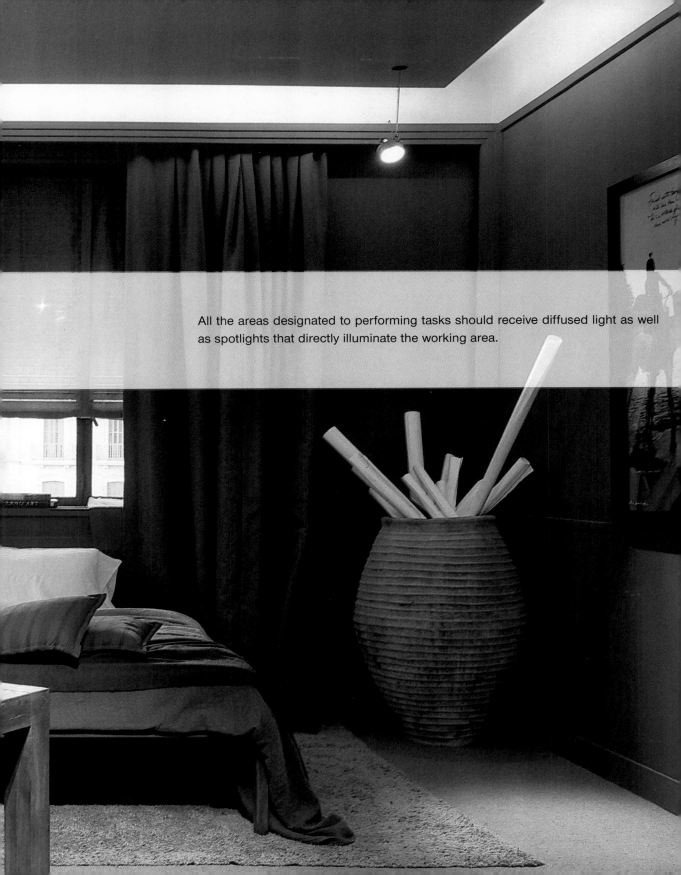

All the areas designated to performing tasks should receive diffused light as well as spotlights that directly illuminate the working area.

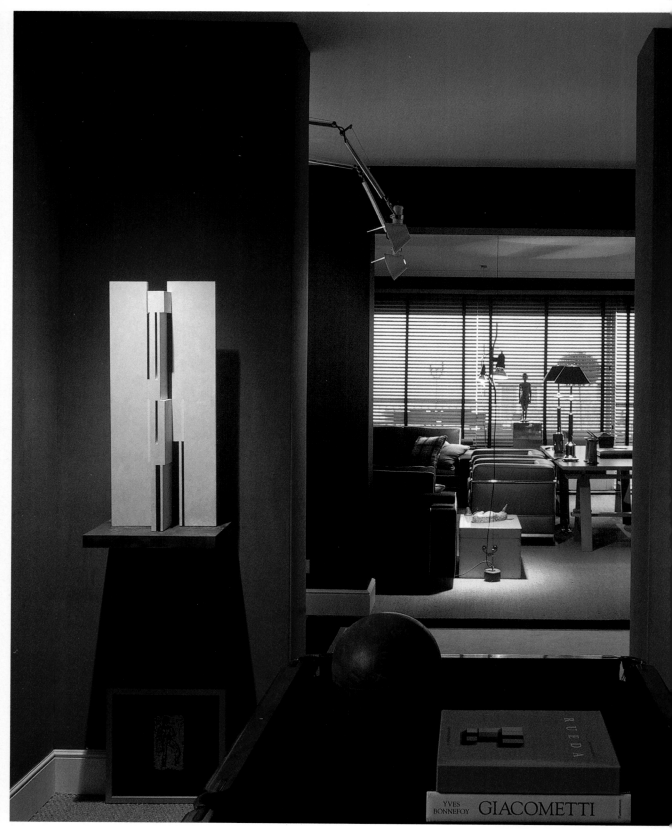

YVES
BONNEFOY GIACOMETTI

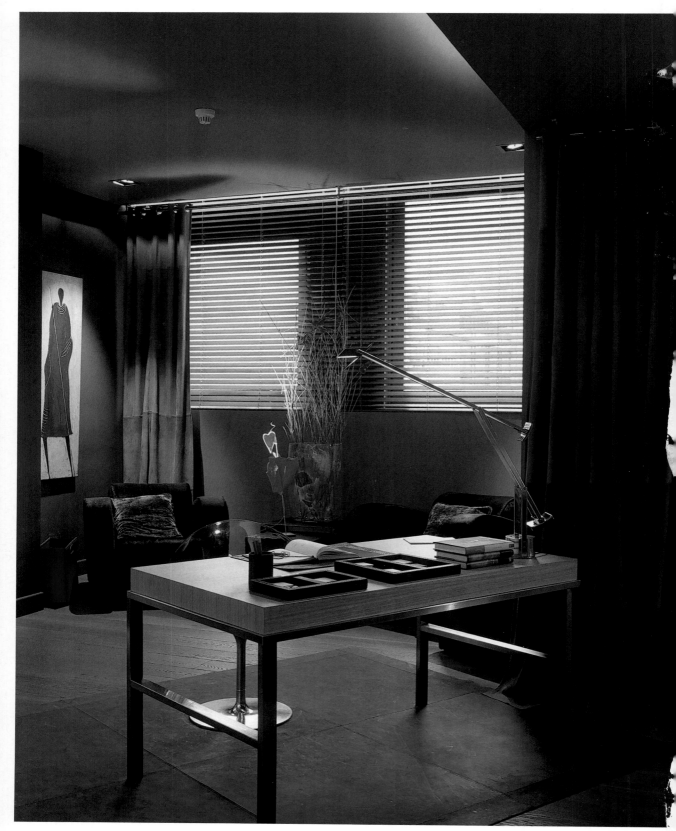

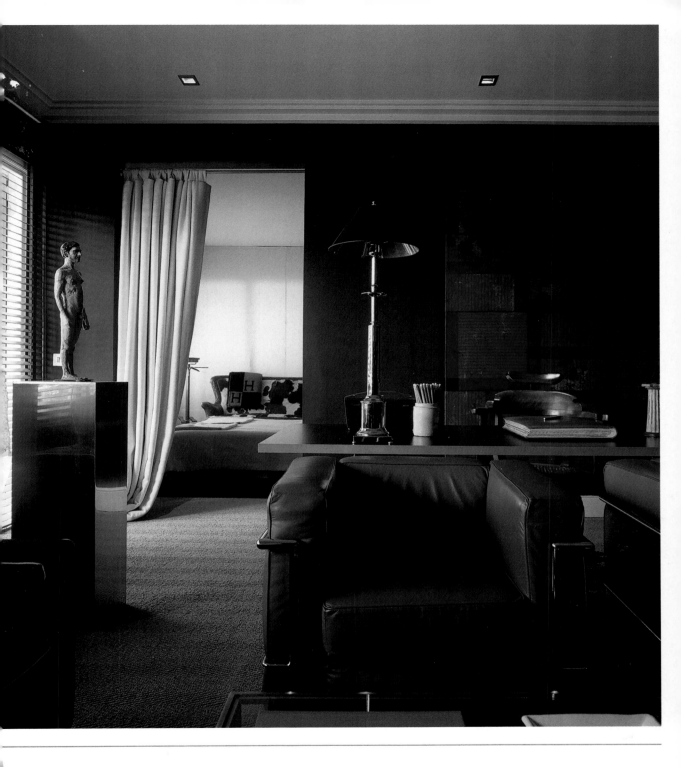

When natural light is insufficient to illuminate an entire room, it should be combined with artificial spotlights.

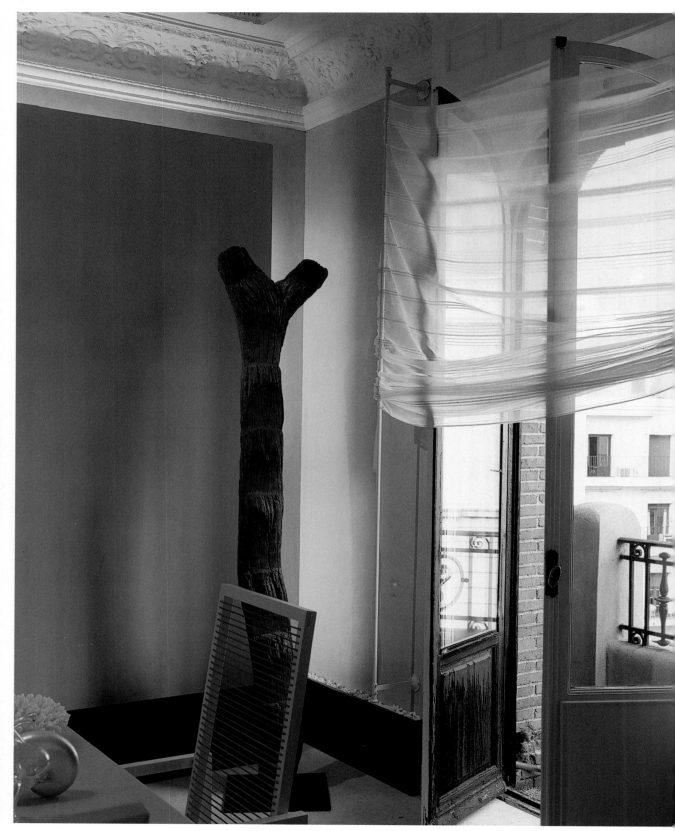

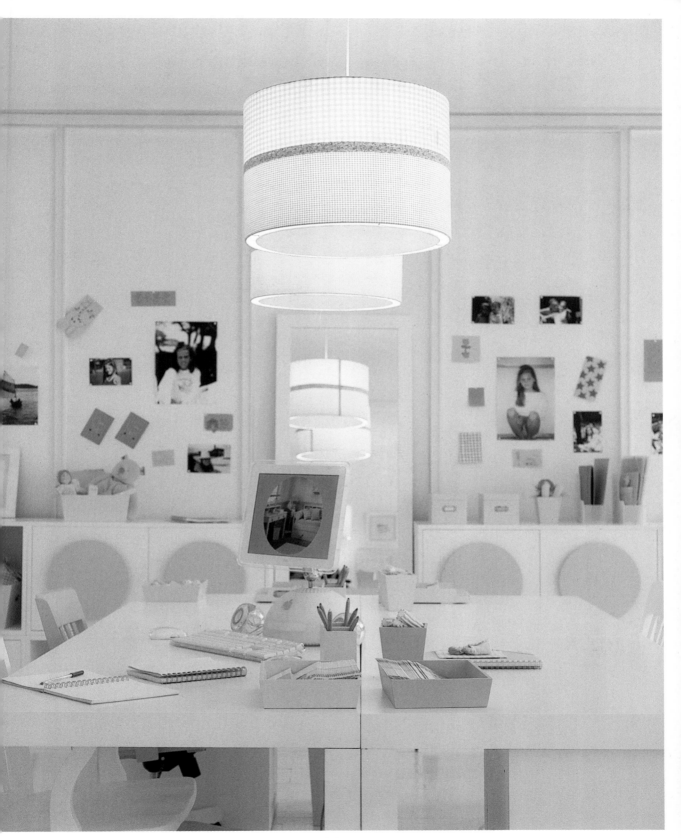

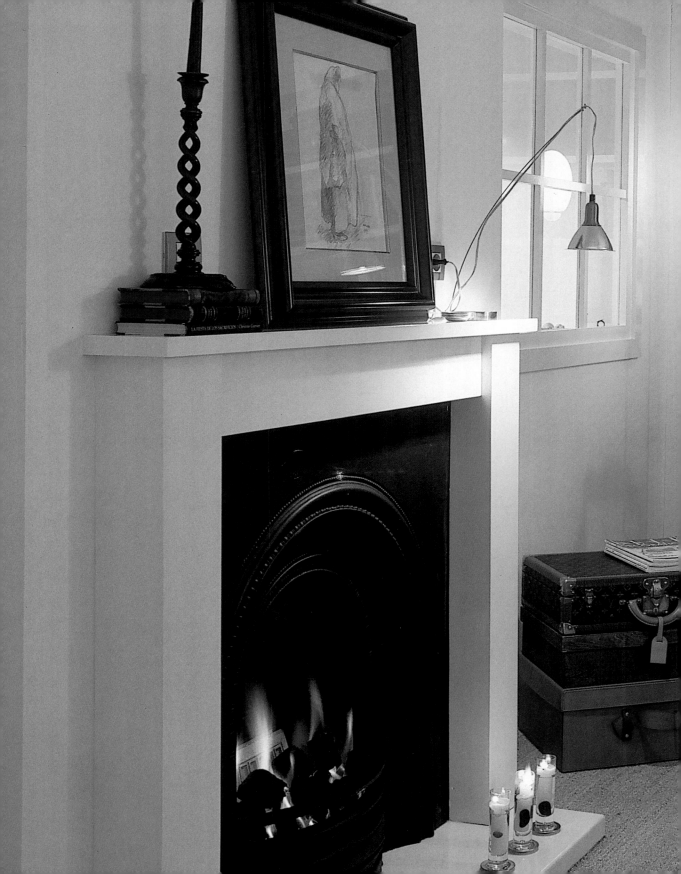

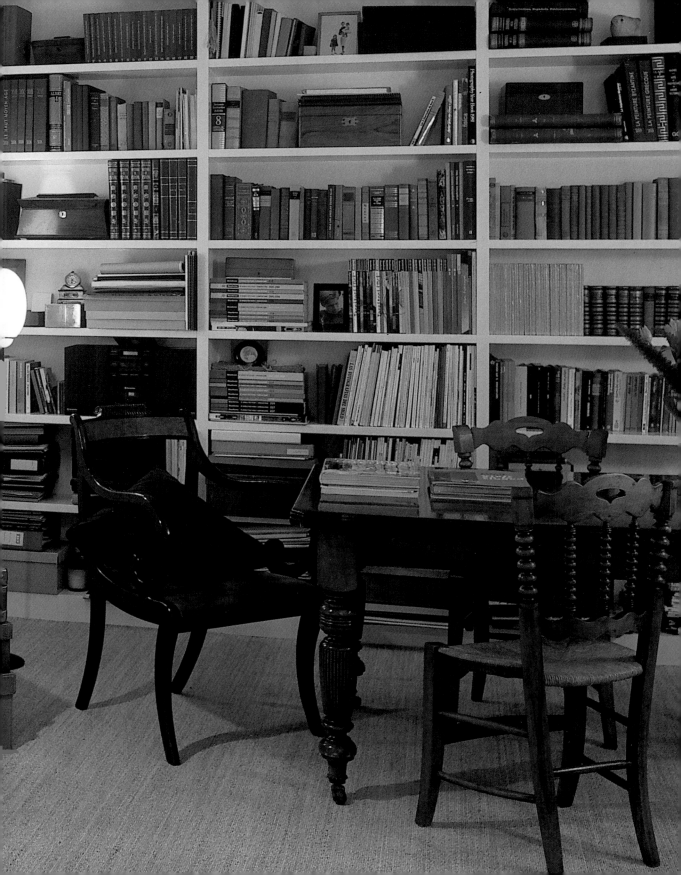

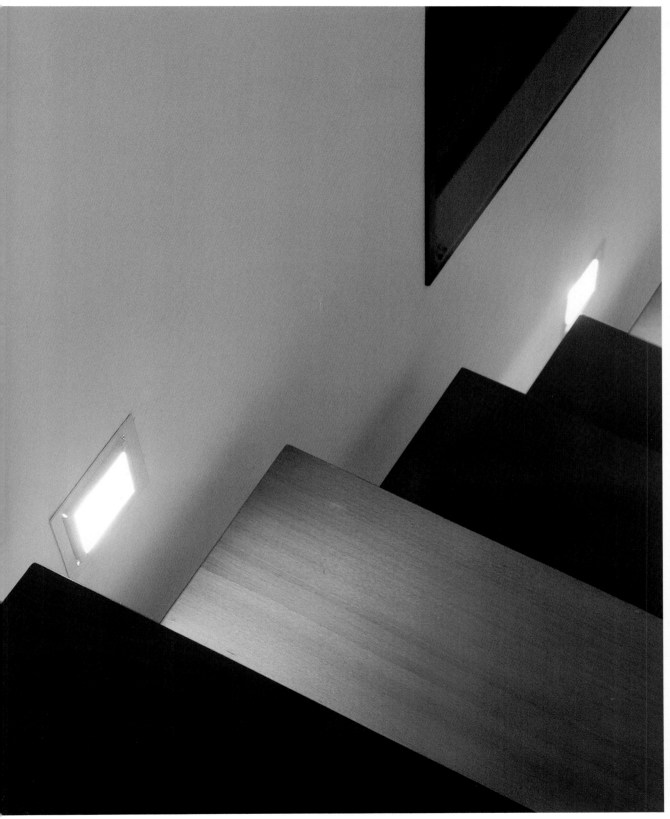

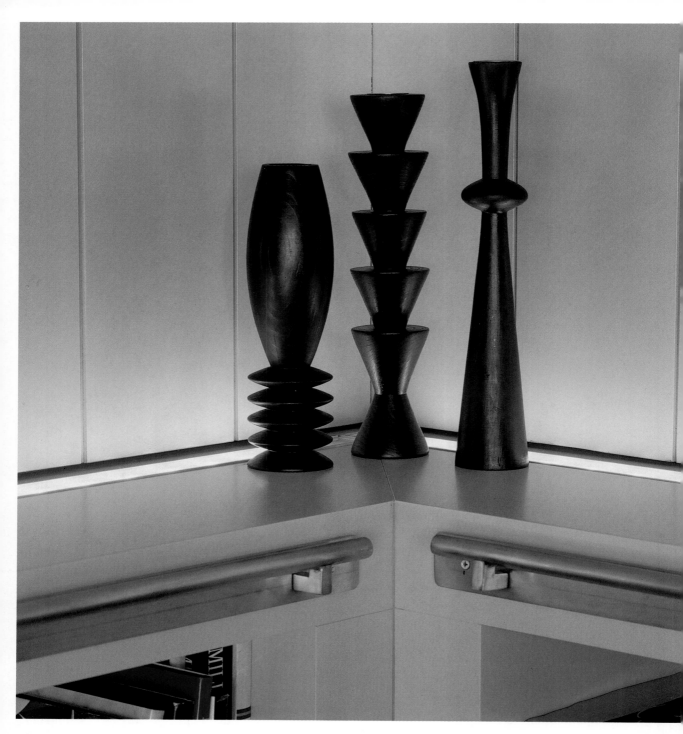

Linestras built into a bookcase and covered with diffusing glass provide ambient lighting and create a dazzling effect of light and shadow on the wall.

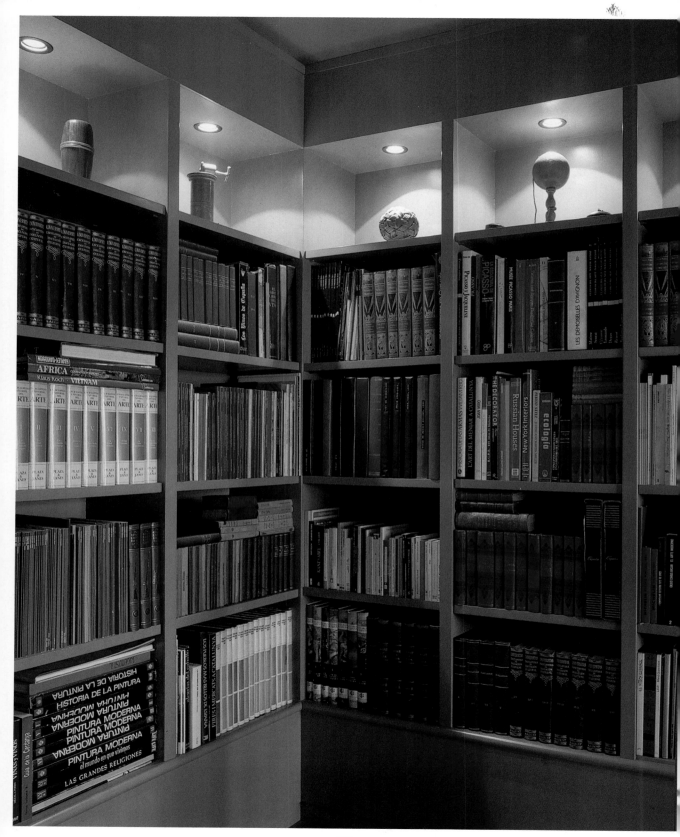

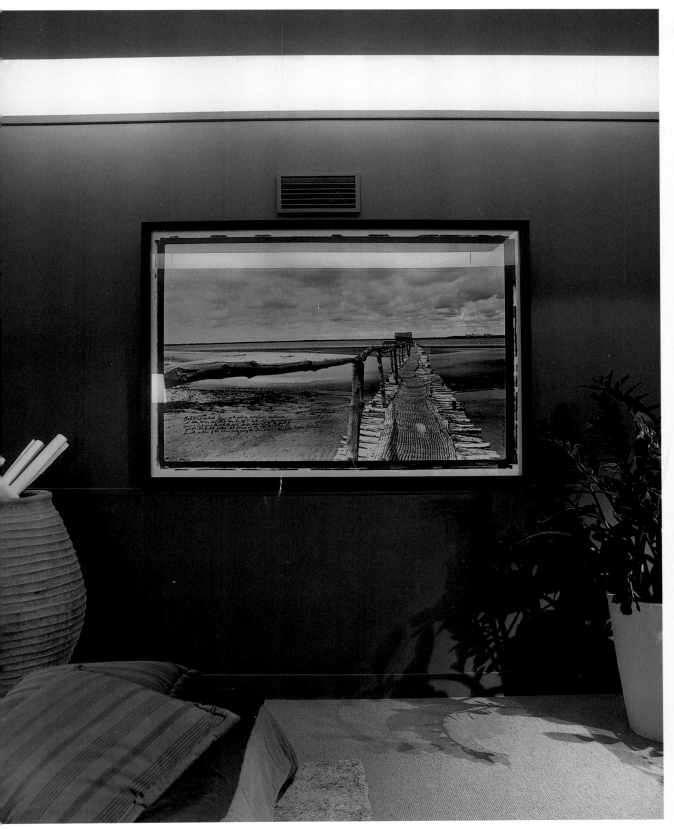

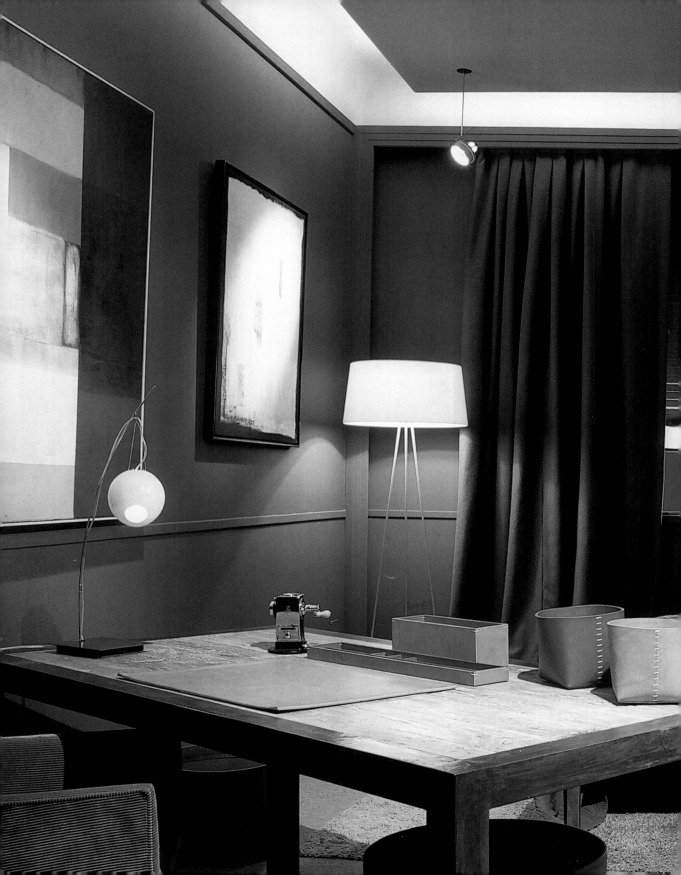

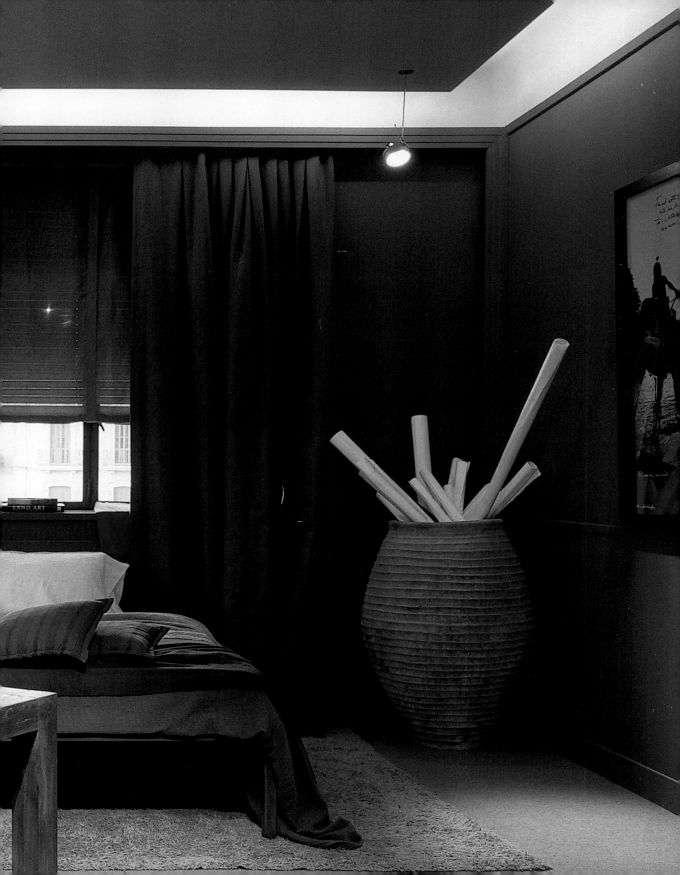

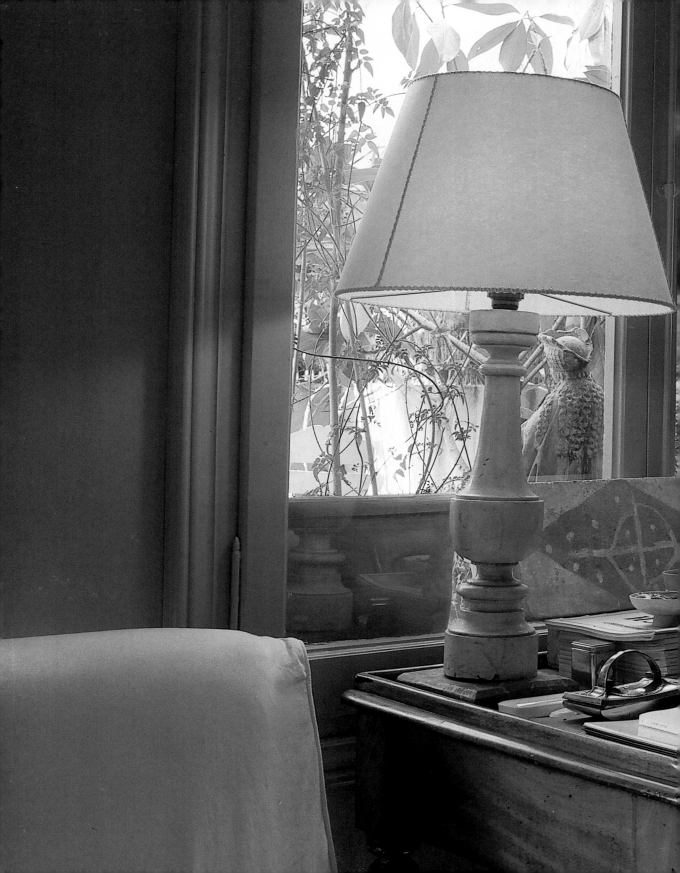

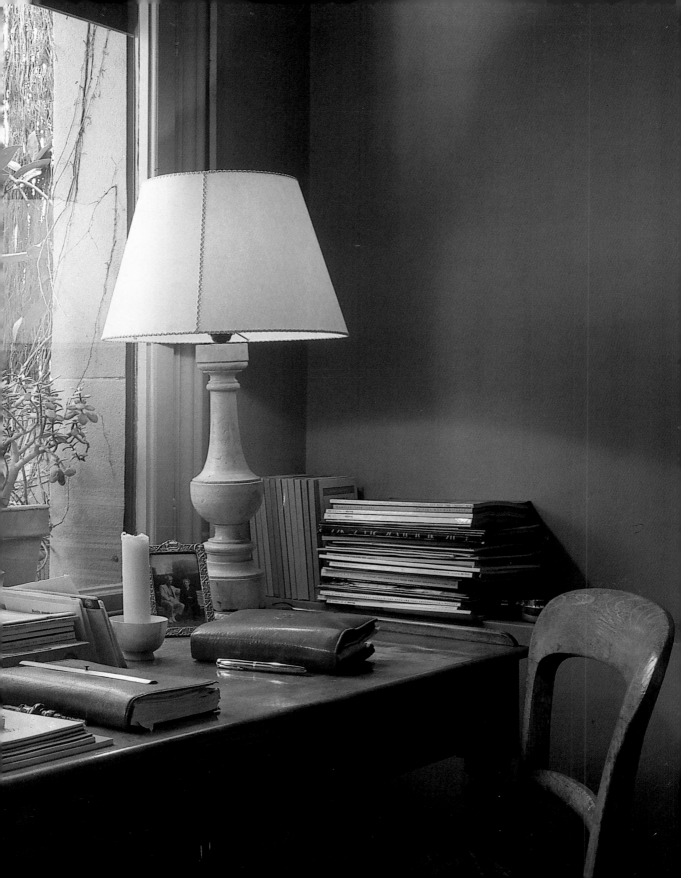

Decorative Lighting

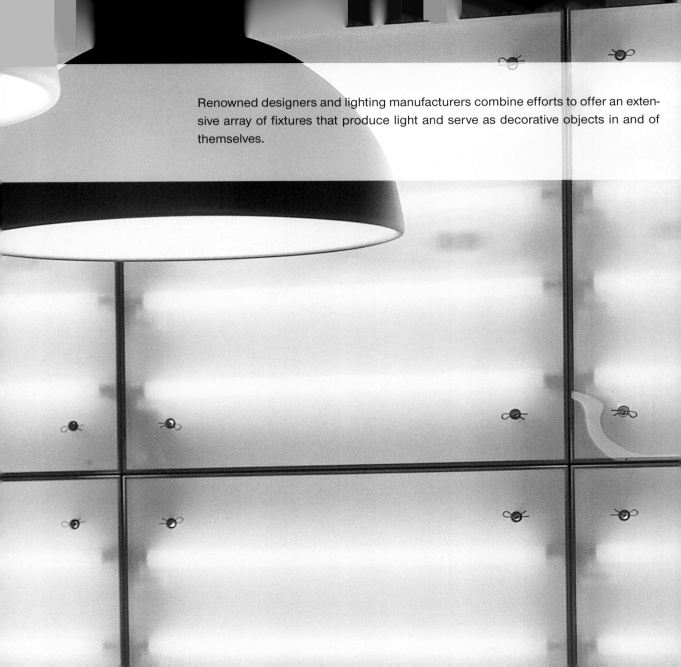

Renowned designers and lighting manufacturers combine efforts to offer an extensive array of fixtures that produce light and serve as decorative objects in and of themselves.

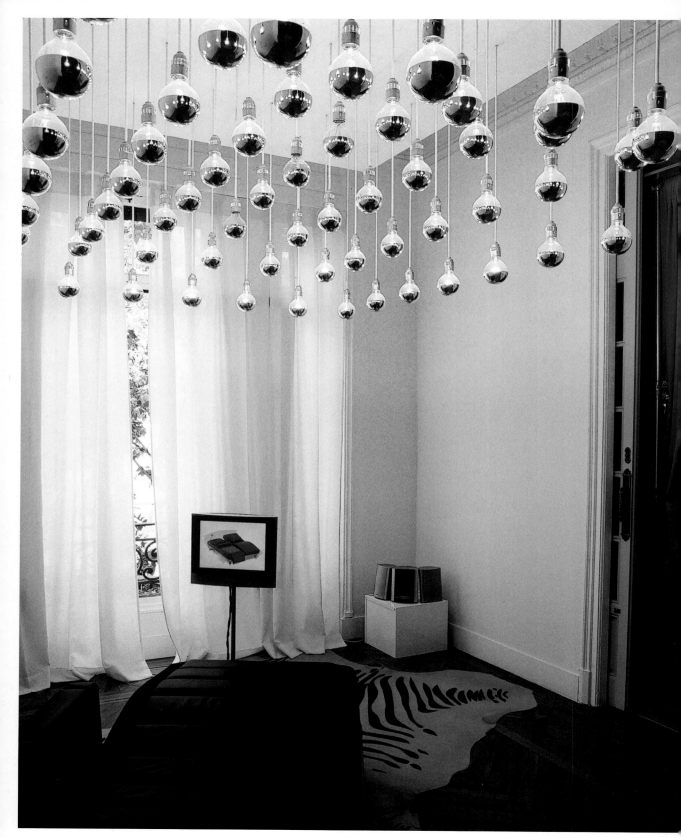

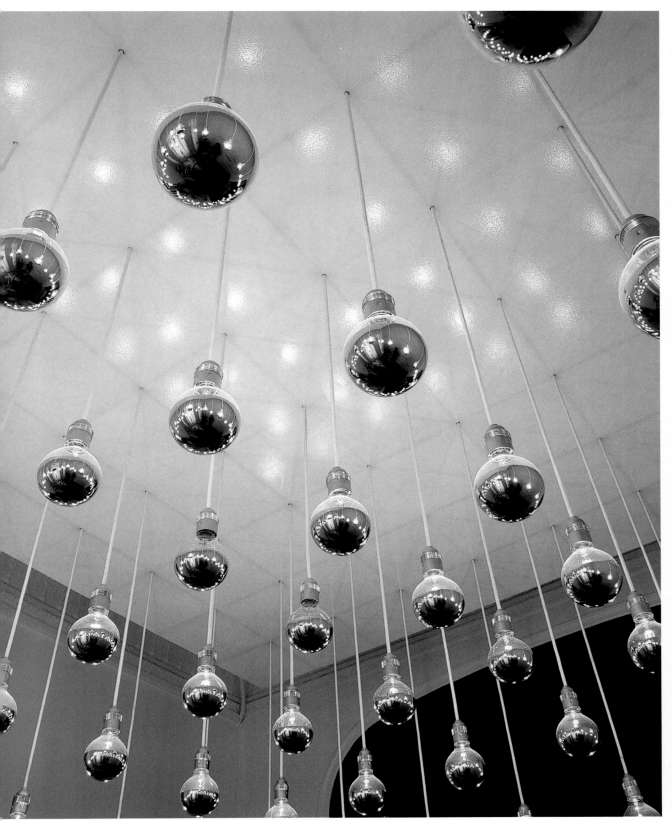

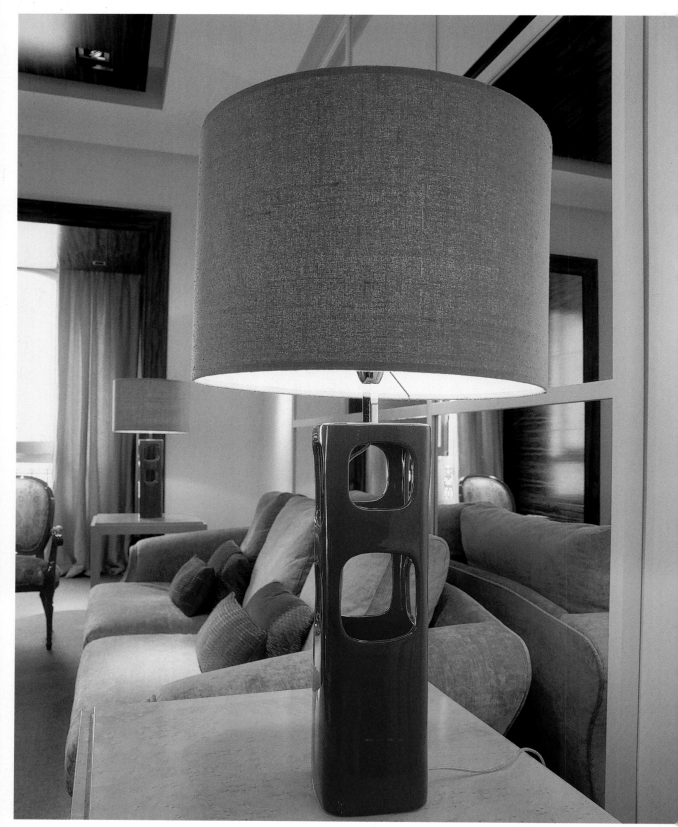

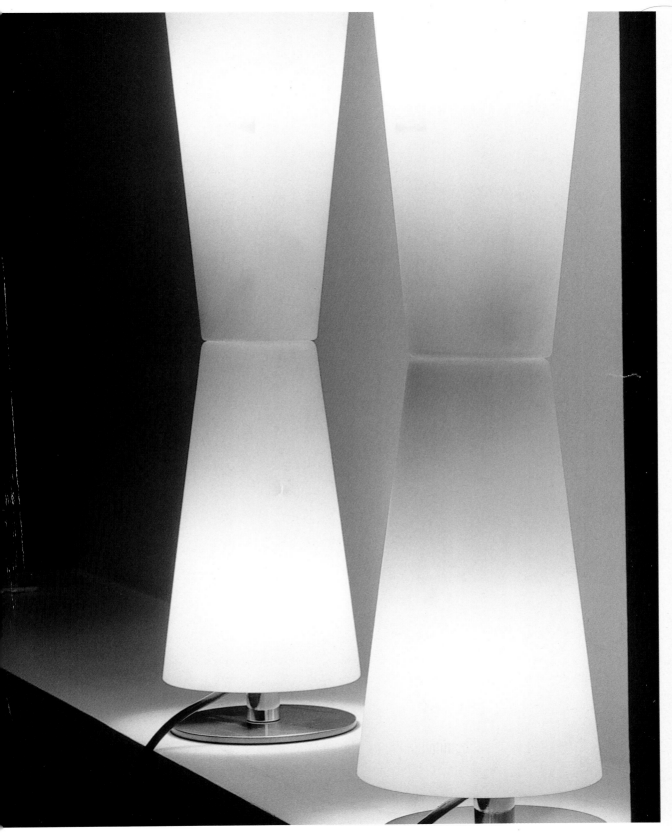

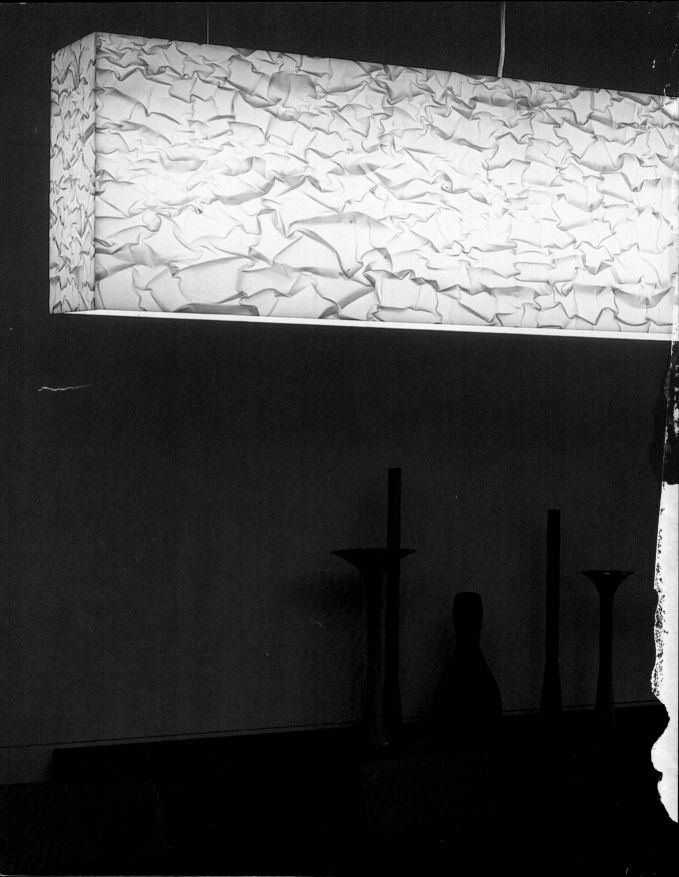

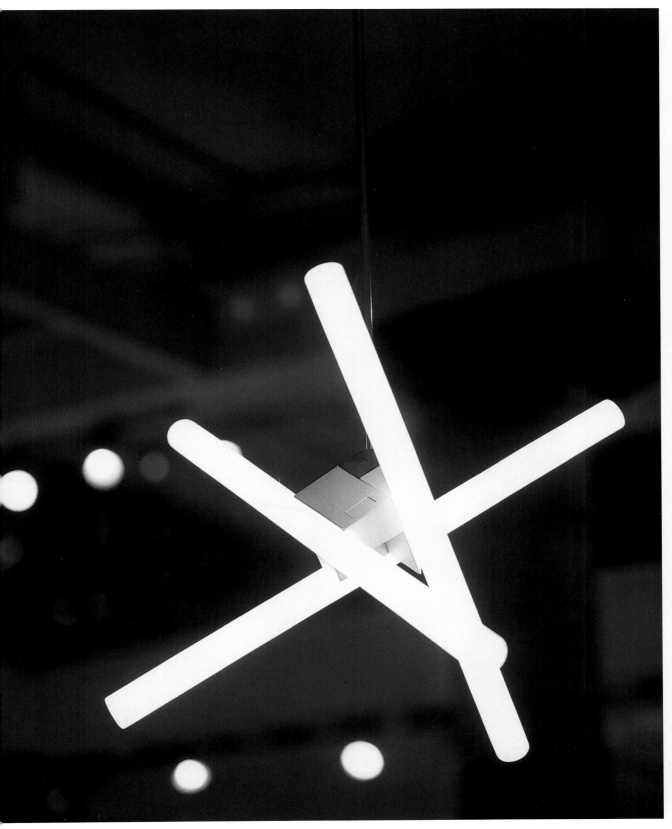

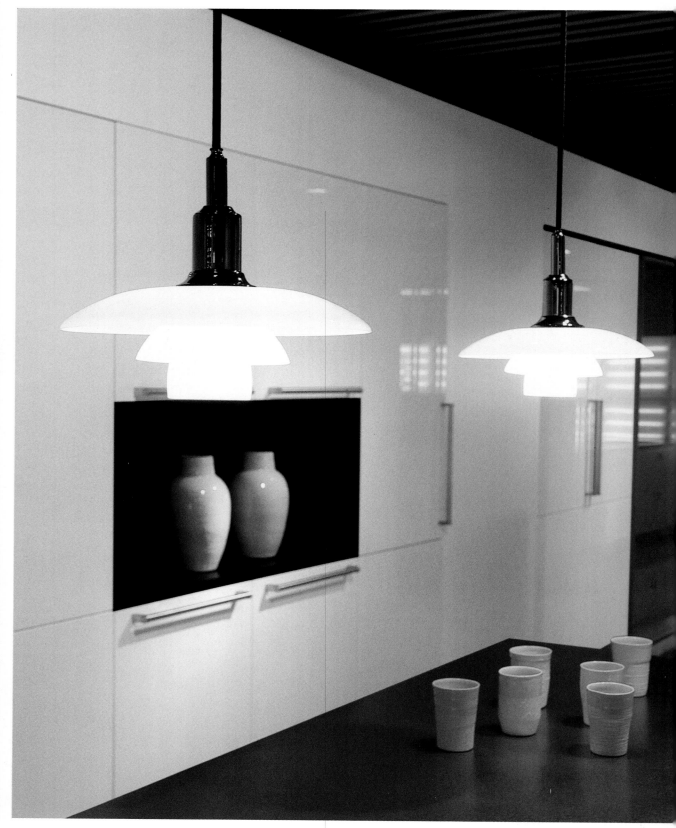

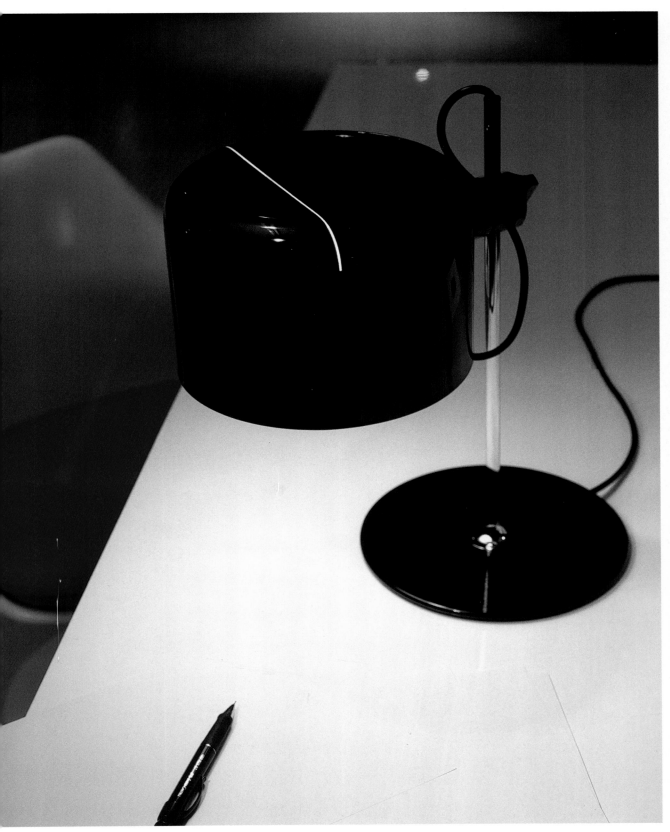

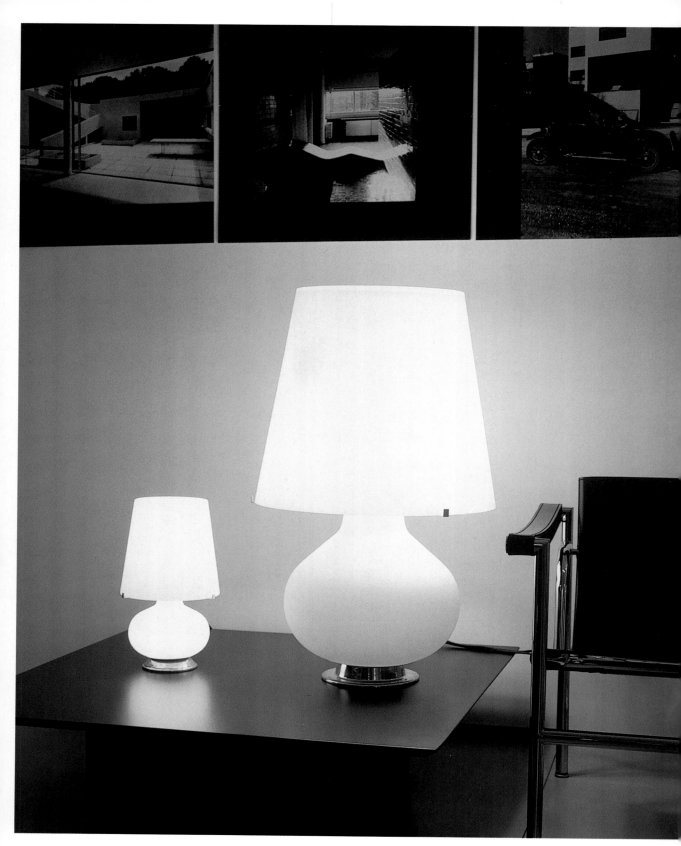

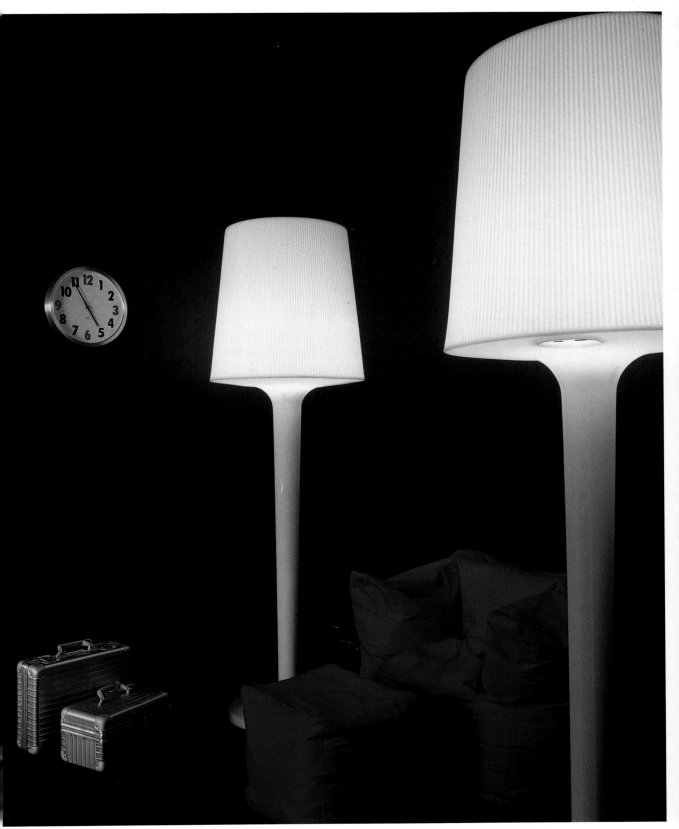

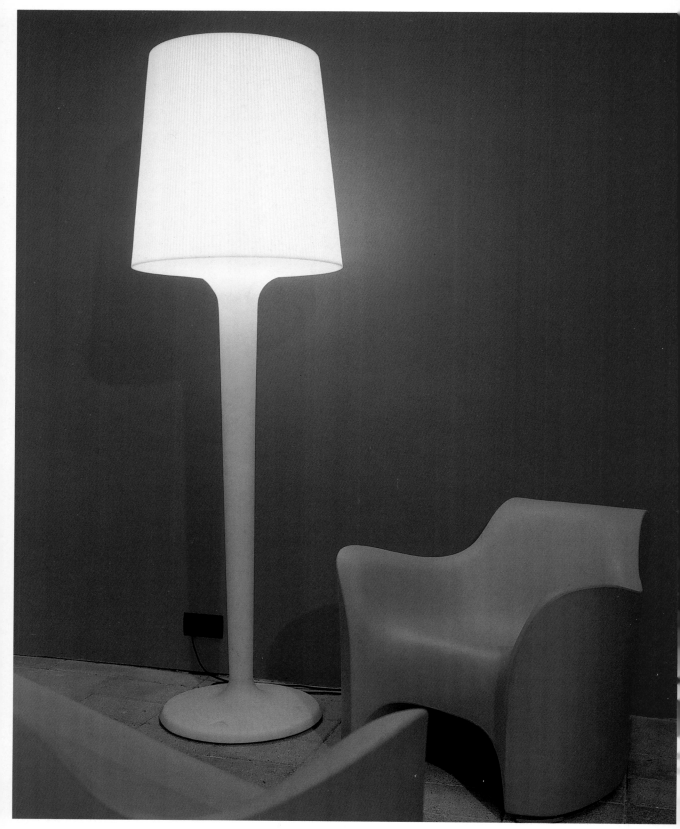

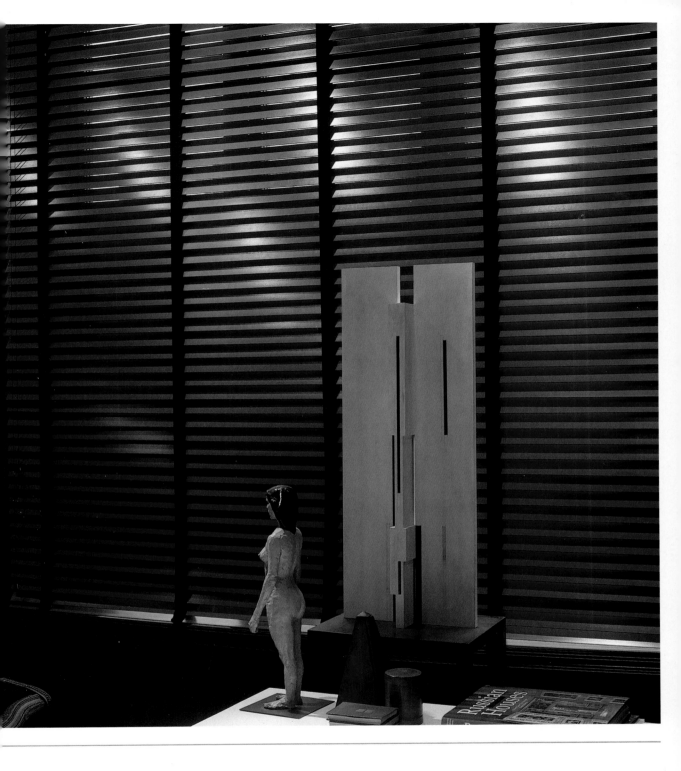

A dramatic effect is produced through the combination of spotlights and halogen lamps built into the ceiling.

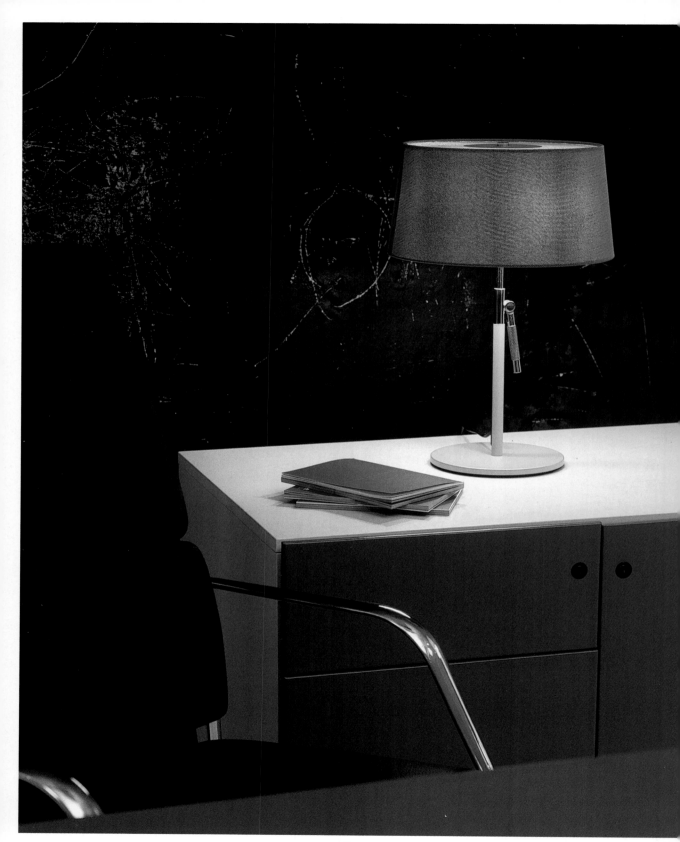

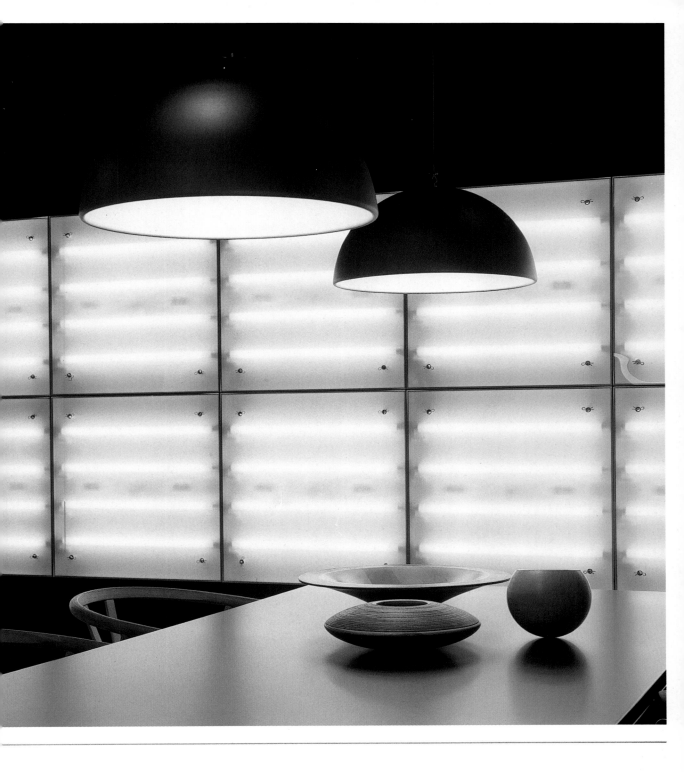

A wall with fluorescent lights behind translucent glass panels provides soft, ambient lighting.

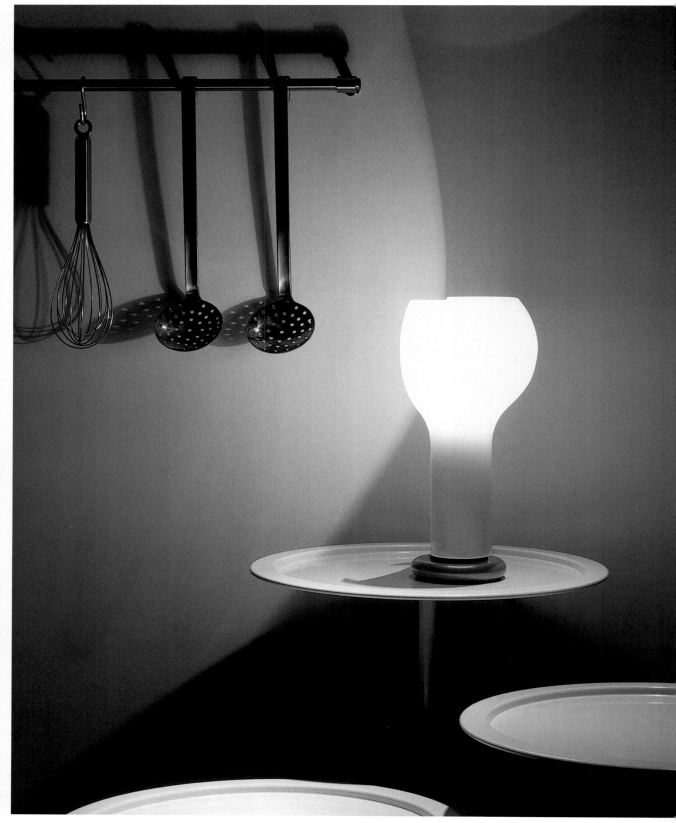

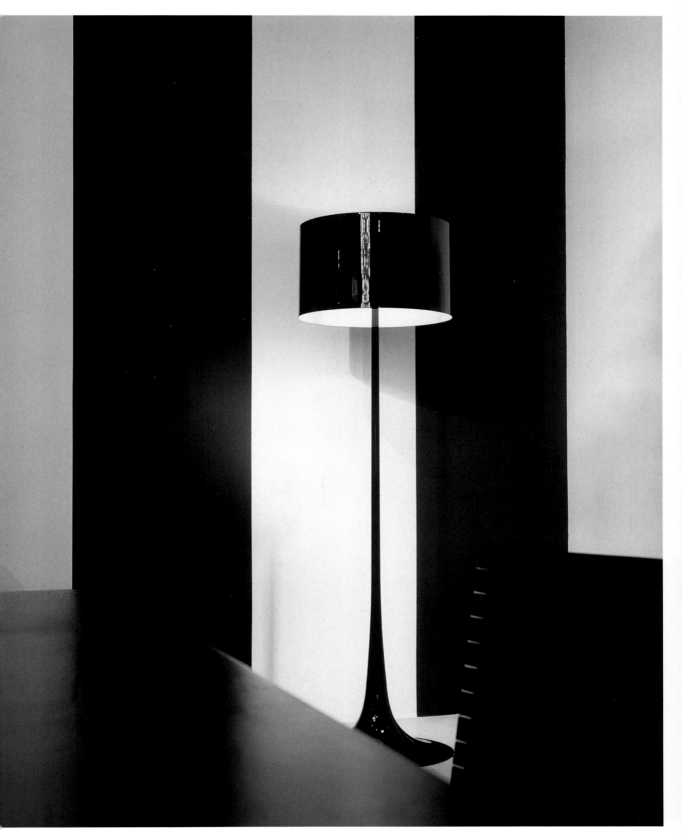

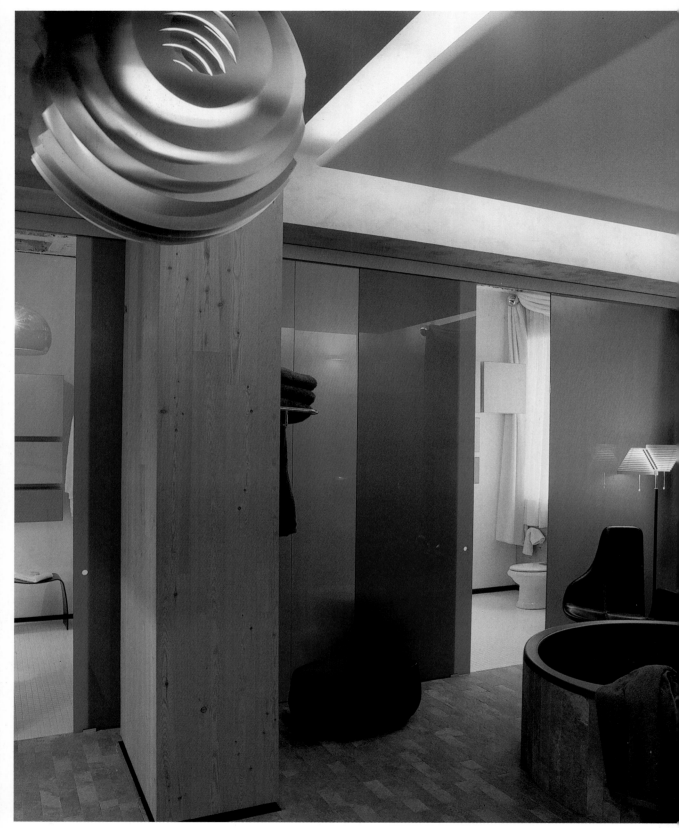

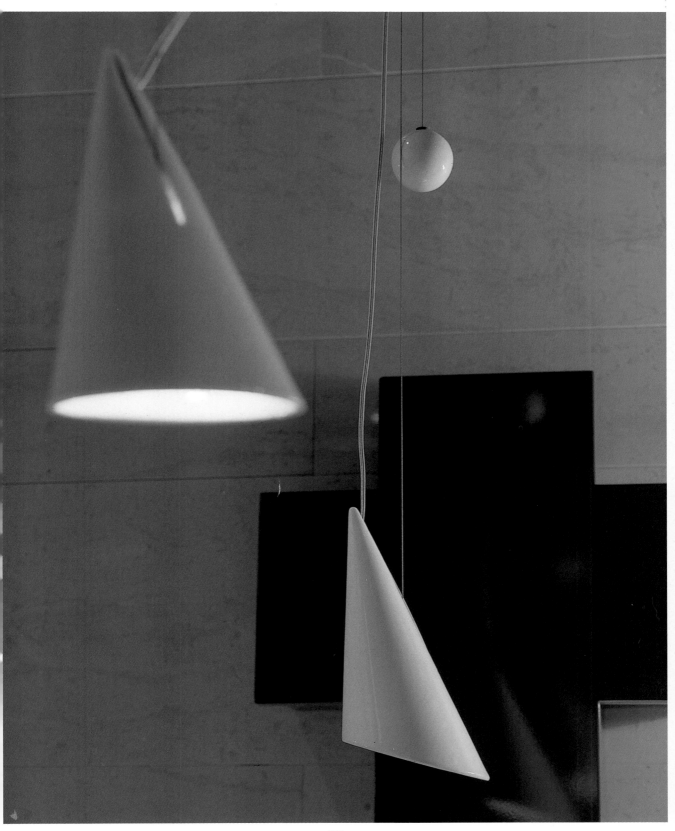

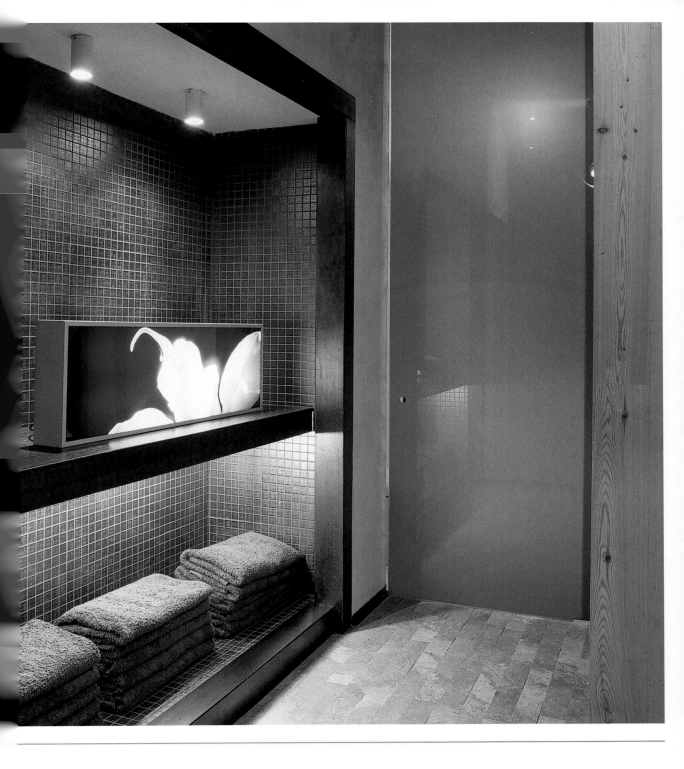

The arrangement of Linestras under a shelf produces a continuous border of light that makes the shelf appear to float.

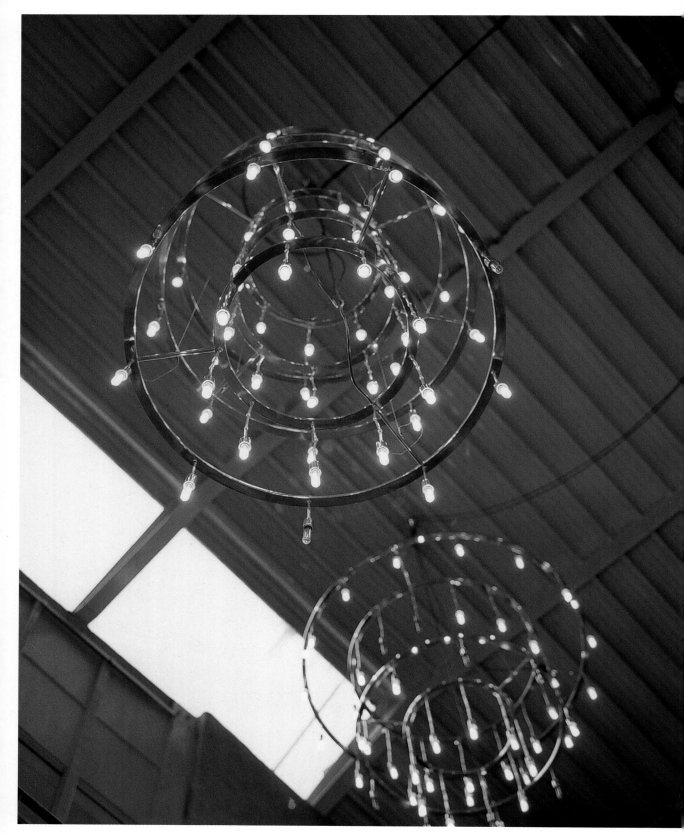

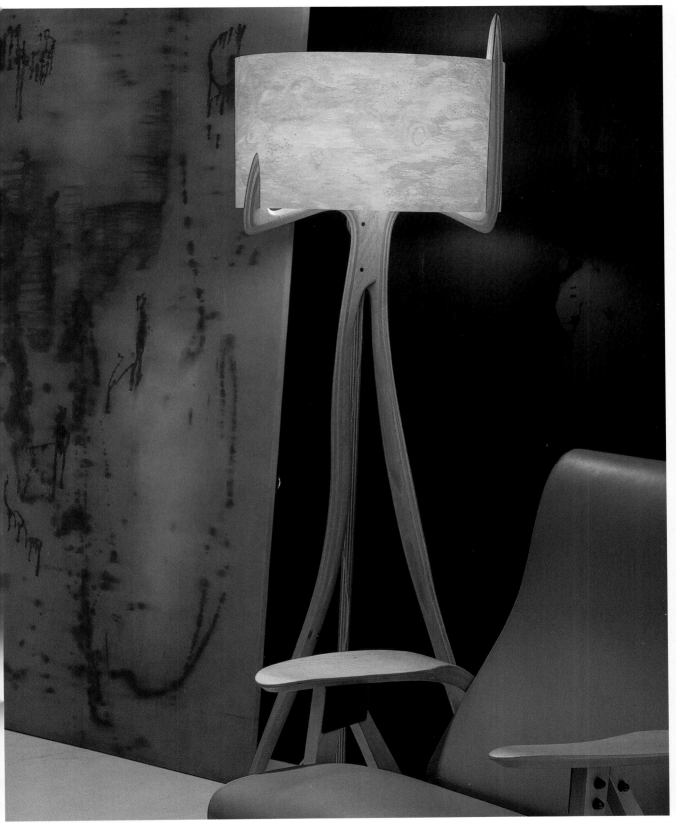

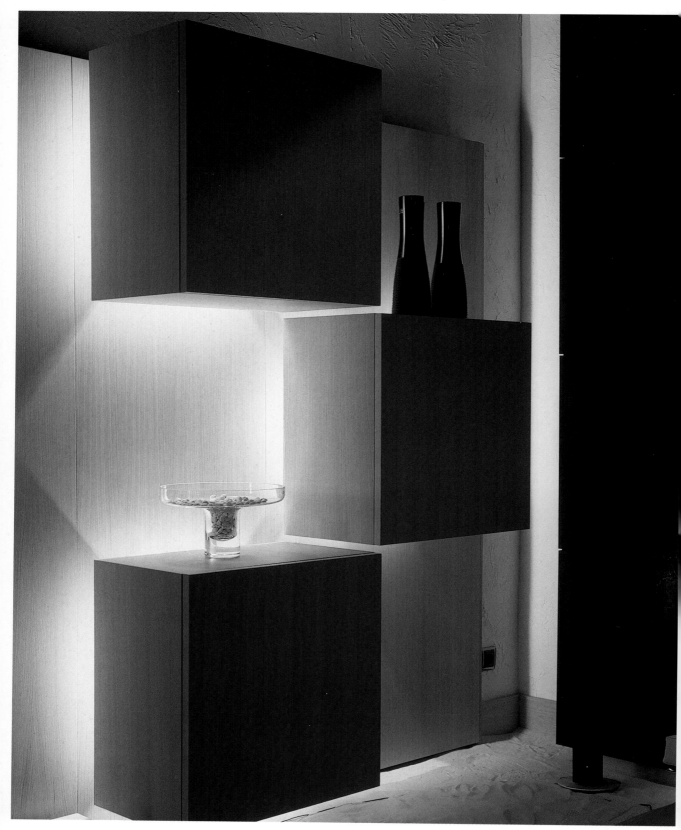

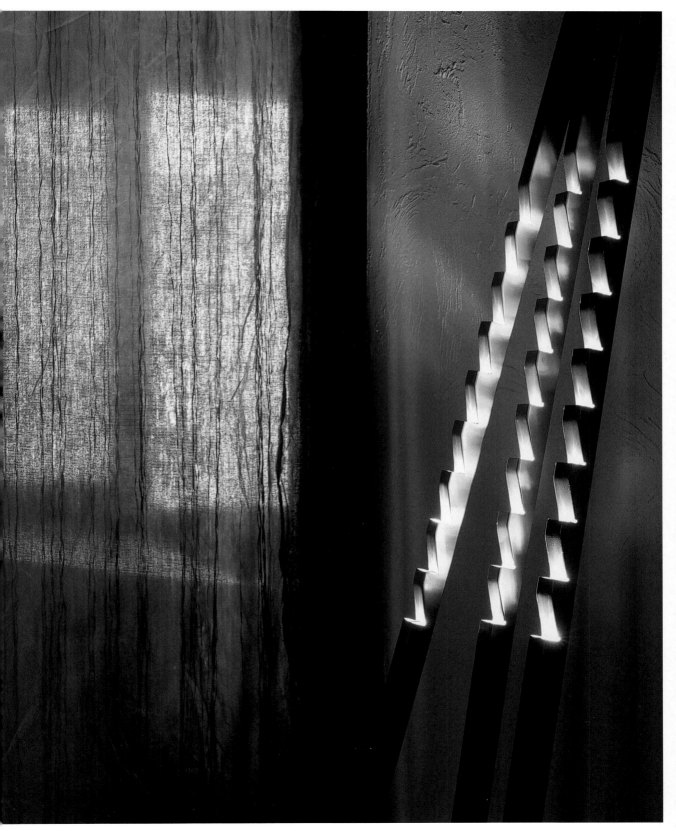

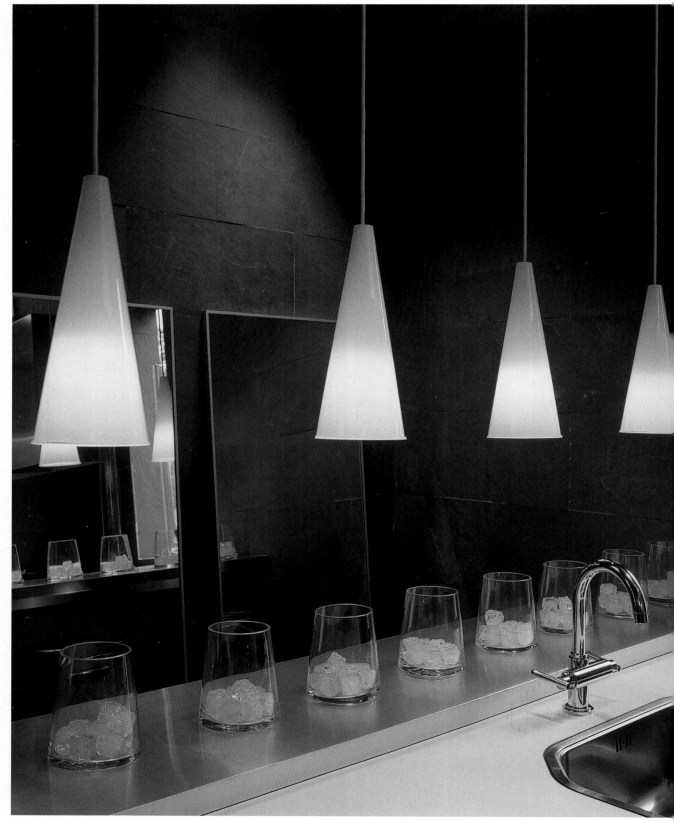

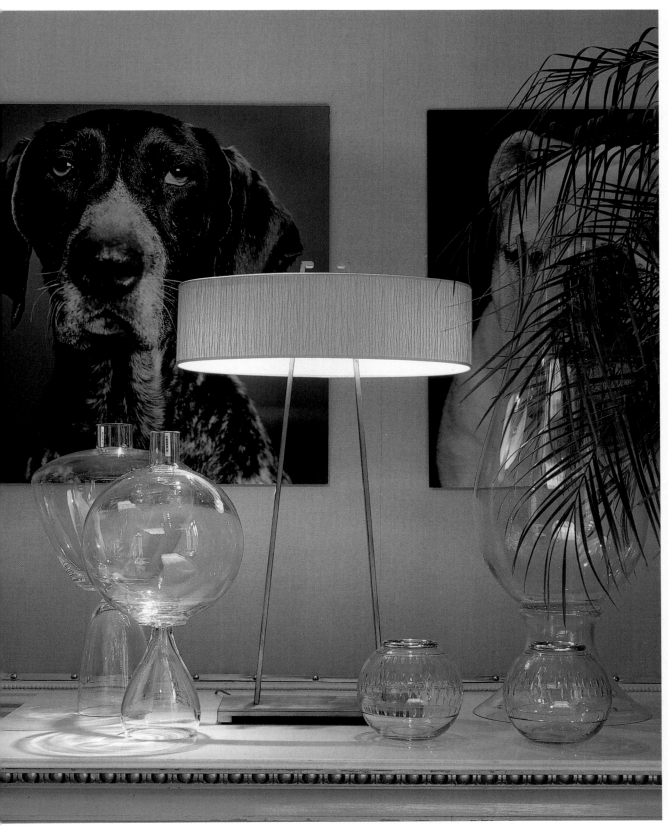

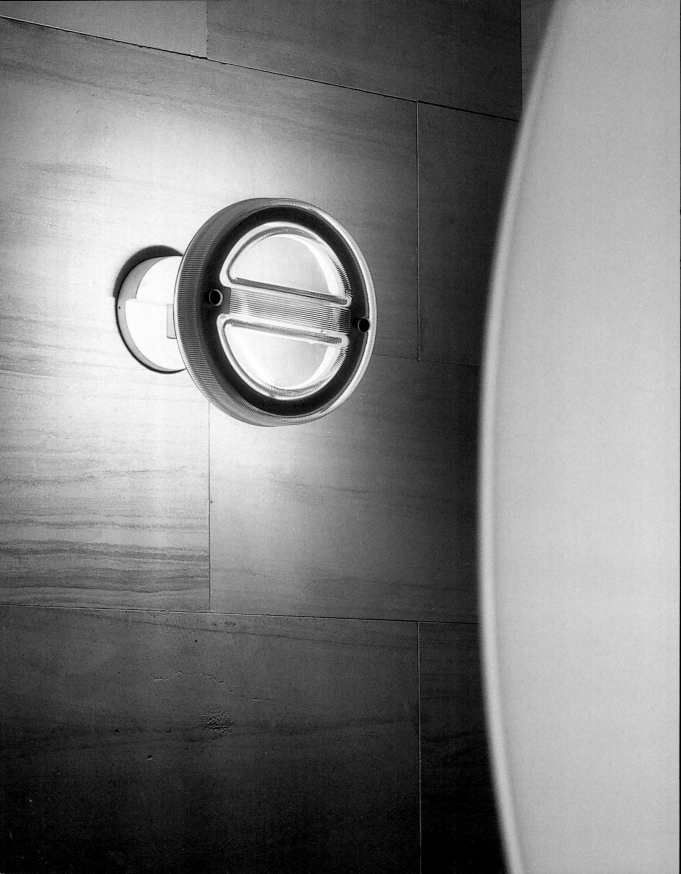

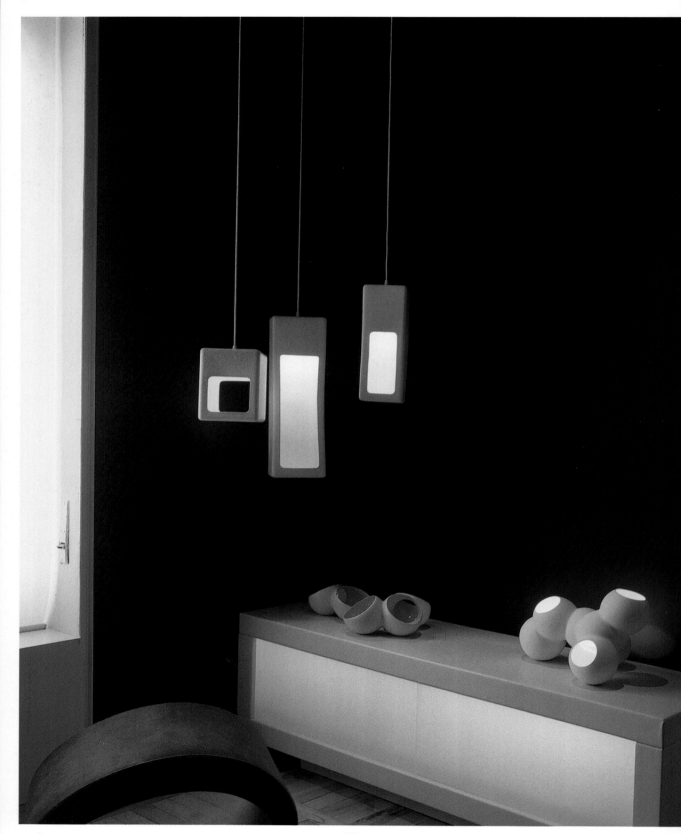

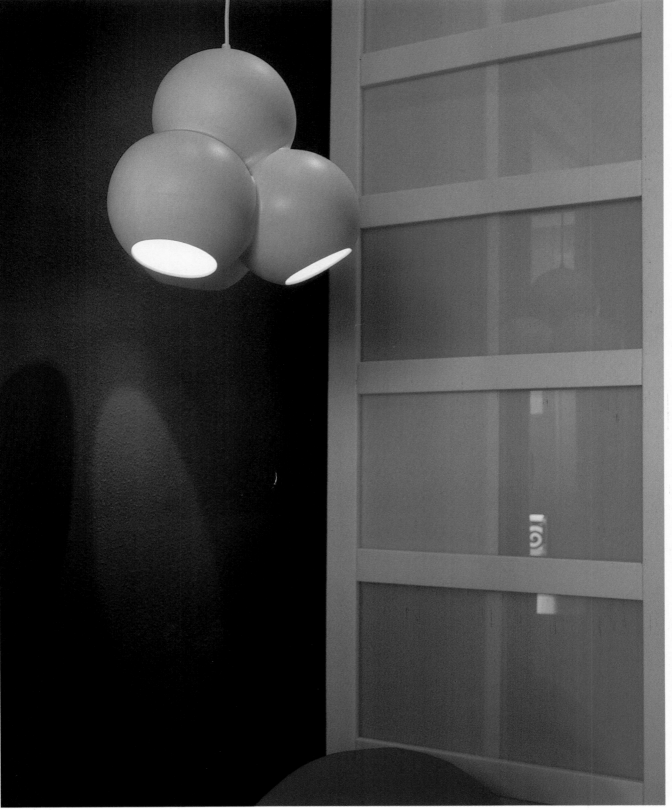

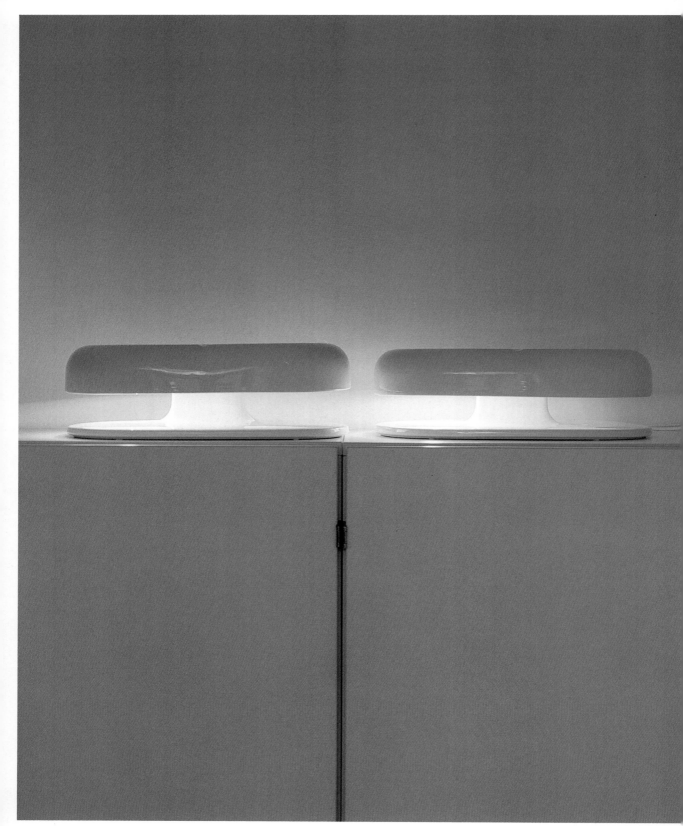

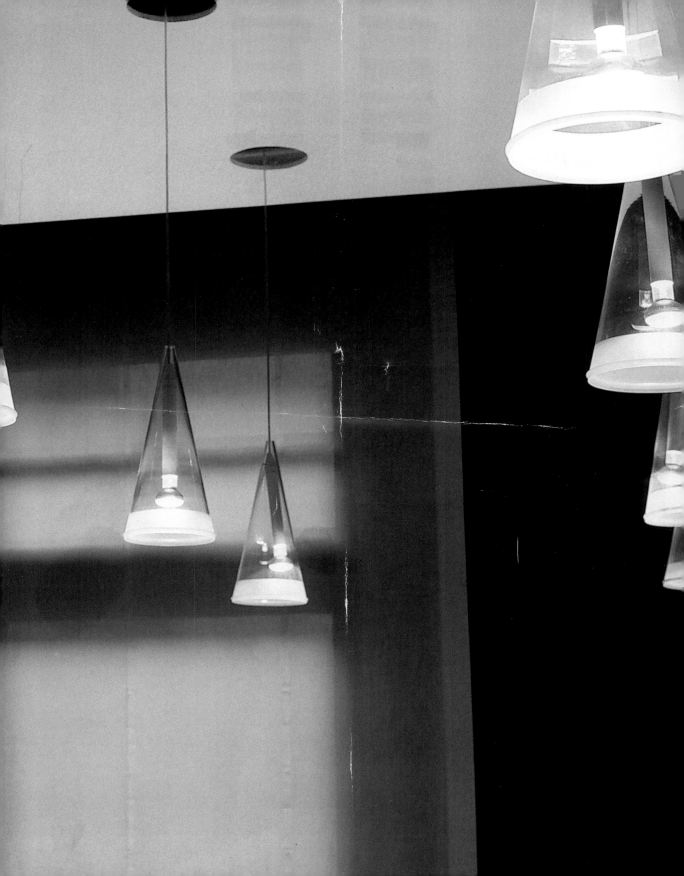

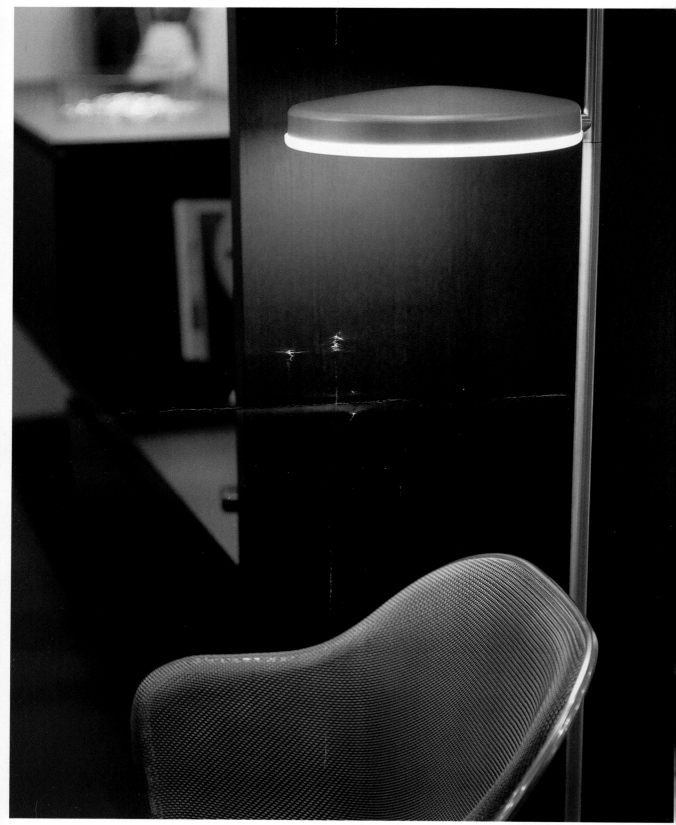

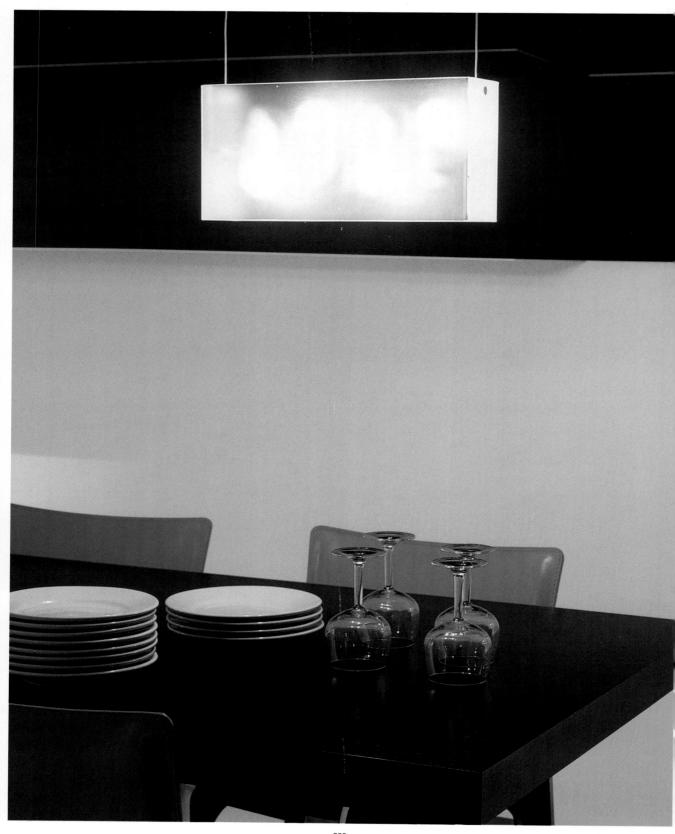

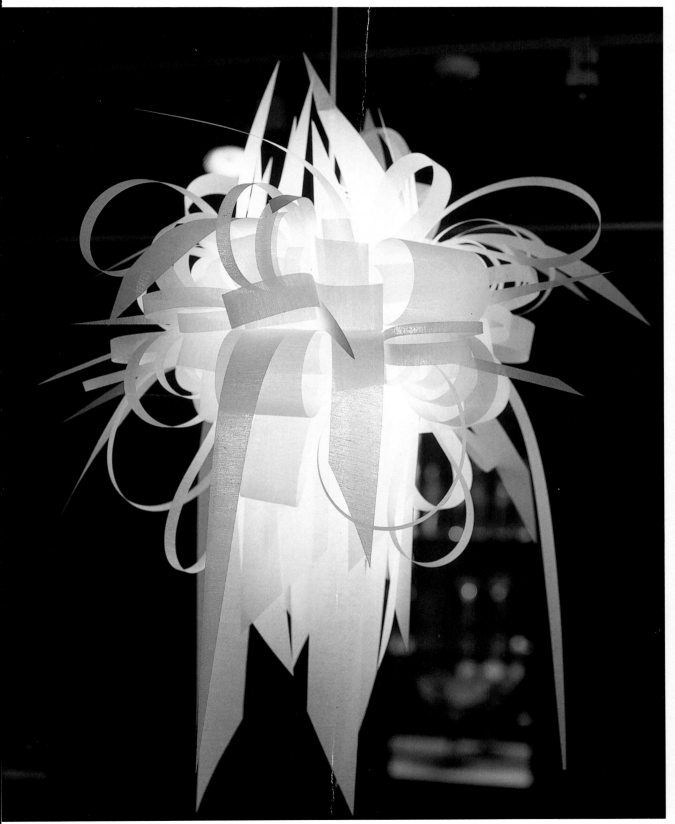

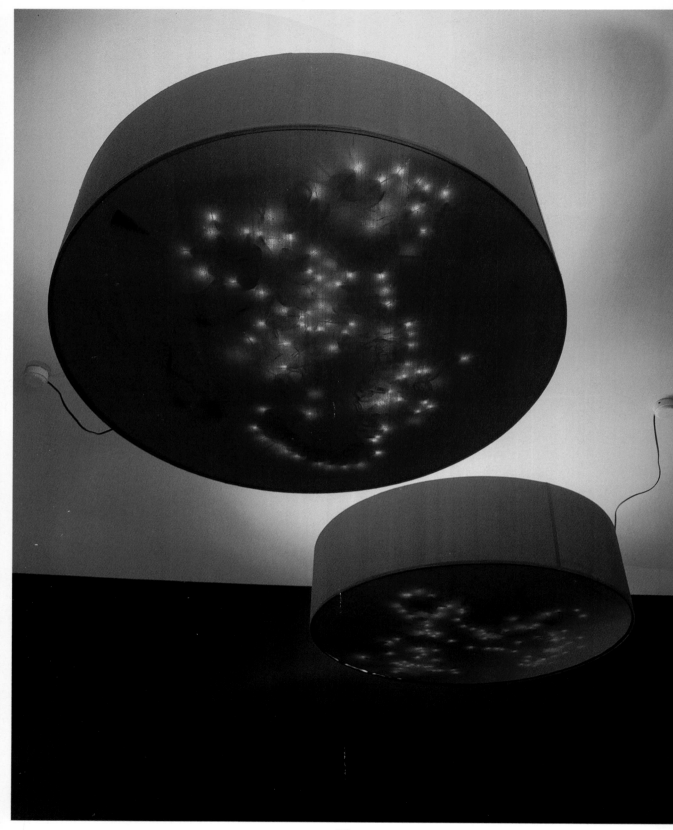

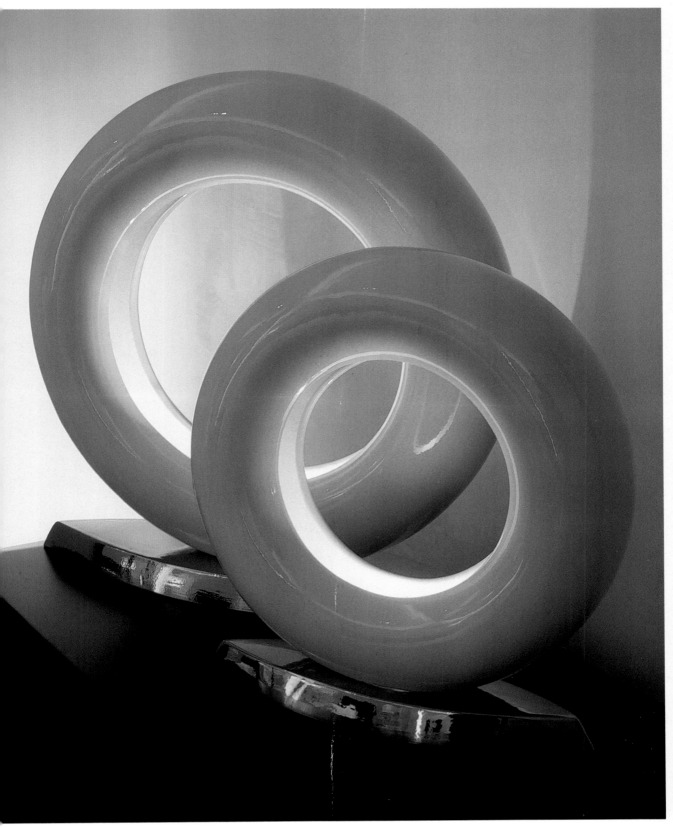

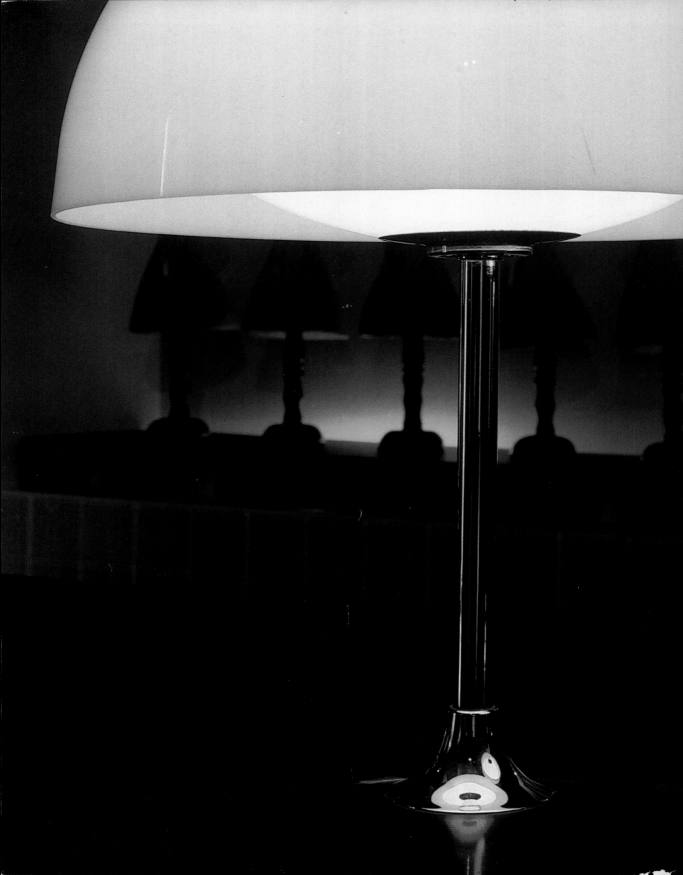

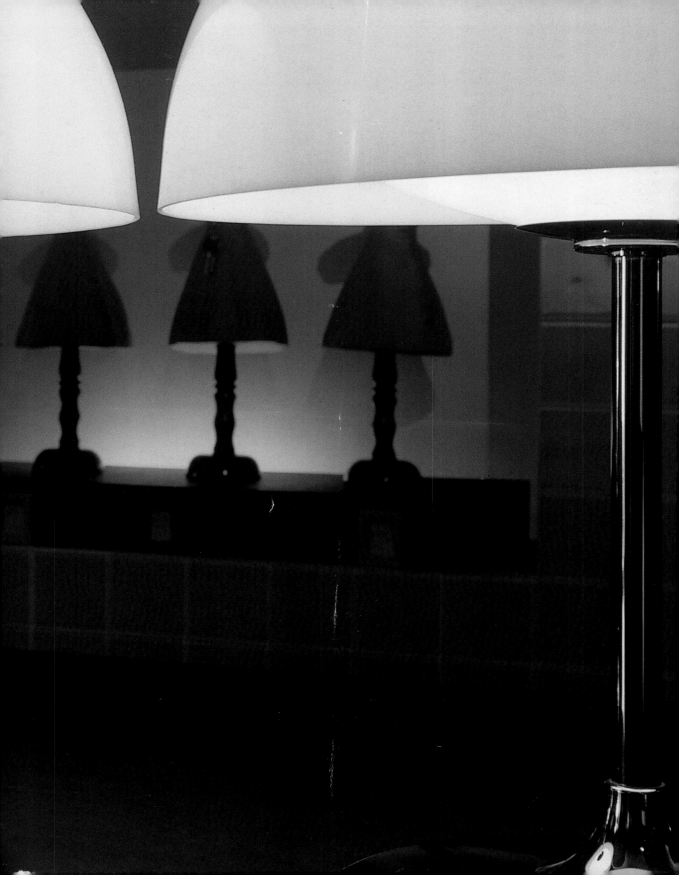

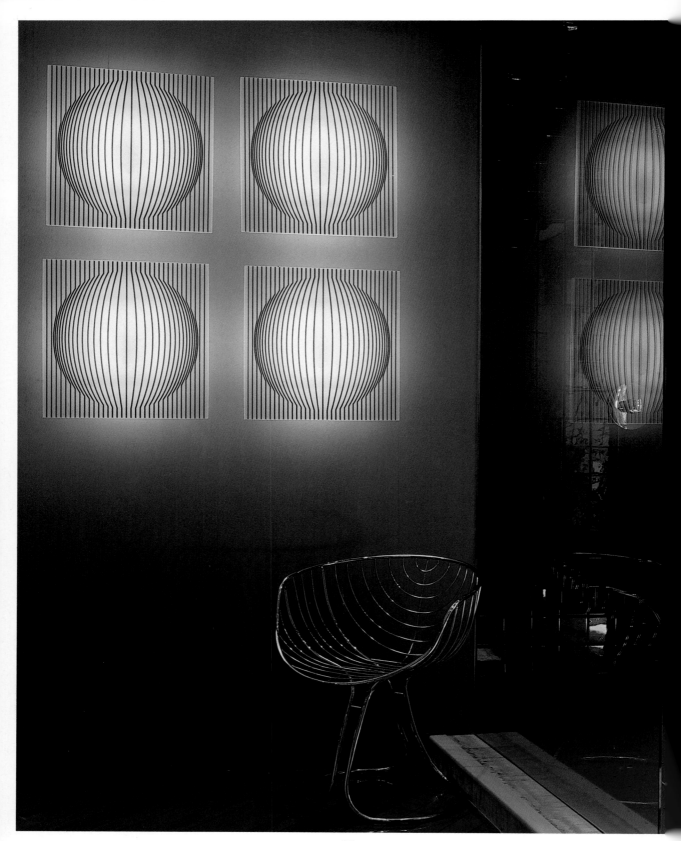

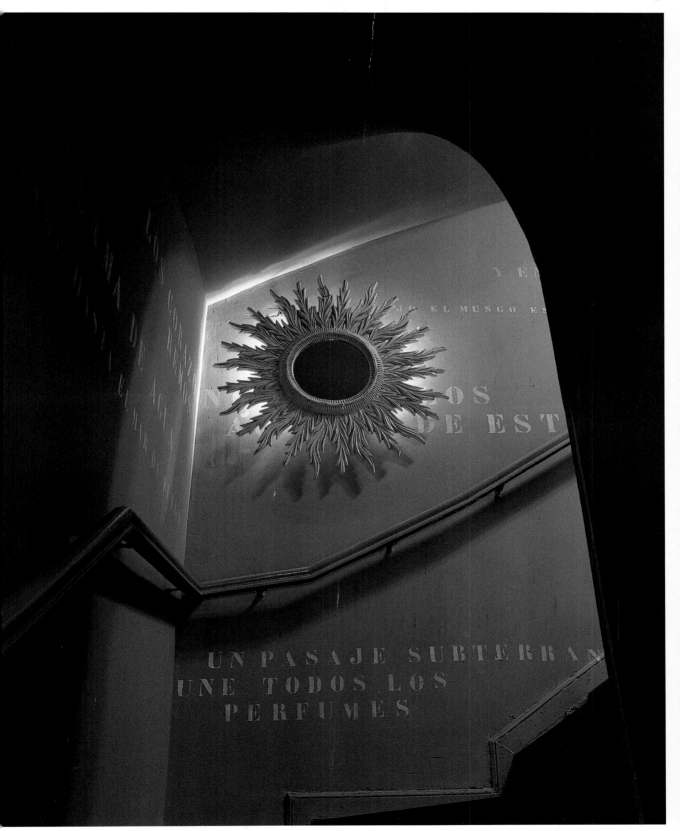

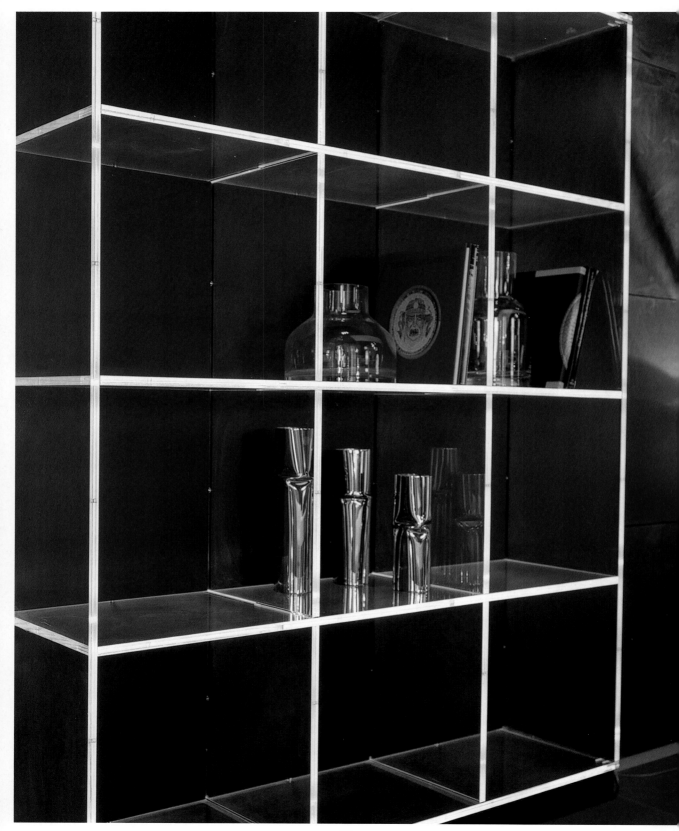

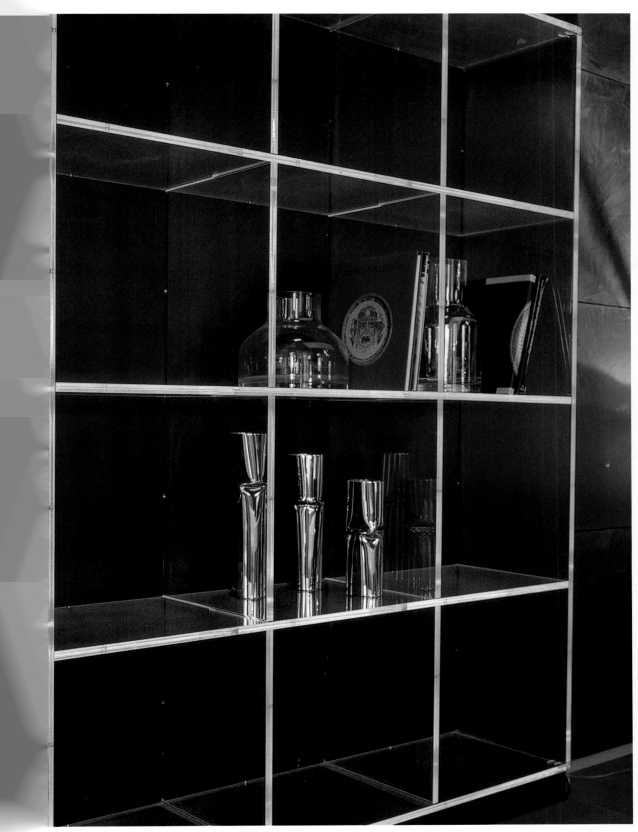

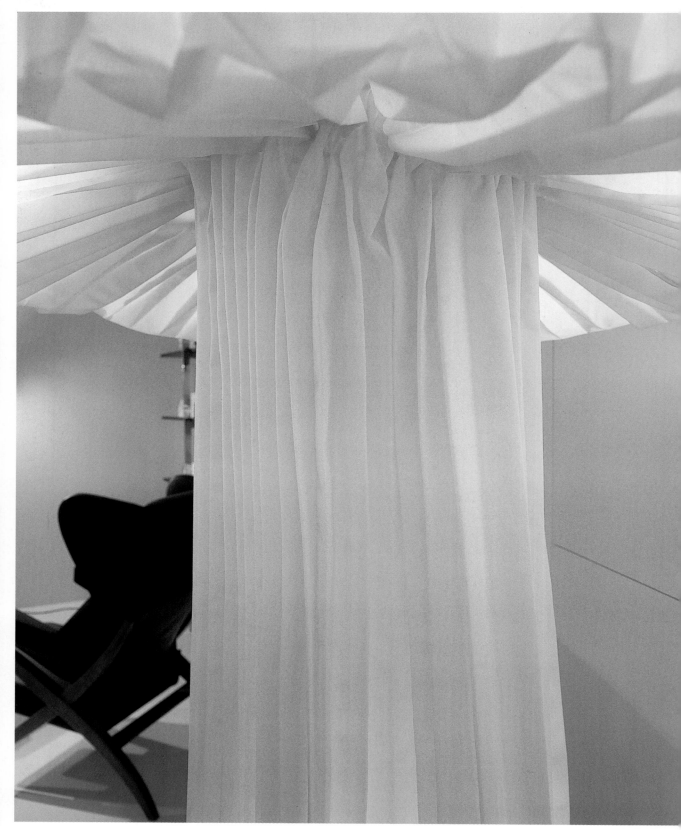

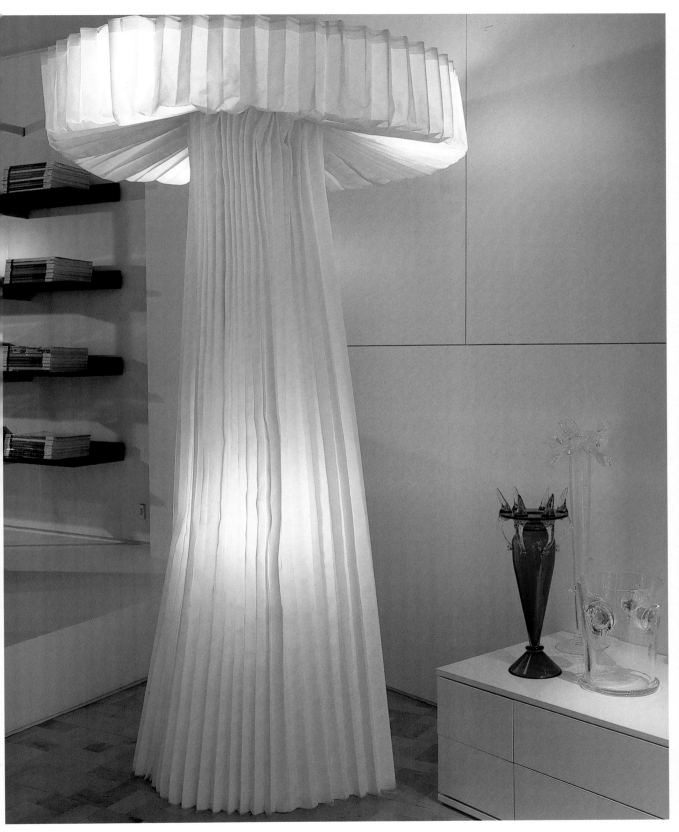

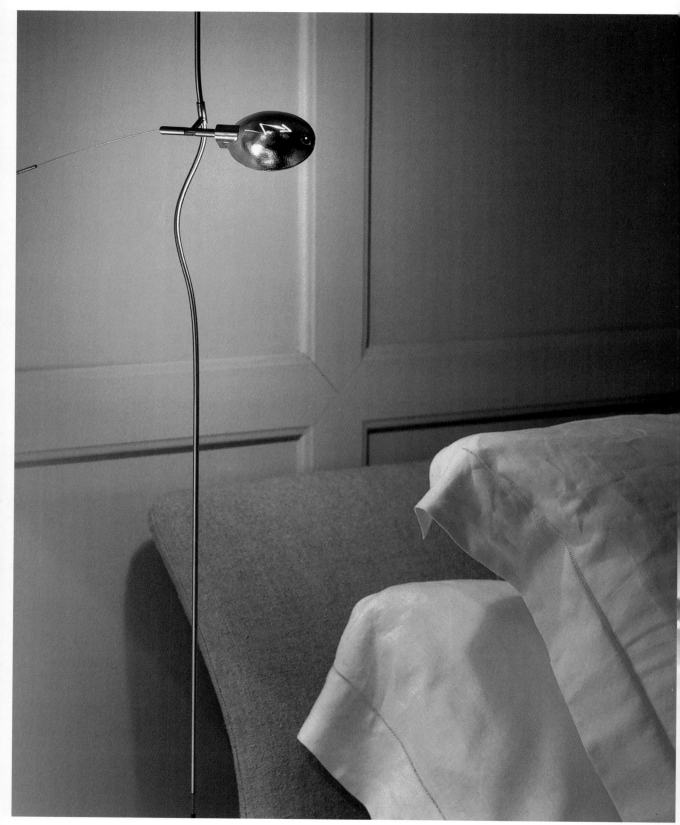

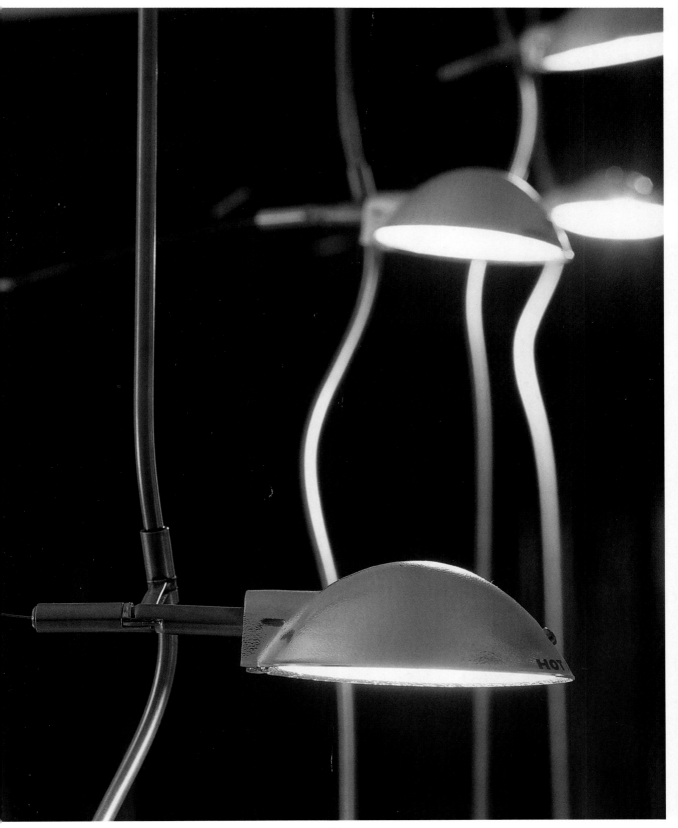

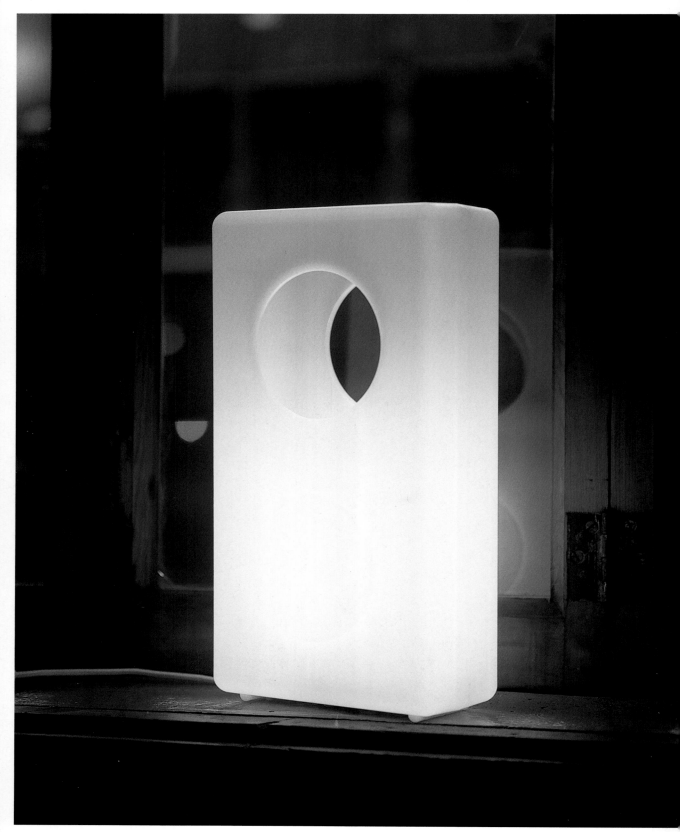

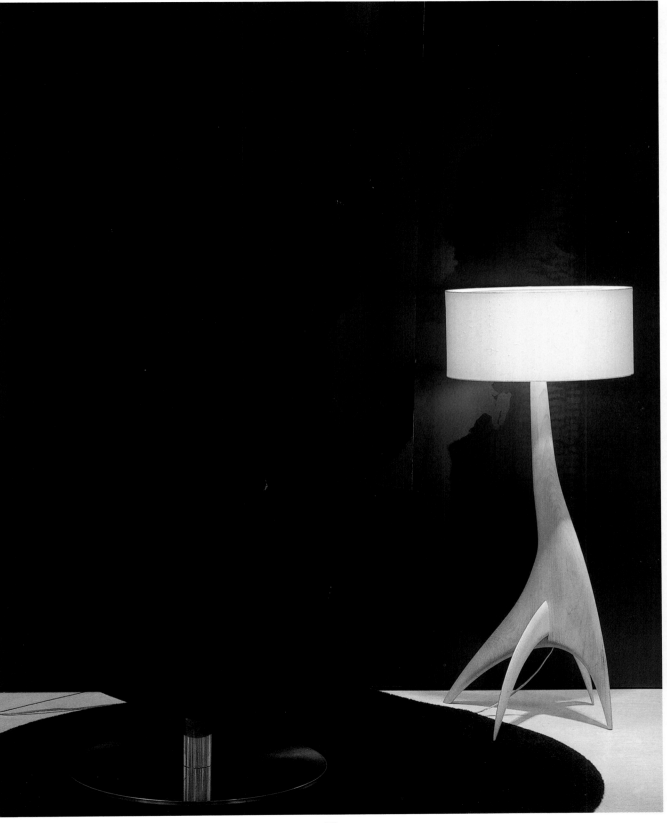

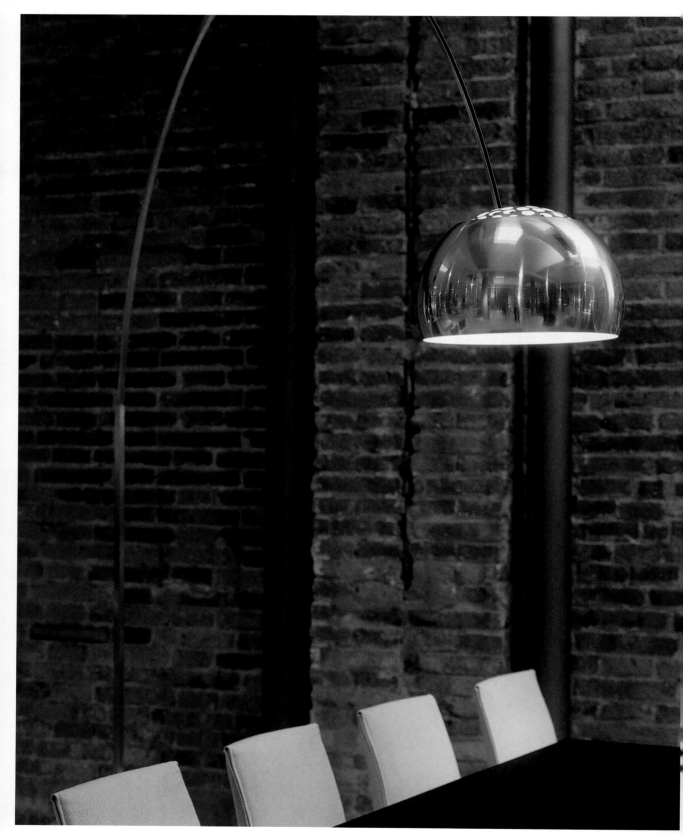

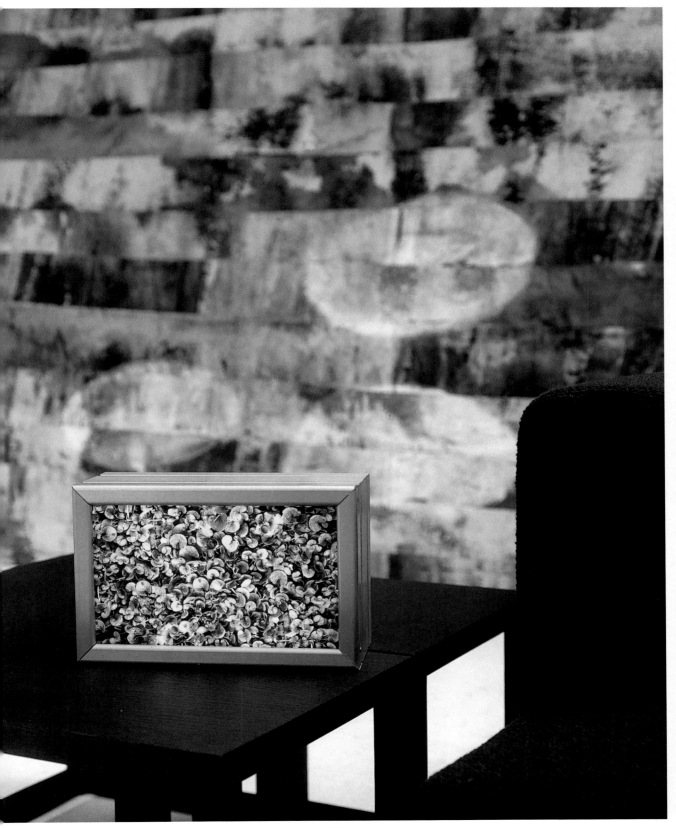

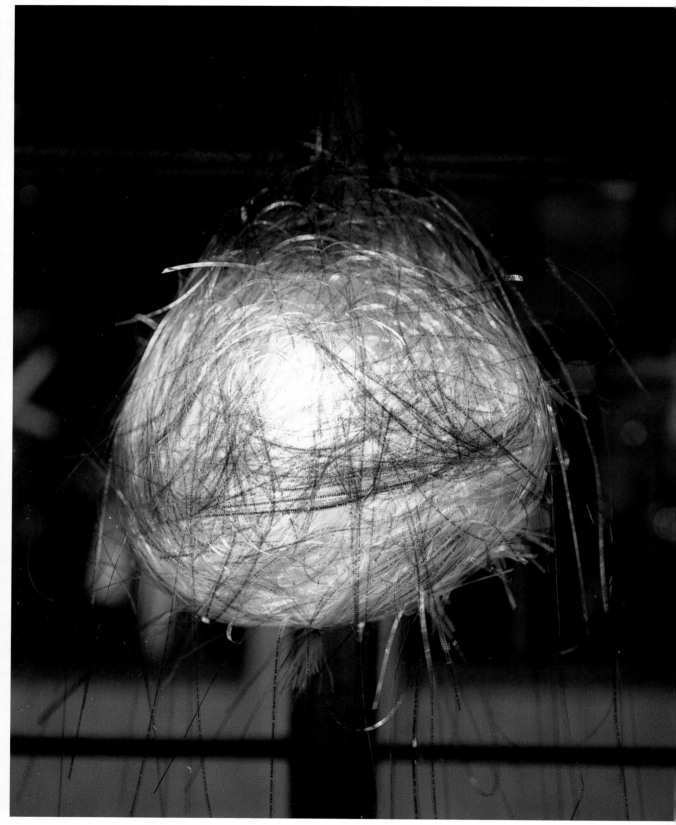

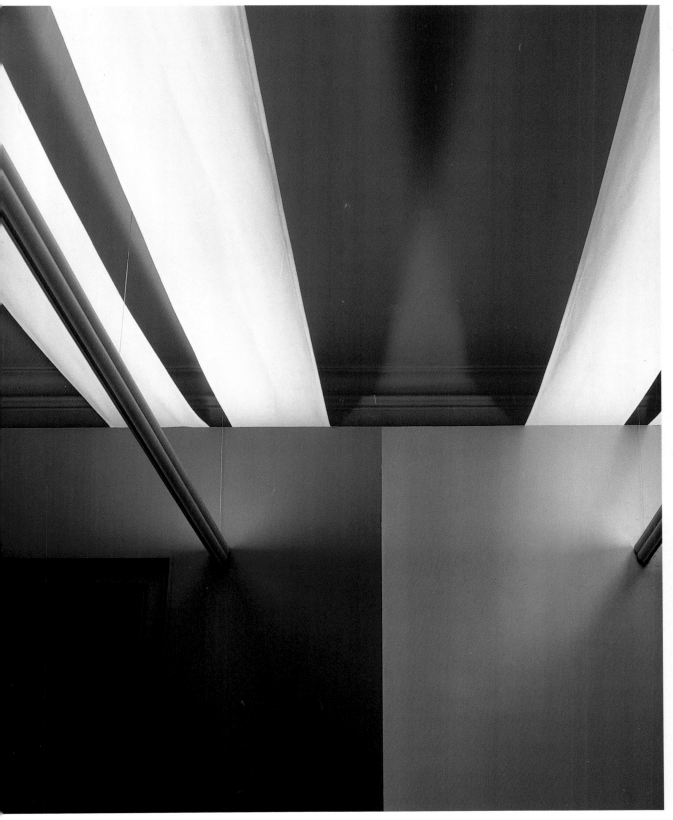

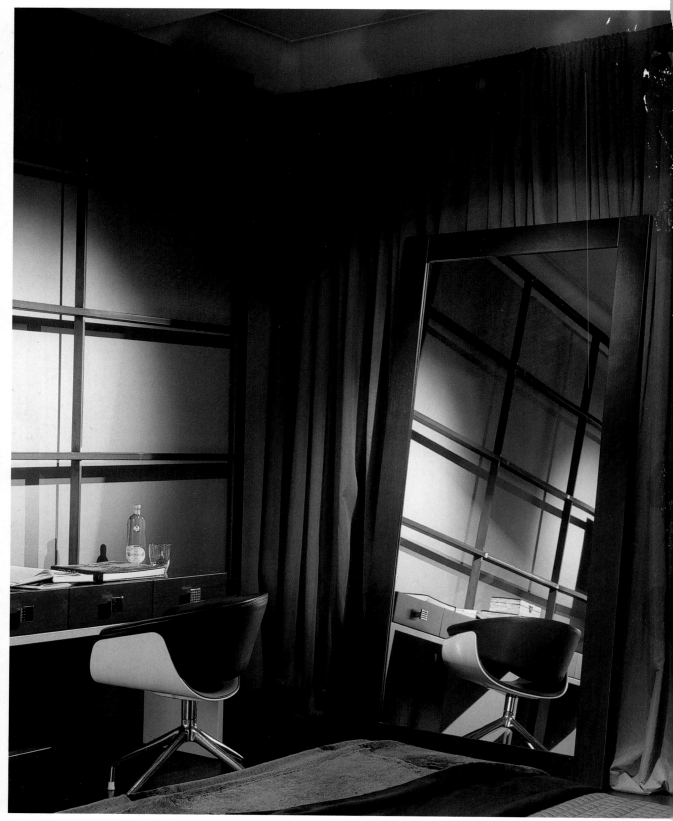

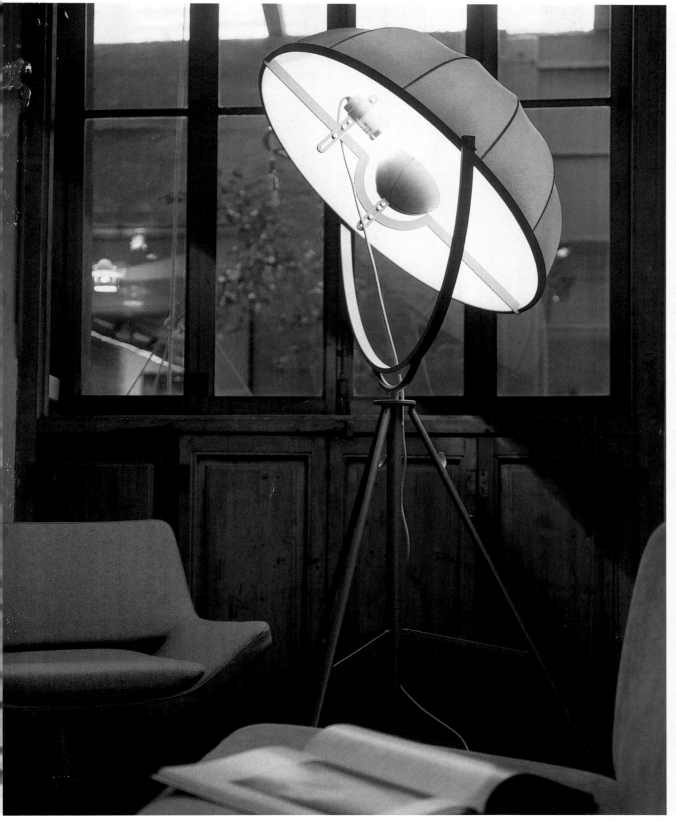

tre un « gentilhomme » égal au poète, cette mise en scène de la séance de pose suggère que, pour a...
dre à la grâce heureuse et souriante dans l'échange entre le peintre et son modèle — dont dépend la « ...
ce » du tableau —, la perception de la beauté du visage doit être soutenue par la musique : l'harm...
immatérielle de son rythme supporte le rythme de la création, quand le pinceau caresse le panneau co...
l'œil le visage et que l'état de grâce » atteint la perfection...

Pour Mona Lisa, Léonard a pris les moyens d'instaurer l'unité supéri...
d'une contemplation et d'une pratique heureuses. Il a chassé la mélancolie; celle du modèle certainem...
elle du peintre aussi sans doute, surtout quand, comme Léonard, il vise une difficile perfection, au-...
toute mesure et, donc, de toute règle : celle de la grâce...

Considérant et méditant, il jugeait ses figures... Léonard s'est (rarement, il...
) expliqué sur son étrange pratique. A propos de la *Cène* précisément quand, selon Vasari, il dit...
les raisons de sa lenteur :

« Il parla de l'art et montra comment c'est au moment où ils travaillent...
s que les esprits élevés en font le plus, car ils cherchent dans leur tête les inventions, et forment ...
parfaites qu'ils expriment ensuite en peignant avec leurs mains d'après leurs conceptions ». Par s...
udes, Léonard confirme que la peinture est une « cosa mentale », non un art mécanique; mais u...
on se pose, à ce niveau d'exigence : est-il toujours possible d'exprimer « ensuite » les « idé...
tes » formées dans la contemplation intellectuelle? Ce qui est en gestation, c'est une conceptio...
de *l'idée*, de l'inspiration du peintre qu'il faut ensuite matérialiser dans la pratique. On admira...
ment chez Léonard comment « ses mains, grâce au dessin, rendaient si bien sa pensée ». Ma...
rd lui-même en était-il toujours convaincu?

ÉTUDE DE MAINS
pointe d'argen...
15 × 21,5 cm...
Windsor, Bibliothèque Royale...

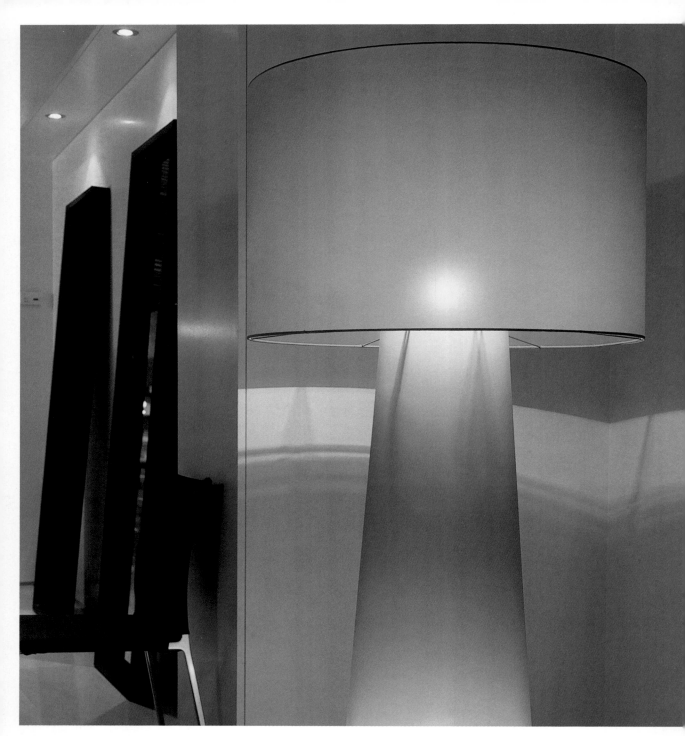

Incandescent light from the lamp is combined with spotlights from the halogen lamps, producing different plays of light throughout the space.

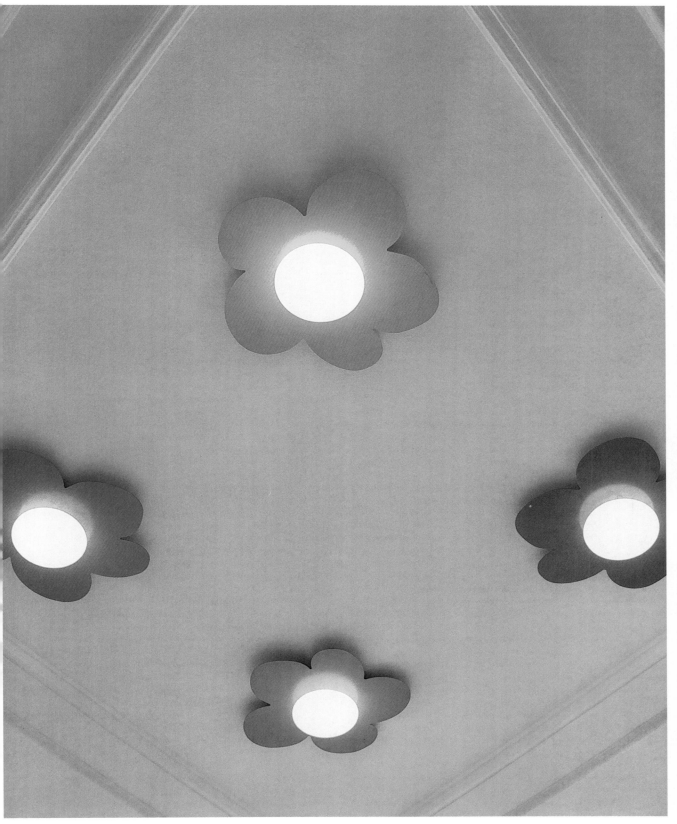

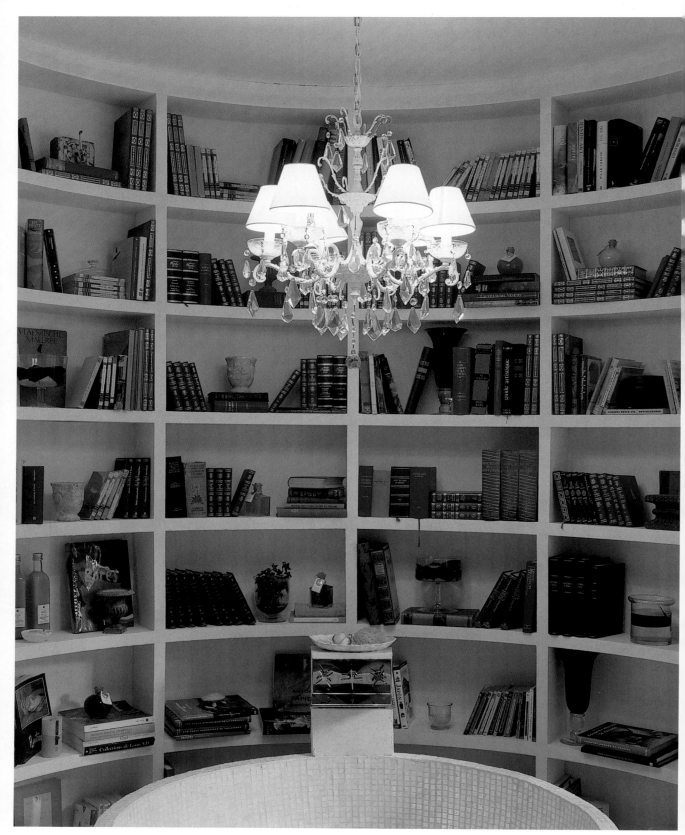

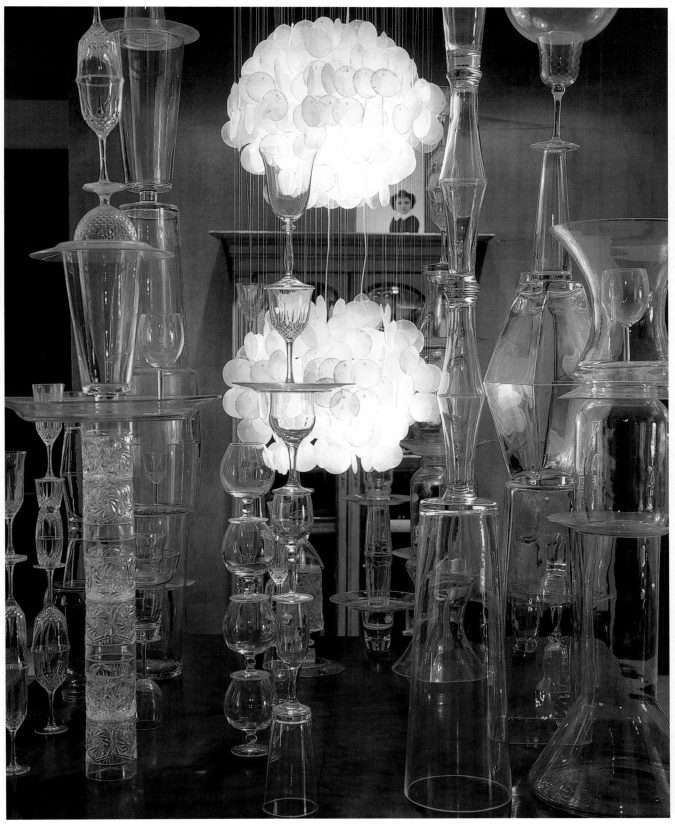

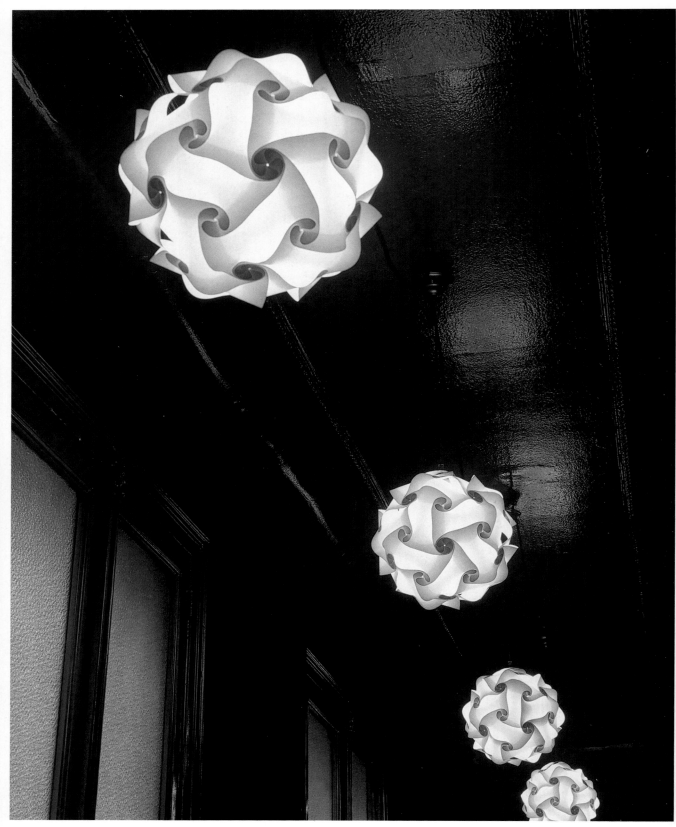

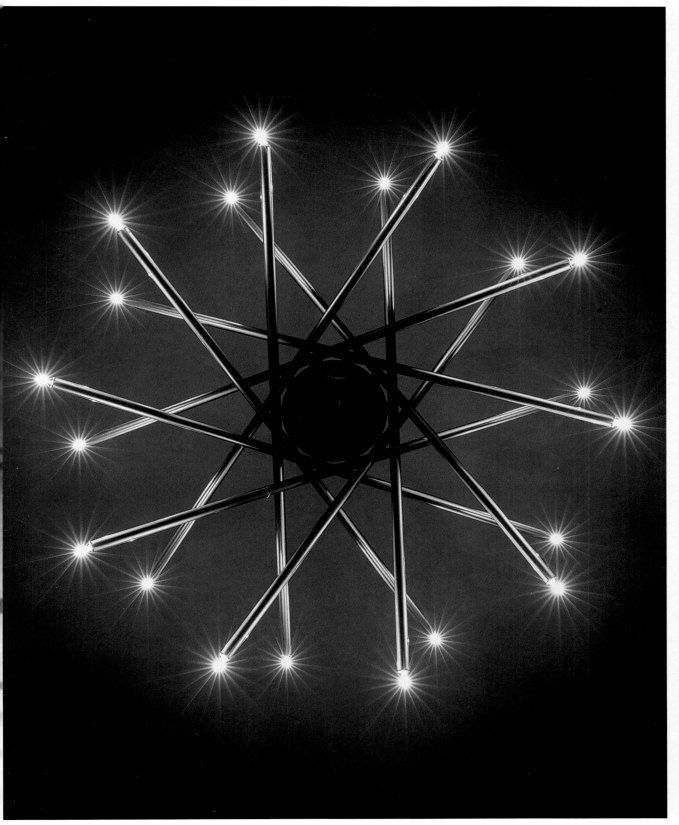

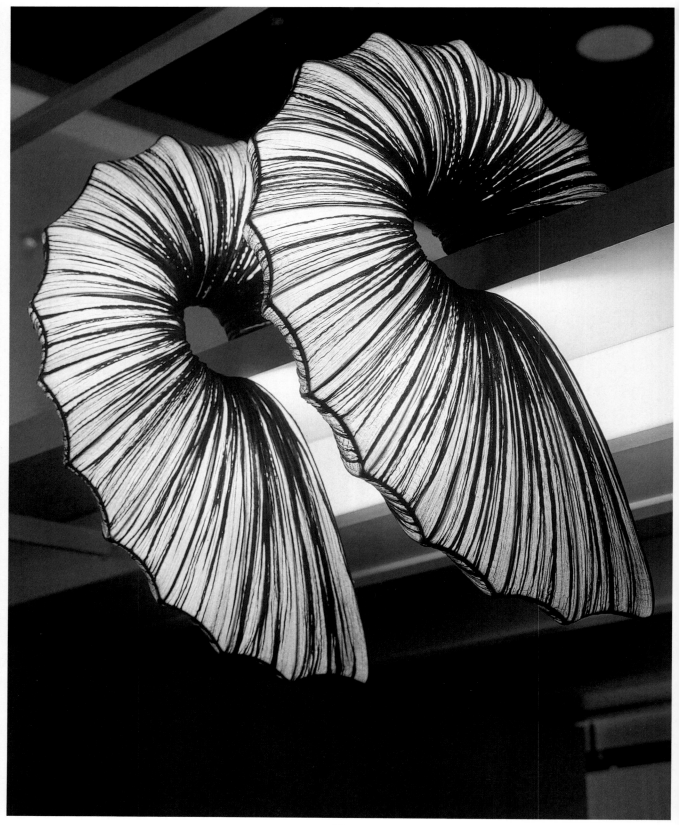

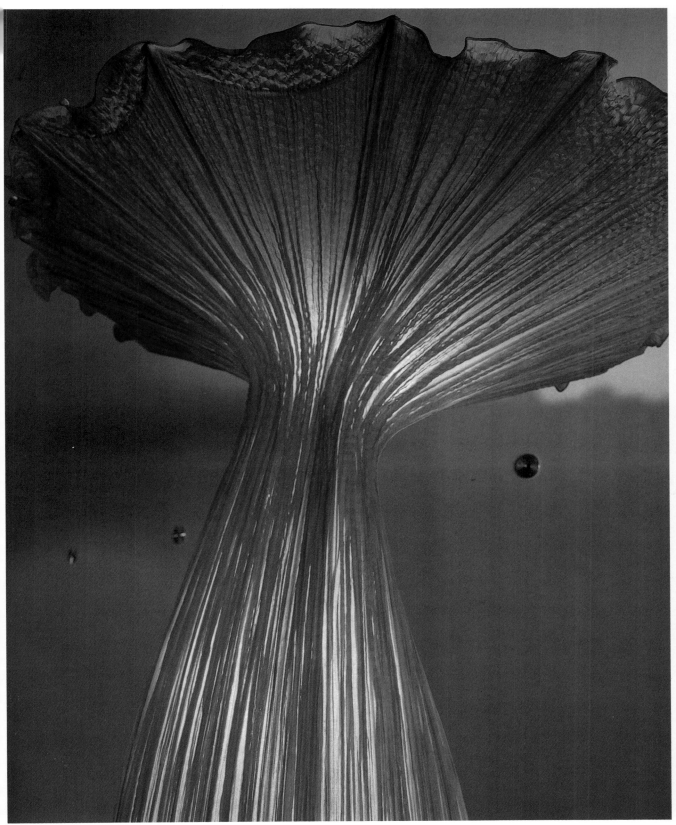

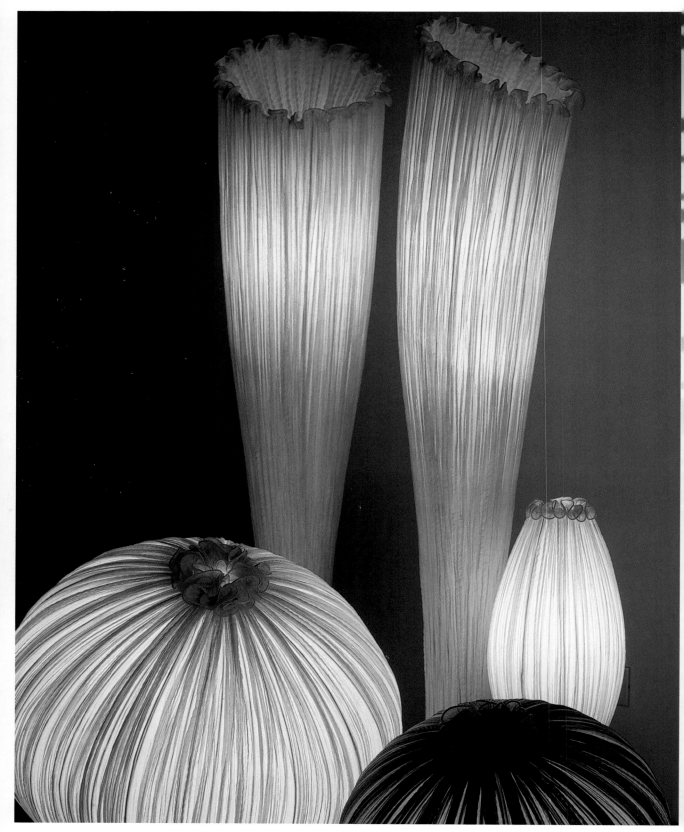

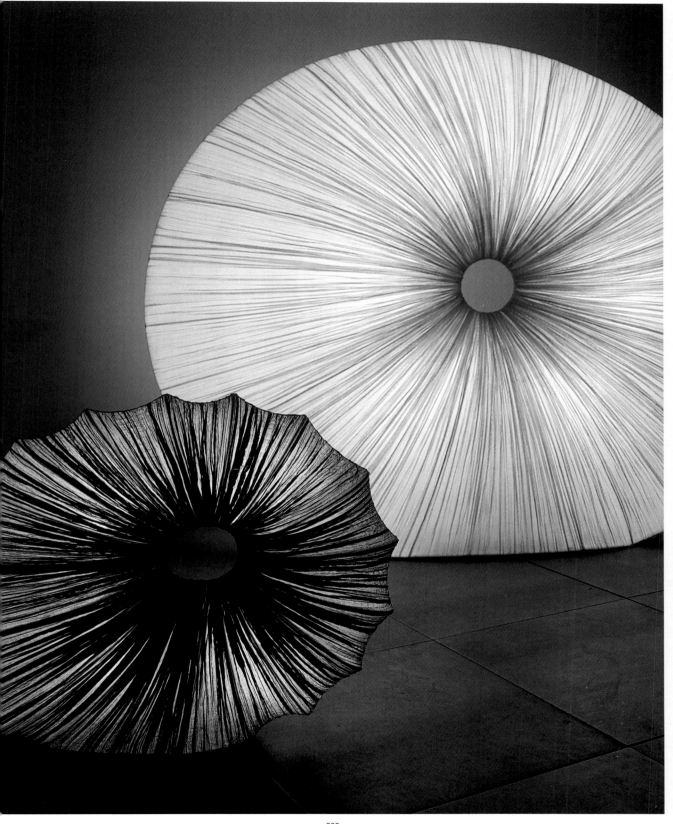

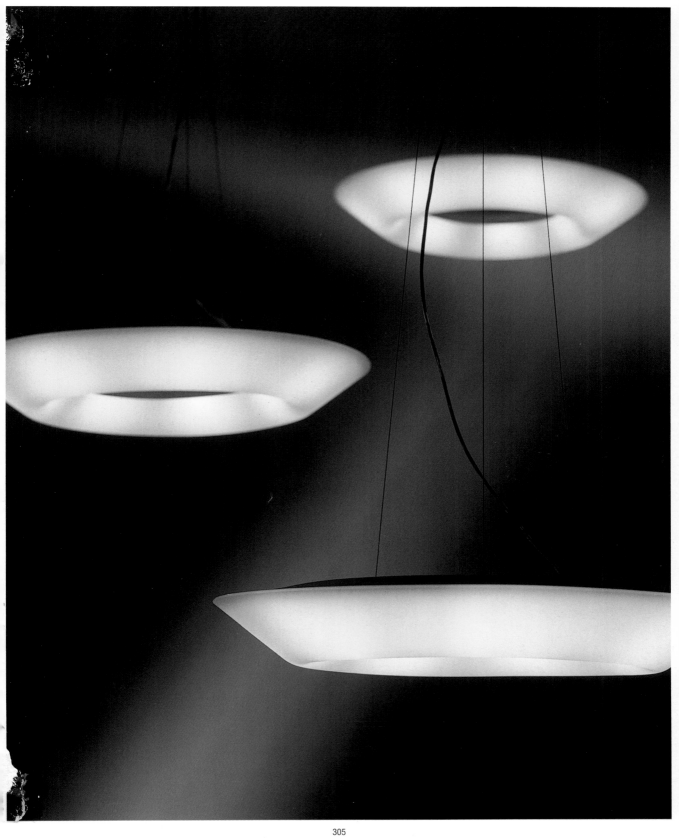

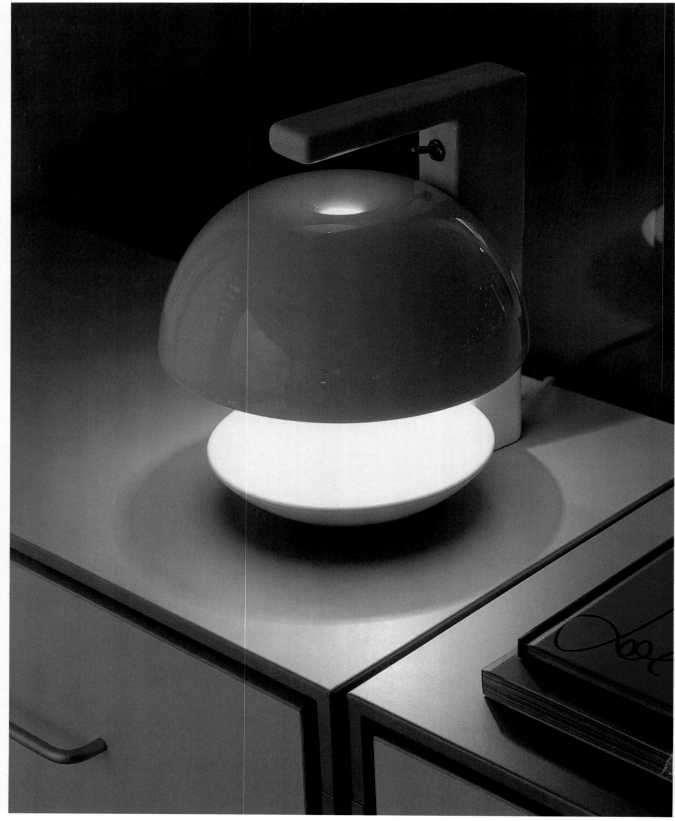

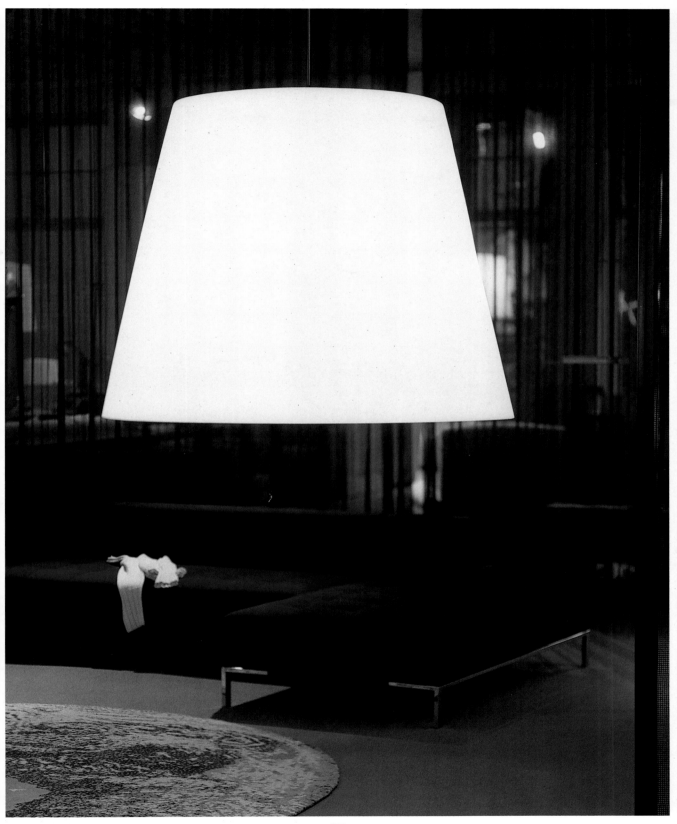

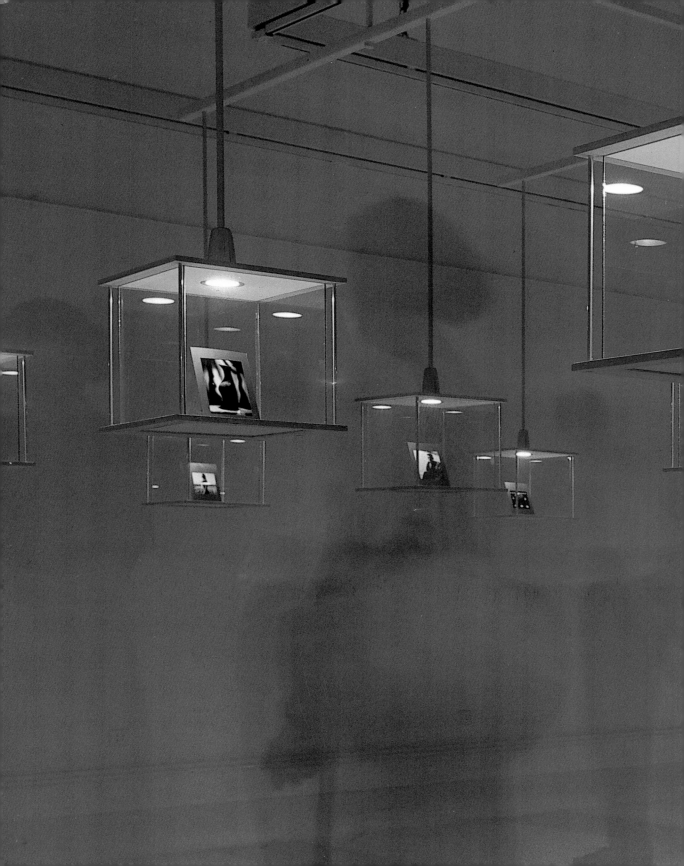

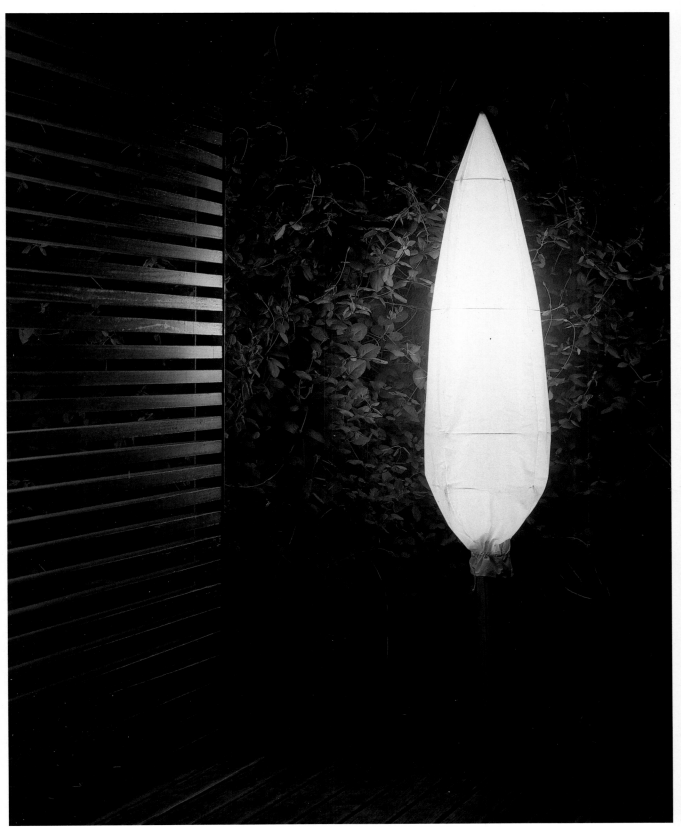

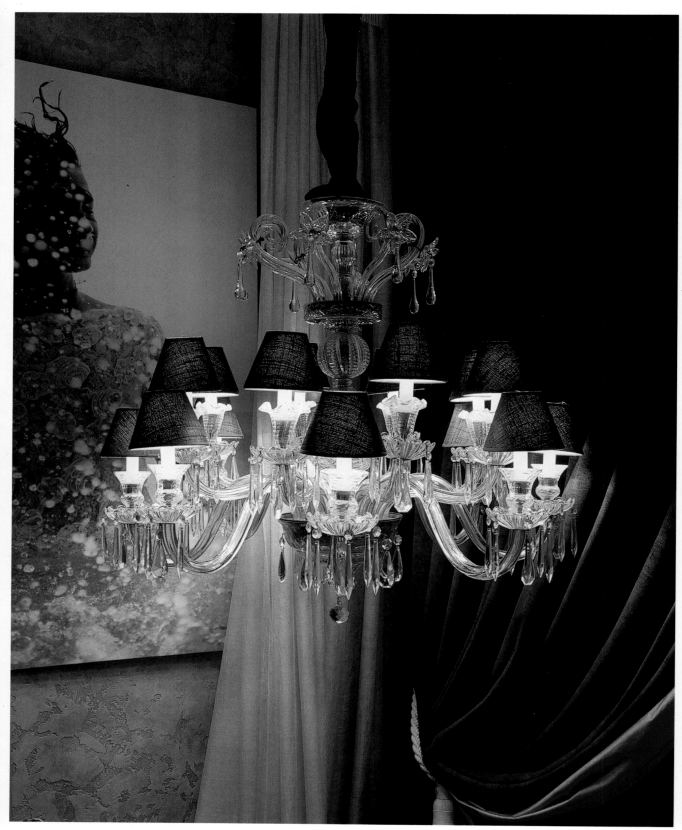

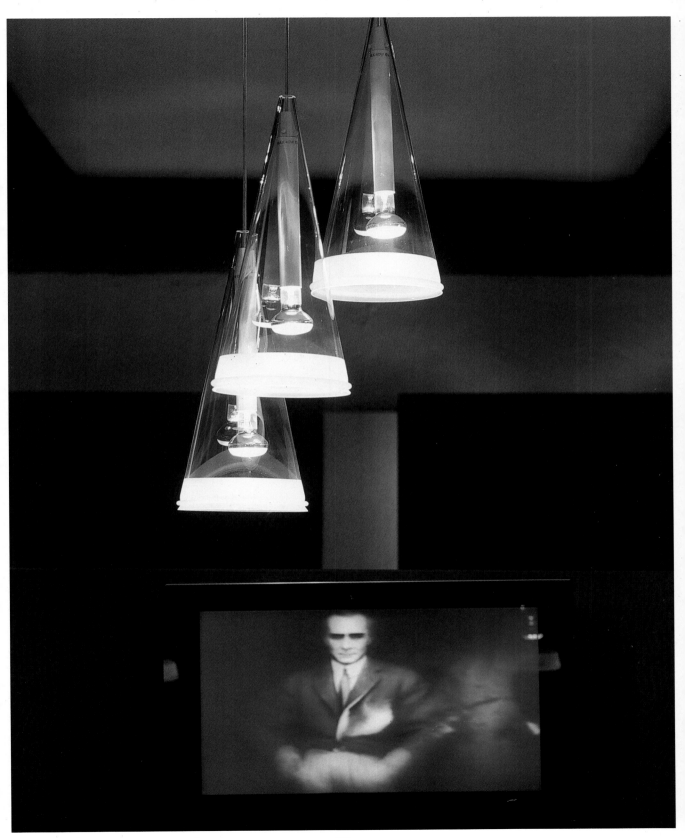

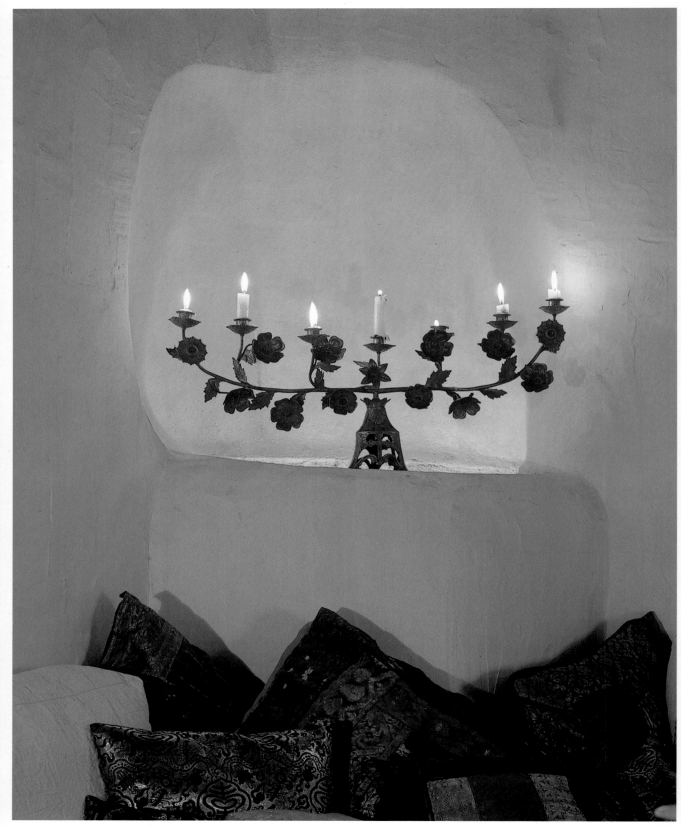

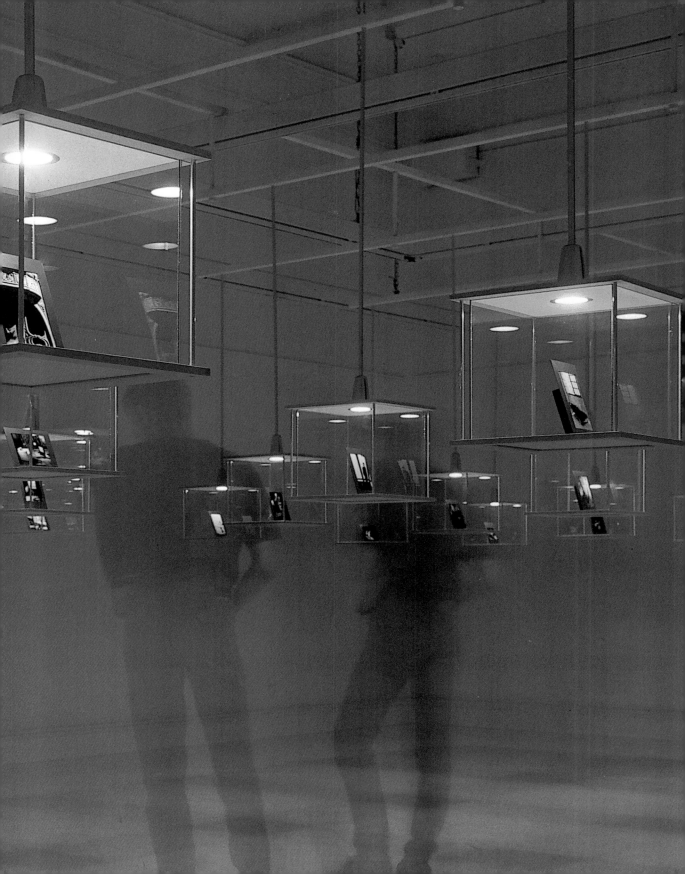

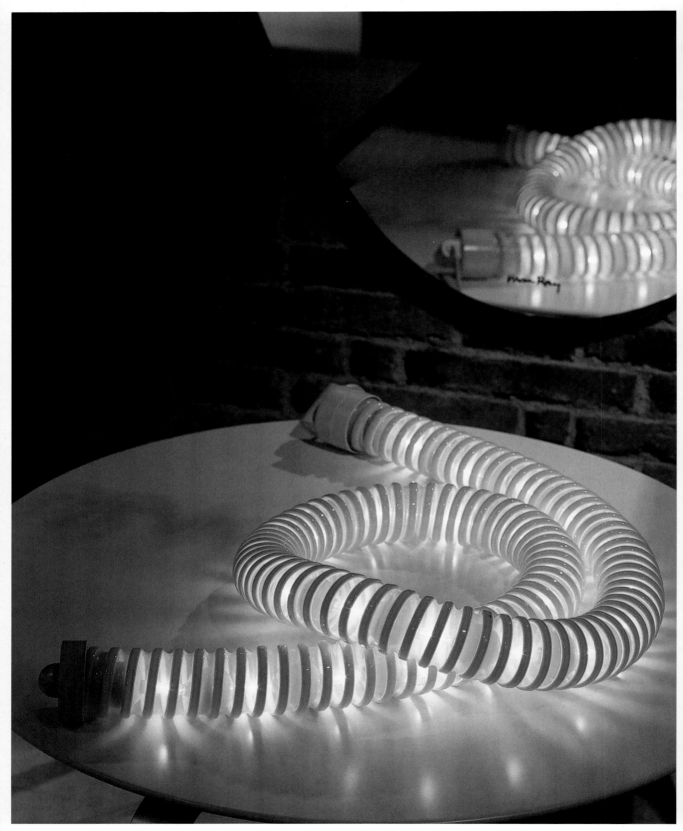

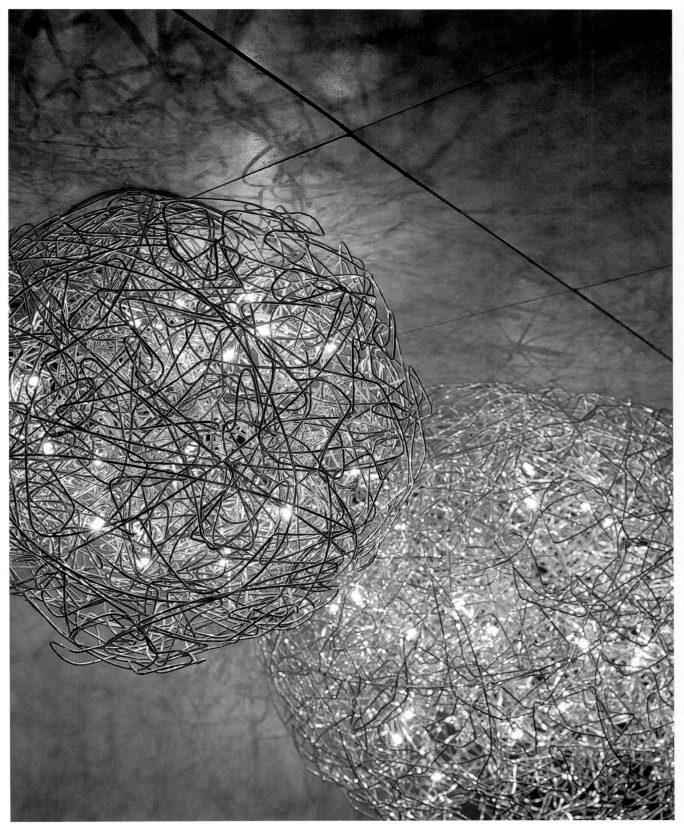

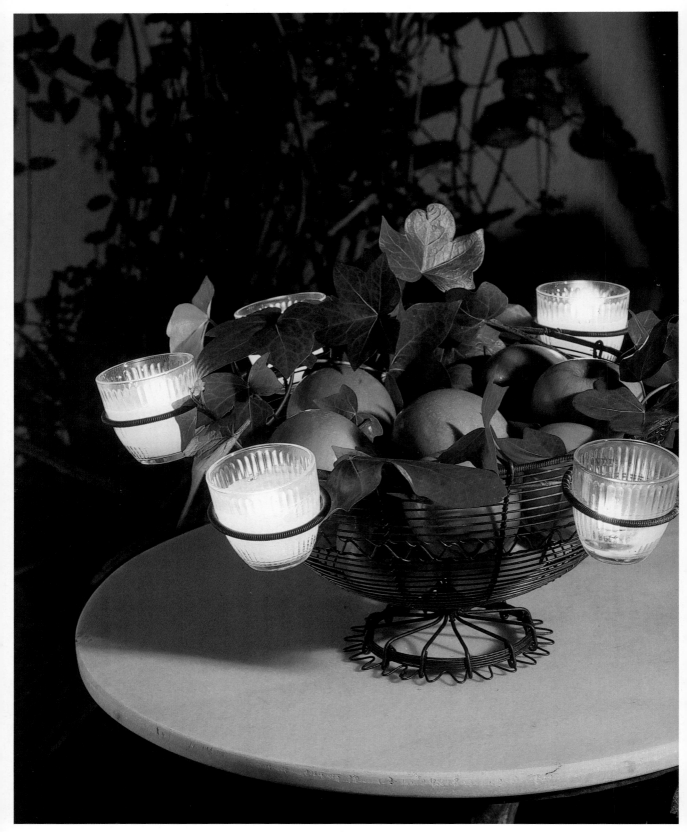

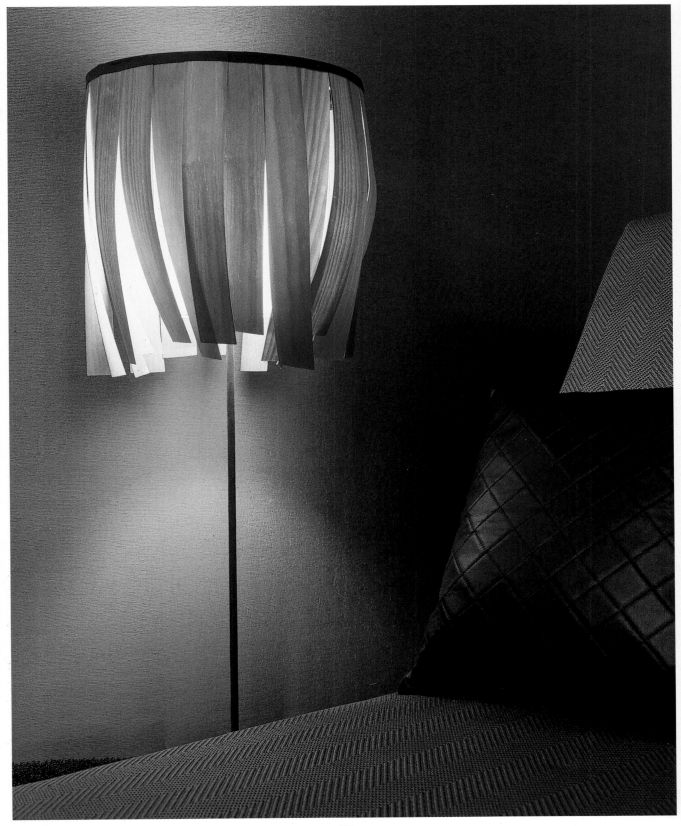

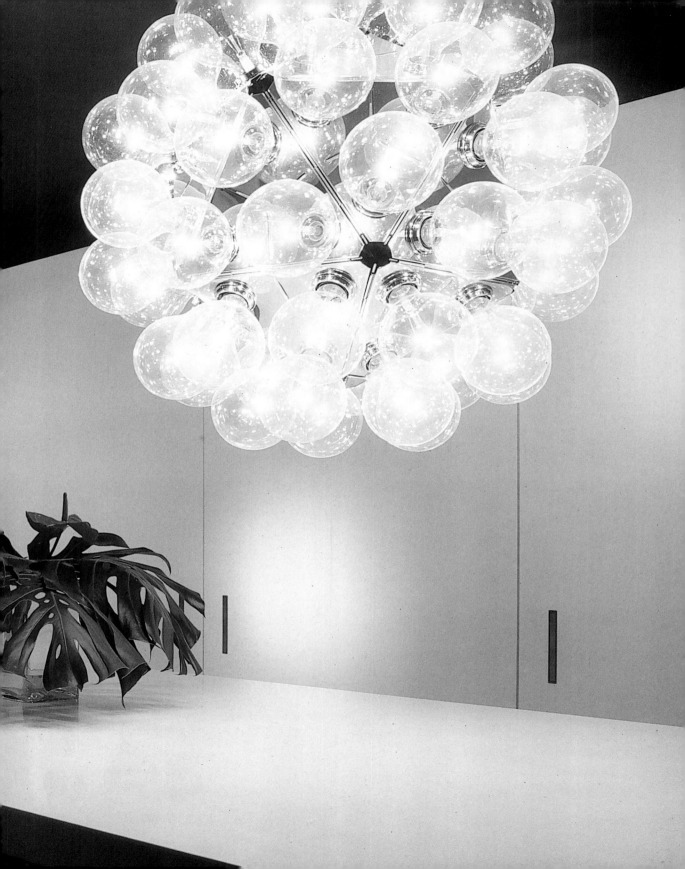

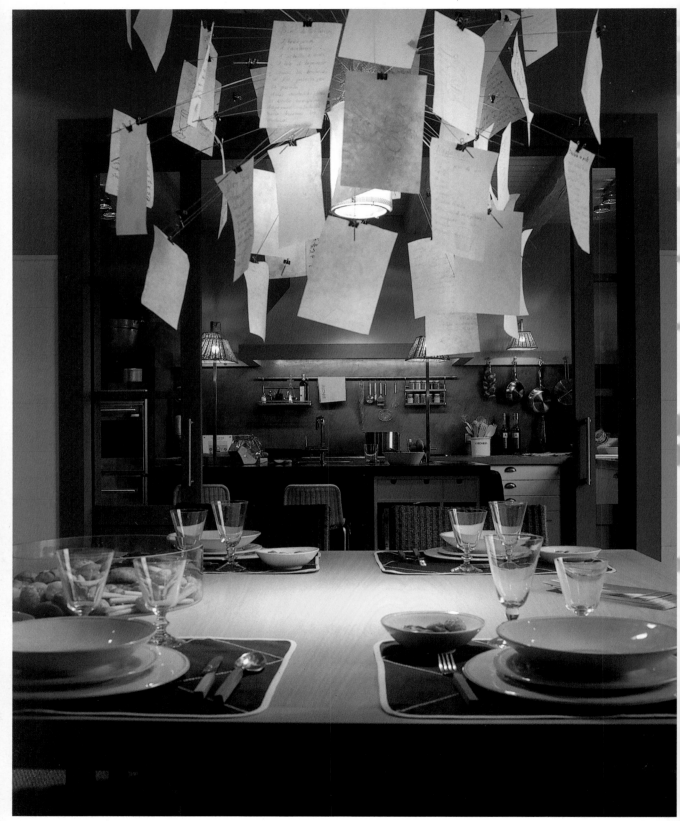

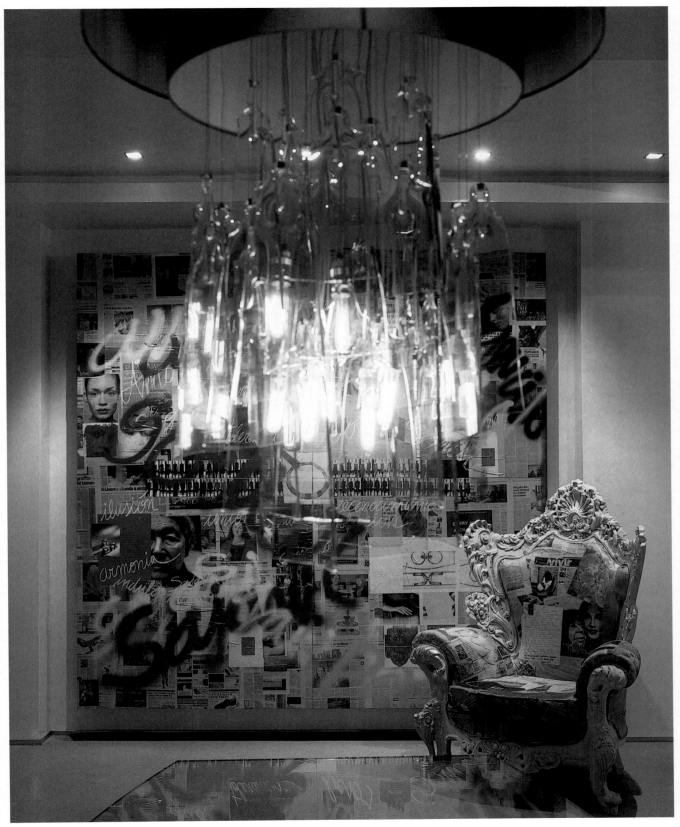

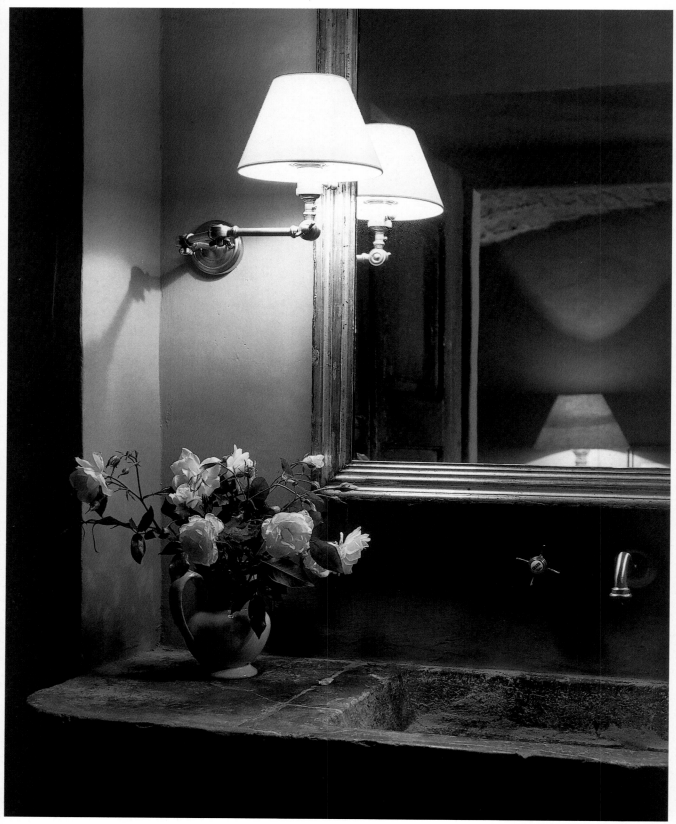

Lamps

Tolomeo table lamp, by Michele de Lucchi for Artemide, at Vinçon. Max. 60 W, clear or frosted incandescent bulb.

Toma lamp, by E. Thome, at BD. Bright 60 W, incandescent bulb with silver dome.

GT5 suspended lampshade, by Santa & Cole. Max. 3x100 W 230 V. E27.

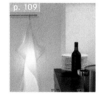

Lamp by Ingo Maurer. Store: Greek.

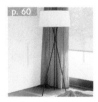

G5 Tripod lamp, by Santa & Cole. Max. 100 W 230 V. E27.

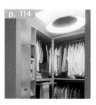

GT7 ceiling lamp, by Santa & Cole. Max. 3x100 W 230 V. E27.

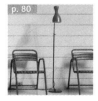

Nordica floor lamp, by Santa & Cole. Max. 100 W 230 V. E27

Pie de garza standing lamp, by Jordi Miralbell and Mariona Raventós. Made by Santa & Cole. Max. 100 W 230 V. E27.

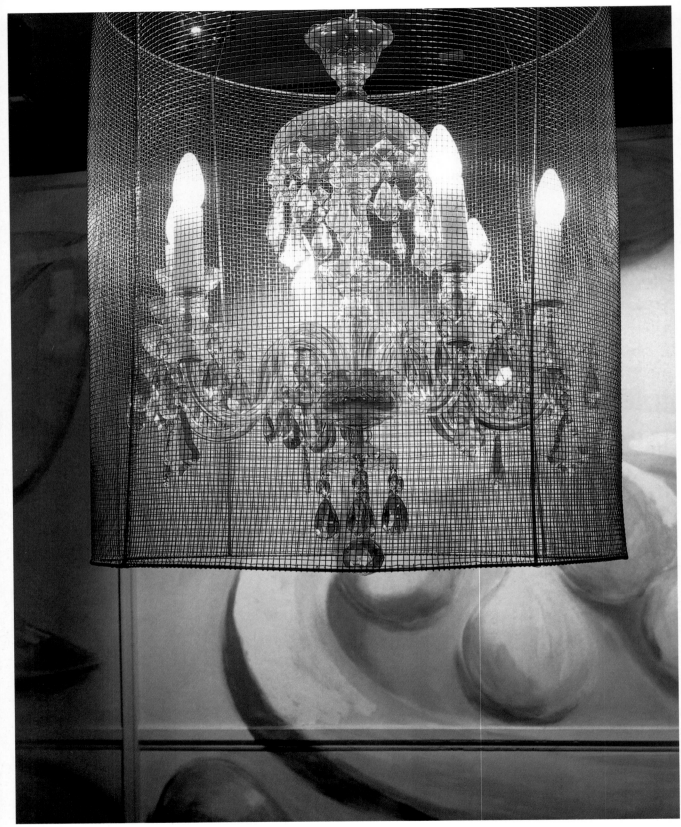

From Mares del Sur collection, Boomerang pie, by Enric Miralbell for Sevenseas, at En Linea Barcelona.

Capellini floor lamp.
Store: Greek.

Tortuga lamp, by Nicoletta Rosetto made by Bossa for Boffi, at En Linea Barcelona.
Max. 60 W, incandescent bulb.

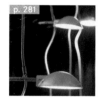

Hot Achille halogen lamps, by Ingo Maurer.
Low-voltage halogen bulb.
Store: Greek.

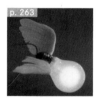

Luccelino lamp, by Ingo Maurer
60 W, frosted incandescent bulbs.
Store: Greek.

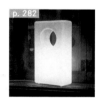

LIO lamp, by Sebastián Bergen for Driade, at BD.
60 W, frosted incandescent bulb.

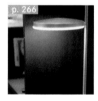

Pia Dim lamp, by Metalarte, at BD.
Circular fluorescent bulb.

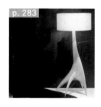

From the Mares del Sur collection, Fidji lamp by Enric Miralbell for Sevenseas, at En Linea Barcelona.
Max. 60 W, frosted incandescent bulb.

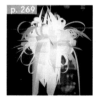

Blow-up lamp, by Alejo Roucco, at BD.
60 W, frosted incandescent bulb.

Top Secret lamp, by Héctor Serrano for Metalarte, at BD.
Max. 20 W. E27.

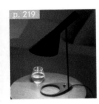

AJ lamp, by Arne Jacobsen for Louis Poulsen, at BD.
Bright 60 W, incandescent bulb.

Olvidada ceiling lamp, by Pepe Cortés, at BD.
Three 60 W, incandescent Linestras.

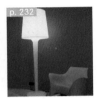

In/out lamp, by Ramón Ubeda and Otto Canalda for Metalarte, at BD and Vinçon.
Indoor/outdoor.
Max. 100 W, frosted. E27.

Lu-Lu table lamp, by Stefano Casciani for Oluce.
60 W, frosted incandescent bulb.
Store: Greek.

Easy Mechanics table lamp, by Christophe Pillet for Tronconi at En Linea Barcelona.
Max. 60 W, incandescent bulb.

Flash table lamp, by Oluce.
60 W, frosted incandescent bulb.
Store: Greek.

Coupe lamp, by José Colombo for Oluce, at En Linea Barcelona.
Max. 60 W, incandescent bulb.

Spun light floor lamp, by Sebastián Wrong for Flos, at En Linea Barcelona.
Max. 100 W. E27.

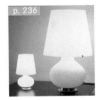

Fontana lamp, by Max Ingrad for FontanaArte.
100 W, incandescent bulbs.
Store: Greek.

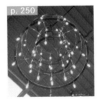

Vague Stelle ceiling lamp, by Antoni de Moragas, at BD.
Max. 25 W, transparent tubular bulbs.

Fortuny moda floor lamp with tripod, by Mariano Fortuny, at BD. 500 W, clear incandescent bulb.

Zero lamp, by Liévore Altherr Molina for Metalarte. Max. 7x60 W. E14.

Samesane silk over metal lamp, by Ayala S. Serfaty for AQUA. Distributed by CA2L. Compact fluorescent bulb.

Elle lamp, by Manolo Bossi, made by Bossa for Boffi, at En Linea Barcelona. Max. 60 W, frosted incandescent bulb.

Morning Glory. Distributed by CA2L. Compact fluorescent bulb.

Boalum lamp, by Livio Castigliono & Gianfranco Frattini for Artemide, at En Linea Barcelona. Max. 25 W, incandescent bulb.

64 happy days (large), 46 happy days (small), and Merkid (long). Distributed by CA2L. One compact fluorescent bulb.

Fucsia ceiling lamps, by Achille Castiglioni for Flos, at BD. 40 W, frosted incandescent bulb, with diffuser.

Sahara (large) and Maestro (small, front). Distributed by CA2L. One compact fluorescent bulb.

Collaborators

The authors would like to give special thanks to all of the home owners for having let us into their homes, to the project designers for their creativity, and to the following people and entities for their help and collaboration during the realization of the photo shoots:

Stylists:
Estele Gómez Lupión
Tona Corominas

Styling assistant:
Natalie Demont

Project designers:
ABR
Adela Cabré
Ágatha Ruiz de la Prada
Agnés Blanch
Alicia Peláez
Amelia Arán
Ana Peña
Ana Simó
Anabel González
Antonio Perez-Mani
Augusto Lemonnier
Bernardo López-Arranz
Bet Figueras
Bjorn Vercauteren
Caroline Grammont
Catherine Grenier
Claudia Valsells
Cristina Rodríguez
Deulonder
Diego Rodríguez
Eduardo Arruga
Elina Vilá
Emma Farrás
Enrique Naharro
Equipo Vinçon
Erico Navazo
Estrella Slietti
Eva Maraver
Fernando Amat
Fernando Salas
Francesc Rifé
Helena Valsells
Hotel Arts Barcelona

Ignacio García Villar
Isabel López
Isabel López-Quesada
Isabel Quirós
Iván Pomés
Javier González Frías
Javier Judrá
Javier Muñoz
Javier Sol Guerrero
Jesús Gimeno
J.G. Ferrater
Jordi Galí
Jordi Sarrà
Jose Luis Cácamo
Josep Boncompte
Laura Granedo
Leonor Barbé
Lorna Agustí
Ma José Cabré
Manuel Menéndez
María de Ros
María Jover
Maribel Caballero
Marre Maerel
Max Llamazares
MC la esencia del color
Natalia G. Novelles
Natalia Gómez
Natalie Denys
Olatz de Ituarte
Olga López de Vera
Oscar Tusquets
Patricia von Arend
Pere Cortacans
Pilar Líbano
Raúl Martins
Reyes Ventós
Reyes Pujol Xicoy
Rosa Roselló
Sandra Tarruella
Santiago Nin

Barnices Valentine (www.valentine.es)
CASA DECOR (www.casadecor.es)
Osram (www.osram.com)

Lighting Shops
and Companies

Aqua Creations (www.aquagallery.com)

Artemide (www.artemide.com)

BD Ediciones de Diseño (www.bdediciones.com)

Blauet (www.blauet.com)

B.Lux (www.blux.es)

Capellini (www.capellini.com)

Carpyen (www.carpyen.es)

CA2L (www.ca2l.com)

Dab (www.dab.es)

Diart (www.diart.es)

En Linea Barcelona (www.enlineabarcelona.com)

Ferruz Decoradors

Flos (www.flos.com)

FontanaArte (www.fontanaarte.it)

Foscarini (www.foscarini.com)

Greek (www.greekbcn.com)

Iguzzini (www.iguzzini.com)

Kartell (www.kartell.com)

Louis Poulsen (www.louis-poulsen.com)

Lumina (www.lumina.com)

Lutron. Domotica (www.lutron.com)

Marset (www.marset.com)

Metalarte (www.metalarte.com)

Minim (www.minim.es)

Ojinaga

Oluce (www.oluce.com)

Santa & Cole (www.santacole.com)

Taller Uno (www.talleruno.com)

Targetti (www.targetti.com)

Vinçon (www.vincon.com)